16

The Cult of the Avant-Garde Artist examines the philosophical, psychological, and aesthetic premises for avant-garde art and its subsequent evolution and corruption in the late twentieth century. Arguing that modernist art is essentially therapeutic in intention, both toward self and society, Donald Kuspit further posits that neo-avant-garde, or postmodern, art at once mocks and denies the possibility of therapeutic change. As such, it accommodates the status quo of capitalist society, in which fame and fortune count above everything else. Stripping avant-garde art of its missionary, therapeutic intention, neo-avant-garde art converts it into a cliché of creative novelty or ironic value for its fashionable look. Moreover, it destroys the precarious balance of artistic narcissism and social empathy that characterizes modern art, tilting it cynically toward the former.

Incorporating psychoanalytic ideas, particularly those concerned with narcissism, *The Cult of the Avant-Garde Artist* offers a reinterpretation of modern art history. Exemplary avant-garde and neo-avant-garde artists, including Picasso, Malevich, Warhol, and Beuys, and such movements as surrealism, expressionism, and appropriationism, are examined in depth to demonstrate their therapeutic aims and intentions, or lack thereof. The varieties of artistic expression and their attendant ideas are viewed in light of Kuspit's basic thesis, providing a fresh understanding of developments in the art of this century.

The Cult of the Avant-Garde Artist

The Cult of the
Avant-Garde Artist

DONALD KUSPIT

State University of New York, Stony Brook
and Cornell University

CAMBRIDGE
UNIVERSITY PRESS

Published by the Press Syndicate of the University of Cambridge
The Pitt Building, Trumpington Street, Cambridge CB2 1RP
40 West 20th Street, New York, NY 10011-4211, USA
10 Stamford Road, Oakleigh, Melbourne 3166, Australia

First published 1993
Reprinted 1993, 1994
First paperback edition 1994
Reprinted 1995

Printed in the United States of America

Library of Congress Cataloging-in-Publication Data is available.

A catalogue record for this book is available from the British Library.

ISBN 0-521-46922-8 paperback

FOR JUDITH

A charismatic group consists of a dozen or more members, even hundreds or thousands. It is characterized by the following psychological elements: members (1) have a *shared belief system*, (2) sustain a high level of *social cohesiveness*, (3) are strongly influenced by the group's *behavioral norms*, and (4) impute *charismatic or sometimes divine power* to the group or its leadership.

Marc Galanter, *Cults:
Faith, Healing, and Coercion*

The first characteristic process [of ideological totalism] is "milieu control," which is essentially the control of communication within an environment. If the control is extremely intense, it becomes an internalized control – an attempt to manage an individual's inner communication. . . . A second general characteristic of totalistic environments is . . . "mystical manipulation" or "planned spontaneity." It is a systematic process that is planned and managed from above (by the leadership) but appears to have arisen spontaneously within the environment. . . . The next two characteristics of totalism, "the demand for purity" and the "cult of confession," are familiar. The demand for purity . . . calls for radical separation of pure and impure, of good and evil, within an environment and within oneself. . . . it ties in with the confession process. Ideological movements . . . take hold of an individual's guilt and shame mechanisms to achieve intense influence over the changes he or she undergoes. . . . The next three patterns . . . to ideological totalism are the "sacred science," the "loading of the language," and the principle of "doctrine over person." . . . in our age something must be scientific as well as spiritual to have a substantial effect on people. . . . The term "loading the language" refers to a literalization of language – and to words or images becoming God. . . . The pattern of doctrine over person occurs when there is a conflict between what one feels oneself experiencing and what the doctrine or dogma says one should experience. . . . Finally . . . perhaps the most general and significant of these characteristics, is . . . the "dispensing of existence." . . . Impediments to legitimate being must be pushed away or destroyed. One placed in the second category of not having the right to exist can experience psychologically a tremendous fear of inner extinction or collapse. However, when one is accepted, there can be great satisfaction of feeling oneself part of the elite.

Robert Jay Lifton, "Cults:
Religious Totalism and Civil Liberties"

CONTENTS

CHAPTER I

AVANT-GARDE AND NEO-AVANT-GARDE
FROM THE PURSUIT OF THE PRIMORDIAL TO THE NIHILISM OF NARCISSISM

The Idealization of the Avant-Garde Artist as Transmuter of Value

Do not
frighten me more than you
have to! I must live forever.
 Frank O'Hara[1]

"Ah! Sir, a boy's being flogged is not so severe as a man's having the hiss of the world against him. Men have a solicitude about fame; and the greater the share they have of it, the more afraid they are of losing it." I silently asked myself, "Is it possible that the great SAMUEL JOHNSON really entertains any such apprehension, and is not confident that his exalted fame is established upon a foundation never to be shaken?"

James Boswell[2]

How little are genuine artists concerned with their artistic prestige! Their primary concern is not the masterpiece itself, but the ability to create, to remain alive, even when this may often push them down below heights previously reached.
 Max Frisch[3]

The apotheosis of the avant-garde or modernist artist as the symbol of heroic resistance to all that is oppressive and corrupt in bourgeois civilization, if not as its savior, has been until recently the major way of stating the significance of modern art. So-called postmodernism or neo-avant-garde art is the symbol of its passing, the indication that the idol has feet of clay.[4]

The avant-garde artist is conceived as a kind of Promethean adventurer, an individualist and risk taker in a sheepish society, an Overman bringing to the more timid world of the herdman, to use Friedrich Nietzsche's distinction,[5] a new kind of fire, burning away blinding darkness and affording new insight as well as sight, a new vision of what art as well as life can be – a comprehensive new enlightenment.

This conception of the avant-garde artist has become the raison d'être – at once the centerpiece, backbone, and justification – of modern art. It has been generalized into an adulatory fetishization of the artist as such. Modern thinkers have attributed special authenticity, integrity, and power to the artist. Because he is able to be himself in a way that is impossible for other people, he is able to experience in a more fundamental, original way than they can. Indeed, he is able to experience, seemingly without mediation, what is fundamental or original in experience, while for them experience is so thoroughly shaped, even permeated, by the conventions that mediate it that they would not recognize what is fundamental to it if they stumbled across it. Not only has the artist been sharply differentiated from and elevated above others, but those others have been regarded as too ordinary to comprehend how extraordinary it is to be an artist – although they are obliged to be his audience, in homage to his creativity, if not necessarily to the particulars of his production. They are obliged to give him fame simply for his being, even if they can make no sense of it.

The artist, then, not only can realize himself more than anyone else by reason of his creativity, but is a beacon to these banal others, even a kind of Moses leading them out of their ordinary world of perception and away from their ordinary sense of life to a promised world of perception and an altogether novel sense of life. He is one of those heroes we are supposed to worship, for he has overcome fate through creativity. We submit to him, and to that collectivity called created art, in order to realize vicariously our own creativity.[6] The artist acts it out for us; by identifying with him we imagine we have a unique identity of our own. An actor on the grand stage of art history, his fame is the audience's surrogate identity and creativity.

There are two kinds of avant-garde constructions – mythologizations – of the artist: those that attribute special perceptual power to him and those that regard him as uniquely authentic in an inauthentic society. In Enrico Baj's words, this is why avant-garde art, even though it takes no "definite stand," is "opposed to things . . . on a formal level," that is, perceptually subversive, and why it "confronts and opposes officialdom," that is, seems socially subversive.[7] In a final mythifying touch, the artist is idealized for the transmutation of value – for the revolution in the sense of life – that his perceptual and personal authenticity effect and symbolize. Not only do they serve his self-transmutation – his personal release from the agony of life, an agony he is conscious of and a liberation he desperately desires – but, through the art that embodies his authenticity, he transmutes the lives of others, giving them a liberation they were too sunk in suffering to know they needed. Indeed, they did not know that life was as much of a suffering as it was until they were released from that suffering through art. Possessed by art, a new spirit of life awakens in them. By an artistic miracle, despair about life changes into joy at living; ecstatic experience replaces a sense of the futility of existence. Indeed, existence itself seems transfigured – new and fresh where it was once old and stale. Instead of the depressing feeling that one's life, and one's world, are in irreversible decline, they feel alive with possibility. Instead of the debilitating sense of decadence, there is the invigorating sense of confident advance. Our exhilaration sweeps aside all

impediments, opening new horizons. Our self and the world seem reborn and transfigured – as ineradicably alive and authentic as the artist himself. His self-overcoming has shown us the way to our own. No doubt he is in a class by himself, not only because he cannot relapse to ordinariness and inauthenticity, but also because he has shown us the way to experience as he does – even to feel as authentic as he feels – however briefly. We too can, transiently, through the experience of art, know what it is to experience primordial reality and feel personally authentic – to be heroic.

I think it is worth the trouble to spell out the details of this belief system, for while in serious disrepair it has hardly passed from the scene. Indeed, this book is about the conflict between two fundamentally irreconcilable conceptions of the artist – the contradictory sense of the artist we have today. Such contradiction suggests that our idea of – and, above all, our attitude toward – the artist is undergoing a so-called paradigm change. Behind the glowing respect for art is a certain doubt about what it gives us. This book is about the simultaneity of this respect and doubt: it is about the new ambivalence about the artist – in contrast to the old ambivalence, in which his deviance and outsiderness were unconsciously admired and envied even as they were consciously deplored. Today, the artist remains an unconventional hero, but he is also perceived as a pretender – all too stylized and privileged in his unconventionality – if not quite a conventional fraud. He is a lover of life and renewer of experience, but also what can only be called a necrophiliac of art, more in love with it – especially if it is dead – than with life. He mediates aspects of experience we never even knew were there, making us aware of it in a way we never knew was possible and disclosing subtleties where we saw only grossly; but he also betrays experience by codifying it stylistically, preserving it in aesthetic amber whose glow in the end becomes more important to him than the experience itself. The artificial aura of art becomes more important than the aliveness of experience. The avant-garde artist is a myth in which we have invested all too much of ourselves; disinvesting, and unmasking him – breaking the spell – we discover the nightmare of the neo-avant-garde artist, giving us a myth of art rather than of experience. He tells us that we can have profound, magical experience by rubbing the Aladdin's lamp of art, while the avant-garde artist tells us that we can have profound, magical art by rubbing the Aladdin's lamp of experience. Who are we to believe and trust?

Alfred North Whitehead writes:

We look up and see a coloured shape in front of us, and we say, – there is a chair. But what we have seen is the mere coloured shape. Perhaps an artist might not have jumped to the notion of a chair. He might have stopped at the mere contemplation of a beautiful colour and a beautiful shape. But those of us who are not artists are very prone, especially if we are tired, to pass straight from the perception of the coloured shape to the enjoyment of the chair, in some way of use, or of emotion, or of thought. . . . I am very sceptical as to the high-grade character of the mentality required to get from the coloured shape to the chair. One reason for this scepticism is that my friend the artist, who kept himself to the contemplation of colour, shape and position, was a very highly trained man, and had acquired this facility of ignoring the chair at the cost of great labour. . . . Another reason for

scepticism is that if we had been accompanied by a puppy dog, in addition to the artist, the dog would have acted immediately on the hypothesis of a chair and would have jumped ᴜnto it by way of using it as such. Again, if the dog had refrained from such action, it would have been because it was a well-trained dog. Therefore the transition from a coloured shape to the notion of an object which can be used for all sorts of purposes which have nothing to do with colour, seems to be a very natural one; and we – men and puppy dogs – require careful training if we are to refrain from acting upon it.[8]

This celebration of the artist inaugurates Whitehead's discussion of the distinction between presentational immediacy and causal efficacy, and more generally, between direct sense perception and symbolism. For Whitehead, "sense-perception is mainly a characteristic of more advanced organisms; whereas all organisms have experience of causal efficacy whereby their functioning is conditioned by their environment."[9] For Whitehead, the artist is clearly a very advanced organism. While the rest of us remain completely dependent on symbols, which more or less facilitate our functioning in our environment, the artist is able to transcend them toward pure "sense presentations," which, as ends in themselves giving us a primordial sense of the environment, have nothing to do with our functioning. The artist deals in "direct experience," which is "infallible" – for "what you have experienced, you have experienced" – while "symbolism is very fallible, in the sense that it may induce actions, feelings, emotions, and beliefs about things which are mere notions without that exemplification in the world which the symbolism leads us to presuppose."[10] As Whitehead says, while it is important for an organism's success in an environment that its "symbolic functionings [be] justified so far as important issues are concerned," the fact of the matter is that "the errors of mankind equally spring from symbolism," necessitating that "reason . . . understand and purge the symbols on which humanity depends."[11] Whitehead seems to think that the artist does not use direct sense experience to symbolic purpose, but exhibits it in all its presentational immediacy. As such, what he does is not subject to the correction of reason. That is, one cannot reason about – rationalize, in all the varieties of that word's meaning – sense presentations; one can only acknowledge and enjoy them aesthetically.

It hardly seems true that art can liberate us from symbols, that it has little or nothing to do with them – that the artist can restrain himself so completely from symbolic functioning as to avoid the slightest hint of the symbolic significance of sense presentations. He is not only an artist but an ordinary man who cannot help wondering what his sense presentations mean. By investing them, however unconsciously, with meaning and with his own sense of life, he cannot help regarding them as signs, if obscure, of something in the environment or in his psyche. The artist's phenomenological reduction, as it were, of symbolic functioning can never be complete, by reason of his human condition. Indeed, what we sense is already fraught with symbolic significance, so that to describe the sense presentation as the kernel of experience and its symbolic meanings as so many shells – discardable dross – seems a gross falsification of experience. It

seems impossible that sense presentations could have nothing inherently to do with intention and function. Why should Whitehead think that the artist can avoid the banality of "the causal side of experience," so "dominating" for everyone else, or disentangle it more easily from sense experience?[12] It is, in symbolic form and fused with sense experience, constitutive of our sense of reality. Indeed, the sense of reality is the by-product of the dialectical integration of sense experience and presupposed symbols. It seems that Whitehead's attribution to the artist of the power of autonomous sensing idealizes him – and it – beyond the reach of theory. The artist is the exception that proves the rule of experience for every-one else. Whitehead's conception of the artist also suggests that the artist is more uncannily objective than the rest of us, for in pushing his sense presentations to the fore in his art he is insisting that there is some-thing more fundamental in experience than any symbolization of it indi-cates – something that every symbolization assumes. Thus Whitehead doubly idealizes the artist, considering the artist's "sensibility" profoundly "realistic."

Such idealization of the artist is classically modernist. Whitehead's seem-ingly absurd assumption, absolutizing one aspect of art and suggesting a blind spot – even a serious philosophical wrongheadedness and inade-quacy – in its inevitable symbolic functioning, is a standard modernist be-lief about art. Indeed, in being conceived as a direct articulation of sense presentation, art becomes as infallible and unique as that experience, and as such the privileged avenue of approach to what is ultimate in experience. Whitehead even implies that if there were no such being as an artist we would not know what a pure sense presentation is, except fitfully and in-termittently. Art not only makes the data of experience directly available but confirms them as fundamental and fated – primordial. Whitehead's elevation of art over symbolic functioning is hardly novel. For example, Leo Bersani asserts that art has nothing to do with the "communication of knowledge," which involves "difficulty" and requires interpretation – Whitehead's "correction" of reason (knowledge would be symbolization of causal functioning for him) – but rather has to do with the "enigmatic display of being" in all its "density."[13] Or, in Susan Sontag's formulation, an "erotics" of art is more to the point than an interpretation of it, which tends to obscure – almost read away – the sense presentations art conveys through its own sensuous presence.[14]

In sum, the myth of the avant-garde artist involves the belief that he is initiated into the mysteries of primordial experience. He is able to display the sensuous density of being with a primordial sensuousness equal to its own, to produce works of art as enigmatically dense as being itself. His art is an amazing act of primordial mimesis, in which he unlearns or suspends ordinary symbolizations of experience – one might say the inhibitory symbolizations of experience that make it ordinary – in order to display its primordial givenness. The intensification of color and shape that art seems to effect – the unusual presence it gives them – bespeaks its power to present them with primordial immediacy. Presentation is all, representation nothing in authentic art.

The primordial immediacy of the sense presentation suggests that it is in perpetual process of self-formation, and as such always new. At the same time, it seems the totality of experience. By its very nature, it cannot tempt us to jump to causal conclusions, for it leads nowhere, points to nothing. Even though it is a kind of limit to experience, it has nothing to do with the unavoidable functional and emotional limits of human experience. By reason of the aesthetic glory of its presentational immediacy, which makes it unprecedented and without consequence, it seems the fundamental reality.

Erich Fromm idealizes the artist's spontaneity, arguing that "while spontaneity is a relatively rare phenomenon in our culture," there are "individuals who are – or have been – spontaneous, whose thinking, feeling, and acting were the expression of their selves and not of an automaton. These individuals are mostly known to us as artists. As a matter of fact, the artist can be defined as an individual who can express himself spontaneously."[15] Why is spontaneous expression so important? Because while "emotional and intellectual potentialities . . . are present in everybody, they become real only to the extent they are [spontaneously] expressed. In other words, *positive freedom consists in the spontaneous activity of the total, integrated personality.*"[16] In a sense, without spontaneous activity we do not know what our potentialities are. According to Fromm:

Spontaneous activity is not compulsive activity, to which the individual is driven by his isolation and powerlessness; it is not the activity of the automaton, which is the uncritical adoption of patterns suggested from the outside. Spontaneous activity is free activity of the self and implies, psychologically, what the Latin root of the word, *sponte,* means literally: of one's free will. By activity we do not mean "doing something," but the quality of creative activity that can operate in one's emotional, intellectual, and sensuous experiences and in one's will as well. One premise for this spontaneity is the acceptance of the total personality and the elimination of the split between "reason" and "nature"; for only if man does not repress essential parts of himself, only if he has become transparent to himself, and only if the different spheres of his life have reached a fundamental integration, is spontaneous activity possible.[17]

Thus Fromm attributes a monopoly on free will and self-integration to the artist, as if he alone could end the dissociation of sensibility – the alienation of thinking from feeling, and vice versa – that T. S. Eliot regards as characteristic of modernity.[18] While Fromm says that "the artist can be defined as an individual who can express himself spontaneously," and thus that "certain philosophers and scientists have to be called artists too," in fact he regards the creative artist's self-expression as the model for spontaneous activity, as suggested by his metaphoric comparison of inartistic philosophers and scientists with artistic ones. The former "are as different from [the latter] as an old-fashioned photographer from a creative painter."[19] Moreover, one needs an "objective medium," such as the artist's, in and through which to be spontaneously expressive. Philosophers and scientists do not, strictly speaking, project themselves into a medium, nor can what they do – communicate knowledge – be regarded as spontaneously expressive. Communicating knowledge inhibits spontaneity and creativity; the

artist, on the other hand, is concerned only with expressing himself spontaneously and with objectifying his creativity in a medium.

"The spontaneous gesture is the True Self in action," writes D. W. Winnicott. "Only the True Self can be creative and only the True Self can feel real. Whereas a True Self feels real, the existence of a False Self results in a feeling unreal or a sense of futility."[20] From this point of view, Fromm's idealization of the artist as more spontaneous than other people privileges the artist as more truly himself than others can ever be. Saying that an artist spontaneously expresses himself in his art acquires another nuance of meaning: it means that through his art he makes his sense of feeling-real alive and real for others. He projects it into his medium, which projects it for others. Perhaps creativity consists in such projection: the artist makes others feel real and integral by his own spontaneous activity, his expression of his True Self. Fromm's differentiation between spontaneous activity and compulsive activity, free activity and automatic activity, the creative expression of an integrated self and the routine doing of things by the unintegrated person, is, in Winnicott's terms, the difference between the True and False Selves. While the False Self's "defensive function is to hide and protect the True Self," and at its healthiest the False Self's "main concern [is] a search for conditions which will make it possible for the True Self to come into its own," the False Self, "represented by the whole organization of the polite and mannered social attitude,"[21] can become all too "compliant . . . to environmental demands," all too imitative of others, all too ready to be exploited by them.[22] One is then not truly oneself, to the degree that one cannot imagine what it is like to be spontaneous or feel really real.[23]

Fromm, and to some extent Winnicott,[24] privileges the artist as more of a True Self than a False Self, or more true to himself than false to himself, because he is more spontaneously expressive than compliant to his environment, more "primary" than "reactive to external stimuli," and as such closer to "the experience of aliveness," associated with "the aliveness of the body tissues and the working of body-functions," than to conformist experience of the environment.[25] Is the artist's False Self defense inadequate, which is why he looks – only looks – truer to himself than other people seem to be to themselves? Is he really all True Self, or more True Self than anyone else? Might his spontaneity be compulsivity in disguise? Fromm doesn't consider these possibilities. The artist never forfeits his primordial spontaneity, his basic sense of True Selfhood. Like Whitehead, Fromm cannot think critically about the artist. He confuses a theoretical construct with a perfected person.

These, then, are the basic articles of faith in the avant-garde artist: he is more spontaneous – primordially expressive – than anyone else because he is more absolutely integrated than anyone else, and he can experience in a more primordial way than other people because his sense perception is not bound by symbolic functioning. It is because the artist is spontaneous in the face of an environment asking him to conform to it that he is able to sense reality in all its presentational immediacy. To put this in Whiteheadean language, it is because the artist does not accept society's symbol systems that he is able to sense with unusual directness what is fundamental. He is more

alive, as it were, or rather more sensitive to his aliveness, than the rest of us, which is why he is ecstatically alive to sense presentations. He is able to quintessentialize reality in a sense of the primordial because he is quintessentially himself.

The avant-garde artist's sense of the primordial embodies itself in what Hermann Broch calls "mysticism of the medium."[26] In objectifying his expression in the medium, the artist invests it with his primordial sense experience and sense of self, transforming it into a primordial substance, as it were, which seems the mythical whole of experience. The medium seems to have the same immediacy as the pure sense presentation, and the same integrity as the True Self. Such mysticism – mystification and mythification? – of the medium intensifies the avant-garde artist's sense of the world's objective reality and his own subjective reality. The medium, now the primary object of sense experience, the field on which it is played out, becomes the surrogate for – indeed, the advocate of – the self. It becomes external and internal object in one, a mode of relation in itself.[27] Indeed, mysticism of the medium means fusing symbiotically with it, establishing a unity of internal and external values. The medium nurtures and supports – indeed, mothers – the artist, embodying his sense of purpose. Insight into the medium gives him his intention as an artist. At the same time, mysticism of the medium is not blind narcissistic investment in it, for the self responds to it instinctively and restlessly, and it is sensuously appealing only when it is sensuously unsettling, that is, when it suggests new possibilities of sensing.

Thus the medium catalyzes introspection as much as it invites inspection; that is, it affords awareness of internal as well as external states of being. It becomes a medium of feeling presentation as well as of sense presentation – the total expression of the self. The avant-garde artist is supposedly privileged to have more intense feelings as well as more intense sensations than the rest of us, and to be able to know and articulate both in a better way. One might say that sense presentations, which quintessentialize currently experienced external objects, are themselves quintessentialized by being objectified in the medium, and as such quintessentialize feelings embodied in internal objects. These are primordially experienced objects, that is, objects constituted when we were in the process of formation; they constitute our psychic form. The medium becomes the perfect transitional space,[28] not unlike Leonardo's wall;[29] it induces hallucinatory images that are as much representations of internal reality (fantasies) as of external reality (descriptions). Indeed, art's aim is to fuse both seamlessly.

In its decadent appropriation of avant-garde art, the neo-avant-garde is narcissistic, however much the avant-garde art produced under the auspices of the idea of art for art's sake seems to be narcissistic as well. If art for art's sake implies narcissism, it is secondary or defensive narcissism,[30] rather than the consummate, cynical, self-celebratory narcissism of neo-avant-garde art. Art for art's sake is in fact a refined mysticism of the medium, in which the feeling presentations implied by the sense presentations count more than they do, or rather in which the sense presentations are spontaneously experienced as – rather than simply seeming to symbolize – feeling

presentations. Art for art's sake is art's final defense against the threat posed to it by modern science and technology, which seem to deprive it of any realistic function, even of any reason for being.[31] Art for art's sake asserts that art may no longer be the most adequate expression of external reality, but that it is still the best expression of internal reality.

Fear of decadence and the wish for rejuvenation haunt – indeed, terrorize – modern thinking about art. Nietzsche's conception of art as the only means of transmuting values – of rescuing life from decadence by rejuvenating it – epitomizes this dialectic of decadence, as I have called it.[32] Nietzsche's artist is an "Overman" – *the* Overman for modern times – signifying, in the words of a commentator, "the possibility of transmutation as a new way of feeling, thinking, and, above all, as a new way of being."[33] He represents the will to power, involving a "*reversal* of values" in which "the active" replaces "the reactive," and, on the basis of this reversal, the "*transmutation* of values, or *transvaluation*," in which "affirmation takes the place of negation."[34] In Fromm's terms, then, personal spontaneity replaces socially automatic reaction; in Winnicott's terms, the True Self's feeling-real replaces the False Self's feeling futile; and in Whitehead's terms, direct sense experience, epitomized in aesthetic awareness of presentational immediacy – the freshness of primordial sense presentations and feeling presentations – replaces symbolic functioning for the sake of causal efficacy. In every case socially induced decadence – one might say the decadence of self necessary for social functioning – is overcome by the power of self-rejuvenation, catalyzed by art. To the freshly young self, the world itself becomes young again: indeed, it is rejuvenated in the artist's senses, which have been rejuvenated by his spontaneity.

Nietzsche's Overman artist is the model of self-rejuvenation, self-transmutation, self-transfiguration – all nuances of the same transvaluation. Through his self-rejuvenation, articulated in and transmitted through his art, he rejuvenates – transmutes, transfigures – his audience. In 1884, when avant-garde art was still in its infancy, Nietzsche wrote, "Disintegration characterizes this time, and thus uncertainty." Later he wrote, "If this is not an age of decay and declining vitality, it is at least one of headlong and arbitrary *experimentation*: – and it is probable that a superabundance of bungled experiments should create an overall impression as of decay – and perhaps even decay itself."[35] But he has a ready solution to the problem of "our religion, morality, and philosophy . . . decadence forms of man," namely, the "*countermovement: art.*"[36]

The artist, who has "a kind of youth and spring, a kind of habitual intoxication,"[37] is the antidote to the "decadence" forms of man, which signify loss of vitality and will, and finally decay and disintegration. Decadence is expressed bodily, as Nietzsche makes clear. It involves a loss of "bodily vigor . . . the *primum mobile*."[38] Nietzsche believes in the "biological value of the *beautiful* and the *ugly*,"[39] with beauty signifying "*enhanced* strength" and ugliness "a decline in . . . strength."[40] But decadence is ultimately psychological: the loss of the power to will is reflected in a sense of the body's loss of strength, indeed, in a weakening, even complete loss, of the sense of its presence and power; and eventually in a sense of its

nothingness, of being nothing. Decadence of the body – saying no to the body – reflects decadence of the spirit, that is, the spirit of saying no to everything. The decadent, like Goethe's Mephistopheles, is *der Geist der stets verneint* (the spirit who forever negates).

For Nietzsche beauty is "the expression of a *victorious* will, of increased co-ordination, of a harmonizing of all the strong desires, of an infallibly perpendicular stress," while "ugliness signifies the decadence of . . . contradiction and lack of co-ordination between the inner [forces] – signifies a decline . . . in 'will,' to speak psychologically," "in organizing strength."[41] For Nietzsche, physical strength follows from inner strength and is in part a metaphor for it. For while physical decline brought on by aging may not be reversible, decadent loss of will is – by the "*aesthetic state*"[42] induced by art. Like intoxication, it affords "an exalted feeling of *power*,"[43] an "altered" state of being and consciousness. Presumably this can be "bestowed" on one, to use Nietzsche's word, whatever one's age.

It is worth quoting Nietzsche at length to get a full sense of the miraculous therapeutic effect he thinks the aesthetic state has on life – the state "in which we infuse a transfiguration and fullness into things and poetize about them until they reflect back our fullness and joy in life":

The sensations of space and time are altered: tremendous distances are surveyed and, as it were, for the first time apprehended; the extension of vision over greater masses and expanses; the refinement of the organs for the apprehension of much that is extremely small and fleeting; *divination*, the power of understanding with only the least assistance, at the slightest suggestion: "intelligent" *sensuality* – ; strength as a feeling of dominion in the muscles, as suppleness and pleasure in movement, as dance, as levity and *presto;* strength as pleasure in the proof of strength, as bravado, adventure, fearlessness, indifference to life or death – All these climactic moments of life mutually stimulate one another; the world of images and ideas of the one suffices as a suggestion for the others: – in this way, states finally merge into one another though they might perhaps have good reason to remain apart. For example: the feeling of religious intoxication and sexual excitation (– two profound feelings, co-ordinated to an almost amazing degree. . . .)[44]

It is as if Nietzsche is describing the expressive aura of the avant-garde work of art and its effect on its invariably decadent perceiver – the healing sense of " 'intelligent' *sensuality*" it ideally emanates and evokes. Awesomely erotic, it signals its service in the religion of excitement, where the feeling of transcendence is the ultimate intoxication. It is in the intoxicated state of artistic transcendence that "the inner need to make of things a reflex of one's own fullness and perfection" is completely satisfied, evoking an exalted "feeling of enhanced power."[45]

Nietzsche's ecstatic account of the aesthetic state clearly involves much wish fulfillment, although he was perhaps so sensitive – one might say desperately sensitive – to art that it did indeed induce in him the extraordinarily enhanced sense of being he reports. However, as he describes it, the aesthetic state is one of hallucination or hallucinatory exaggeration brought on by self-intoxication. That is, it is a narcissistic state of self-affirmation, a state in which the wish to be an integral self with a strong

will is realized in fantasy. In this state the will is magically restored, as though reborn, and the disintegrated self magically integrated. The vitality whose loss signaled the loss of the will to live, the sense that life has no value – the ultimate morbidity – is renewed. The artist is able to revive the decadent audience's will to live, restoring it to health, in effect, by giving it a work of art that seems so full of life, has so powerful a presence, and is so intensely and bodily immediate that it seems to overflow onto the audience with life. The result, as Nietzsche says, is that the audience spontaneously sheds its morbid decadence, for however short a time. The work of art affords a kind of relief from the suffering that decadence represents, and at its best initiates a process of self-rejuvenation, giving the audience a taste of what it would feel like to be young again, to feel the spring of youth. For the work of art is emblematic of and embodies the artist's will to power, that is, the personal process of self-rejuvenation that restored his will to live; and the decadent audience, through its engagement with the art, unconsciously identifies with the artist, even to the extent of permanently incorporating him in its own identity – making his difference part of the audience's own. There is in effect a transfer of vitality and willpower from artist to audience. The artist is a natural therapist, as it were, and the work of art a natural medium of healing.

One might say that the artist is someone who can overcome his decadence without the aid of art, or rather by creating it rather than re-creating it through reception, as the audience does. Indeed, artistic creation, requiring the strength of will to organize form – emblematic of integral selfhood – involves firsthand, indeed hand-to-hand, emotional combat with decadence. In contrast, audience reception of art is secondhand, vicarious combat, arising out of the recreative appropriation and generalization of the artist's highly personal victory over decadence. The artist's deliberate will to create art stops the drift to decadence, and the advance of art embodies the reversal of this drift. Of course, the artist himself is emotionally helped in his efforts by the artists with whom he feels an affinity and whose vision he appropriates; thus his overcoming of decadence can also be regarded as "derivative." He too has a need for spiritual help – a need that should not embarrass him, as the audience's need for his art should not embarrass it – in fighting decadence. Indeed, the experienced, critical audience is aware of the variety of artistic forms, which it can take or leave depending on their usefulness in the audience's quest for self-rejuvenation. The audience's attempt to recover a sense of the primordiality of its existence, which can poetically overflow onto and rejuvenate all existence, makes the audience itself seem primordial, eternally fresh, immediate, and as such intrinsically valuable.

The will to power is finally the will to "power over [the] opposites" in oneself, this being, for Nietzsche, "the highest sign of power."[46] In "beauty opposites are tamed," eliminating "tension" and "violence" in the self, the self-conflict that saps strength of will. The artist, who has overcome the opposites in himself by integrating them in his art – who uses art to overcome their opposition and makes of their opposition a kind of art – presents that art as a guide to the audience perplexed by the opposites within itself. The

taming of opposites transfigures them into art, and the tamer of opposites is himself transfigured and able to transfigure others. "That man becomes the transfigurer of existence when he learns to transfigure himself."[47] The artist enables the audience "to become master of the chaos one is; to compel one's chaos to become form."[48] Such mastery curbs decadence, a regression to formless chaos, in which one is at the mercy of the opposites in oneself. It is important to understand that for Nietzsche the decadent's apparent loss of vitality, his passivity, and above all the "no" to existence these things embody, is a kind of defense against the violence and chaos he experiences in himself – indeed, these traits are a kind of weak attempt to stand up to that chaos. His decadent lassitude and quietism mask a turbulent, seemingly unresolvable, war of opposites. Art offers him a psychologically active way to deal with and gain power over these opposites. "Those susceptible to art," as Nietzsche calls them, "reach the high point of their susceptibility when they receive" the work of art,[49] which, like the host, is magically – wishfully – transformed by its receiver into something vital and powerful and in turn transforms the receiver into a vital and powerful being. To Nietzsche, the reciprocity between the artist and his audience – the connection made between them through the work of art, which is their common ground – is "desirable" as well as "natural." Indeed, unless art is made for an audience in desperate need of transfiguration, of control over the chaos in itself, of form, then art is merely the expression of vanity.

Clearly, Nietzsche expects salvation from art, as suggested by his assertion that "what is essential in art remains its perfection of existence, its production of perfection and plenitude; art is essentially *affirmation, blessing, deification of existence*" – in a word, sublimely therapeutic.[50] Until the present state of postmodernist disillusionment, belief in art's profound healing power – in the artist-healer, the artist's place in what has been called the "triumph of the therapeutic"[51] – was the cornerstone of belief in avant-garde art. This belief endured, overstated and unconscious as it may have been, and regardless of disbelief in the particulars of avant-garde art, that is, the sense that many so-called experiments were bungled (which is why the art hid behind the word "experiment").

The therapeutic intention is the ultimate object relationship – the most intense engagement possible with an object, in a sense more intense than a sexual relationship with a beloved or a religious relationship with God. (These are in fact kinds of therapeutic relationship – unconsciously fraught with therapeutic intention.) The rise of postmodernism signals, among other things, that art has lost its therapeutic will, one might say its will to heal its audience (which may indeed be incurable). It no longer engages the audience's deepest needs, and in fact has no sense of its audience's existence. It makes no investment in its audience's experience. It does not attempt to transmute its audience's values, enhance its strengths and purge its weaknesses, or rejuvenate its audience by restoring its will to live. It exploits its audience's susceptibility to art, its unconscious hope for transfiguration by art, but offers little in return. It certainly does not address the audience's condition. For postmodernism signals that art has lost its will to power. It no longer affirms, blesses, deifies existence, producing perfection and plen-

itude for its audience. The only existence it believes in is its own. It exists for itself, not for others.

In fact, postmodernism undoes or reverses modernism's own reversal of values: postmodernism returns to passive reaction rather than active assertion, negation of life rather than affirmation of it. It eschews spontaneity and denies primordiality, presenting the compliant False Self, with whatever irony – and it is not clear that it intends any – triumphant over the True Self. It standardizes the True Self into a stereotype, reifying it into a ready-made, indeed, a dummy as routine as the False Self. Postmodernism offers the decadence of déjà vu – a kind of compliance to the environment, including the historically given environment of art – rather than rejuvenating advance. It denies the Dionysian without offering the Apollonian. It prefers the secondary to the primary. Certainly this is transparent – more than subliminally – in appropriative or quotational postmodernist art from Andy Warhol to Sherrie Levine and Mike Bidlo. Postmodernism signals that art no longer exists to satisfy the need for transfiguration of the self. Indeed, it banalizes the transfigured self and its symbols, as in Julian Schnabel's mimicry of the variety of romanticisms and Peter Halley's mimicry of geometrical abstraction. There are in fact postmodernist transfigurations of past art that attempt to evoke a new sense of self, but they end up presenting a powerless and will-less self – for all its chaotic Sturm und Drang, its sense of being at odds with itself – as in the Starn Twins and Anselm Kiefer. That, indeed, is the truth of the self today. Art today has reached a new extreme of decadence, in which it dialectically incorporates all the past signs of artistic rejuvenation – the dregs of old and already won struggles for reintegration, reinvigoration – while denying their contemporary possibility.

Thus Nietzsche's sense of the transfiguration of existence art can effect, Whitehead's sense of art's sense relationship to reality, and Fromm's sense of the artist's integrity and spontaneity have been lost in postmodernism, or are at serious risk. Indeed, postmodernist art does not speak to the profound possibilities of human existence. Does this mean it demythologizes modernist art – deconstructs it, as some have claimed? No, it means that postmodernist art remythologizes it in what might be called a narcissistic way, that is, reduces it to an entirely narcissistic enterprise, speaking only to and about art, rather than to the self and its needs and experience.

Postmodernist art does not embody and epitomize the experience of the object for the sake of the subject – does not mediate sense presentations and feeling presentations that suggest the subjective character of experience, indeed, strongly suggest a subject overflowing with the sense of its own plenitude, a subject transfigured and rejuvenated. Rather, it overobjectifies art, reifying it until its subjective implications seem beside its visible point, its spectacular appearance. This is a kind of narcissistic self-assurance, as it were. This narcissification of the work of art, as it can be called, is far from the narcissistic desperation of Nietzsche's audience, in need of serious support for its will, in need of a sense of the value of its existence and that of existence as such. The only will the postmodernist work of art supports is that of the postmodernist artist, and that is no longer exactly a creative will – a will to power, a will to transfigure. It is not a will with an

embarrassment of riches – a will subject to "the primary artistic force, the pressure of riches," as Nietzsche says[52] – but an impoverished, predatory will, a will full of *ressentiment*.[53] In postmodernism, Friedrich Schlegel's conception of artists as "Brahmins, a higher caste: ennobled not by birth, but by free self-consecration," and "at the threshold of things,"[54] has become a farce.

Belief in avant-garde art's therapeutic intention and power has been lost, for whatever psychosocial reasons. Perhaps it has been abandoned in recognition of the fact that avant-garde art has not been therapeutically effective, has not strengthened the will to live – or no longer can. The emergence of decadent neo-avant-garde art suggests that art today no longer even tries to rejuvenate the self, in unconscious acknowledgment that there may no longer be any way of doing so, any way of strengthening the will to live. This emergence also implies that the pathology of the self to which modernism was a response, perhaps only a stopgap, has become epidemic, because the world itself has become irreversibly decadent, pathologically possessed by the death wish, beyond cure. No one in such a world has any wish to live or be cured.

Fame, Fortune, Publicity, Parasitism: The Narcissistic Illusions of the Neo-Avant-Garde Artist

... the egoistic desire for fame – "that last infirmity" – is an inversion of the social impulse, and yet presupposes it. The tendency shows itself in the trivialities of child-life, as well as in the career of some conqueror before whom mankind trembled. In the widest sense, it is the craving for sympathy. It involves the feeling that each act of experience is a central reality, claiming all things as its own. The world has then no justification except as a satisfaction of such claims. But the point is that the desire for admiring attention becomes futile except in the presence of an audience fit to render it. The pathology of feeling, so often exemplified, consists in the destruction of the audience for the sake of the fame. There is also the sheer love of command, finally devoid of high purpose. The complexity of human motive, the entwinement of its threads, is infinite. The point, which is here relevant, is that the zest of human adventure presupposes for its material a scheme of things with a worth beyond any single occasion. However perverted, there is required for zest that craving to stand conspicuous in this scheme of things as well as the purely personal pleasure in the exercise of faculties. It is the final contentment aimed at by the soul in its retreat to egoism, as distinct from anaesthesia. In this, it is beyond human analysis to detect exactly where the perversion begins to taint the intuition of Peace. Milton's phrase states the whole conclusion – "That last infirmity of noble mind."
 Fame is a cold, hard notion.

<div align="right">Alfred North Whitehead[55]</div>

She [Lee Krasner] had seen him [Harold Rosenberg] do it before: pump Jackson [Pollock] full of liquor, then wait for him to make a fool of himself. . . . "How *dare* you!" she roared. "How *dare* you? He's a famous man and you speak as if he was just anybody." Rosenberg stood up, rising to his full six feet four inches in exaggerated indignation. "Don't tell me who's famous . . . But if there's going to be anyone famous here, it's me and not that drunk upstairs."

<div align="right">Naifeh and Smith[56]</div>

The neo-avant-garde artist, I have suggested, reverses and undoes the avant-garde artist's affirmation of life and self – his will to power. The neo-avant-garde artist feels peculiarly powerless, unable to effect a therapeutic transmutation of existence through his art – an avant-garde ideal embodied as much by Piet Mondrian as by Vincent Van Gogh[57] – and thus unable to produce a primordial art, that is, one that seems freshly fundamental because it articulates the fundamentals of the lifeworld and self. Behind postmodernist celebration of the copy and mockery of modernist originality is disbelief in primordiality and its transmutative power.[58] Simulation is one postmodernist strategy of discreditation and mockery of modernist primordiality, and destruction of the boundary between avant-garde and kitsch – between the authentic and inauthentic, the high and low – is another.[59]

Nonetheless, avant-garde art continues to exist as a narcissistic illusion – as a decadent myth that like all myths is a totalization of its theme, a universalization of the belief it embodies. Avant-garde art lives on as the quintessential art, the most primordial art; neo-avant-garde art deifies it as the embodiment of purposeless primordial creativity – creativity as such, responsible only to itself. But deification is also reification and to create an illusion of absoluteness is to make illusion absolute. Reification is decadence, for it involves the monumentalization of the past, which seems to block the path to the future, and illusion – the fantasy of wish fulfillment – is the ultimate decadence, in that it suggests that there is no need to grow and change. Whatever we have an illusion about seems complete and consummate in itself, indeed, completed and consummated through the fantasy of it. Thus there seems to be no need for another kind of art, and it becomes impossible for another kind of art to develop – an art that is not derivative of avant-garde art, not a new wrinkle on it – because of the neo-avant-garde illusion that avant-garde art is the consummate art, a necessity implicit in the history of art, and indeed the climax that brings the development of art to a conclusion.

As the avant-garde therapeutic intention, activated through opposition to the decadent world, loses its convincingness (because it comes to be recognized that the world is not changed – "cured" – by art), a generalized, normative avant-garde style develops, a decadent avant-garde art convincing to the world. The avant-garde intervention in art, amounting to a revolution in it, is pointless without the assumption that it is correlated with a revolution in the world and is itself a kind of intervention in the world. It becomes the numinously abstract regulator of art practice, rather than a social phenomenon whose disruptiveness signals the underlying contradictions and tensions in society. As such, it is acceptable to the world, which subsumes avant-garde products as superior decoration rather than resisting them as threatening interventions.[60] Ironically, these products also come to seem superior means of communication; avant-garde style becomes the preferred mode of intelligibility, as in Jacques Lacan and Jacques Derrida.[61] The worldly neo-avant-garde style, narcissistically satisfying to both society and art, becomes the venerated symbol of authenticity or intrinsic value in art. Never mind the bankruptcy of its therapeutic value, or whatever little transformative effect – abreactive or maturing – on life its artistic illusions

retain.[62] Indeed, with the shedding of therapeutic value as a pretentious attempt to justify art to a world eager to cure itself of its unconscious fear of decadence – at the least, the "sick" recognition that it is not as inevitable and perfect as it would like to believe it is – avant-garde art becomes a completely pure, intrinsic aesthetics, symbolizing a completely pure, intrinsic creativity. Society appropriates both as its own, for they dispel its underlying bad feeling about itself, make it seem good to itself. They convince it that underneath its surface it is truly vital rather than decaying, and thus that it has a right to feel sufficient unto itself, to narcissistic self-congratulation: for does not that ultimate good, creativity, flourish in it?

Art in fact can only change, and then modestly, the individual, not society. That is, its illusions can cure the individual of society – give him a sense of being liberated from and even transcending it – even as he lives in and suffers it. Oscar Wilde wrote that "it is through Art, and through Art only, that we can realize our perfection; through Art, and through Art only, that we can shield ourselves from the sordid perils of actual existence."[63] This statement admirably summarizes the therapeutic intention of art: to make the self feel safe – the alpha of existence[64] – and then to make it feel perfect – the omega of existence.[65] Art presents and attunes us to the ideas of safety and perfection, rather than helping us realize them in our own lives. The work of art signifies safety through its delimited and enframed – self-contained – character and signifies perfection through the luxury of unity or self-integration it enjoys within that formal containment. The work of art is the ideal garden of the self, proverbially cultivated for itself.

Claude Lévi-Strauss has noted that "the originality of each style . . . does not preclude borrowings; it stems from a conscious or unconscious wish to declare itself different, to choose from among all the possibilities some that [have been] rejected."[66] But the neo-avant-garde artist neither pursues originality and possibility nor borrows. He does not try to differentiate himself dialectically from his predecessors. He is not interested in "answering," through his art, "other past or present, actual or potential, creators."[67] Indeed, he does not think of his art as a creation, and he is not really creative, nor does he intend to be.[68] Rather, he is concerned about surviving in a world that seems to have no future and so has become all past, which is the ultimate decadent attitude. The present is a thin division between this nothing and all. The neo-avant-garde artist lives among the ruins of the avant-garde past. He preys on it like a cynical vulture on a rotten carcass; he is not a child happily fed by his mother's body. He lives on decay, not fresh milk. For the neo-avant-garde artist the avant-garde past is not a land of milk and honey, but a desert with half-buried, broken, dubious treasures, to be excavated with ironic curiosity.[69] He incorporates these fragments in his art the way medieval church builders subsumed the stones of ancient temples, and thus the gods they housed – who were thereby trivialized, but also generalized into an abstract aura (which may be the same) – in their own transcendental structures. Only the postmodernist structures of art are descendental rather than transcendental, and the modernist stones they use are crushed completely rather than elevated to new heights – pulverized into stylish pulp rather than given unexpected presence by their in-

tegration into a new structure. "The barbarians," Arnold Toynbee wrote, "are brooms which sweep the historical stage clear of the debris of a dead civilization."[70] But it is not clear that the neo-avant-garde artist is a barbarian, clearing away the debris of the avant-garde. Rather, he is a kind of castrato, singing art falsetto. His is an ultra-arch art masking the return of the anxious feeling of decadence repressed by avant-gardism. His archaeological investigations into avant-garde art are a form of decadence: he sits in the archaeological echo chamber of his art as in a self-torture chamber.[71] The archaeological attitude is not dialectical, but one that, in reconstructing the past, acknowledges the painful, insurmountable distance of the present from it.

Archaeological, mannerist archness as both defense against decadence and as a new kind of decadence: that is the postmodernist method. For the neo-avant-garde artist, only the way backward seems clear, sometimes all the way back to pre-avant-garde art – old master art – as in the archaeological work of Gian Carlo Mariani, which also acknowledges the avant-garde masters as old masters.[72] Indeed, neo-avant-garde art completes the project avant-garde art began: not only does it democratically continue to open the closed sphere of art to all creations – affirming a universal pluralism that shatters all canons – but it archaeologizes them into relics. André Malraux's imaginary museum becomes a gruesome graveyard, an old battlefield haunted by the ghosts of dead artists whose works are memorable artifacts rather than living art. They may be set in more or less intricate relationship with one another, but they can never truly be integrated. Indeed, art becomes an increasingly random – if routine – field of memories, an assemblage of history in which every new work acquires the patina of a generalized past almost as soon as it is produced. Paradoxically, it is this patina that gives it vitality, not its presentational immediacy.

Avant-garde art's perpetual scrounging for fresh resources in its search for rejuvenation becomes more and more aggressive and restless in neo-avant-garde art, but this change has an opposite effect from that intended: the sources lose the rejuvenating power of their sacred alienness almost at once, for they are facilely appropriated as abstract, purely aesthetic signs of creativity rather than as particular products with particular significance, whose sense is hard to learn and perhaps indigestible. Initially desired because they seemed primordially alien (which meant that they signaled alien primordiality, making them amulets of eternal youth), they become instant history – instantly age – because they are matter-of-factly accepted as proof of creative prowess. Thus the subliminal decadent point of avant-garde curiosity about and colonizing embrace of exotically alternative arts becomes explicit in neo-avant-garde art. Decadence accelerates, in an attempt to make good the sense of no progress, no possibilities, no way forward, no way out of where one is, and no alternatives – the attempt to put the feeling of being spent to good artistic use. It is a way of marching in place – an ingeniously dynamic stasis. But to march in place is to regress, and not necessarily for the good of the ego, even the ego of art.

The inner sense of decadence, from which Nietzsche and so many others tried to flee but were never able to escape completely, oscillates wildly

between feelings of prolonged decay and impending doom. Catastrophe is experienced as a welcome, merciful reprieve from slow death. The sense of decadence is eschatological; it is attuned to ultimate reality, finality. But this obscures, through philosophical rationalization, the "horror of life," even "hatred of life," that is the real force behind decadence.[73] This horror drove Flaubert and other decadents "to rank art above all else."[74] As Roger Williams observes, Jules Romains

noted the extraordinary contrast between the vigorous advance of European civilization in the nineteenth century – its social and political progress, the benefits of science and technology – and the writers' tendency to see the period as a time of decadence. . . . And A. E. Carter has since observed that the nineteenth century looks amazingly massive in retrospect, "an accumulation of steam, cast iron and self-confidence," an age of astonishing vigor at home and abroad. It remains equally astonishing to see the numbers of writers, philosophers, and critics who devoted entire careers to deploring the decadence of their age. . . . Jean Carrere, who loved their novels and poetry, called them "the bad masters" and deplored their influence on subsequent literary generations. He saw Baudelaire not as immoral, but as a demoralizer and a coward in his confrontation with life. Throughout Flaubert's novels he found a horror of man and society.[75]

No doubt the morbid sense of decadence, so at odds with the self-confidence, vigor, and progress of society, implies a subjective critique of it. The decadent calls attention to the uncertainty behind the self-confidence, the feeling of vulnerability behind the vigor, the anxiety behind the bravery, and suggests that the new world is less progressive than it seems to be – that there is more human fallout from its advance than it cares to acknowledge. The decadent functions as the obscene unconscious, contradicting its conscious sense of itself, which is to be a kind of conscience. Indeed, he signals the seemingly incurable blindness of the new technological society to the inner life of the subject, narcissistically injuring it. Social progress is made at the expense of the existentially concrete individual, who is treated callously and indifferently, as though he were a cipher. The decadent signifies this narcissistic infliction through his own morbid attitude to society: while presenting himself as its detached witness, he in fact shows it as a funeral scene, indeed, the scene of his own as well as everyone else's funeral.

The decadent projects the bad feeling about himself society induces in him back onto it in the form of an art that describes it as decadent – deliberately bringing its secret rot to the surface – and thus compensates for his unconscious feeling of decadence. But while he does so, his art, insofar as it is avant-garde in character – that is, insofar as its form repudiates conventional modes of communication, thus becoming socially opaque (which may make it seem more elemental than it is) – becomes an affirmation of self, against all social odds. (Inexplicable density of being is a side effect of social incomprehensibility.) Indeed, his avant-garde style becomes a substitute self. Avant-garde style becomes a perverse symbol of the self liberated from hurtful society, standing, however obscurely, on its own, in aesthetic self-sufficiency. It may not be possible to change society, but it is possible to change the decadent self into an affirmative style – more vigorous, confi-

dent, and progressive than society, that is, more authentically bene
than it is. Avant-garde style functions as compensatory therapy for th
defeated by society.

The inner sense of decadence that avant-garde art overcame through a
style that was partly projection of it and partly individualistic – even idio-
syncratic – reversal of it, returns in neo-avant-garde or post-avant-garde art
with ironic vengeance. Avant-garde art climaxes in the belief that every
member of a society can be an innovator, that is, can transform himself,
through the therapeutic practice of art, from a wounded decadent into a
healthy Overman. This celebration of everyman's creativity, found in artists
as different as Duchamp and Beuys – the alpha and omega of twentieth-
century conceptual art[76] – amounts to a kind of social revolution. Indeed, it
is the quietest but most impressive and successful revolution avant-garde art
has effected – a kind of undermining of decadent society from within, as it
were. Avant-garde art's openness to the variety of so-called outsider arts,
and its own variety of styles, signals the seemingly limitless possibilities of
artistic creativity, in subtle personal rebellion against society. But this vision
of art as individual reparation of social injury and of the curative power of
creativity – creativity as universal panacea – degenerates, as Lévi-Strauss
suggests, into the endorsement of "innovation for its own sake." We are no
longer interested in "what fertile innovation can still produce," but in the
production of novelties – fertility as such. This is the final, subtlest, most
utopian decadence: innovation that leads nowhere, develops nothing, pro-
duces nothing of social or individual consequence – that looks like rejuve-
nation, but is in fact senility, that is, superficial, second artistic childhood:

Not content with having virtually deified it, we now implore it each day to grant us
new signs of its omnipotence. Everyone knows the result: a frenzied cavalcade of
styles and mannerisms, each within the work of an individual artist. Ultimately,
painting as a genre has not survived the incoherent pressures on it to renew itself
endlessly. And other creative areas are suffering the same fate: all contemporary art
is hard pressed.[77]

But for the neo-avant-garde artist this pressure of renewal is not what it
seems, this deification of innovation is not an impasse. The avant-garde art-
ist's cavalcade of styles and mannerisms – this frenzied creativity – has an-
other meaning: it signifies the domestication of creativity, as it were, and
confirms that the avant-garde artist, that exemplary creator, has become a
universal model – a perverse version of a Baudelairean beacon. His "impas-
sioned keening," in Baudelaire's words, has become a commonplace sign of
creative authenticity, easily emulated – as the neo-avant-garde artist shows.
No longer is the avant-garde artist simply a defiant figure idealized by in-
tellectuals; he is, rather, a cultic presence embraced by the world. For he
signifies the all-healing power of creativity – or perhaps the correlate of its
special omnipotence in modernity, namely, its accessibility to all, desancti-
fied, regardless of its products. The avant-garde lesson – codified by the
neo-avant-garde – comes to be that it does not matter what we create, only
that we are all creative – and thus not morbid. In other words, we can

accept the world and see it "objectively," which the nineteenth-century decadents could not. In sum, the neo-avant-garde artist garners the ironically sweet fruit of the bitter seed the avant-garde artist sowed and cashes in on his unexpected success. This success is indicated by the fact that avant-gardism, in the guise of belief in the universal healing power of creativity, independent of its products – for the newly accepting, entranced masses the particular products of avant-garde art become so many idolized symbols of pure creativity – has become a basic lifeworld attitude, as it were. Just as the world has come to accept and celebrate the avant-garde artist as a charismatic figure who stands for no particular principles beyond the general principle of creativity, so the neo-avant-garde artist comes to accept and celebrate the world. He reestablishes the traditional, easy reciprocity between society and artist denied by the avant-garde artist and destroyed through his self-imposed ostracization, or so-called exile from it, in his art.

A major symptom of this new artistic worldliness is the explicit use of artistic innovation to win fame and fortune – something more than critical recognition – independently of what the innovation produces. The charismatic neo-avant-garde artist benefiting from the charismatic mantle belatedly accorded the avant-garde artist by bourgeois society, exploits society's belief in him as a symbol of creativity at its most primordial and pure. He gains fame and fortune for no clear accomplishment, but simply for being a stylish symbol, which is all that his production testifies to. Novelty is proof enough of his artistic power and credibility. There is no deep concern about the significance of the novelty; rather, the work takes its place in a predetermined scheme of art-historical significance once it has been confirmed as indeed novel. This suggests that the – small? – price the charismatic artist has to pay for his success is not to question the contexts of significance society uses to organize itself (not that he is inclined to be so decadent as to doubt them). Fame and fortune are the neo-avant-garde artist's reward for forfeiting the therapeutic criticality of avant-garde art. Indeed, in muting avant-garde art's significance as a transmutative context, the neo-avant-garde artist becomes an unquestioned context of significance in himself, a controlled milieu of narcissistic meaning in which others go to purify their existence, to rebaptize themselves, or, in what amounts to the same thing, to have their true existence "dispensed" to them.[78]

A second symptom of this artistic worldliness is that belief in novelty for the sake of novelty – the fetishization of innovation – becomes inseparable from the perception of the work of art as the supreme commodity. Of all commodities, the work comes to epitomize the idea of the commodity as a fetish, in the psychoanalytic as well as Marxist sense of that term. Like the artist, it becomes a commonplace cultic presence. As has been said, "A painting being auctioned off for $50,000,000 [has] more impact on how art is perceived and understood today than the actual art . . . produced."[79] And impact on desire, we might add. Money, dominating art, is more exciting than it, but art becomes as exciting as money in postmodernism. Correlate with this is the belief that the artist's charismatic publicity image is more important than his actual work (which borrows its charisma from the publicity image), to the extent that the image has come to be regarded cyni-

cally – without moral embarrassment or intellectual irony – as "the central document" in his career.[80] The image must be charismatic and successful, or the reputation of the work will suffer. The production of publicity pictures of artists has become a major part of the art industry. It is as if what was once a damnable thought – that the artist wanted the same worldly success as everyone else but went about winning it in a different way than anyone else (making the success all the more savory when it finally came) – has redeemed itself because every producer of art, however innovative, believes it, however unconsciously.[81] The idea that art was an unworldly means to worldly fame and fortune, or that the fame and fortune that come from art mean more than it does, is related to Lévi-Strauss's idea that innovation has come to mean more than its products. Moreover, the artist wants to win success by the same facile means everybody else does – by making a good personal appearance. The wish for success at any cost influences stylistic decisions, especially the decision to coopt avant-garde art because it proved successful. More insidiously, however, it can lead to the coopting of avant-garde therapeutic intention and its claim to moral compassion by repressively desublimating it, to use Herbert Marcuse's concept. Thus avant-garde therapeutic criticality is not, after all, dismissed as entirely irrelevant, but rather, in some neo-avant-garde art, appears as an impotent promise – a sign of artistic goodwill. The neo-avant-garde artist's appropriation and desublimation of this intention, as in Anselm Kiefer's work,[82] affords him great publicity and fame.

In general, art in postmodernist culture can no longer live without publicity, which bathes it in the meaningful atmosphere necessary for it to seem worth the economic and social trouble. Of course, this reduces meaning to suggestive atmosphere, reduces criticism and interpretation of every kind to instruments, indeed symbols of publicity. Publicity gives art charisma – the aura of success before actual success occurs. The properly publicized work of art seems to have passed the judgment of history, or rather does not seem to have had to wait for it. It is famous before its time, as it were, and of instant historical significance, however unspecified the significance, or however much it is specified in terms of the current clichés. Its fame masterminded by publicity, its economic credibility and social authority are sustained. Or is it that publicity, which is what criticism and theory have become whether they know it or not, creates a smoke screen so that such credibility and authority, epitomizing the power of fame, will not come into question?

Finally, the inherently parasitic character of the neo-avant-garde commodity especially confirms it as a cultification of the avant-garde creation. Sherrie Levine's parasitic disintegration of high art and Barbara Kruger's parasitic integration with popular culture are salient examples. Copying, of course, is the ultimate parasitism and castration, as Mike Bidlo's neutralizing appropriations make clear. Even so, the conversion of esoteric abstraction into glamorous decoration runs a close second, as the work of Peter Halley and Philip Taaffe suggest. Every parasite wants the charisma of its host, which is the nectar that is aggressively appropriated, the phallus that is kept as a trophy.

Postmodernist self-satisfaction is as decadent and morbid as modernist dissatisfaction. Indeed, the former presents itself as the answer to the latter. Their relationship can be understood through Franz Kafka's assertion that "the clocks are not in unison; the inner one runs crazily on at a devilish or demonic or in any case inhuman pace, the outer one limps along at its usual speed. What else can happen but that the worlds split apart, and they do split apart, or at least clash in a fearful manner."[83] In postmodernism the clocks are in unison, as they are not in modernism. Indeed, modernism is a kind of anxious recognition of their discrepancy, as modernism's preoccupation with dissonance and discontinuity suggests. In postmodernism the two times, as Erich Heller calls them – tower clock time and wristwatch time – are synchronized. The insidiously deep frustration caused by their being at odds – the frustration signaled by their discrepancy – turns into smug ecstasy when they are coordinated. The seemingly insurmountable split between "the external world and the world within" that is "one of the most persistent calamities of modern persons, incurable patients of the fatal disorder,"[84] is overcome. Their harmony makes for postmodernist happiness.

Modern art, for all its variations, consistently articulates this conflict of times, the sense of their radical difference and irreconcilability that is the core of the feeling of decadence, the sense that the lifeworld and self are in decay, are living death. The sense of "duplicitous" seeing, evident in movements as different as cubism, futurism, surrealism, and in much abstract art, which so often seems haunted by afterimages of the external world – the sense of simultaneity which began in earnest with impressionism and has been consistently misinterpreted as the conjunctive simultaneity of external views rather than the disjunctive simultaneity of internal and external worlds – testifies to the pervasiveness of this sense. Indeed, the conflict of times is responsible for modern art's manneristic "fondness for farfetched connections," which in fact acknowledges profound disconnection – exactly what makes for a sense of the "far-fetched."[85] This false dialectic of farfetched connection, typically taking the form of magical simultaneity, is a commonplace of avant-garde art.

What is intriguing about Kafka's characterization of the split is that he reverses its terms: it is normal, in modernity, to experience the external world as moving faster than the internal world – however fast the internal world may seem to move in manic states – and abnormal to experience the reverse. The self always seems slower than the world because of the pace of technological change in comparison to the pace of the self's development, and also because there is a constant effort in the modern world to appear young. (To look old is to be outdated, traditional, obsolete – threats to being modern.) This suggests that what Kafka describes as a discrepancy between internal and external times is in fact a split within the internal world, projected outward as an abstract disharmony. Splitting is at once a fundamental form of and defense against injury,[86] and it can be understood in terms of time: it signifies that the subjective wish for immediate gratification cannot be reconciled with the reality of having to delay gratification.

Fear of decadence is fear of infinite delay, crippling desire itself, while the wish for rejuvenation is a form of the wish for immediate gratification, a surge of primary desire. Neo-avant-garde art seems to satisfy the wish, affording an illusion of immediate gratification not unrelated to that of kitsch.[87] The illusion is all the more gratifying because it embodies the belief that the frustrating feeling of delay that haunted avant-garde art – that seemed to be the beginning of the end of primary desire, an inward decay avant-garde art attempted to stop and reverse by its pursuit of primordiality, the magical touchstone of eternal youth for the senses and self – is beside the real point of art, which is to restore the feeling of immediate gratification we supposedly had as infants. Thus neo-avant-garde art infantilizes us, while avant-garde art gives us pleasure as we maturely experience it – delayed.

If the two times – inner time, with its insistence on immediate gratification, and outer time, indicative of delayed gratification – are equilibrated, a sense of appropriately paced gratification is suggested, which is what traditional art conveys. Such equilibrium between inner and outer worlds is not possible in modernity, by definition; for a modern to expect it is for him to misunderstand his modernity. Kafka had no idea how to reconcile the times; he only anxiously observed their irreconcilability. To be modern means to be split between a deep fear of decadence and an equally deep wish for rejuvenation. In tradition, decay and death mysteriously led to regeneration and resurrection. The miracle of salvation in fact occurred, however obscurely and incredibly. In modernity decadence and transcendence are in uncertain, quirky relationship, if in any at all. Modernity can be defined as the desperate search for means of rejuvenation – symbolized by the value placed on newness – to counteract decadence, but it is not clear that any will be found. The transcendence of rejuvenation is not inevitable in modernity, as it was in tradition. Modernity seesaws – often violently – between feelings of decadence and rejuvenation, the sense of imminent decline and unexpected rebirth. The avant-garde point is that renewal is possible only when the two times are in fact split, when inner and outer worlds are actually at odds, for only then can the miracle of primordial sense presentation and self-presentation occur. Only then can sense experience be liberated from symbolic functioning in the external world, and the self from the behavioral patterns of the external world – nonconforming, altered states of consciousness that indicate successful transmutation of value. Only when one exists on the verge of total disintegration – when one lives the split that portends complete fragmentation – is a unique integrity of perception and self possible.

Thus the equilibration of the times neo-avant-garde art effects, which involves the conceptualization of avant-garde art as an equilibrated, uniform development – a big lie that turns it into a tradition – precludes the experience of primordiality, with its power to transfigure our sense of life. We are left with a comfortable narcissistic relationship with the status quo of art and society, such as we find in neo-avant-garde art itself. We are also left with a subtle sense of decay – a peculiar feeling of self-decay, that is, of

undeveloped potential, and of the lack of need to develop it. For we feel complete – narcissistically happy – and no amount of self-realization can compete with that feeling. Narcissism is the subtlest of decadences.

Postmodernist juxtaposition, as in David Salle's images, which stylize far-fetched connections – that is, suggest their hypermodernistic integration in a generalized avant-garde style – equilibrates the split of inner and outer worlds in the very act of declaring it. The split, which is the source of the sense that connection is farfetched, becomes another general fact of quasi-avant-gardistic style. Unlike the tense, abruptly farfetched connections of surrealism, Salle's slick, passive conjunctions afford a shallow satisfaction. They give a brief shock of recognition, gratifying because it involves acknowledgment of the artistry of the connection, rather than frustrating because it involves acknowledgment of its absurdity. Salle's incongruities do not signal the depressing, traumatic loss of the self's cohesiveness or integrity – its recognition of its own absurdity – as those of avant-garde surrealism do. Its incongruities bespeak infinitely delayed connection – the loss of primordial connection – rather than superficial contact. Salle's slack juxtapositions afford immediate gratification through their predictability, or, in what amounts to the same thing, through their stylized unpredictability. In contrast, those of surrealism seem truly farfetched and arbitrary, signaling the loss of all coherence as well as the desperate struggle to recover it, never successful. Salle's juxtapositions do not bespeak a hidden order of unconscious frustration and uncontrollable tension – the agony of the split – but rather form an order of superficial control, a kind of facile gestalt of tension, which becomes a self-equilibrating aesthetic.[88]

It is fame, that ultimate narcissistic satisfaction, and the character of the expectation of fame – the reason the artist thinks he should be famous, and more crucially the way he imagines his fame – that makes the difference between the avant-garde artist and the neo-avant-garde artist especially clear. The former expects his product to become famous, and secondarily his person, although he tends to hide his person in and behind his product. The latter expects his person to become famous, and secondarily his product, which is one among many symbols of his person, and not always the major one. In fact, his personality can survive without his products, indeed can outlast them and become famous in its own right, as in the exemplary case of Andy Warhol. It is his personality that is innovative, that must be endlessly renewed and exhibited, which is the point of Lévi-Strauss's emphasis on the fact that the "cavalcade of styles and mannerisms" occur "within the work of an individual artist," not simply in general as a collective historical phenomenon.

Each new appropriation of a style, making it into a personal mannerism, testifies to the individuality of the neo-avant-garde artist – not to the historical staying power of the style. Presumably a given style counts for nothing in itself; only when it is "personalized" by the neo-avant-garde artist – indeed, only to the extent that it seems to become his private property to do with as he pleases, functioning as a solipsistic source of identity – is it completely meaningful. He may generalize a style in the course of applying it, giving it a new lease on life, the way Picasso, who was both avant-garde and

neo-avant-garde, refined the cubism he invented in the course of "cubify-ing" various themes. From a neo-avant-garde perspective, this is an imperial extension of personality, a kind of self-deification. Refining a style, the art-ist renews his personality, indeed, reasserts his original narcissistic belief in it. In a sense, neo-avant-garde art is applied avant-garde art – a reaffirma-tion of the mythified avant-garde personality.

But the avant-garde artist begins without any narcissistically satisfying myth of himself, only with his dissatisfaction with himself and existing styles, symbols of a frustrating world. He struggles to create one style, one artistic identity, as both a bulwark against and a form of recognition of the world, as well as an expression of his individuality. He cannot imagine that he exists in and for himself – narcissistically – or that his art is simply a cel-ebration of his inherent creativity as an artist. He knows he and it exist through their dialectical relationship with the world as well as with each other. His style, then, grows out of the unhappiness of this three-cornered dialectical relationship, an unhappiness that shows itself in his sense of the discrepancy between his internal world and the external world. He is aware that the external world is indifferent to the discrepancy, and expects him to conform to it. He has an anguished feeling of not being of his time and yet comprehending it with completely clear eyes: he is a Cassandra of sorts. In contrast, the neo-avant-garde artist is happy with himself and the world; there is no dialectical tension between his person, his art, and the world. After all, he is primordially creative, and the world knows it and is happy with him for doing his creative thing.

I submit, perhaps too obviously, that there are two basic ways of becom-ing famous, one by being of serious service to the world and the other by doing it a serious disservice. The distinction between the avant-garde artist's difficult, constructive way to fame and the neo-avant-garde artist's easy, destructive way demonstrates the difference. The avant-garde artist expects fame because of the transmutative power, the therapeutic primor-diality, of his art, reflected in its transgressive originality. In contrast, the neo-avant-garde artist seeks fame, no doubt unwittingly, the way Herostratus did. This "ancient Greek . . . deliberately set fire to one of the most renowned buildings of his time, the temple of Diana at Ephesus," giv-ing as his reason that "he wanted to do something by which he would be known and famous through all the ages. He accomplished his goal. His name has become a byword and is known to many who do not know the names of the heroes of Thermopylae, the Bastille, or Stalingrad. . . . it is safe to speculate that he must have suffered from some tremendous frustration, some overwhelming inferiority, that made him seek acclaim and punish-ment at the same time."[89]

The frustration of the neo-avant-garde artist is that the temple of avant-garde art was built without his participation and before his time. This is all the more galling because avant-garde art is regarded as the quintessential art, the grand climax of art history, the art that changes our perception of all other art. Every new art must follow in its footsteps, but can never have its originality and depth. Instead, the neo-avant-garde artist stands in a mannerist relationship to avant-garde art, which stands between him and

his own creativity. Nevertheless, by emulating it, in whatever attenuated, cunning form, he appropriates its sacred creativity, if in clichéd – petrified – form. This appropriation – sometimes wittingly sardonic, sometimes intended as a pious homage, sometimes unwittingly ambivalent – makes the neo-avant-garde artist a kind of Herostratus. He destroys what he identifies with by regarding it as a sterile form rather than a living truth – as shadow, not substance, as a text instead of an experience. Herostratus wanted to be as famous as the temple itself, but he had neither interest in nor understanding of its sacredness – its power to bless life, to make it seem sacred – which is what made it famous. One might say that Herostratus wanted the fame of the sacred without its responsibilities. An unconsciously revengeful Herostratic attitude, as it can be called, motivates mannerist appropriation of art that has come to seem "naturally" great. Some neo-avant-garde artists are no doubt more ingeniously Herostratic than others, but all are filled with the desperate desire for fame, and, more important, with the sense that they are entitled to it without having to prove that they are. That is, they do not have to make works that are genuinely sacred by reason of their transmutative, curative power, but only works that look creative, earning their author blind respect. Indeed, they want to be worshipped blindly the way the gods are. Such entitlement is inherently narcissistic, perhaps the ultimate narcissism.

In short, the neo-avant-garde Herostratic artist uses avant-garde art as the instrument of his resentful narcissism – as an ironic mirror and ideal at once.[90] But through this process he deprives it of its therapeutic ambition, which is what makes it of service to humanity – not to speak of the distorted form his own ambition takes. In general, his disservice is that he denies art its sacred function as a temple in which humanity can find sanctuary, an inviolate space in which its spirit can be restored by the experience of the primordial. He profanes the temple of art by treating it merely as an instrument of fame.

What else does Salle do in his parasitism of Jasper Johns and Robert Rauschenberg, or similarly, does Julian Schnabel in his of Jackson Pollock and Joseph Beuys, but declare their supermanneristic Herostratism? Their punishment is that they know their art is not as heroic – as much of a "breakthrough" – as that of the artists they Herostratically appropriate. Their punishment is also the paranoid knowledge that they are epigonic, that their art is mock-heroic. They are wrecked by success, but it is not their own. What they desire is the aura of fame, the gratification of fame without the effort, in compensation for the unconscious feeling that no amount of effort could make them heroic, original artists, famous for their work.

In becoming an avant-garde generalist, the neo-avant-garde artist assumes that his capital is the already presupposed fame of the avant-garde. Indeed, it has been archaeologized to the point of becoming a sacred treasure – artistic gold bullion. To put this another way, the avant-garde artist did not so much wish for fame as struggle with life, issuing in works that have the power to transfigure it, reflected in the transfiguration of sense experience and self-experience they reveal. They brought him fame, almost as the world's appreciative afterthought of him (an old man's consolation,

in any case). In contrast, the neo-avant-garde artist assumes that he enjoys the "generic" fame of being an artist. He thinks he is significant simply because he is an artist. He takes fame for granted, resting on the laurels of the avant-garde artist's fame – indeed, I venture to say, on laurels the artist has garnered since the Renaissance, when he began to be perceived as a unique being of special sight and insight. For the neo-avant-garde artist, the artist has an inherent right to fame simply by reason of being an artist, which is a transparently narcissistic assumption. He begins his career as a self-styled overman, presupposing that the artist is the primordial creator – a misconception ironically created in the first place by avant-garde art, as I have suggested.

CHAPTER 2

PRELIMINARY THERAPEUTIC ATTITUDE
THE PROVOCATIVE OBJECT AS A PATH TO PRIMORDIALITY – PICASSO AND DUCHAMP

What mattered was an attitude, more than an influence. . . .
<div align="right">Marcel Duchamp[1]</div>

It is a relief when an individual is able to be mad and to be serious and to enjoy the relief afforded by a sense of humour, and to be able, so to speak, to flirt with the psychoses. Through modern art we experience the undoing of the processes that constitute sanity and psycho-neurotic defence organisations, and the safety-first principle.
<div align="right">D. W. Winnicott[2]</div>

Fame, we might say, is narcissistic compensation for therapeutic failure. What is therapeutic success? More particularly, what is the nature of the health gained by therapeutic success? The basic contention of this book is that the avant-garde artist makes his art to restore himself to health, an intention that not only informs his art but influences his public's perception of that art. That is, his art may or may not have therapeutic effect, however limited or extensive, but its therapeutic intention becomes its context of significance, the source of its value. Historically, every art dead-ends in the aesthetic; it becomes a decadent object of aesthetic contemplation, a formal conceit, or, as Robert Motherwell says, a kind of pleasingly organized "surface [for] the senses" – a form of visual flattery.[3] But as he observes, it must have "an ethic" underneath its aesthetic surface, have ethical purpose even to be aesthetically engaging. To begin to take it seriously the perceiver must be unconsciously convinced that it stands in some sort of ethical relationship to him, that it has good intentions toward him, however "bad" it may look according to conventional aesthetic standards. The unconscious ethic of avant-garde art – the unconscious relationship in which it stands to the world – is its therapeutic intention. The good it wills the world is its will to health, whatever vicissitudes that will must suffer, especially the irony of being dismissed as an epiphenomenon of aesthetic perception.

Avant-garde art, as I have suggested, involves a wish to regress to the primordial beginning to escape the decadent end. How is this therapeutic? How does this restore psychological health and overcome the sense of the morbidity of existence, the sense that existence begins to decay before its potential has been realized? How does avant-garde art help one deal with the self-negating feeling – the blunt, engulfing recognition that overtakes one in the course of one's widening experience of the lifeworld – that one has been inwardly destroyed by society before one could come fully into one's own? The ego, according to Freud, is healthy when it has the strength to meet and mediate the demands of id, superego, and external reality and hold its own. But prior to the health of the ego is the health of the self – the establishment of "an at least potentially cohesive self, that is, of a potentially efficient energic continuum." Ultimately this is the "secure consolidation"[4] of self that gives it the "firmness and freedom to carry out its intrinsic program of action."[5] This ability, "given minimally favorable circumstances . . . to realize its nuclear program in the course of its life span," constitutes the "psychological health or psychic normality" of the "healthy nuclear self," or what Nietzsche called the affirmation of life.

According to Kohut, "the psyche of modern man – the psyche described by Kafka and Proust and Joyce – is enfeebled, multifragmented (vertically split), and disharmonious."[6] At the same time, their avant-garde art attempts "to describe the indescribable," the "disintegration anxiety" that constitutes the core of the fear of decadence – "the deepest anxiety man can experience," for it involves fear of "psychological death" or "loss of humanness," in a sense much more devastating than "physical extinction."[7] Their art, then, shows an incipient "presence of a firm self" that seems to thrive on disintegration anxiety, and amounts to "a creative way of responding" to it.[8] If, as Kohut says, "every self . . . consists to a greater or lesser extent of compensatory structures,"[9] then the forms of avant-garde art function as so many compensatory structures of self, affording a certain sense of firmness and strength despite their often fleeting, improvisational look.[10] Form may seem to "melt" in avant-garde art,[11] but its melting forms are new discoveries, new ideas. After giving initial offense because of their visual unconventionality and disturbing expressive effect, they are "welcomed because, heightening the self-esteem of those who become acquainted with them, they enhance vitality through the merger with the idealized innovator – unless, of course, they threaten positions of personal privilege and power."[12]

In other words, avant-garde art's melting forms are simultaneously symptoms of disintegration anxiety and indications of a process of creative reintegration of the self. The notion of "breakthrough" conveys this double meaning. It is epitomized in Baudelaire's conception of the two stages of imagination,[13] in effect a statement of therapeutic as well as artistic method. A wall of tradition blocking the artist's path is destroyed by sheer force of artistic will; going through it, he finds himself in an unexpected artistic situation that remains to be explored. "Breakthrough" signals the ruins of the confining old wall as well as the passage to a new openness. The breakthrough – avant-garde – artist dissolves an old tradition perceived

as a dogmatic trap, a stifling uniform. But he does not make of his new artistic nakedness – the sense of being newborn, of having new possibilities that comes of stripping off the old artistic uniform – a fixed position or dogma, another stylistic uniform, although others will do so later. His followers will make his melting forms "uni-form" by copying them until they become a new system and thus, ironically, old and decadent.[14]

In a breakthrough the artist endures disintegration anxiety – breakdown. He experiences and symbolizes loss of humanity,[15] the threat of psychological death. Certainly this is what one saw in cubist fragmentation before it became a sanctioned style. (In my opinion the invention of a new style is inseparable from the intuitive discovery of a new psychological truth.) At the same time a new, inarticulate sense of humanness is taking shape as a kind of question mark or puzzle. The fragments come together in a strange new way, suggesting psychological resurrection. The abyss is an unexpected embryo: this is the avant-garde therapeutic message. The melting forms are an unresolved dialectic, which is why they seem especially intense and peculiar, arbitrary and unstable: they are test integrations as well as apocalyptic disintegrations. In other words, a breakthrough is the breakdown of an old integrity but also the transition to a nameless new integrity. It is a change from the habitual to the mysterious.

It may seem strange to link Picasso and Duchamp as similar in intention, but however different their works, they pursue primordiality in the same "regressive" way: through the provocative representation of actual objects, ultimately involving the presentation of provocative art objects, thus doubly antagonizing the audience. If art objects are illusory objects – if they embody illusions – then those of Picasso and Duchamp fulfill a profoundly aggressive wish toward the worlds of both ordinary objects and ordinary art objects, and thus toward the audience that comfortably inhabits both worlds. The audience's wishes and illusions are violated, seemingly malevolently, by this art. But the artistic violence Picasso and Duchamp perpetrated against the status quo of these worlds, destabilizing and finally disintegrating them – destroying their credibility – is the measure of their power to evoke the primordial. The question is, What exactly is the nature of their violent intervention in the conventional? And how is their particular deconventionalization therapeutic?

In a famous remark, Picasso asserted that "in my case a picture is a sum of destructions. . . . In the end, though, nothing is lost . . . the first 'vision' remains almost intact, in spite of appearances."[16] The result is a provocative "deformation," partly an internal, purely formal matter – the result of "an interaction, an intereffect between the lines in a painting," resulting from the "attraction" between them[17] – but also an external matter, an issue of content. "All traces of reality" seem to have been removed from the picture but "the idea of the object [has] left an indelible mark. It is what started the artist off, excited his ideas, and stirred up his emotions. Ideas and emotions will in the end be prisoners in his work."[18] As Picasso says, "I want nothing but emotion to be given off by it"[19] – the emotion aroused by the real object, but without the sense of its real presence. Hence the feeling of deformation.

This expressive intention seems remote from Duchamp, but he has acknowledged that "the artist's attitude counts more ... than his art," that "the individual, man as a man, man as a brain ... interests me more than what he makes."[20] As with Picasso, what is made is simply a "sign"[21] of his attitude. "It's not what the artist *does* that counts, but what he *is*," said Picasso.[22] While Duchamp's "brain" seems remote from Picasso's heart, in fact Picasso's "ideas and emotions" correlate directly with Duchamp's brain and attitude. Indeed, Picasso has said that "art is not the application of a canon of beauty but what the instinct and the brain can conceive beyond any canon."[23]

In fact, at an important turning point in his career, Duchamp produced "a particularly intense Fauvism" – emotionally powerful "Fauve canvases ... striking in their vehemence" and comparable in their "acid stridence" to those of German expressionism.[24] He thought of Braque as "an important Fauve" if "primarily a Cubist," and acknowledged his enormous (competitive?) interest in Matisse, an important discovery for him.[25] Also, Duchamp "always felt this need to escape myself,"[26] not unlike Picasso's need "to unload himself of feelings and visions. . . . One swallows something, is poisoned by it and eliminates the toxic" through art.[27] Moreover, they resemble each other in their strong interest in humor.[28] Most important of all, their "sign-ature" work is intended as a "provocation." For Duchamp it ideally makes "its own deformation," the way chance does.[29] This work always involves "adding distortion" to the real object that is its point of departure.[30] "Distorting" is "a characteristic of our century," and "with all the painters, whether they're Fauves, Cubists, and even Dadaists or Surrealists," it is "a reaction against photography,"[31] an avantgarde method and an end in its own right. Picasso was a master of distortion, which is why he was "a very powerful lighthouse" for Duchamp.[32] In his own way, he rejected the retinal for the conceptual,[33] created images that were visual plays or puns on objects,[34] and vigorously pursued "the madness of the unexpected,"[35] sign of inner freedom.[36] He was also a loner and individualist, eschewing the group,[37] even if he worked with Braque to create cubism.[38] While Duchamp emphasized "experiment" and "research," and Picasso "discovery,"[39] both were obsessed with newness and were in dread of repeating themselves, of being bound by their own and any past.[40] This is why they often seemed to contradict themselves as well as tradition. Above all, both ad-libbed their art.[41]

I submit that the provocation or scandal[42] of deformation or distortion is therapeutic in intention, and that it is a way of realizing and articulating the primordial. A distortion is a contradiction, and it is the spirit of contradiction that informs the art of Picasso and Duchamp. The illogic of contradiction, tolerable in the unconscious, is intolerable when made conscious, even in the disguise of art. It must be corrected, and when it cannot be, as in the deformed or distorted work of art that absolutizes it, it becomes a provocation dangerous to the audience's ego, arousing anxiety. It threatens to reawaken conflicts already under the ego's control, suggesting that the ego has no lasting control of them. Indeed, it seems to symbolize conflict as such, and its ultimate unresolvability.

The provocatively distorted work of art forces recognition of primordial contradiction upon the viewer. Such recognition is inevitably traumatizing, for it implies intuition of one's own incompleteness, "unwholesomeness," self-contradictoriness – intuition of the deep, permanent split within oneself. One is split the way the distorted work of art is split, torn between contradictory elements and tendencies. Recognition of one's inner distortion evokes disintegration anxiety, replacing the signal anxiety the distorted work of art initially provoked. What seemed to be a contradiction between ego and impulse, control and spontaneity – brain and instinct, in Picasso's distinction – threatens to become complete collapse of the self, loss of all cohesiveness. The conflict or split widens, as it were, until the very idea of integrity of self seems impossible, unreal, a fiction. The crazy contradictoriness the deformed work provocatively announced has made one completely crazy.

At the same time, the intense awareness of internal contradictoriness, catalyzed by the explicitly distorted work of art, has an abreactive effect, ultimately emancipating and maturing. It triggers emotions and memories associated with a traumatic past, bringing this past to consciousness, in whatever fragmentary form. Under the inspiration of the distorted work of art, one unconsciously – with reckless compulsivity – works through the past in which one had to split oneself to preserve oneself, works through the traumatic split which became the form of oneself. After the fit of madness – the purge – induced by the distorted work, one spontaneously coheres again and acquires fresh self-possession, greater ego strength. One has a sense, however short-lived, of being whole – as subtly whole as the distorted work of art. Its distortion becomes merely aesthetic, losing its traumatic, emotionally dangerous character – its evocative power, its excitement. It becomes an interesting, perhaps even intriguing, bit of art history, but humanly irrelevant.

In short, the work of art's emotional history takes an ironic course, as Duchamp implied in his recognition of its short-livedness.[43] Its contradictoriness takes one by surprise, triggering unexpected anxiety, but that anxiety contains the seed of its own dissolution, of cure, however covert, delayed and slow to be felt, especially in comparison to the work's immediate traumatic effect. With that dissolution, the work of art has outlived its newness and usefulness.

Perception of the provocatively distorted work of art, evoking the idea of primordial distortion or contradictoriness, thus goes through two stages, paralleling those of the imagination. It initially terrorizes one with the threat of disintegration, then ultimately elates one with the promise of reintegration. (The so-called surprise of the new, which always seems provocatively distorted in comparison to the old – and thus more exciting than it – is really the terror and exhilaration of the new. Its ambiguous evocative power explains our ambivalence about it.) Having mysteriously done its dirty work, after the rush of being perceived internally, the new artwork settles into aesthetic anonymity – into complete externality.

Francis Picabia, in effect Duchamp's mentor, was "a negator. . . . Whatever you said, he contradicted."[44] It was his "amazing spirit" of contradic-

tion that gave Duchamp the courage to complete his "break . . . with conventional forms"[45] and "adopt an antiartistic attitude," liberating him "completely from the past."[46] It was not simply an art-historical but a personal past, and this liberation saved him the trouble of having to reconstruct it in detail. "Fundamentally, I had a mania for change, like Picabia,"[47] he wrote, and a mania for change is a mania for contradiction.

We consciously think that Picasso "suppressed the real in painting," but at the same time we unconsciously realize that "the elements of the real had been scrupulously preserved during their transposition on canvases."[48] Thus we experience his images as contradictions. "Reality has gone to the devil" since the Renaissance, when it was measurable, as Picasso said,[49] because it has become confusingly self-contradictory. It no longer seems self-same, and thus is not measurable in any conventional sense. Picasso was not interested in abiding by the conventional interpretation of its appearance – in copying reality, as he said – but in its inner reality: "Any form which conveys to us the sense of reality is the one which is furthest removed from the reality of the retina; the eyes of the artist are open to a superior reality; his works are evocations."[50] They evoke "the ideas which objects suggest to me, connect, fuse and color in my way the shadows they cast within me, illumine them from the inside."[51] Thus he creates "a more profound likeness, more real than the real, achieving the surreal."[52]

Duchamp was also interested in the repressed shadow – the "anti-social" – side of things, the suggestive "image of a real object" rather than the object itself,[53] especially so in *Tu m'*, 1917, with its ironic shadows of shadows, that is, of ironic works of art (readymades).[54] "Each thing brought up a memory," in effect embodied in the distorted shadow.[55] Duchamp described the "erotic" intention of his art as "really a way to try to bring out in the daylight things that are constantly hidden – and that aren't necessarily erotic – because of the Catholic religion, because of social rules. To be able to reveal them, and to place them at everyone's disposal – I think this is important because it is the basis of everything."[56] But self-contradictorily, his eroticism is hidden – "always disguised, more or less, but not disguised out of shame."[57] The pervasiveness of self-contradiction in his art is conveyed especially through its irony and indifference, or "delay," in relating to the world – as in *The Bride*[58] – a delay also conspicuous in Picasso's forms.

In other words, Picasso and Duchamp, in their different ways, keep the lifeworld's objects at arm's – at art's – length, which is a way of contradicting them. Picasso seems to consume them in a crushing embrace, to " 'take possession of' " them so that he seems their "creator,"[59] while Duchamp seems to withdraw from them in the very act of presenting them. The readymade, for example, is at once a withdrawal from the object by its presentation as art, and a withdrawal from art by its conception as readymade and found (rather than handmade and created). But the effect is the same: the destruction of the object, or rather the repression of the relationship to it, and more particularly, of the rationale for the relationship as embodied in the feelings it arouses. The moment a relationship is established – the moment the object has an emotional effect – it is negated, contradicted,

annihilated, that is, distorted to the point of amnesia. Such negation is not only a perverse way of affirming the object, but suggests the intensity of the original investment in it. The difficulty of artistically rooting it out – of melting its form – testifies to the depth of its rootedness in the artist's life and the extent to which it is a content of his form.

Duchamp's nihilism openly declares itself in his notion of "stripping bare" to effect "a 'non-sense' " or " 'antisense,' "[60] in effect a withdrawal of sense from an object that has become too personally meaningful. That is, stripping bare is a stripping bare of feeling as well as of sense, indeed, of the sense of feeling. It is antifeeling as much as antisense, which means not simply that Duchamp is as opposed to showing feeling as he is to making sense, but, more deeply, that for him there is no sense in having any feelings. From this it follows that there is no sense in making sense, for sense is always made for others, just as one always has feelings for oneself. Ultimately this means there is no sense in relating to others, which means there is no sense in having a self – or at least a self able to relate to others, to make sense to them. Duchamp contradicts Rimbaud's conception of "the self [as] an other" – his implicit recognition of the internal objects that constitute it. Duchamp is determined to show that the opposite is true: that the self is not the other, that the self is not possessed by others nor interested in taking possession of them.

In purging meaning and feeling Duchamp purges the self of the internal others – the identifications – that took possession of the self before it knew what it was, before it knew its own name and identity.[61] Just as he began his career as a librarian as "a sort of excuse for not being obliged to show up socially,"[62] so he became an artist as a sort of excuse not to show up psychologically, as it were. Art was a means of annihilating the internal objects – acknowledged in the shadows of external objects – that psychologically owned him. Duchamp said he did not want the "Large Glass" "to be the expression of a sort of inner life,"[63] but by reason of being an experiment in the elimination of the expression of inner life – as all his works are in my opinion – it profoundly, if obliquely, acknowledges his inner obsessions. Indeed, there is an expressionistic basis to his art, as his fauvist works suggest. Duchamp's later antipaintings are a kind of inverse expressionism, with many expressionist traits, however mock, from the bride in the *Large Glass* to the female figure in the *Etants Donnés,* from the malic molds to the vaginal molds. Clearly, his determination to disengage himself from the external and art worlds symbolizes his determination to disengage himself from his internal world, suggesting deep – indeed, inescapable – erotic attachment to its objects. He wants to make no new attachments – the purpose of his famous indifference – in order to detach himself from old ones. Indeed, the relentlessness of his will to withdrawal – one of its main methods being intellectualization (a kind of willful scotomization in his case?) – not only ironically acknowledges the strength of his attachment to old internal objects, but disguises and masters the anxiety they arouse in him. By disavowing the conventional social meaning (and use) of an object, then, he "eroticizes" it into a hidden internal object; or, more simply, he obliquely calls attention to the emotional meaning such social meaning typically hides.

Picasso and Duchamp try to maintain perpetual artistic motion through self-contradiction. Indeed, one might say that their entire careers are a perpetual motion of contradiction – of contradiction heaped upon contradiction. Alone among his artist brothers, Duchamp maintains the family name, while hating the idea of family as inimical to one's individuality.[64] Picasso asserts that "you have to take objects seriously. And lovingly."[65] But he distorts them, often in a seemingly cavalier comic way, until they seem to become hateful, as well as unrecognizable in any ordinary sense. They may be inwardly recognizable – recognizable as an expression of the artist's attitude toward them, and finally of his general attitude to the lifeworld – but Picasso insists that they remain outwardly recognizable as well, in every major detail. Duchamp negated art by not practicing it for many years, but during those years he was negating his negation by making art secretly. Picasso states that "in art intentions are not sufficient . . . What one does is what counts and not what one had the intention of doing." But he also states, contradictorily, "that the only thing that counts, in painting, is the intention. What counts is what one wants to do, and not what one does."[66] One can never fully do what one intended, and what one does always turns out to be different than one intended – an "error," as Picasso said. For all his painting, he comes close to an antipainting position when he states that "what was important" in cubism was that it showed that "one cannot paint."[67] In a similar antiart vein, he sets up a contradiction between art and truth, preferring a little truth to a large amount of art.[68] He seems to be more interested in truth than in art, which to him is a means to truth rather than an end in itself. Indeed, he despises art for art's sake – but at the same time speaks of forms as having a life of their own, as neither abstract nor concrete.

It was especially in their attitude to fame that Picasso and Duchamp showed their perverse spirit of contradiction. It was their contradictoriness, understood by their audience as a sign of creative power and complexity, that brought them fame, but also threatened to undermine it. For their contradictoriness suggested that their creativity was a kind of arbitrariness, and meant that their audience could not keep up with their art (all the more reason to dismiss it as arbitrary) – as they intended. For them, fame was not cheap narcissistic satisfaction, but rather mocked and inhibited their creativity. They tried to outdistance their fame, to keep ahead of it by making works that contradicted those that brought them fame. (Whatever Duchamp's narcissistic problems, as indicated by his self-styled indifference – a withdrawal from objects and emotions that gave the lie to his assertion that he "never had . . . melancholy or neurasthenia"[69] – he did not turn to fame to comfort himself. Fame, in fact, is the most complex of object relationships, implying profound reciprocity with an audience, in which one "erotically" enacts its, as well as one's own, secret wishes, that is, functions as the audience's "medium," as Duchamp said.)[70] Fame is a provocative trap and distorting mirror – ironically, like the artists' objects. The artists try to free themselves from it, but also ironically – and sometimes not so ironically – court it.[71]

Duchamp mocked Picasso, claiming that he "fills the role the public demands, that of the star,"[72] but Duchamp also seemed to be vigorously

pursuing stardom by his invisibility[73] and contrariness, which began to seem all too calculated. Both Picasso and Duchamp had a desperate desire to be known, Duchamp going so far as to say that "the artist exists only if he is known."[74] Both claimed to give the spectator ultimate power over their work, for only the spectator could make it – not to speak of the artist's person – a "legend," as Picasso said.[75] But this is a strategy of success, for if the work is known and celebrated only through the spectator's relationship to it – if it survives through the spectator's devotion and attention to it – then the spectator must be cultivated, respected, met halfway. To do so in modernity is, perhaps paradoxically, to make things difficult for him: thus challenged, the spectator cultivates, respects, and meets the work halfway. It is as if Picasso and Duchamp deliberately made a puzzling, distorted art to court and seduce the spectator – to keep him fascinated and engaged as long as possible. The more he had to struggle to understand the art, the more likely the art was to become legendary – the ultimate social success. The difficulty of their art can be understood as a deliberate publicity strategy.

Duchamp was "slightly embarrassed by the publicity aspect which things take on, because of that society of onlookers who force them to re-enter a normal current, or, at least, what is called normal," acknowledging that "the group of onlookers is a lot stronger than the group of painters."[76] But he did nothing to avoid publicity and submitted weakly – but cannily – to the effort to normalize his art, indeed, to make it normative for avant-garde art. He apologized for the fact that his "entire work would be in a museum" as a "practical" necessity which could not be stopped.[77] It would be "insanely pretentious" to show his works in "a nonpublic place," and an "idiotic gesture" to "have torn them up or broken them."[78] No doubt, the preservation of antiart in a museum, thereby making it art, is its most ironic negation. It is a way of contradicting it for all time, and as such was Duchamp's grandest gesture of self-contradiction, his most private joke. He said that "the idea of the great star comes directly from a sort of inflation of small anecdotes ... the entire thing is based on made-up history."[79] Duchamp, in his interview with Pierre Cabanne, certainly made up his history, piled up anecdotes about himself. Indeed, his works can be regarded as a series of anecdotes about himself, not unlike those of Picasso, who described his art as a kind of autobiography and diary.[80] In other words, the art of both Picasso and Duchamp takes us back to the artist, indeed, seems to make him legendary. He, not his art, makes the ultimate claim on our attention. His life and his art seamlessly fuse, which may be the ultimate grandiosity.

The biggest fear held by Picasso and Duchamp was that they would copy themselves, in life and art. For this would mean that they were living off the fruits of their past, resting on their laurels. They kept contradicting themselves to avoid doing so, hoping to remain uncategorizable and "infamous." Being copied is a sign of being famous, for it indicates that one's art has become an institutional uniform – "universalized" – but Picasso and Duchamp discovered that being contradictory made one all the more famous. Ultimate avant-garde fame comes from being categorized as uncategoriz-

able, that is, as utterly individual. This threatens the fame that comes from being swallowed whole in a copy, but gains one the superfame accorded those who cannot be coped with easily, perhaps never completely digested, making them of lasting interest.

In fact, the artist has it both ways: he sets the pace by being copied, then outpaces his copiers by contradicting himself. He sets the standard and even becomes canonical – an absolute measure of authenticity – but remains a bone stuck in society's throat, one on which the art world and art history continue to choke. He becomes more of a provocation and conundrum than ever. The avant-garde artist's ambition is to have his art remain freshly provocative and enigmatic, even to grow in provocative power and mystery with each new generation of audience, making his person seem larger than life, which is the ultimate falsification of fame.

One knows an artist not only by his creativity, but by his attitude toward fame, and secondarily toward money. Picasso and Duchamp were skeptical about both and ironic about their necessity. Picasso said: "Of all – hunger, misery, the incomprehension of the public – fame is by far the worst. It is the castigation by God of the artist."[81] At the same time, "an artist needs success. Not only in order to live, but primarily so that he can realize his work," even if "few people understand much about art," and most people judge "a work of art in relation to its success."[82] As for money, he said, "What I want is to be able to live like a poor man with plenty of money."[83] I assume this means that he did not want the money that comes with success to create more needs than he already had, compromising him in his very being. Money, then, should not disturb the simplicity of his lifestyle, the conditions of life necessary for him to work.

Duchamp was never interested in having more than enough money to live and work, and determined not to sell his independence for a mess of pottage. Early in his career he rejected an exclusive contract with the art dealer M. Knoedler, offered to him in recognition of his fame in the United States. He was ironic about fame and saddened by it. "A work is also made of the admiration we bring to it," he said, but admiration changes into indifference, and "works which were important at the beginning . . . have disappeared."[84] "The pruning" [of history] is done on a grand scale."[85] Duchamp remarked that he "liked [the poet Jules] Laforgue a lot," admiring his "humor," and liked "him even more now, although his public stock has gone down"[86] – as if that were a sign of his enduring credibility, especially of his attitude of humor. He also admired the painter Pierre Girieud, who is ignored today. Asked whether he thought "Girieud made an unknown masterpiece," he remarked, showing his complete skepticism, if not cynicism, "Not at all. Properly, any masterpiece is called that by the spectator as a last resort. It is the onlooker who makes the museum, who provides the elements of the museum. Is the museum the final form of comprehension, of judgment?"[87] In fact, Duchamp did not believe in "real, absolute judgment,"[88] and "almost never" went to museums, "because I have these doubts about the value of the judgments which decided that all these pictures should be presented to the Louvre, instead of others which weren't even considered, and which might have been there."[89] Duchamp

believed that "there exists a fleeting infatuation, a style based on a momentary taste; this momentary taste disappears, and, despite everything, certain things still remain. This is not a very good explanation, nor does it necessarily hold up."[90] The public makes a masterpiece, in other words, projecting its expectations into a work of art as if that will satisfy them. But it can also unmake a masterpiece, withdrawing from it in indifference – whether the work is in a museum or not. The audience engages the work in a love–hate, attraction–repulsion process not unlike what Stendhal calls crystallization.[91]

Duchamp was not interested in the prestige of works of art but in their attitude, which may or may not be publicly acceptable, that is, approved for showing in a museum. His attitude toward the fame of art resembles that of Max Frisch, who, in one of the epigraphs to this book, observes that the genuine artist is not concerned with prestige but with remaining creatively alive, although Duchamp's idea of creative aliveness is undoubtedly different from that of Frisch. Duchamp also shares Popper's democratic belief that there are "countless numbers of men who are just as worthy, or worthier," than those who become aristocratic "heroes on the Stage of History" – which is what a museum is – but who "will always be forgotten." It is as if the public can hold only one famous man – one accomplishment – in mind at a time. Too many make it conscious of its ignorance and incapacity.

Picasso and Duchamp believed in the primordiality of paradox, and their sense of their paradoxical relationship with their public was part of their myth of themselves. Their split with their audience was part of the split within themselves. Duchamp was at his happiest when no one – not even his closest friends, his admirers – liked what he made.[92] He was always ready to split himself – to take on a Jewish name or change his sex[93] – to confound and alienate his public. Picasso was also determined to alienate his audience, like Frenhofer, the painter in Balzac's *Chef d'oeuvre inconnu,* who, "thanks to the never-ending search for reality . . . ends in black obscurity" nobody can comprehend.[94] Like Duchamp, Picasso wanted to be the Jew of painting, sufficiently alien to society to confront it with an alternative integrity.[95]

For both Picasso and Duchamp it was imperative that internal and external times never strike in unison, that they have neither the narcissistic satisfaction of their audience thinking their art is on the audience's time nor the kind of stylish fame that would bring, because it would inhibit their contradictory creativity. They perform the service of the scapegoat, and enjoy its fame. They make the audience aware, through the deformed character of their art, which seems to deform art itself, that the audience is out of synch with itself. Of course, it can fully realize this only when it knows that it is out of synch with their art, thus banishing the art to the wilderness of the audience's unconscious. To this day their art remains alive in the collective unconscious.

Their art achieves its effect by realizing the split basic to modernity: the lack of synchronization of the retinal and conceptual, of the immediately perceived and the slowly understood, of the instinct and the brain. These

PRELIMINARY THERAPEUTIC ATTITUDE 39

are irreconcilable, except in artistic distortions. The fame of Picasso and Duchamp is risky; it can backfire, and has. The audience, determined to maintain the illusion of its unity of being and "wholesomeness," can withdraw from their art or, more subtly, hypermodernize – postmodernize – it, convinced that it is decadent. Nonetheless, we still debate their significance, indicating that we have not yet completely absorbed their intention – their therapeutic irony – however much we have made them legends, serving their wish for fame at almost any cost.

CHAPTER 3

THE GEOMETRICAL CURE
ART AS A MATTER OF PRINCIPLE –
MONDRIAN AND MALEVICH

Yes, that will be readily agreed: geometry is knowledge of the eternally existent.
 If so, it will tend to draw the soul towards truth and to direct upwards the philosophic intelligence which is now wrongly turned earthwards.

<div align="right">Plato, Republic, 527A–B</div>

Dürer imagined a being endowed with the intellectual power and technical accomplishments of an "Art," yet despairing under the cloud of a "black humor." He depicted a Geometry gone melancholy or, to put it the other way, a Melancholy gifted with all that is implied in the word geometry – in short, a "Melancholia artificialis" or Artist's Melancholy.

<div align="right">Erwin Panofsky[1]</div>

Distortion, however brilliantly conceived, is a kind of primordiality manqué in the art of Picasso and Duchamp. Genuine primordiality lies beyond distortion, in an altogether different psychoartistic space – that of the geometry of Mondrian and Malevich. Distortion no doubt makes an object seem enigmatic, and thus possibly primordial in import, but this effect wears thin once it is discovered that distortion is a dead end. The distorted objects of Picasso and Duchamp are Delphic riddles that can never be conclusively deciphered, however much the outline of an ordinary object can be recognized behind the veil of distortion. Indeed, Picasso and Duchamp seem mischievously to cultivate the unintelligibility of distortion, as if to make the object more perceptually exciting than it ordinarily is. But this does not make it primordial; the ordinary object is neither perceptually nor cognitively fundamental, no matter how visually intriguing.
 In contrast, the geometry of Mondrian and Malevich has a more substantial mysteriousness: that of fundamental simplicity. At first glance their geometry may seem trivially basic and self-evident, but to the viewer in a certain frame of mind it seems to epitomize primordiality – seems fated. (Mondrian and Malevich try to induce this epiphany by composing with

geometry or by making geometrical simplicity seem composed. The latter is especially the case with Mondrian, whose compositions seem to unfold geometrical form into grander intelligibility, like a Euclidean demonstration.) Geometry then becomes the magical touchstone of existence. One turns to it with basic trust, like a prodigal son returning home to the father, who is always ready to forgive one's sins. Indeed, divine geometry seems to redeem one's life and restore one to happiness by lifting one's self to a higher plane of existence where it is absolved of the guilt that comes of unhappy relations with objects.

But one does not and cannot put one's trust in the distortions of Picasso and Braque. In fact, they arouse distrust, for they are all too ironic and ambivalent. That is, they are unresolvably double, in contrast to simple geometrical form, which is radiantly one. They bespeak a guilty attitude toward the object. The distorted objects of Picasso and Duchamp are Gordian knots; only the geometrical sword of Mondrian and Malevich can cut them.

Ironic detachment does not emancipate the self from the object, as the ambivalence implicated in it suggests. That is, irony is a futile, last-ditch attempt at detachment; its failure is caused by insurmountable ambivalence toward the object. Thus ironic detachment from the object is not what it seems, because it implies profound pathological involvement with the object. Furthermore, it suggests that there is no such thing as a healthy involvement with the object, that the self can presumably never escape its distorted attitude toward it. The ironic distortions of Picasso and Duchamp suggest this futile situation, but the primordial geometry of Mondrian and Malevich is hopeful: it does not simply propose, as it were, another kind of attitude about the object, but liberates one from the object, thus transcending the pathos of attitude as such. In achieving this disinterestedness, it implies that the object has a secondary reality, in contrast to the primary reality of geometrical form. To put this another way, self and object cannot help but wound one another. Distortion embodies this truth, in fact seems to be the wound itself. (One might say that distortion embodies the dialectic of the wound, as suggested by the relationship of irony and ambivalence immanent in it. As such, distortion restates the dissociation of sensibility: irony is the intellectual reflection of ambivalence and ambivalence the emotional truth of irony.) But primordial geometry suggests that the wound can be healed if the self's ordinary objects are replaced by the eternal objects of geometry.

It seems that Picasso and Duchamp distort the object to dig themselves out of their relationship to it, for it proves unexpectedly beyond their control, even beyond their comprehension. The more they pursue the object, trying to encompass and consume it, the more it resists them, the way Daphne resisted Apollo. The myth is a metaphor for the equivocal, ironic transformation of the object that art effects, suggesting that it can never completely possess the object. (Apollo and Daphne are not unlike the artist and model in Balzac's *The Unknown Masterpiece*. Picasso illustrated the story, identifying with the artist who makes an image of the model that nobody comprehends and that is not true to her.) The distortions of Picasso and Duchamp suggest that in attempting to escape their

unhappy relationship with the object they unwittingly bury themselves more deeply in the hole which it has become. Distortion is a kind of free-fall into the abyss of the object.

Thus once one gets beyond its provocativeness, one has to recognize that distortion of the object is not a simple subjectification of it, but a plea for therapeutic help. It is a kind of anxiety about the object and an expression of the self's wish to "recover" from it, ultimately by changing itself. That is, in consciously changing the object so that it looks grotesque, the self unconsciously struggles to change its own grotesque attitude about the object – but nevertheless only embodies it. Thus the more the distortions of Picasso and Duchamp make the object seem like a fantasy, the more desperate their desire to revolutionarily change themselves. But that alchemy can be accomplished only through an encounter with primordiality. Unlike the philosopher's stone, distortion does not have a truly alchemical effect – does not turn the base metal of the self into pure metal – but is simply a vivid way of exhibiting the baseness of the self. Extreme distortion forces one to admit what one did not know existed in oneself, so completely had one denied it: one's inner distortion and baseness. In the peculiar reversal that occurs once art makes one aware of something one did not want to acknowledge, the artistic distortion now seems provocatively to mimic – even to caricature – the inner distortion. The art is appropriated as its externalization.

Modern art sometimes seems to be nothing but a sum of distortions that do not add up to a whole, for many modern artists turned to distortion as the promised land of primordial creativity. Distortions seem like free gifts of creativity. They appear like mirages, without effort. These artists are less creative – less astoundingly original – than they think. In fact, they misconceive the meaning of creativity, which involves a revolution in consciousness and attitude, not willfully novel distortion. Picasso, for whom distortions existed for the asking – were the secret of his fecundity – seems to live on them. But behind his compulsion to distort the object lies disillusionment with it. Indeed, the abundance of distortions suggests the numerous forms taken by disillusionment with the object. They readily appear, suggesting how ingrained disillusionment is.

At best, the most compelling distortions of Picasso and Duchamp are a kind of critique of ordinary consciousness, which keeps the self in bondage to the object by not revealing the seriousness of its conflict with the object. Ordinary consciousness is not blind to this conflict, but signals it mechanically, as if it is incidental to life. Above all, ordinary consciousness refuses to face the fact that the conflict is too deep to be resolved, however dialectical it becomes. Ordinary consciousness pours the oil of cliché on the troubled waters of the subject–object relationship. Distortion disrupts repressive cliché, undermining its false consciousness of the relationship as well as embodying its conflict. But that is not the same as creating the "extraordinary" consciousness of primordiality that alone can rise above subject–object conflict, a transcendence that is the ultimate therapy. There is no other way to break out of the vicious circle of subject–object relationship. Thus the altered consciousness of the object represented by distortion does

not alter the character of the subject's relationship to it; that can be done only by evoking what is more fundamental than both. Nonetheless, distortion reveals the subject's bewildered frustration by the object. While this is hardly the best frame of mind in which to transcend the object, it can lead to the wish for transcendence, to a sublimated form of the desperate desire to change the self. If it does evoke the hope for transcendence – a kind of absurd faith in the possibility of liberation from the object – distortion becomes purposeful, as it were, the way the sense of futility Dante and Spinoza suffered does. Indeed, the most extreme distortion symbolizes this feeling of utter futility – the ultimate crisis in the subject's relationship to the object. Mondrian and Malevich overcame it the way Dante and Spinoza did, by achieving a sense of the primordial.[2] Through this they achieved true detachment, as Picasso and Duchamp never did. Those artists became fascinated with distortion for the sake of distortion. Biting its own distorted tail, their art became a narcissistic snake, which can hardly be called detachment.

Primordiality, then, is a sweeping solution to the pathological struggle with the object, for it decisively terminates the relationship to it. The subject, purged of problematic relationship to the object, recovers its conviction in itself. Its nonobjectivity makes it more mature and self-aware than it was when object-related, as Mondrian wrote. It turns inward and finds itself to be a structure of primal opposites whose seeming conflict in fact bespeaks their unity. This universal structure is embodied in a new abstract religious art – Mondrian's painting.[3] In it the primal opposites step out from behind the veil of natural appearances and shine forth in sacred harmony. A Mondrian abstract painting schematically symbolizes the elementary dynamic of therapy, as he himself recognized. The oppositional structure – the basic split – of the self is abstractly represented, but the opposites are in dynamic equilibrium rather than in unresolvable conflict.[4]

For Mondrian, art that relates to natural objects, whatever its stylistic character, is psychically immature and a distortion of universal truth, which is "unnatural," abstract. While for him geometrical abstraction, the articulation of eternal objects, is the only mature art – the only primordial art – gestural abstraction, its antithesis, also has primordial, therapeutic effect. Construction and expression – the one trusting to perfect form, the other to spontaneity – remain modern art's consistent poles, inconclusively reconciled despite persistent artistic efforts to do so. The key to both is the level of consciousness signaled by the abstract, whatever its manifestation. At their best both convey an effect of "living" primordiality. Geometry seems to have an "aura," gesture seems to be an "emanation," for however short a time. Alive as aura and emanation, the abstract work of art has transmutative effect. It gives us a new sense of "full and complete life," as Mondrian said.[5] Indeed, geometric form, masterfully given an aura of transcendental significance by art, evokes the lost psychic paradise of the whole self; and gesture, artfully formless, evokes feelings and energy we didn't know we had, suggesting a fresh surge of life. Both seem to rejuvenate us. We seem to recover the innocent vision we presumably had as children. There is hardly a modern artist who has not idealized the child's vision, or

its equivalent, the so-called primitive's vision.[6] It is always presented as being more inward than the adult's vision, because less burdened by entangling relationships with objects. Indeed, the child's vision seems fresher than the adult's because it never seems to get further than the first, spontaneous impression of the object. Feeling and thinking are integrated in that impression as they never are again. Fetishization of the child's vision is wish fulfilling and suggests anxiety about adulthood, a reluctance to grow up. Is abstract art a form of arrested development, or is it a narcissistic regression that in fact successfully deals with the frustration objects invariably arouse, as experience teaches? Is it a reaction to objects that leads to a fresh development of the self, in which one realizes a universal perspective on life, and from which life can be seen more clearly than from the limited perspective of the object? Indeed, from the abstract perspective, the object, which once loomed large to the self, occupies a small place in the cosmic scheme of things.

In sum, if the first commandment of modern art is "Thou shalt distort" – a commandment made law by Picasso and Duchamp and prophesied by Manet, Van Gogh, and Cézanne – the final commandment is "Thou shalt be universal."[7] The former acknowledges the pathology inevitable in involvement with objects, while the latter suggests the cure for it. The distortions of Manet, Van Gogh, Cézanne, Picasso, and Duchamp are equally obsessed with the object, as if to work its personal meaning through. They never do. In contrast, Mondrian and Malevich, becoming universal, also become impersonal, implying that the ordinary self, taking objects personally, does not really know how to regard them. This is especially true of Mondrian, who never regressed to object representation, as Malevich did, for a variety of sociopolitical and psychodynamic reasons. These two are the truly transmutative artists, not the distortionists, for their geometry evokes the original wholeness of the self by affording a peak experience of primordiality. Picasso's exorcism and Duchamp's eroticism are inadequate therapy in comparison. Their distortions make one aware of one's incurably divided – distorted – attitude about the object, whereas the primordial geometry of Mondrian and Malevich suggests a healthy attitude about the object, and about the undivided self.

Picasso's hatred of the abstract is well known,[8] as is Duchamp's of the retinal. These attitudes are not unrelated, for they lead to the same psychic place: masochistic repudiation of primordiality because of pathological enchantment by objects. At best, their art is a Sisyphean attempt to free themselves from the seductive power of objects by stylistically overpowering or at least resisting them; but this is a way of obliquely acknowledging the object's power rather than becoming free of it. For as Picasso recognized, objects are never completely destroyed by style, and in fact seem spontaneously to reconstitute themselves – and their personal significance – in defiance of it. The stylistic process has to be repeated again and again, ad infinitum.

Total retinality is in fact one kind of abstraction; it dissolves the object, as begins to occur in Cézanne. Duchamp could not accept this complete dissolution because he was in ironic bondage to the object by reason of his

intellectualization of it. He repudiated retinality because of the sensuous and sensual way it presented objects, not because it represented them. Matisse was his model retinal artist, and Duchamp, like Matisse (and Picasso), was preoccupied with the woman-object, but in an antithetical way.[9] Thus a nonobjective retinality was beyond Duchamp's scope, even though retinal art necessarily becomes abstract if its subjective implications are followed out. It comes to articulate the self's sensuous and sensual processes, rather than the object that dissolves into them.

Similarly, but in the opposite direction, a completely intellectual art, which is what abstraction was for Picasso, meant complete abandonment of the object. His art depended on his sensuous and sensual involvement with objects, so that to abandon them would be to give up art. The object was the source of his creativity, however mixed his feelings toward it were. He could not imagine that the void such an abandonment created – Malevich's desert,[10] a true void, a desert without little oases of distortion – might be a new artistic opportunity as well as a panacea for objects.

Picasso and Duchamp never became completely abstract artists, nor could they ever. They could never take the step that would have completely freed them from objects because it was inconceivable to them that one could in fact be free of objects. They thought dialectically relating to objects was an inescapable fact of life, of which one had to make the best. (Art was one way of doing so for them.) Life was unending tension between subject and object, each wanting power over the other. They could never conceive disinterested primordiality because they could not imagine the subject and object in tranquil relationship. They resigned themselves to the self's tragicomic relationship with objects, distorting it and them, and embodied in their distortions. In this they differed from Mondrian and Malevich, who realized that abstract primordiality not only resolves the self's conflict with objects, but seems to renew it. That is, authentic nonobjectivity, replacing subjective relationship to a particular object with objective relationship to a universal object, gives one a sense of being a new kind of subject – a higher self. The question is what this means psychodynamically. That is, how does geometry cure?

Mondrian, I want to suggest, was a follower of Spinoza. His writing strongly resembles that of Spinoza's *Ethics* and, together with his painting, has the same ethical purpose: to free the self from human bondage, that is, from "the impotence of man to govern or restrain the emotions."[11] This is clearly a therapeutic intention. As Spinoza wrote, man "is often forced to follow the worse, although he sees the better before him," because he is "under [the] control" of the emotions and thus "not his own master."[12] To be controlled, the emotions have to be understood; to "detest and scoff" at them does not give one power over them.[13] They are not simply "vanities, absurdities, and monstrosities" "opposed to reason," but have a logic of their own.[14] This can be formally demonstrated "by a geometrical method."[15] On the basis of axiomatic "definitions and postulates," Spinoza proved certain "propositions" about their functioning. His deductive method follows that of Descartes, in that "it starts from data which are so simple, so evident, so clear and distinct, that they cannot be doubted by the

mind, and . . . nothing else is accepted as true until it has been shown to follow no less evidently from these data."[16] Descartes's method assumes not only that "all true knowledge originate[s] in intuition," but that "it is solely by way of intuition that it can be further developed."[17] In addition, "Our knowing is a seeing . . . it can do no more than disclose to us the 'objects' on which it falls."[18] But for Spinoza the understanding gained by this method, which ultimately affords "knowledge of the union existing between the mind and the whole of Nature,"[19] should be used "to lend a helping hand" to others[20] so that they can also "enjoy [the] continuous, supreme, and unending happiness"[21] that comes with its possession. This is why knowledge must be presented "in a manner intelligible to the multitude."[22] It is the thinker's moral obligation to make his knowledge accessible, so that it can have moral effect.

Spinoza is clearly preoccupied with mental health. For him, understanding must "relieve the great burden of human anxiety."[23] Otherwise it is simply a display of "the acuteness of . . . intellect," as in Descartes's case.[24] It must make us happy, or it is irrelevant and possibly erroneous. Its moral effect is its test, as it were. For Spinoza, understanding must be ethically responsible, or it is not understanding. Geometrical understanding is not the indifferent intellectual demonstration of abstract truth, but the moral demonstration of eternal truth. Spinoza's conception of geometrical knowledge is not unlike that of Plato: in showing us that eternal truth is vital to our existence, it transforms us. It directs us upward, toward reason, so that we are no longer trapped by emotion, "wrongly turned earthwards." Geometrical comprehension shows us that reason and truth are within us, so that we can master our anxiety.

Geometry not only educates us about ourselves – shows us a part of ourselves we did not know we had – but discloses the object that can make us happy.

Happiness or unhappiness . . . depend on the quality of the object which we love. When a thing is not loved, no quarrels will arise concerning it – no sadness will be felt if it perishes – no envy if it is possessed by another – no fear, no hatred, in short no disturbances of the mind. All these arise from the love of what is perishable, such as the objects already mentioned. ["Ordinary objects of desire," such as "Riches, Fame, and the Pleasures of Sense."][25] But love toward a thing eternal and infinite feeds the mind wholly with joy, and is itself unmingled with any sadness, wherefore it is greatly to be desired and sought for with all our strength.[26]

It gives reason "the power [to] control the emotions," which is "freedom of mind or blessedness."[27] We do not "delight in blessedness because we restrain our lusts, but, on the contrary, because we delight in it, therefore are we able to restrain them."[28] Geometrical demonstration is a way of loving, as well as of communicating, in an intelligible manner, "a thing eternal and infinite," or, as Spinoza also called it, "a fixed good."[29] Or rather, through geometrical demonstration this "real good . . . communicate[s] itself."[30]

Thus it is through geometrical demonstration that Spinoza attempts "to arrive at a new principle, or at any rate a certainty concerning its

existence."[31] "The search for a new principle" motivates Spinoza,[32] and geometrical demonstration is the method of stating as well as reaching the goal. It is the "most perfect" method, in that it "affords the standard of the given idea of the most perfect being whereby we may direct our mind."[33] The most perfect method and the most perfect being are inseparable for Spinoza. The former demonstrates the veracity of the latter, and vice versa. Geometry convinces us that God is not an impostor, and God convinces us that there is no

reason for doubting . . . mathematical truths. . . . If, after attaining the idea of God, we carefully consider the nature of the Triangle, this idea will compel us to assert that its three angles are equal to two right angles; but if we consider the idea of God, it will force us to assert that he is supremely veracious, the author and the continuous preserver of our nature and hence does not deceive us in regard to this truth respecting the Triangle.[34]

It is as if the triangle were God's representative on earth, being angelically close to him.

The resemblances between Spinoza's and Mondrian's philosophies are too numerous to be coincidental. There are in fact so many that one has to assume that Mondrian's geometrical painting is an attempt to demonstrate Spinoza's *Ethics,* or at least its geometrical spirit, in visual terms. Like Spinoza, Mondrian is in search of a new principle on which to base a new man: "an *abstract,* a *truly* new plastic . . . for the new man."[35] This new plastic principle or "new truth is nothing other than a *new manifestation* of universal truth, which is immutable," an "enduring *truth*" on the order of Spinoza's God.[36] At the heart of Mondrian's determination to demonstrate the "inward universal" through geometrical understanding — his conception of geometry as a kind of *"crystallized inwardness . . .* independent of time," or as *"a direct representation of inwardness* (the universal)"[37] — is the conviction, familiar from Spinoza, that to do so would completely transform the self, and ground it in a new principle, perfecting it. That is, it would fully realize its essence, prefigured, as it were, by geometry. The geometrical manifestation of the essential self liberates the natural self from its obsession with outward objects, turning it inward.

In their different ways, Spinoza and Mondrian are acutely sensitive to the issue of the self's melancholy decadence and happy rejuvenation. It can be argued that Mondrian's philosophical painting, like Spinoza's ethical philosophy, heroically attempts to reverse seemingly irreversible decadence by initiating a process of rejuvenation. For both, this comes through contact with the universal, and more particularly through the recognition of the universal within oneself. "Formerly," Mondrian wrote:

Periods of culture arose when a particular individual (standing over and beyond the people) awakened the universal in the masses. Initiates, saints, deities brought the people, as from without, to feel and recognize the universal; and thus came the concept of a purer [more universal] style [of life as well as art]. When the power of one of these Universals was spent, the sense of the universal decayed, and the masses

sank back into individuality until new power from other Universals could again enter them from without. But precisely because of this relapse into individuality, individuality matured within *man-as-individual*, and he developed a consciousness of the universal within himself. Thus in art today the individual can be expressed as the determinately-universal.[38]

Spinoza seems to have originated this postreligious, enlightened understanding of the universal and the saving power of belief in it: we can save ourselves, for the universal – God – is within us, not in some remote heaven. One has only to turn inward to find it. The problem is how to do so, how to turn away from the outward – how to feel and recognize the universal within, the unveiling process of interiorization, as Mondrian calls it.[39] The mind cannot do so on its own, for the inward seems as remote as heaven. Even the modern, unsuperstitious mind needs help, needs to be initiated into inwardness, though not by saints and deities, who can no longer convincingly do so. Geometrical demonstration, as in Spinoza's philosophy and Mondrian's painting, comes to the therapeutic rescue: it initiates one into interiority and affords redemptive understanding of the "union of mind and the whole of nature," as Spinoza called the universal within. The first difficult change the geometrical method effects is that it turns us inward. It overcomes our resistance to being inward, evident in our fascination with the outward or corporeal, as Mondrian also called it. But this is not all: it also affords insight into the universal, changing us inwardly forever. Thus it is a method of introspection, and ultimately of intuition. Through geometrical awakening to the universal one is saved from individual pathology and despair; one is rejuvenated and gains new faith in existence. Acquiring a sense of one's universality through geometrical understanding of oneself, one gains a healthy new sense of one's nature and individuality. For Mondrian, transcendental geometrical form effects this transmutation and shows its good result.

Mondrian's geometrical painting has a missionary purpose, like Spinoza's philosophy. In both, "the appearance of the *universal-as-the-mathematical*" is of the moral as well as intellectual essence, and for Mondrian "the essence of all feelings of beauty as pure *aesthetic* expression."[40] Primary color, planarity, and the right angle are as axiomatic for Mondrian as Spinoza's definitions and postulates are. Deduced from them, art becomes morally right as well as aesthetically absolute. Mondrian's compositions are not concerned with the properties of space and of objects in space, as geometry classically is, but with geometry in the broader sense, as a means of abstractly articulating the universal, affording instant intuition of its primordiality. His paintings are "measured" – "geometry" is derived from the Greek words *ge* (earth) and *metron* (measure) – but they do not survey any object or space. Space does not exist distinct from geometry in his paintings. They are reciprocal and inseparable. Mondrian does not apply geometry to the world of objects in space, but invents a geometrical world in which there are no objects. This abstract world represents the universal within for him. Mondrian's geometry is an attempt to represent and demonstrate the "abstract-real life" of the basic self in all its immanence,

free of empirical entanglements. The geometry of the representation no doubt gives us the illusion that it is precise, but the self does work in precise ways. Moreover, geometrical representation of the self suggests control of as well as methodical reflection on it, but then the point of methodical reflection is control.

Geometry does not distort, which is the secret of its psychological meaning for Mondrian as well as Spinoza. It differentiates wholeness, or articulates a differentiated whole. As Mondrian would say, it is a dynamic equilibrium or harmony of parts. In contrast, distortion is pseudodifferentiation, a monstrous differentiation of parts that destroys the whole. At best, it is a disequilibrated whole, which is not a whole at all. "Wholeness connotes an assembly of parts, even quite diversified parts, that enter into fruitful association and organization. This concept is most strikingly expressed in such terms as wholeheartedness, wholemindedness, wholesomeness, and the like. As a gestalt, then, wholeness emphasizes a progressive mutuality between diversified functions and parts."[41] In distortion the parts are not mutual. (Hence the famous "incommensurateness" of modern art.)[42] There is no fruitful gestalt. There is an air of disassembly rather than of assembly, an air of self-deconstruction becoming self-destruction.

A Mondrian painting is an autonomous, complexly differentiated geometrical whole, seemingly self-determined. For all its differentiation, it never seems on the verge of disintegration. In contrast, a distortion always does, indeed, seem in the process of disintegration – inherently decadent. There is a happy, jubilant air to Mondrian's geometrical paintings, perhaps most explicit in *Broadway Boogie-Woogie*, 1944, and in other late works. As he said, he wanted an art that was "free of the tragic."[43] In these works Mondrian was not simply trying to illustrate the abstractness of modern dance or to make a painting that was like a machine,[44] but to demonstrate primordial wholeness. Its parts cannot be separated, however much they can be distinguished. Such wholeness is emblematic of "the *mature individual*; once matured, the individual will be open to the universal and will tend more and more to unite *with* it."[45] The geometrization of art matures it, just as the geometrization of the individual – its reduction of itself to its universality – matures the self within it. For Mondrian the "nuclear self" is grounded on universal principle, which is why a principled geometrical art can guide the self to its universal core, consolidating it. In contrast, distorted art signifies the self's fragmentation into numerous unprincipled, tragic, and immature relationships with objects.

Geometry induces the self to turn inward toward its forgotten universality, initiating its cure. But the resulting integrated self also takes geometrical form; different geometries indicate different selves, suggesting that cure can be ambiguous. For Mondrian, the geometrical turn inward was more or less deliberate, systematic, and gradual. For Malevich, it was abrupt, more on the order of a sudden conversion. The geometrical results were necessarily different, suggesting radically different versions of the integrated self. Thus "integration" as such begs the question of cure. The self can assert and interpret its universality in contrary ways. One seems more to the point of cure than the other, although the other is also free of distortion.

Malevich persecuted naturalistic art – I don't think that is an overstatement – as if he might relapse into it, which he did. It was as if the violent certainty with which he attacked it as an error could quiet his doubts and uncertainty about the correctness of the abstract art with which he replaced it. Where he militantly insisted upon the discontinuity between naturalistic and geometrical art, Mondrian saw their continuity. For Mondrian abstract art made explicit the universality in nature, obscured by naturalistic art's representation of its particulars. Malevich wanted a sharp break with the naturalistic past, but Mondrian knew there was none, however new the abstract present was. This led them to conceive the new integral self in crucially opposite ways.

"And any hewn pentagon or hexagon," Malevich wrote spitefully, "would have been a greater work of sculpture than the Venus de Milo or David."[46] For the pentagon or hexagon is a geometrical "zero of form,"[47] a "desert" in which there is "no more 'likeness of reality,' no more idealistic images" to distract one from "nonobjective feeling."[48] Geometrical form is "intuitive form" affording "intuitive feeling,"[49] a " 'desert,' where nothing is real except feeling."[50] "This was no 'empty square' which I had exhibited but rather the feeling of nonobjectivity."[51] Only "abstraction" affords such "pure feeling."[52] Art that "serve[s] the state and religion," that "wishes to illustrate the history of manners," that creates an illusion of verisimilitude, can "never partake of the gladdening content of a [nonobjective] work of art."[53] The glad news of nonobjective representation is "that feeling had here assumed external form."[54] It was " 'unmasked'," as in the "primitive marks (symbols) of aboriginal man."[55] It conveys the same primordial feeling of the "eternal."[56]

The salient fact about Malevich's square, and later his cross,[57] is that it is an intransigent absolute – a predetermined wholeness or categorical gestalt – especially in comparison to Mondrian's more flexible, even informal, dialectical geometry. The latter conveys a different sense of eternity. The primordial or pure feeling it evokes is altogether different in quality from that evoked by Malevich's geometry. Malevich's geometrical desert is not as playful; indeed, it is not playful at all. It is a true zero of form, which is why it is experienced as empty. Mondrian's playful geometrical paintings seem like paradises of plenitude in comparison. Malevich's geometrical space never becomes "transitional" – a fluid zone of contrary forces, suavely integrated or equilibrated – as in Mondrian's case.

In his development Malevich leaps from labored naturalistic distortion to rigid geometrical clarity. This suggests that for him, abstraction is not so much a process by which the self comes to know its immanent wholeness by purifying itself of its external relationships, as it is an authoritarian revelation of a doctrinaire self that crushes every other self. In contrast to Mondrian's realization of the self's complicated universality, Malevich's geometry suggests a utopian simplification of self. Where Mondrian's dialectical geometry suggests a differentiated wholeness, Malevich's authoritarian geometry is in effect an undifferentiated totality. What is the difference? In contrast to wholeness, where the emphasis is on the "mutuality between diversified functions and parts," as noted, "totality . . . evokes a Gestalt in

which an absolute boundary is emphasized: given a certain arbitrary delin-
eation, nothing that belongs inside must be left outside; nothing that is out-
side should be tolerated inside. A totality must be absolutely inclusive as it
is absolutely exclusive."[58]

While Malevich's square and cross are hardly arbitrary delineations,
their declarative starkness suggests they are imposed totalities. They are
boundary markers, totalizing abstraction as Mondrian's dialectical abstrac-
tion never does, even though it constitutes an abstract whole. You are to
pledge allegiance to the square and cross; they are forms to swear on, not a
geometry to play with. They are crusader insignias, not transcendental wit,
like Mondrian's geometry. You either stand on their side – the side of ab-
straction – or on the side of nature, the enemy's side. It has been said that
there is a "need for a totality" within which there is no choice – choice such
as Mondrian's dialectical geometry affords – "even if it implies the aban-
donment of a much-desired wholeness. . . . Where the human being de-
spairs of an essential wholeness, he restructures himself and the world by
taking refuge in totalism."[59] Did Malevich have such despair, and take ref-
uge in totalistic geometrical form? I think so, as his abrupt, affect-laden
switch – characteristic of conversion, as noted (a "total reorientation in
which black may turn into white and vice versa")[60] – from objective to
nonobjective representation suggests. But Malevich probably also mistook
totality for wholeness because he could not comprehend its dialectical char-
acter. (Mondrian obviously did, which is why his wholeness never has the
look of stark totality characteristic of Malevich's abstraction.) Any contra-
diction in the whole seemed like a flaw to Malevich, which is why he could
not believe in a dialectical whole, in the mutuality of opposites. Even when
he celebrates the "dissonance obtained from the confrontation of two con-
trasting forms,"[61] he could not conceive of their dialectical integration.

In contrast to Mondrian's dialectical geometry, Malevich's total geometry
is a facile way of achieving an artistic identity. Malevich shows that it is
easy to be undistorted, but that this does not necessarily mean one is cured
and mature. It may be that Malevich's superego square, dominating and
forcing the painting to completely conform to it – as in Malevich's famous
White on White, 1917 – is a kind of preventive medicine, a strong geomet-
rical dam against distortion. Nevertheless, it has its own pathology. Mon-
drian and Malevich are both geometrical purists and equally fanatic, but
the geometry of the former is less orthodox and suppressive than that of the
latter. In comparison to Mondrian's open geometry, which seems to allow
the spectator into its space without forcing him to conform to any one
form, Malevich's insular geometry seems to lay down the Procrustean law
to the spectator. It is the cult object of the self-proclaimed leader, a coercive
fetish, a geometrical bludgeon compelling obedience. In contrast, Mondri-
an's geometry, which seems to change as one looks at it without losing its
universality, becomes prophetic of inner change, and even seems to invite
one to speculatively consider it. Perhaps Malevich had no real sense of the
healing power of geometry, for he rarely used it with any great subtlety, and
certainly not with Mondrian's subtlety. Perhaps it was only a means of
defiantly withdrawing from the world, if not exactly moving toward the

universality within the self. Malevich's one-dimensional total geometry, with its rigid perfection, is the ideal metaphor for the narcissist's hermetic self-containment. Narcissism is a hollow universality. It is a perverse transcendence of the world and a distortion of the universal within – an empty desert indeed. Thus avant-garde transcendental form can have the same narcissistic twist as avant-garde distortion.

CHAPTER 4

THE EXPRESSIVE CURE
ART AS THE RECOVERY OF PRIMAL EMOTION – EXPRESSIONISM AND SURREALISM

That which belongs to the spirit of the future can only be realized in feeling, and to this feeling the talent of the artist is the only road.

Wassily Kandinsky[1]

Liberating the elements, subdividing them, simultaneously and on all sides tearing them down and building them up, a pictorial polyphony, peace achieved by harmonizing motions: all these are very important formal issues, crucial to wisdom about form, but not art in the highest sense. In the highest sense an ultimate mystery lies behind all this complexity and in its presence the light of intellect sputters and goes out.

Art plays an ignorant game with ultimate things and yet manages to reach them.

Paul Klee[2]

The day is not far off when a picture will have the value, and only the value, of a simple moral act, and yet this will be the value of a simple *unmotivated act*.

Salvador Dali[3]

From the expressive point of view, the "ultimate thing," the "ultimate mystery," is emotion, but not ordinary emotion: "Emotions such as fear, joy, grief, etc.," Wassily Kandinsky wrote, "will no longer greatly attract the artist. He will endeavor to awake subtler emotions, as yet unnamed. Living himself a complicated and comparatively subtle life, his work will give to those observers capable of feeling them lofty emotions beyond the reach of words."[4] Such emotions are *the internal truth which only art can divine, which only art can express by those means of expression which are hers alone.*[5] Without this "internal truth of art," this "soul" that is "the 'what' " of art, "the body (i.e., the 'how') can never be healthy, whether in an individual or in a whole people."[6] Through art "the soul undergoes an emotion which has no relation to any definite object, an emotion more complicated, I might say more supersensuous than the emotion caused by the sound of a bell or of a stringed instrument."[7] This emotion liberates the

soul from "the insecurity of ignorance and fear," from "the decadence . . . of the spiritual atmosphere" prevailing in the world.[8] The artist, a "seer of the decadence," expresses its "terrible atmosphere of empty desolation" and "sense of utter fear," the feeling of being "eternally menaced by some invisible and sombre power."[9] But his art also embodies a supersensuous emotion – the most profound, subtle emotion possible – that triumphs over the sick sense of decadence, regenerating the self.[10] His art is a battle of feelings, in which good feeling wins out over bad feeling, the good feeling becoming the new fundament of the self. Regarding the artist as "a reformer and seer,"[11] Kandinsky attributed special healing power to him.

Like Mondrian and Malevich, Kandinsky was deeply troubled by a sense of decadence or "spiritual darkness,"[12] and like them he believed that art is the "way of . . . inner knowledge"[13] that can cure the self of this darkness. For art leads "from the outer to the inner basis,"[14] where it finds the supersensuous emotion that effects the cure. This innermost emotion seems remote and abstract from the point of view of external life, but it is palpable and concrete from the point of view of internal life, and it affords the most real sense of self possible. Thus by evoking what is deepest in the self, abstract art cures it of its morbidity. Kandinsky's supersensuous emotion, Malevich's nonobjective feeling, and Mondrian's "abstract-real life" or "abstract vitality," are all of a piece, and all have the same revitalizing effect on the self. They "vitalize life in its wholeness and fullness" and "in its most essential nature."[15] As Mondrian wrote, abstract-real life is the true actuality of the self, and "Abstract-Real painting" is its "expression."

Their faith in abstract art would be naive were it not born of desperation. They sensed that modern society was suffering from an epidemic of decadence, from modern melancholia, we might say. This feeling is the dark side of the feeling of being modern or "advanced." In modernity emotional suffering intensifies almost to the extent of seeming irremediable as society becomes more materially advanced. Deep down, and not so deep down, individuals feel old, unhappy, and dispensable – left behind emotionally – the more materially new and advanced society becomes. External advance imposes hardship on inner life, which society regards indifferently in its determination to move forward materially. Those not emotionally up to the regimen of modernity are discarded with an almost Darwinian disrespect for their lack of fitness, as if they were irrelevant to material progress. In general, the more society invests in external progress as if it were the be-all and end-all of existence – or even its panacea – the more individuals tend to regress inwardly, expressing their alienation from society. This is not an iron law, but frequently observed in modern society. It makes more meaningful the familiar idea that man does not live by bread alone.

The psychologically striking thing about the original abstract artists is that they never succumbed to the tragic feeling of decadence, even as they acknowledged its depth and pervasiveness in the materialistic modern world and in their own lives. Kandinsky, while suffering "inner unrest, even uncertainty," was also full of "prophetic self-confidence and high spirituality."[16] Was the latter a manic defense against the former? It is hard to say. What seems clear is that his first abstract works – remarkable for

their hyperactivity – are in revolt against the passivity, the "dreamy" lassitude, typically associated with decadence. Their rebellion against the passive relation to perceived reality typical of traditional representation was in effect a refusal to submit to the exhaustion – the so-called ennui – supposedly inevitable with decadence.

In general, the first abstract artists thought the process of abstraction – of interiorization – could free the individual from the sense that life, especially his own, was a tragedy. It had done this for them when they had nowhere else to turn except inward in an attempt at self-help. Abstract art was the fruit of the interiorization process, rescuing them emotionally. They had experienced the living death of decadence, had felt trapped by morbid fear and inner desolation, and in working their way toward abstract art had worked through their suffering. In the generosity of spirit that was part of the happy emotional result of this self-rescue, they wanted to share the glad news of their conversion to the abstract cure, hoping to convert others for their own good. For Mondrian, Malevich, and Kandinsky, the individual had greater need of abstract art in modern times than at any other time in history. He had an inner need of art: where other art had been made more for society than for the individual, abstract art was made exclusively for the individual (however much society might come to appropriate it). It existed, in effect, to save him from society, to give him a certain inward distance from and perspective on it (and indeed, to remind him that inwardness could be a sanctuary from society). As such, it was a necessary part of his maturation and individuation. (Mondrian even thought abstract art could show society the error of its tragic ways, redeeming it. In contrast, Malevich and Kandinsky seemed to think society was hopeless. This difference in belief in art's power of social – as distinct from individual – intervention may reflect the difference between the Netherlands, with its tradition of tolerant democracy and support for free thinking, and Russia, with its long history of tyranny and psychosocial oppression. Nonetheless, for all three, abstract art was a form of radical and free thinking.)

Until postmodernism, with its masochistic skepticism about art – in postmodernism art is made, but with little or no expectation of any positive human gain from it, and certainly with no conviction in its healing power – the attempt to develop and manifest art's latent potential for healing was inseparable from the idea of "advancing" art. I believe one of the unconscious reasons Kandinsky regarded music as the model art is that, of all the arts, its powerful, instantaneous healing effect was universally recognized, as the stories of Orpheus and David indicate.[17] Orpheus's music ended the conflict between the animals that was symbolic of inner conflict. David's music cured King Saul's melancholy. The malaise of the current end of the century is deeper than that of the last one, for now there is no countermovement toward cure, no sense of the music of art, only a regressive sense of déjà vu.[18] Postmodernism, coldblooded and calculating about art – Warhol epitomizes this "realistic," objective attitude – pessimistically reduces art to its own history, implicitly acknowledging art's lack of significant effect on human existence and world history. In contrast, postimpressionism, in conceiving of the music of abstraction, kept faith

with the ancient belief that art was able to do profound emotional good. In a sense, abstract art is the grand climax of this belief, the fruit of a long, no doubt unconscious historical effort to find visual forms that are instantaneously, miraculously therapeutic, like music. Indeed, in quintessentializing art, abstract art seems to renew its therapeutic intention (which always has to be renewed, and unconsciously motivates the renewal of art). Thus abstract art is visual art at its deepest, in that it epitomizes the healing intention and power – the magic – of art as such.

Traditional society was protected from the sense of decadence by belief in the meaningfulness of transcendence, embodied in religion. Abstract art re-embodied it for modern society, which is one reason the first abstract artists felt imbued with a sense of religious mission. (The sense of decadence is the most emotionally ugly underside of the sense of transcendence, exposed when it is lost.) No doubt the conviction in the healing power of art has narcissistic roots, but it is not altogether an illusion. It does seem absurd from the view of art history, with its objectivist emphasis on art as a matter of social and aesthetic convention and ideology. But our subjective willingness to enter the illusion of art – to suspend disbelief in and submit to it – in order to let it make its "impression" on us, is already therapeutic in import and effect. For to trust its illusion is to free ourselves of the disillusion and distrust implicit in the sense of decadence. It is to become, however subliminally, happy, to be cured. Believable art becomes the happy alternative to the unbelievable world.

The first abstract artists probably gave their all to art to quiet their self-doubt, and overestimated its power when it seemed to do so, as people with any fanatical belief will. Their belief in its healing power ensured its significance. Moreover, standing their abstract ground in Luther-like fashion, they found the footing they needed to withstand the pressure of tradition that threatened to overwhelm them with a sense of inferiority. Indeed, their conscious feelings of desolation, anxiety, and persecution unwittingly acknowledged – defended against – their unconscious feeling of vulnerability. The sense of decadence bottoms out in the abyss of vulnerability. Thus there is an undertone of destructive competitiveness and Savonarola-like fanaticism to their abstract fundamentalism. The desperateness – and greatness – of their ambition is evident in their attempt to invalidate all prior naturalistic art by declaring their abstract art a basic revolution in art making, and as such the inner truth of art. They outsmarted the tradition that made them feel inferior, cunningly defeating it while paying it the lip service of claiming to have developed from it. But abstract art also served their will to recover from decadence, suggesting their genuine belief in it. As Franz Marc said, "Like everything genuine, its inner life guarantees its truth,"[19] and because abstract art conveyed a strong sense of inner life, it was genuine. In a sense, by spreading its good word they attempted to heal all those for whom the malaise of decadence meant the failure of the old way of looking at the lifeworld, symbolized by traditional representational art. They wanted to give them a new inward way of looking.

Nonetheless, Kandinsky wanted to transform the old representational way, not abandon it. "Must we then," he asked, "abandon utterly all ma-

terial objects and paint solely in abstractions?"[20] No, he concluded, not if the "inner vibration" of the object is made evident. As long as the work is the expression of "inner need"[21] and "inner meaning"[22] it is artistically valid. The artist must realize "the impossibility and . . . uselessness of attempting to copy an object exactly," and instead give it "full expression."[23] Re-formed according to the imperatives of inner need, the object expresses the subject's inner meaning. Its form, always relative, becomes *"the outward expression of this inner meaning."*[24] For Kandinsky, "there is no 'must' in art, because art is free,"[25] however much "the greatest freedom of all, the freedom of an unfettered art, can never be absolute."[26] For in every age there are "boundaries of . . . freedom," beyond which "the mightiest genius can never go."

The expressive cure differs decisively from the geometrical cure, as their formal difference suggests. Both are concerned with freeing the spirit, but in the latter case the turn inward leads to axiomatic security – a feeling of fundamental safety inherent in the geometrical, which has a kind of *hortus conclusus* effect. In the geometrical cure the self is given a firm new boundary, as it were. In the expressive cure, the determination "to set art free"[27] bespeaks the search for positive feeling where the only feelings are negative. The expressivist plunges through the self's seemingly limitless bad feeling about itself in search of a pearl of positive feeling, never certain that it will find it. This fear contributes to the general atmosphere of anxiety in which the expressivist makes art.

It seems possible to argue that Mondrian and Malevich transpose the feeling of being constrained they experienced in the world onto the more sublime plane of art. This no doubt makes both the world and the feeling easier to live with, but it does not exactly plumb the depths of the self. The geometricist has no need to go so deep; his inner need is different from that of the expressivist. However intense that need, there is still the sense that geometrical art is of more limited import for the self than expressivist art. However vital and expressive geometry can be made to look, it nevertheless conveys a sense of rigid control, all the more so by reason of its look of preformed perfection. The self-certainty it affords has a strong odor of sanctimonious inhibition. Mondrian and Malevich, while feeling integral, are hardly fully free, alive spirits. There is a perverse sense of pathos to geometrical transcendence. The pathos of expressive transcendence is even deeper. The sense of irrepressible, free feeling it creates – of feeling that once again freely circulates in the self, awakening it from decadent numbness – never entirely frees the self from a sense of impending doom.

I submit that where the geometrical cure addresses the threat of identity diffusion in the world, the expressive cure addresses the threat of psychological death – the catastrophe of not feeling alive, which only the feeling of being limitlessly alive can counteract.[28] Geometrical abstraction addresses the ego – that part of the self that has the task of dealing with society, among other tasks – that feels its "selfsameness and continuity" under siege, an internalization of its experience that it has no "sameness and continuity of . . . meaning for others."[29] The ego despairs of its identity – feels itself at a peculiar loss – in society, which seems indifferent to it. Taking

society's indifference to heart, the ego feels anonymous, as indifferent to itself as it feels society is indifferent to it. It feels so imbued with society's indifference that it feels diffuse in itself. Identification with axiomatic geometrical integrity is the ego's way of recovering from this feeling of being anonymous to itself, from its identity crisis. Geometry gives it the sense that if it lives by strict rule, which concentrates it in itself, it can hold its own in and against the world.

In contrast, expressive abstraction addresses the self of which the ego is a part, the self that feels threatened in its very wholeness, almost completely annihilated by its relentlessly bad feelings (superficially about the world but ultimately about itself). In the midst of this almost sensual plague of feelings that seem to take over the self so that it loses solidity, good supersensuous feelings arise, creating the feeling that the self is not entirely lost. This is the typical ambivalent atmosphere of expressive works of art. Expressive transcendence gives the self an unexpected last chance to feel good about itself, while geometrical transcendence gives the ego a ready-made model identity. Or, in Kohutian terms, to take the geometrical cure is to deal with the kind of guilt that arises from the ego's conflict with the world, while to take the expressive cure is to deal with the self's deep sense of the tragedy of its existence arising from its feeling of unreality, its uncertainty that it exists.[30] The former deals with the lesser decadence, as it were, the latter with the greater decadence.

However, at bottom both address the schizoid feeling of not truly being a person, which is deeper in those who need expressive therapy than in those who need geometrical therapy. Expressive abstraction mediates a sense of extraordinary, even absolute fullness of being – a sense of never having been empty – that the profound schizoid is incapable of experiencing. For feeling either empty (Kandinsky's "empty desolation") or threatened by the catastrophe of emptiness[31] (Kandinsky's invisible, lurking menace) is basic to the feeling of never having been a person in one's own right. Expressive abstraction addresses this feeling of fundamental deprivation, while geometrical abstraction addresses the feeling that one has no mastery of the world, and so has no future in it. Geometrical abstraction offers a certain remedial clarity about oneself and one's place in the world, while expressive abstraction offers a sense that one has a depth one did not know one had, which makes one feel more alive than one ordinarily thinks one is. Expressivists show an endless pursuit of ever deeper and more primitive feeling that is always located somewhere other than where they are. Thus their manic interest in primitive art, with the "primitive" always conceived as the emotionally as well as spatially and temporally remote. Behind the novel cultural experience of the primitive stands the novel emotional experience of feeling alive because one has deep – primitive – feeling.[32] In sum, expressive abstraction gives one a sense of self one ordinarily lacks, while geometrical abstraction gives one a sense of worldly identity one ordinarily does not have. The latter allows one to hold one's own in the world, the former to hold on to oneself whatever world one is in, to feel that one has inherent value.

But the geometricist is also schizoid: his geometry is an intellectual defense against the frustration of feeling empty (against which the expressivist has no defense at all).[33] Indeed, however embellished with resonant color, geometry remains peculiarly empty, desert-like, as Malevich acknowledged. It is an empty identity, signaling the very feeling of emptiness it defends against. Like a social role, it gives one an insufficient sense of fullness of being and personhood. Behind the geometricist's alienation from the world is anxiety about annihilation of the self, if not, as in the case of the expressivist, the sense that the self has in fact already been annihilated, that it exists nominally if at all.

There is a sense of secrecy and superiority – indeed, of secret superiority – to both geometrical and expressivist abstraction, which is another schizoid symptom.[34] This is correlate with the sense of being "odd art out." It also leaves the audience out in the cold, in effect devaluing it, for the audience belongs to the threatening world. In a sense, the abstract artist denies the personhood of the audience even while ministering to its problems of personhood, whether they involve the sense of loss of identity or of self. This contradictory attitude about the audience – addressing and consuming its inward life while denying that it has any (at least the way the profound abstract artist does) – is typically schizoid.[35] To split the audience, to turn it inside out while denying that it has the same inner depth of the artist, thus alienating it from itself and narcissistically elevating the artist over it, is a standard avant-garde strategy of relating to the audience. This is evident at least from Courbet, whose arrogance was legendary.[36] It epitomizes the schizoid characteristics, which are "(1) an attitude of omnipotence, (2) an attitude of isolation and detachment, and (3) a preoccupation with inner reality."[37]

The last "is undoubtedly the most important of all schizoid characteristics."[38] It is clearly responsible for the abstract artist's depreciation of external reality – including the audience – and for his withdrawal of affect from it. The peculiar impersonality of abstract art is a consequence of this.[39] Indeed, the emotion it communicates as well as its form is impersonal. While it involves the return of repressed affect, the affect returns in the impersonal form of the primordial or primitive, that is, isolated from any representation of or relationship to the real world. Thus it is likely to be misunderstood; in fact, abstract art is regularly charged with failure to communicate, with a breakdown in intimacy or inward relation with the audience by reason of the very abstractness which is meant to turn it inward. Like many schizoids, the abstract artist is acutely sensitive to his own inner processes, but he is insensitive to – indeed, cut off from – those of others.

Moreover, because he conceives and articulates his feelings as abstractions,[40] he continues to seem repressed, however expressive the abstractions are. There may be no representational intention to distract and detract from pure expressivity in abstract art, but it seems peculiarly repressed in itself. This is especially the case in geometrical abstraction, but abstraction as such perversely denies inner life in the very act of articulating it. The

"mystical inner construction"[41] is a "Gordian knot,"[42] for it is expression and repression in one. This is because it bespeaks the self in process of transition from decadence to renewal, and thus ambiguous in character. Unsure of itself, the self seems abstract to itself. Thus while incommunicado abstraction may imply profound self-communication, it also suggests that the abstract artist has no reliable self, however genuine his inner life may be. His "nonobjective hieroglyphs"[43] may signify supersensuous emotions, but they do not constitute a self as such. Incessant emotion, whether good (supersensuous) or bad (decadent), does not constitute an integral, structured self, but rather suggests its fluid, unresolved state. Bad emotions suggest its disintegration, good ones its will to recovery, its hope for renewal. In neither case is there a secure sense of self. Abstract art shows profound emotion, not stable selfhood. Indeed, it is because the abstract artist has no real self to give that his art is so emotional.[44] As its enemies have said, abstract art may be seriously empty for all the drama of its first appearance in the world, and for its internal drama.

The so-called obscurity and incomprehensibility of avant-garde art, especially abstract art – and most of all abstract expressionist art, by reason of its tendency toward formlessness or indeterminate form – are the basis for the belief that it is inherently mysterious, and as such articulates an enigma. In a sense, an enigma is a reified or stylized secret – Fairbairn regards the "vaguely mysterious air . . . as pathognomonic of an underlying schizoid tendency"[45] – but the enigma is the indifference of the world mischievously thrown back in its face. Keeping a secret from the world, creating the effect of knowing something it does not and will never know that is so central to avant-garde art, is not only a paranoid withdrawal from the world's indifference, but also a vicious, however sublimated, attack on it.

Is there in fact a secret or mystery that art knows that the world does not? Spontaneity says there is. The special importance of expressive abstraction, in contrast to geometrical abstraction and the art of distortion, is that it is spontaneous, or strives for spontaneity. That is, to use Dali's word, it is "unmotivated" or unpremeditated. And "total spontaneity of expression," as Breton said, [46] is the most direct avenue to the primordial unconscious. The unconscious – mysterious in itself, and working in mysterious ways – is art's secret. What adds to art's mystery is that it can express the unconscious spontaneously, yet in a way that makes it tolerable to society. Only through spontaneity, or automatism as Breton called it, can a work of art

encompass the whole psychophysical field (in which the field of consciousness constitutes only a very small segment). Freud has demonstrated that at these unfathomable depths there reigns the absence of contradiction, the relaxation of emotional tensions due to repression, a lack of the sense of time, and the replacement of external reality by a psychic reality obeying the pleasure principle alone. Automatism leads us in a straight line to this region.[47]

Both the surrealists and expressionists want to make art spontaneously. The former seem to think one can learn to do so, as their methodical use of incongruity and chance suggests. It is a deliberate attempt to disorder the senses, in Rimbaud's famous phrase, in order to make unconscious sense.

While consciousness may be a small field in contrast to the seemingly infinite unconscious, it is equally fundamental to the self: there can be no self without it. Even the most narcissistic self is conscious, however limited the object of its consciousness. Where geometry leads upward toward primordial consciousness, spontaneity leads downward toward the primordial unconscious. Each embodies a different mystery of the mind. The austere clarity of geometry bespeaks consciousness at its most pure, while total spontaneity of expression seems purely unconscious. Both can cure modern melancholia – "miserabilism," as Breton called the sense of decadence, a "plague . . . of misery" which has many "categories . . . physiological misery, psychological misery, moral misery, etc."[48]

However, the expressive cure for misery seems easier than the geometrical cure, for while one must consciously take possession of geometry, the unconscious already exists within one. But this is deceptive, for it is hard to be spontaneous. And however spontaneous one becomes, one's unconscious remains remote, fathomable only to a limited depth. One never really knows how big the iceberg is below its tip. The "Eureka effect" of spontaneity quickly fades into forgetfulness. Consciousness tends to take geometrical form; in a sense, this is an attempt to make geometrical sense of the lifeworld, to clarify it as it is experienced, creating the illusion of being in control of it. It is never more than partially successful, however, and always subject to revision, for there are other geometries. In general, consciousness is in a process of perpetual construction, or a construction in constant repair, with the futile aim of becoming geometrically perfect. And the construction is always limited, confirming the smallness of the field of consciousness. In contrast, the unconscious is an ingenious chaos. It has its logic, but the forms it takes are ramshackle and temporary, improvised and unstable. Thus the expressive cure does not claim the durable results implied by the geometrical cure. However, the sense of freedom it evokes has a more immediately tonic effect than the sense of identity the geometrical cure suggests.

Surrealism and expressionism want to evoke the same sense of freedom. Indeed, Breton often sounds like Kandinsky, whom he regarded as one of the "two leaders" of the spiritual "rebellion [that] began around 1910."[49] Kandinsky was as "imbued with eastern culture" as Picasso, the other leader, was "imbued with western culture." The "many daring exploits" of both

served to remind us that . . . the primitive form of any entity is feeling. It is feeling that triumphs here, that splits the rough crust right open . . . and by virtue of the resistance it has vanquished, is able to transcend all doctrinaire viewpoints and instill in succeeding generations of artists a boundless love of liberty.[50]

Their art "should inspire suddenly the kind of unique emotion which, when it grips us, provides unassailable evidence that we have just been granted a revelation."[51] It is a revelation of desire. When art expresses an object, in effect it articulates the desire invested in it; however, when it represents the object it represses this desire. In Picasso's art the "external object" becomes

"synonymous" with desire,[52] while Kandinsky gives desire *"symphonic"* form.[53] Completely liberated from the representation of the external object, his art seems to render "a brilliant *interior*" directly.[54] Breton describes Kandinsky as "one of the most exceptional, one of the greatest, revolutionaries of vision,"[55] and endorses his *"principle of inner necessity,"* which transcends "purely technical procedures."[56] For Breton, "Kandinsky . . . presents deeper philosophical understanding in his work than any other artist since Seurat."[57] And like Seurat, his "inward-direct spirit"[58] leads directly to the unconscious, establishing "in an absolutely original fashion [a] relation to desire."[59] In his search for precedents, Breton gives special place of honor to Kandinsky, who carries to an extreme the Symbolist attempt to give "priority" to the "deepest desires" rather than to ordinary feeling, to create an image which "an irrepressible desire seizes."[60]

To express unconscious desire spontaneously is to defy the world's militant denial of spontaneity as a threat to consciousness. This is another manifestation of the world's indifference to the inner life of the individual. The world cannot imagine anything beyond the small field of consciousness that it systematically cultivates. It brings desire itself into the field, conventionalizing it into a system of meaning, believing that it has thereby diminished or domesticated it. The world can accept spontaneity only in stylized form (not just in a strictly controlled situation). Like a Prometheus throwing off his chains, the spontaneous eruption of desire destroys the world's systems of meaning, rebelliously replacing them with the madness – the "meaninglessness" – of unconscious desire.[61] Spontaneity convulses the psyche, engulfs it in a fit of desire.[62] However short-lived this fit, it is enough to discredit all conventional meanings. Indeed, it undoes the world's attempt to claim consciousness from the unconscious the way land is claimed from the sea. Spontaneity in effect pulls the plug from the dam of consciousness, letting the waters of the unconscious rush out violently. This is the famous violence avant-garde art does the world and its representations and meanings. At the same time, this release and overflowing of primordial unconscious desire, and the chaotic flux of feeling that accompanies it, restores a sense of freshness and vitality to life, refertilizing it in the process.

Nonetheless, the convulsive, spontaneous, revolutionary release of desire, an expression of desire shedding all objects of desire (which is the meaning of the metamorphic distortion and final elimination of external objects) is schizoid in import. The world forces it upon one by the rigidity of its conventions and systems of meaning. The world also forces one to turn inward, away from it, and to turn the desire inside one disruptively outward in order to convince oneself that one is still alive and well. Otherwise, one is smothered by the world's conventions, entombed in its systems of meaning. One's meaning to oneself is lost, and the unconventionality and specificity of one's existence goes unacknowledged. (The sense of the concreteness and irresistibility of desire that occurs in spontaneity is individual existence's declaration of independence.) Spontaneity tells the truth of desire that keeps one true to oneself, turning the tables on the world's sense of truth, on its attempt to sever truth from desire and deny the truth of desire. Thus the solitude or inwardness of hermetic avant-garde art – its antisociality being

part of its anticonventionality – is paradoxical; for this inward solitude is part of its spontaneity, but also indicates its schizoid isolation and misery. (The postmodernist conventionalization and socialization of the hermetic avant-garde seem to bring its tragic state to an end, but these effects are in fact more tragic than the art's schizoid defense against the world, for they bring the rebellious desire implicit in the defense under control once again. That is, postmodernism represses the desire avant-garde art spontaneously expresses by conceiving of – or by administering – avant-garde art as a system, that is, as a traditional kind of art developing in a traditional, systematic way.)

Thus spontaneous expression is profoundly narcissistic in import, as Breton implicitly acknowledged. It is an attempt to heal the narcissistic injury the world carelessly inflicts on the self. Spontaneous expression is a reactive, secondary narcissism, an attempt to exist without relating to the world's objects, and ultimately to deny being-in-the-world. Or rather, it is an attempt to turn the world so completely into a symbol of the self that the world seems to have no other reason for existing than to empathically reflect the self. But this magical metamorphosis of the world into the good mother shows that art has become a way of lying to oneself.

CHAPTER 5

FAME AS THE CURE-ALL
THE CHARISMA OF CYNICISM –
ANDY WARHOL

Nowadays if you're a crook you're still considered up-there. You can write books, go on TV, give interviews – you're a big celebrity and nobody even looks down on you because you're a crook. You're still really up-there. This is because more than anything people just want stars.

Andy Warhol[1]

In the case of fame the mind is still more absorbed, for fame is conceived as always good for its own sake, and as the ultimate end to which all actions are directed. . . . Fame has the further drawback that it compels its votaries to order their lives according to the opinions of their fellow-men, shunning what they usually shun, and seeking what they usually seek.

Benedict de Spinoza[2]

Avoid being conspicuous and keep away from a position of power. Do not live for . . . fame. Thus you will not criticize others and others will not criticize you. The perfect man has no (thought of) reputation.

Chuangtse[3]

For Andy Warhol, fame was the cure-all.[4] Like every panacea, fame presupposes global illness; in this case, the sense that everyone is terminally ill with the feeling of being nothing. Unconsciously everyone feels decadent: everyone is living death, whether they know it or not. However, Warhol was not everyman, but a very famous man, a superstar. Fame, he superstitiously believed, could ward off the feeling of nothingness, even keep death – actual nothingness – at bay. It was the ultimate defense against the reality of death and the feeling of being nothing, which Warhol wrote a good deal about.[5] He shrugged off the feeling by saying "so what?" to it[6] – a typical Warhol strategy of avoidance, even denial, of the emotional truth – but only fame truly freed him from it. It was, however, only a brief respite, a deceptive relief. The paranoid feeling of being nothing, suggesting serious narcissistic suffering, quickly returned. The compensatory wish for

fame, in which all of his libido came to be invested, could not expunge it. In fact, fame perversely intensified the feeling. Perhaps this is one reason Warhol never stopped wanting to be famous.

Obsessed with the feeling of being nothing, Warhol took his revenge by turning everything he touched into nothing. It was the opposite of the Midas touch, a sign of his omnipotence and of the omnipotence of nothingness. He took credulous human beings, eager to believe in him, and turned their innocence into cynicism. He was a Pied Piper, luring many with the magic of his stardom, which they thought could free them from the misery of their existence; but he betrayed them and caused them to betray themselves. They wanted to live in the aura of his fame, for its glitter made them feel life was exciting and extraordinary. In fact, his fame mirrored the banality of their existence, just as his works reified the banality of whatever they represented while seeming to elevate it to high art, which indicates just how unavoidable banality is. His art spotlighted those already in the limelight, as though to confirm their glamour. Indeed, at first glance he seemed to distill glamour as if it were the essence of being. But Warhol's art is like the harsh light a detective shines in the face of a suspected criminal to force a confession from him. Warhol grilled the glamour of the famous, interrogated it until it disintegrated, and showed it to have been a shallow camouflage, a masquerade, all along. The famous disintegrated with it.[7] It was a cosmetic farce, not only because it was only skin-deep but because it was applied all too mechanically. Warhol showed the glamour of fame to be a hollow artistic construction: in his hands art became a banal method of glamorizing banal people and things – a tautologization of banality, as it were. If, as Baudelaire said, banality is the only vice, Warhol's consciously hypocritical attempt to show the *virtu* in banality confirms it as the prevailing vice.

Warhol's art, then, is an extended, relentless exercise in entropic banalization. Indeed, for him more than for any other pop artist it is the master method of art. Without it popular fame – the saturation of public space with a standardized appearance constructed in a standard way – is impossible. Warhol uses seriality to enforce the banal self-sameness of his subjects, whatever their appearance. This affords fame to whatever it multiplies, suggesting that to be famous means to be repeated ad nauseam, like a record stuck in a social rut. Such repetition, initially comic, is eventually banalizing, as Bergson suggested. Warhol implies that the famous are willing to surrender to banality to sustain their fame, as if they believe that only when fame has been completely domesticated by banality is it convincing, even to themselves. Thus he shows the banality of fame, as well as its power to banalize. It is a banal illusion, unable to free one from the feeling of nothingness, being itself nothing. In a sense, Warhol's whole career is a perverse demonstration that fame, the last therapeutic hope, does not heal. Through his art he projects his feeling of being nothing and of the nothingness of fame onto name-brand things and famous people, undermining them by implying that they exist only insofar as they are notorious, that they have no substance beyond their exaggerated reflection in the public eye.

Warhol's art signals the end of the belief in the therapeutic power of art. It exists to disillusion us about art, and is an art of disillusionment. As such, it is the first genuinely postmodernist art. Belief in the healing power of art is the cornerstone of modernism, as if its revolutionary transformation of art demonstrates the power of art to transform the individual's life for the better. This is, indeed, the ultimate rationale for modernist utopianism. By the same token, disbelief in the healing power of art is the cornerstone of postmodernism, from which its regressive historicism and semioticization of art follows. That is, its reduction of art to its own panoramic history suggests art's involution, exhaustion, and futility. More particularly, postmodernism involves the intellectual reification and deindividualization of avant-garde, therapeutic styles into dead historical languages. This archaeologizes the avant-garde, generalizing it into a tradition correlate with the revival and revalidation of tradition, whose steady state and psychosocial irrelevance is disguised by its ironic manipulation. Where the modernists were forward-looking psychic revolutionaries, the postmodernists are backward-looking social reactionaries, even if they have ironic insight into the status quo of art and the society, a status quo they help sustain. They have no intention of changing art or society to indicate the need for individual change, let alone to catalyze actual change. Just as the therapeutic intention defined the avant-garde and kept alive belief in innovation and faith in art – each new style was in effect a new therapeutic technique – so disbelief in art's therapeutic power defines post-avant-garde art, which mocks innovation by turning the new into a cliché and believes in art only insofar as it is a "concept." One could say that with postmodernism, art loses its therapeutic pretensions and becomes more modest, and so more sane; or one could say that it becomes masochistic and cynical. Warhol's art epitomizes the abandonment of the therapeutic intention, the semioticization of art into a facile public language, and the use of art to maintain, however ironically, the psychosocial status quo. While Warhol does not revive tradition, photography becomes traditionalized, as it were, in his art, becomes *the* cliché of the new. Sociopolitically reactionary,[8] he cynically turns the contemporary into archaeological detritus. In Warhol's ambiguous vision of current fame, obsolescence seems built into the success story. At the same time, success secures social, indeed historical, privilege and attention, which are gratifying to narcissism. That is, Warhol makes his success stories seem like pillars of the old order, still secretly running the world, as well as like pillars of salt. Both are postmodern pillars – restorations of the ancient regime in all its decadence.

For all his demonstration of fame's hollowness and his ironic use of it to express his feeling of being nothing, fame gave Warhol a sense of omnipotence. It was really this that stilled his feeling of being nothing. His persona and art – indeed, his persona was perhaps his most important, consummate art – were determined by this dialectic between the feeling of being nothing and the feeling of not only being something, but being something powerful to the point of invulnerability. Of course, he had the power only to destroy, to turn to nothing, not to create. He felt invulnerable because his art was in a sense a preemptive attack on the object before it attacked him, especially

because his artistic attack was impartial and impersonal. He did not care why something or someone was famous, nor how or why it got its fame, only that it was famous. Satisfying himself that it was fair game by reason of its publicness, he appropriated its fame as if sucking an oyster from its shell. The rest was discarded, like the shell.

As is well known, Warhol described himself as a machine.[9] His art was in effect a machine for extracting fame from human beings as if it were their soul, compacting them in the process. The concentrated distillate of fame was the product, to be drunk like a rejuvenating elixir by Warhol. He refueled his own machine on fame; driven by it, he could never get enough of it. I do not think Warhol's sense of himself as a machine – even a rather hardworking machine – was a completely ironic, idle metaphor, for the machine was implicitly God for him. In identifying with it he identified with the God of the modern world. The camera and tape recorder were different senses as it were, of the same all-powerful machine of modernity. I suggest that Warhol unconsciously thought of himself as an "influencing machine." That is, he projected his insane sense of himself – the delusion of grandeur and omnipotence as well as the feeling of being nothing and thus not human that was its correlate – onto the modern machine.[10] The modern machine succinctly embodied both by reason of its extraordinary, indifferent power, by its amoral productivity. It could not help but taint with its subtle "negativity" whatever it produced. Warhol's machine-made libidinous color seemed to drug or anestheticize his subject matter into machinelike indifference so that it would feel nothing as he remanufactured it, à la Dr. Frankenstein. He turned whatever he touched into his psychic double, into an inhuman machine, a glorious thing. Indeed, as a machine making art things to "justify" and glorify his feeling of being a thing, he was probably more comfortable representing things than people. The former were already like him, so that they could more readily become his surrogates. The latter first had to be reduced to things to be of "personal" service as self-representations.

In his preoccupation with reification and self-reification – his sense of himself and others as things – Warhol carried a modernist idea to reductio ad absurdum. It was clearly stated by Giorgio de Chirico, the one artist with whom I believe Warhol came to identify because of de Chirico's repudiation and reification of his earlier enigmatic work:[11] "Completely . . . suppress man as a guide . . . once and for all to [be] free . . . from . . . anthropomorphism . . . to see everything, even man, in its quality of *thing.*"[12] This amounts to depersonalization; it contrasts sharply with the intention of repersonalization that is the other side of the modernist coin, especially, but not exclusively, in expressionism. Warhol's depersonalization of himself was yet another defense against his feeling of being nothing.

So, for that matter, was de Chirico's depersonalization of the human. But for him it was a matter of shedding the everyday sense of man in order to reconceptualize him as enigmatic. De Chirico wanted to show that the unconscious – it was unconventional and socially disruptive in his heyday – held more of the human essence than consciousness. Thus he repersonalized man by representing his unconscious fantasy and anxiety, usually kept

from everyday consciousness and repressed. Warhol refused this second step, eschewing all sense of unconscious enigma and symbolization in his art. But his candor – his staying on the mechanical surface – hid the enigma of his narcissistic anxiety. He was militantly opposed to subjective statement, as though making his feeling of being nothing visually conscious, however verbally conscious of it he was – by letting that dangerous cat completely out of the bag by representing it in his preferred medium of expression – would show him to be nothing in reality, completely disintegrating him. (Did he keep repeating the anxiety-arousing words "I feel like nothing" to himself until they no longer aroused any anxiety, indeed, until he no longer felt anything about them – until he numbed himself into feeling that they had no meaning, and so held no emotional terror?) He tried to stamp out art that made a point of subjectivity, or rather to cancel its subjective import, as in his repetition of de Chirico's *Disquieting Muses*, undoing its absurd import by standardizing it.

De Chirico himself had mechanically copied that work, in effect denying that there was anything enigmatic and uncanny about it and suggesting that he, like Warhol, believed that to deny disquieting feelings was the best way to handle them. The muses, in fact, look mechanical, for all their antiquity, and their fragmentation seems engineered: fragmentation as well as depersonalization is a defense against profound disquiet. The question is whether Warhol's depersonalizing approach, and that of the later de Chirico, tells the modern truth about the human, namely, that it is a machine-like thing; or whether depersonalization is, as it was for de Chirico, a necessary first step. Was it, perhaps, a method of clearing away obsolete, traditional conceptions of the human, of reenvisioning the human as unconsciously motivated, presumably truer to the human than the depersonalized mechanistic model? There is no clear answer. Modernity is split between the depersonalized and repersonalized models of man, which is another instance of the dissociation of sensibility T. S. Eliot remarked as characteristic of modernity.

It must be emphasized that both Warhol and the later de Chirico used serial copying destructively. By implying that human beings and symbols of human life can be repeated ad infinitum and are virtually interchangeable, the artists turned the human into nonsense, in effect annihilating him. Repressed by its repetition, the sense of being human can never return except by a miracle of the unconscious – by its renewal in the unconscious. But Warhol's art was not about unconscious miracles, and de Chirico, in a kind of creative collapse, lost his will to make any – lost his early repersonalizing and generally rehumanizing attunement to the unconscious. His later humorless copying or repetition, his self-conscious traditionalizing of himself, suggests a false maturity, like that of post-therapeutic postmodernist society. Like it, the self de Chirico institutionalized through his copying was dead on arrival.

Copying not only kills the unconscious import and power of the image but implies necrophiliac intimacy with the empty appearance that is its residue. The famous were Warhol's preferred subjects because they could be instantly and exhaustively grasped, appropriated, and consumed through

their appearance, which could be endlessly copied because it was empty and unchanging. They were originally a copy – an original copy, that is, a copy without an original. A copy cannot change or become different, whereas an original can reoriginate itself, that is, it can regress to the origin to begin again in a different way. Human beings are of the origin, and therapy is a way of returning to that origin in order to redifferentiate, reindividuate, and rehumanize. Warhol's ambition to turn human beings into copies of themselves shows how determined he was to root out the idea of human originality and the recurrent need for therapy or reorigination as a means of better realizing one's humanness. In fact, he never thought he needed therapy.[13] The denial of human originality and, correlatively, the repression of the need for therapy are the ultimate cynicism about human beings. (One is always in need of therapeutic reorigination, for one is never human enough, never a good enough human being. Even if one does not have therapy, the awareness of a need for it implies one's hope for renewal and signals acceptance of one's unconscious origins.)

Warhol's denial assumes that human beings are forever fixed and finished, that is, fated. The possibility of a therapeutic return to origins in order to renew one's humanness, indeed, to realize it more fully – the idea that one can have a second chance at humanness in unhappy recognition that one was not adequately human before, in oneself or to others – defies fate. (Since one's sense of humanness catalyzes one's growth, not to renew it is to shrink.) This possibility is precluded by the idea of the copy, which reifies fate. There are no second lives for a copy: there is no renewal, only repetition. The copy reifies the status quo so as to obviate the very idea of originality. The famous subject is the infinitely repeatable subject in no need of reorigination. Those who have no origin to return to are truly lost souls.

In a sense, Warhol simply stated the obvious truth that the popularly famous were nothing more than their appearance. Fame made them seem copies of themselves and their humanness an act. Warhol simply stole their act. But Warhol was attracted to the popularly famous not only because they seemed to master the act of being human while inwardly giving up on humanness, but also because they seemed unironically indifferent to the very idea of being human. They played at being human, indeed, seemed to make an art of it; but their artistic game nihilistically reduced the human to a simple routine, rather than enriching our sense of its complexity and subtlety. Thus they took Duchamp's ironic indifference to human originality a final decadent step further.

Warhol was envious of the feeling of imperviousness to existence given one by such complete indifference, by the expression of authoritarian narcissism. The popularly famous became emotional role models for him. They were narcissistically whole (and as such without – and in no need of – a complicated inner structure) and rewarded with social success for their narcissism and uncomplication. They were more rewarded, certainly, than were esoterically famous avant-garde artists, who still did not realize the futility of wanting to change – reoriginate – life through art, thus changing art in the process. The indifference to reorigination of the popularly famous, and the way life and art seemed seamlessly integrated through their

fame, suggested that they had successfully bluffed their way through life and art, reducing both to trivial games, easily played and won. In contrast, Duchamp's irony hid a regressive wish for – a nostalgic awareness of – being human, but the popularly famous were altogether beyond such dialectical irony. They knew that if one totally invested one's humanness in one's public persona one could live without that humanness and it would not catch up with one. They came to accept it as normal to be treated like one-dimensional things, to exist the way others saw them. Warhol came to live the same nonhuman way, as if laid out like a corpse in the coffin of a photograph, always on show. Keeping up one's simple public appearance – now and then introducing small, pseudocomplicated variations in it to keep it lively, engaging, "enigmatic" – was more narcissistically satisfying than the complicated business of being human for others. It was as if one's death instinct, acting through one's narcissism, made one want to become famous. There may have been some lingering irony in his representation of the famous, but Warhol gratefully projected his identity onto – or shall one say sunk his vampire teeth into? – the famous, suggesting the necrophiliac depth to which narcissism can sink.

The destructive nihilism of Warhol's narcissism is most evident in his power to make nothings like himself famous, to create superstars. In their human bankruptcy they epitomize the basic attitude implicit in Warhol's imagery. They show not simply his lack of compassion for his human subjects or their symbolic attributes (Coca-Cola bottles, dollar bills, etc.) but the ruthless indifference with which he trivialized them, whether by treating them like scapegoats or by turning them into meaningless illusions. Nevertheless, he was able to make them feel happy about it, feel that it was a kind of art game. He sadistically projected his feeling of being nothing onto his subjects by turning them into photo-real illusions. Even so, by convincing them that it was all good art fun, he permitted them to take masochistic pleasure in being empty appearances. Indeed, Warhol even convinced others that in "discovering" their unreality he had found their tragic flaw, indicating that his art was a serious aesthetic achievement. Warhol was able to get away with hollowing out human beings into shallow appearances – the basic pathological act of his art – because art, in bestowing fame on our appearance, ironically appeals to the death wish implicit in our narcissism, as fame does. That is, both lead us to take our appearance as our substance, which it hardly is. Indeed, our appearance invariably distracts from and betrays our substance, and Warhol's art is a form of pathological distraction from substance. Warhol perfected the pathology of his art – purified his conception of appearance – in his vision of the superstar.

It bespeaks his sense of fame as a perverse joke: like the crook in this chapter's epigraph, one becomes famous by being crooked. One gets "up-there" by being openly low-down. This makes one think one is different from others. But one is not, for those others made one famous to represent their own crookedness: you are the dream that fulfills their wish to be crooked and get away with it, and you represent the sense that they unconsciously are and can. Warhol's photographs make the famous look crooked and imply that one has to be a crook to become famous. He clearly iden-

tifies with the crook "up-there." Fame legitimates crookedness, and crookedness gives one a chance to become famous, satisfying society's narcissism.

Fame is not liberation from the decadent feeling of being nothing that the crook acts out, but rather its theatricalization. That is, the theatricalization reifies the feeling that life is unreal. The feeling is so perfectly staged by its theatricalization that it seems to harden into an objective fact. In theatricalizing life to the extent of regarding theater as life, Warhol showed how profoundly unreal he felt life was. This suggested how completely false and grandiose a self he was, for he had to make the world completely over in his false image. (It should be noted that his collecting of people and things – people as things – expressed his necrophiliac narcissism [since what is collected is implicitly dead, thus ready to be invested with one's life which gives it a certain finish]. It also expressed his sense of his own, and the world's, theatrical unreality. For a collection is a kind of theater in which the things collected represent abandoned possibilities. Thus they seem true to one's false self.)

At the same time, theatricalization affords a certain escape from decadence, with its depersonalizing effect, in that it allows the acting out or discharge of the hostility inhibited or masked by depersonalization. Theatricalization – and the superstars were Warhol's tragicomic masks, almost in Oscar Wilde's sense – allows the expression of otherwise repressed destructive feelings. Expressed, they are at least no longer self-destructive, no longer make one feel like an unreal, empty automaton, but they can destroy others. Even so, theatricalization alleviated the symptoms of Warhol's profound narcissistic anxiety without curing it. For theatricalization is not understanding, but rather hyperbolic description. It elaborates surface rather than exploring depth. It reifies the already manifest rather than manifesting the latent. It stays on the surface of experience – indeed, fetishizes it into an end in itself – rather than stripping it away to disclose the depth it hides, as well as symptomatically reflects. Thus in expressing and promoting narcissism, theatricalization becomes a way of avoiding self-analysis, and ultimately self-criticism and self-change as well.

Theatricalization is the modus vivendi of postmodern society. It prefers to stay on the surface; it has a vested interest in narcissism. Unlike modern society, it is reluctant to analyze, criticize, or change itself. Indeed, it denies that there is a self to analyze, criticize, or change: to postmodern society, the self is nothing. At the same time, that society wants to stay the same. It does not have an exploratory spirit: it does not think there is anything new to discover. There is only the old that must be made to look new by the technique of theatricalization. Postmodern society has no convictions to be courageous about. Warhol is its hero and symbol. It rewarded him for epitomizing its superficiality and theatricality by making him a rich celebrity.[14] In turn, he furthered its aims by showing that the perverse could be theatricalized, suggesting that the perverse had no depth to it.

It is time to distinguish between celebrity and fame, indeed, to sharply separate them. Warhol's celebrity signals the shift from modern to postmodern society – or rather society's psychotic split into the modern and postmodern. In the modern part of society people are encouraged to pursue

fame; in the postmodern part of society they are encouraged to become celebrities. One becomes famous for expanding the horizon of reality, creatively uncovering a new sense of reality in the process of individuation. This leads to one's differentiation of oneself from others and a correlate sense of separateness and difference from society. In fact, this also liberates society from its unconscious sense of decadence, rejuvenating it.

In contrast, one becomes a celebrity for standardizing the existing sense of self so that it seems universal, thus making it narcissistically satisfying to the masses. They come to think it represents the wholesome truth about themselves. Fame, then, exists for the sake of the reality principle, while celebrity is perverse regression to the pleasure principle. One becomes famous for finding, exploring, and understanding what was a hitherto hidden reality – an unknown depth – while one becomes celebrated for elaborating the surface of one's self in a way that makes it narcissistically satisfying for others as well as for oneself. To put this another way, one becomes famous by showing that one can test for reality where there seems to be none. In contrast, one becomes a celebrity by theatricalizing reality so that there seems no reality to test for, allowing people to sink, however unwittingly, into a satisfying narcissistic stupor. Society rewards one with fame – albeit at first, no doubt, with infamy – for narcissistically injuring it by destroying its illusions. At the same time, it rewards one promptly with celebrity if one comes up with new, narcissistically satisfying illusions. I believe society alternates between modern moments, when it feels strong enough to sustain the narcissistic injury inflicted by new truths, and postmodern moments, when it needs the consolation of narcissistic entertainment. Nevertheless, the two dialectically converge. On the other hand, narcissistic entertainment seems generally more prevalent and socially acceptable than does the willingness to appreciate the therapeutic potential of the truth. For the truth can catalyze reorigination – create a second chance to individuate and humanize – if it is fully faced.

Modern society, in encouraging people to pursue fame, implies that risk is the essence of life. The rediscovery of depth – in effect a return to origins – disturbs the status quo of society as well as that of the individual, without proposing a way to replace it. The consequences of the discovery are as unpredictable as the discovery is unanticipated.

In contrast, postmodern society, in encouraging people to become celebrities by theatricalizing themselves, shows its narcissistic determination to maintain the status quo. Picasso, the archetypal modernist artist, once said that he experimented to make discoveries, not just for the sake of experimentation. His discoveries destroyed the status quo of art and suggested new truths about life. In contrast, Warhol, the archetypal postmodernist artist, had no interest in discovering any new truths about his subjects. He was interested only in theatrically repeating their old and familiar – celebrated – faces. He maintained the status quo of art as tried and true illusion. Picasso was obsessed with the not yet given and known, Warhol with the already given and known. Postmodernism bespeaks the shallow, peculiarly hollow theater to which life is reduced when everything in it seems a

matter of fate. (Therapy is futile if life is fated.) No surprising new sense of reality lies in wait in the unconscious to suggest that life is not what it seems to be. Postmodernism thus makes the possibility of reoriginating one's own and the world's reality seem beside the theatrical point. So completely does postmodernism theatricalize the lifeworld, turning it into a kind of kitsch, that it becomes impossible to determine what is or is not real and valuable in life.[15] The postmodern lifeworld is a Potemkin village, a fool's paradise. In postmodernist society people are given theater so they will believe they are really living. Such a theatrical society is by definition indifferent to the emotional reality of life. The individual is reduced to the spectator of his own life, which becomes part of the general spectacle. He in effect becomes one more theatrical throw of fate's dice. The postmodernist theatrical attitude hides postmodern society's profound indifference – whatever its lip service – to subjective needs, especially the need for renewal that presses upon the individual after prolonged exposure to postmodern society. It implies that there is no real reason for self-concern, since the self is ultimately show. The theatrical attitude not only reinforces the subjective as well as social status quo, but totalizes it.

To abandon the avant-garde idea of art as therapy is to make art pathological. Warhol opens the Pandora's box of pathologies that art can represent, beginning with narcissism. His films show a wide range of pathological behaviors within a general framework of the human abuse of other human beings. Not only are his celebrities pathologically narcissistic – and postmodern society invests its own defensive narcissism in celebrities – but they seem generally demented. Unlike the famous, who are recognized for being true to themselves and reality, celebrities are heralded for falsifying the self to the point at which it seems pathologically unreal – indeed, psychotic at the core – and as such unwilling or unable to deal with or even conceive of reality. Indeed, the celebrity implies that there is no reason to do so, since the real is unreal, that is, a theatrical illusion: the celebrity is a kind of Nero, fiddling while the Rome of his self burns. The celebrity confuses true and false self, which is in my opinion the ultimate insanity because it completely undermines one's sense of humanness.

An everyday example makes the point, suggesting how commonplace "celebrity psychosis" has become. The comedian Joey Cheezhee is appreciated because "he has a false sincerity that's more real than most. It's a celebration of everything that's been thrown at us."[16] Warhol was the Joey Cheezhee of the art world, epitomizing its cynical, false sincerity – or is it sincere falseness or cynicism?[17] – if with less humor than Joey Cheezhee.[18] More particularly, Warhol was a celebrity's celebrity; that is, he was celebrated for showing how to become a celebrity. His art presented the formula for celebrity and fetishized it. His persona especially reified celebrity into a hollow tautology. It became a theatrical act anyone could learn; anyone would do as a celebrity. Similarly, art is an act anyone can learn to perform, as in the 1962 *Do It Yourself* paintings that suggest anyone will do as an artist. It is simply a matter of following a formula. Moreover, the formula for making art and avant-garde art converge. In these decadent days,

to know that art making is reducible to a formula is to be avant-garde. Warhol was the celebrity avant-garde artist, manufacturing himself according to social formula.

To be avant-garde once meant to undertake a sincere, risky search, carried out in social obscurity, for the touchstone primordiality that could re-originate the self. It would only disclose itself if the artist had the purity of creative purpose and emotional stamina to continue to search even when there seemed nothing to find. It is only when the search becomes bitter and seems fruitless, when one's creative power appears exhausted and in doubt, that one is in a position to have a primordial encounter within oneself. Only when one has become impatient with one's own sincerity so that the insincerity of the world seems to press in, inviting one to falsify oneself while promising celebrity, can one become truly sincere about creativity and renew faith in one's power of reorigination. When one seems to be falling into an abyss of meaninglessness so that the idea of coming to rest on a meaningful ground seems absurd, one can face the task of restoring conviction in oneself. From this, a sense of integrity and vitality follow. One may then become famous for one's reorigination – one's freshly "realized" self may generally inspire hope in self-renewal and become a model or ideal of selfhood – but not necessarily.

Today, to be avant-garde has reversed meaning: it is to accept cynically, guiltlessly, a facile, impersonal formula for making art and being an artist, rather than to be a missionary converting the fallen to the faith of the true self by way of an original art. One does not have to be in a state of emotional grace to be para-avant-garde, as today's avant-garde impersonator might be called. One does not need any strength of character and inner conviction, not even creativity. The formula is invariably a popular mantra numbing the self into illusory self-sufficiency, affording a sense of narcissistic plenitude that makes the self indifferent to others and to its own creative potential. Where avant-garde art was self-regenerative in import, para-avant-garde art is peculiarly self-defeating, for it abandons the self to its own narcissism. The self is no longer a mission with an uncertain outcome, but a fait accompli with no purpose. The self forfeits the sincerity that makes it feel human and creative, and becomes a narcissistic act: it compulsively acts out its narcissism, as it were. In a sense, the para-avant-garde self is insincerely itself because there is no longer any substance to sincerity, which is typical of postmodern society. Thus the self, socially unsupported in its wish to be sincere or true to itself, seems an illusion to itself. To fill the vacuum of selfhood this creates, it insincerely acts as if it can be any self, which is a delusion of narcissistic omnipotence. In a sense, it celebrates itself without knowing what it means to truly be a self, as Warhol's celebrities do. They insincerely act the public illusion of themselves, which gives them a narcissistic satisfaction that deludes them into thinking they are true to themselves.

In fact, the celebrity never performs his act perfectly; rather, it seems simultaneously sincere and insincere. One can see through it to the celebrity's vacuous, pathetic self even as one is impressed by the triumph over it his celebrity represents – the fullness of being it seems to give him.[19] But the act

invites one to see through it; in fact, seeing through it is part of the works only when one does so, when one is simultaneously spellbound disillusioned by the celebrity. The point is that the boundary between sincerity and insincerity must be blurred to the extent that there seems to be none. Warhol was a master at creating the effect that there is no distinction between them, which was the ultimate theatrical effect, indeed, the essence of theatrical spectacle. (The obliteration of the distinction between fullness and emptiness as well as between art and nonart follow from this.) Warhol's celebrities are falsely sincere but also sincerely false; that is, they are sincere about being false – theatrical – because it is all they can be. Indeed, their celebrity consists in their making falseness a fine art. Thus their celebrity seems true to them and they seem true to themselves. Insincere, socially compliant false self and sincere, spontaneously personal true self have psychotically collapsed into one another in their act. Indeed, Warhol's celebrities are psychotically pure, that is, spontaneously compliant, to the point of being symbiotically merged with their appearance in their audience's eyes. Their charisma bespeaks the narcissism they share with their audience, that is, the narcissistic pleasure each takes in the narcissism of the other. So seamless is this mutuality that both celebrity and audience lose all sense of sincere, true selfhood. Indeed, they hate the very idea of it, as does postmodernist society. Being beside the self-theatricalizing point of narcissism, sincerity becomes incomprehensible.

Without mutual narcissism, both celebrity and audience lack any sense of self. Without the other, each feels like nothing. Warhol's celebrity images dangle both celebrity and audience over the abyss of the feeling of being nothing, in effect threatening both with oblivion. His celebrities seem about to disappear – indeed, some of them have already dwindled to a few parts – leaving the audience at a loss. Without the narcissistic fix the celebrity gives it, the audience too will vanish. Many of Warhol's celebrities in fact have a Cheshire cat look. They seem to be performing a disappearing act – theater with a perverse twist. Warhol seems to suggest that the very narcissism which makes them true to each other necessarily makes them false to each other, that the celebrity needs new audiences to conquer in order to calm his narcissistic anxiety, while the audience needs new celebrities to feed its voracious narcissism. Indeed, narcissism is insatiable and restless. It quickly consumes the narcissism of the celebrities proffered it by society, and must have more of every kind. Warhol's own narcissism led him to attempt to expand his audience beyond the art world. He fantasized himself to be all-American and to appeal to all Americans. As interchangeable as any American, he could narcissistically merge with every American. The fantasy that all of America was his audience implicit in his fantasy of himself as the president – a true narcissistic orgasm – was his ultimate theatrical act.[20]

Attunement to the audience is all for Warhol. He personifies the psychotic theatricality that prevails in and is perhaps definitive of postmodernist society. In modernist society the self believes in sincere relations with others. Internalizing the good relations affords the self enough confidence to be creative – to "progressively" develop. In postmodernist society, relations with others are insincere, cynical, and external – inherently

indifferent. Others become an audience for which the self (and its artistic surrogates) act, as the self fantasizes itself a superstar. That is, it becomes a consummate narcissist, so completely theatrical as to imagine it has no need of creative relations with others – or of creativity in general – to develop. After all, it is a fully developed act. The postmodernist self knows how to perform for others, but not how to be with them intimately, for better or worse, as does the modernist self. Warhol epitomizes the postmodernist attitude. While not the only attitude – it is still possible to be sincere – the success of Warhol's art bespeaks the appeal of the postmodernist attitude as a way of adapting in a crowded society of transient relationships based on exchange value.

Warhol, an actor in no need of reality, was a "natural" psychotic, as it were. As such, he acted his attunement, which was necessarily a false attunement, on a par with false sincerity. To be falsely attuned to the other is to fail to understand the primordial creative power of sincere attunement – its power to make the other creative. The basis of all human relationships has been said to be affect attunement or an affect feedback system, as it has variously been called. With positive affect feedback – true attunement – there is secure attachment to the other; with negative feedback – false attunement – there is anxious or insecure attachment, casting doubt on the reliability of the relationship. Affect attunement, carried out through gaze interaction, and even more deeply through "somatic recognition,"[21] is the major mechanism of self-creation as well as of bonding to the other. It establishes reciprocity and trust, which guarantee sincerity within the relationship to the other and to oneself. Unless both relationships are grounded in sincerity they seem like nothing.

Insincerely attuned to his audience, Warhol not only subtly lets it down, he puts it down. He betrays its trust. He undermines, even emotionally annihilates it – reminds his audience of its nothingness or decadence – rather than revitalizes it. That is, Warhol's act does not establish a playful, trusting intimacy or reciprocity with the audience, affording what Winnicott calls the "moment of illusion" that renews the audience's unconscious sense of "subjective omnipotence."[22] This sense, broken down under the pressure of the indifference of objective everyday life, could be regenerated and refreshed by art, which would give it a healthy new sense of self and will to live. (These last until its next depressing "breakdown," which may come all too soon. Thus one may become addicted to art for continuous fixes of freshness of purpose, or go to a real therapist, or find lasting true love.) People go to art – willingly become an audience – to recover from unconscious breakdown of the sense of self and of the will to live, brought about by their inability to tolerate the world's indifference to their inner life, and especially by their narcissistic need to be mirrored and to idealize. True art seems to care about inner life and respond to narcissistic need. It thus makes people feel inwardly alive, renewing their faith in themselves. More particularly, the playful unity of the true work of art – playful because it seems simultaneously a disintegration of old form and an integration of new form – becomes a hopeful model to the self. True art gives the self leave to become playful, leading it out of the wilderness of feeling like nothing

into the promised land of feeling like something new. True art and true self seem in perpetual playful transition between old form, which embodies the feeling of being nothing, and new form, experienced as everything one could ever want.

But Warhol's false art – his antiart or art act – toys with his audience rather than plays with it, preying on its breakdown by insidiously suggesting it can never recover. (As noted, there is nothing even technically playful about Warhol's art, which follows a formula – thus trivializing creativity – even to achieve an organic appearance.) Because the feeling of being nothing is inescapable, as its recurrence suggests, the best one can do is anesthetize oneself to it so that it causes no pain. Indeed, one has to dull oneself to the painful truth the feeling signals, that is, to the smallness of one's existence, always in danger of becoming literally nothing. To conceive of one's futile little life as a grand act in the theater of life, making oneself a kind of decorative dandyish presence in the world, is the narcissistic anesthesia for the feeling of being nothing. The theatricalizing of life, which reaches a climax in the reductive transformation of it to a frivolously decorative appearance – as if the act of decorating oneself were the most creative act in life – makes the self feel glamorous. This is certainly better than feeling like nothing, and helps one feel nothing about life, even if one remains far from truly feeling like something. Warhol, of course, was the master of the nonexpressive, [23] which is an elegant way of acknowledging the futility of feeling. (The feeling of being glamorous is not only a last-ditch narcissistic defense against the self-defeat of the feeling of being nothing, but ingeniously projects the rage implicit in that feeling back into the world. The glamorous want to aggressively engulf others in their narcissism.)

In a sense, Warhol's feeling of being nothing reflects the fact that he had no one significant to relate to: he felt insignificant because he had no primary relationships. He was, in fact, involved in many false, cynical relationships, reifying his feeling of the insignificance of all relationships. And of course they would be secondary to a consummate narcissist. At the same time, he turned everyone he was involved with into an audience. More particularly, he handled his psychotic sense of insignificance by regarding society as the "scene" in which he was the chief decoration, the ultimate superstar. He became so completely decorative that he was the scene – literally made it. This allowed him to become narcissistically indifferent to it and to everyone in it. The feeling of the insignificance of it all, suffered passively, became the feeling of active indifference to it all.

Thus Warhol took perverse pleasure in feeling nothing for others. By doing so he imagined he turned them into nothings who could not be related to, paying them back for his inability to relate to them. This, of course, made them mirrors of himself. His indifference sadomasochistically turned others into the decorative façade – with nothing behind it – that he felt he was. As with Duchamp, indifference was a basic necessity of emotional survival, perversely reassuring and grandiose. But where Duchamp was enigmatic and exclusive, Warhol was obvious and inclusive: he invited his audience to be as indifferent or uninvolved as he was. Anyone could join his

art act, and everyone did. He assumed that everyone wanted to become as hypernarcissistic as he was, for he assumed they all felt as insignificant and decadent as he did.

The false self is narcissistically satisfied by becoming part of the glamorous decor of a social scene. In contrast, the true self is narcissistically satisfied by affective attunement, by intimacy, with a significant other. The false self needs an audience, and thinks that the self is fully itself — truly exists — only when it gives an audience. The true self needs no audience, and gives none. Indeed, it remains largely incommunicado, as Winnicott suggests, if partially expressed in intimacy with a significant other. The theatrically decorative is the decadence of the false self turned inside out: it shows that the depressing feeling of being nothing follows from complete social compliance, to the extent of feeling dead — nonexistent — apart from the lively social scene. Similarly, one feels one's life lacks color without the colorful decor of the scene. The predictability of the decorative reifies the compliance the scene demands, just as the artificiality of the decorative signifies the scene's falseness, glamorously alluring to the false self. Warhol, of course, enjoyed feeling nothing in the scene, and fantasized that everyone in it was nothing, which gave him complete control of it and of them. Indeed, he had the pallor, demeanor, dress, and regular habits of a para-avant-garde angel of death, as was appropriate for the scene's most compliant and false member.

The celebrity, with his completely artificial, false self — a self so false it cannot stop itself from exploitively representing the true self, that is, turning its unpredictable spontaneity into a "personal" act — is a model of compliance and complicity. In becoming socially decorative he becomes part of the world's "sublime" indifference, which is why he is peculiarly oppressive, even while narcissistically gratifying. The celebrity perverts the meaning and purpose of creative illusion; in his hands it ingeniously reifies the false self rather than restoring a sense of the true self, which is the main goal of reorigination. This is why celebrity is the ultimate kitsch. It makes one comfortable with one's false self, and as such indifferent to one's true self: it makes one like the world. It leads one to betray oneself unwittingly. However, Warhol's kitsch celebrity art eventually makes one fear for one's true self, if one is not completely corrupted or taken in by that art. One becomes uneasy looking at so many people who have betrayed themselves to become celebrities; it is a regular gallery of crooks. Slowly but surely one becomes depressed by them, which is the real letdown and put-down. This depression, however, suggests that there is still hope, for one's true self is still alive if not well, however much one's false self is abandoned to envious identification with the celebrity. In this depression one begins to fantasize that the Warhol celebrity secretly despises himself. He must be as shallow as he looks, and hate himself for it. However, the fantasy is unconscious retaliation and revolt against the celebrity image for making one feel untrue to oneself. To despise a Warhol celebrity image is to begin to get a grip on the true self again. In fact, celebrities do seem to let themselves as well as their audiences down. They seem to have secret contempt for themselves. To

Warhol's credit, he may be articulating the moment when they become depressed with themselves, when they feel their celebrity is nothing. This does not mean he is criticizing celebrity, but only acknowledging an unexpected facet of it. Is he also signaling that he is depressed by his own celebrity, that it doesn't rejuvenate him? Some art and some people do seem to invite one to despise them, confirming their feeling that they are worth nothing and unexpectedly freeing one from the pernicious influence of their nothingness. Warhol's "people's art" seems a case in point.

Warhol's menagerie of superstars, each a psychic clone of Warhol himself – an emblem of his mentality – is the ultimate collection of false selves, of decorative nothings. They bespeak the decorative nihilism of Warhol's narcissistic art. Indeed, narcissism and nihilism converge in the decorative. Warhol turns ordinary narcissistic stars into completely decorative presences, into hermetically sealed narcissists or superstars like himself. The superstar creates the illusion that in performing for an audience he is holding a mirror up to himself in admiration of the exclusivity of his decorative appearance. He is indifferent to the question of being true or false to himself or others, since there is neither truth nor falsehood nor selfhood nor otherness in his decorative-narcissistic state of being. All differences are dissolved in it. So completely did Warhol exist in the decorative-narcissistic state of being that he readily lent himself to becoming a cult figure, as in fact he was. For his insular yet public and successful narcissism – something that seems allowable only to artists, especially para-avant-garde artists – is everyone's envy and dream. People identify with him, hoping that their narcissism might become as perfect and socially accepted as his. Warhol was the center of an uncritical, worshipful circle that was blinded by his dazzling narcissism even as they fed off of it. Indeed, the food was virtually limitless.

The cost of being a superstar – of the sumptuous narcissistic look – is photographic embalming. The cosmetic flourish of color that completes the process washes all feeling out of the superstar, making him a perfect celebrity machine. A superstar should feel nothing while seeming to feel profoundly, which is the effect Warhol's color achieves. In fact, his appliqué color suggests flat affect. Indeed, Warhol's superstars are incapable of any affective, let alone somatic, recognition of anyone. (The slightest inclination to primordial intimacy would puncture their hypernarcissism.) The strongest evidence for the inhumanity – indeed, of the inability to be human – of Warhol's celebrities is the character of their gaze. In fact, they do not gaze (a gaze is flexible), so much as stare in a fixed, even rigid – empathically blunted – way. Such a stare is hardly interactive, and it clearly precludes intimacy. It does not imply positive attunement to the audience. While performed for the audience, the stare is a weapon intended to make it feel inferior, even irrelevant. At the least, the celebrity's false gaze keeps the audience at a distance and affords detachment from it.

In sum, the noninteractive stare gives the celebrity a certain authority. It also protects him from the pain of losing the audience, while causing that loss. The inconsiderate stare traps the celebrity in a vicious circle with the

audience. The audience is initially lured by its apparent, however theatrical, intensity, but in the end is put off by it, for the stare does not speak to its narcissistic needs. The aggressively blank stare confirms that the celebrity's aura was after all a lie. The Medusa-like stare testifies to the fact that the relationship with the celebrity is brutally one-sided rather than reciprocal and personal, for the celebrity performs the same act for everyone. It thus generates a strong undertow of frustrating affect.

Is Warhol a "psychotic realist"? Does the very notion of celebrity embody psychotic realism? If this were the case, would Warhol and his celebrities be let off the hook for their false attunement, their psychotic theatricality? Warhol's deflating, devaluing, and finally disintegrative style can be regarded as the psychotically realistic "reflection of the deconstructive recognition that 'the subject no longer can be conceived as a self-assured center of his opinions and perceptions,' that 'he is always lost in the chain and texture of signifiers,' that he is 'necessarily disseminated in the field of language' – has no center and is no center, however much 'self-glorifying intentionality he may display'."[24] The result is a kind of psychosis in which signifiers such as Warhol's photographs do not so much refer to a real subject – his manipulation of them seems to make this clear – as to an illusion of one. The unexpected effect of the postmodernist recognition of decentralization is a psychotic sense of reality. Warhol may deglorify his celebrities in the very act of technically glorifying them, but in doing so he also derealizes them, as it were. This conveys not so much their unreality as Warhol's psychosis.

This is no doubt a typical celebrity psychosis, a consequence of the celebrity's unconscious recognition that he is disseminated to the point of being dissolved in the field of his audience's narcissism, and thus completely vulnerable to it. The celebrity's relentless self-congratulation and self-glorification – his megalomania – function in a schizoid way to resist this disintegrative dissemination and maintain some sense of integrity, even as they further it. An initial psychotically realistic response to the audience, derealizing the celebrity's self, is thus compounded by another kind of psychotic response, compensatorily rerealizing the self as a megalomaniac delusion. These are the poles of celebrity psychosis. They are also the method in the madness of postmodernist society and art.

Postmodernist psychosis, epitomized in the reconstruction of all selves and things as celebrities – Warhol's fifteen minutes of fame that everyone is entitled to – can be understood in terms of what has been described as the postmodernist "shift from objects to objectifications, from reality to constructions of reality."[25] Warhol's art deals with the construction of celebrity, which involves the construction of an audience. It is a "communal construction," and as such an "invitation to [social] play."[26] The large number of celebrities reflects the saturated social scene and the impossibility of giving one kind of celebrity self preference over another. All are valid constructions, valid and significant at least as long as they have an audience. Was Warhol the exemplary saturated self, even the first artist to dare to acknowledge himself as a saturated self? As such, was he the first postmodernist artist, a protean artist-self with no core and no need of any, as his

flighty art indicates? Does he signal that it is no longer necessary to be a sincere self to function socially and artistically, that one only has to be able to construct a self and an art that is nominally one's own out of the apparent selves of others and from existing imagery? Perhaps. But such a completely insincere (postsincere?) "relational self"[27] is one that has learned the language of social relationship but not its emotional substance. Rather, it thinks of emotions as a kind of social language, of "emotional scenarios" or performances as a part of the language of relationships.[28] Such a self is not so much in possession of itself, nor as much a master of the social scene as the superstar artist thinks, but rather completely dissolved in it and at the mercy of its shifting trends. The superstar artist is in fact a selfless self, in that he has no way of representing himself apart from the other, and no way of making sense of the contradictory character of the other and of the social scene, including that of art. The inability to decipher contradiction, whether between oneself and the other or between various others and "scenes," or indeed between the true and false selves, between sincerity and insincerity, is to be unable to test for the reality of either society or art. Above all, the inability to face the difference between these opposites involves the refusal to recognize their irreconcilability, and hence to register the anxiety this arouses.

Warhol's refusal to deal with irreconcilability while nevertheless recognizing it – he reduced it to a decorative "aesthetic" difference, anesthetizing himself to it – indicates that he had an undeveloped sense of self. All selves that are purely relational – overadapted – implicitly acknowledge that they are botched creations. It is not that Warhol, in conscious self-reflection, ironically constructed a relational self that absorbed other selves; but rather that he became completely relational, a creature of the scene, because he had no choice, no autonomous self to fall back on. Warhol never disintegrated; rather, he never had any integrity, any rounded, whole self, to begin with. Indeed, I venture to say that the indifference with which he related to others indicated that he was so unformed as to exist almost entirely in terms of prepsychological flux.[29] The chaotic yet peculiarly selfsame fluidity of his relationships bespeaks this. (Prepsychological flux does not develop, which is why it remains the same, in all its turbulence.) If he existed in a relational field, it was at once completely open and one-dimensional.

No doubt the stabilizing factor of his indifference was (almost) another dimension. Warhol never even reached the level of having a self, or rather his indifference – his only role – was his only hold on having one. That his relationality had a decided, consistent tone of indifference suggests that it was not postmodernist relationality in the ordinary sense. His militant indifference and the ironic curiosity about others that was a part of it suggests that he was not simply in the social "swim of things," comfortably adapting to them as they came. He was never as socially at ease and capable as a relational self supposedly is.[30] He was not as accepting as he superficially seemed to be, but rather imposed his indifference on his audience as a way of maintaining a vestigial sense, a semblance, of self. He invented a pseudo-self out of his indifference, in effect denying his anxiety, which was too great and too deep to be healed. His simulated self was a way of living with

it, a functional alternative to the self so overwhelmed and crippled by anxiety it no longer seemed real. Warhol's make-believe, theatrical self looked like the believable real thing only to the other celebrity psychotics with whom he surrounded himself. He himself never mistook it for a real self: he knew it was a prosthetic self. Warhol's indifference masked his brittleness, but it also got him the audience he needed to exist for himself.

CHAPTER 6

ENCHANTING THE DISENCHANTED
THE ARTIST'S LAST STAND – JOSEPH BEUYS

... we want to have pure and whole personalities ... like Hitler's. He and his friends in the struggle seem to us like a gift from the God of past ages when races were still pure, men were greater, minds less deceived.
Grossdeutsche Zeitung, May 2, 1924[1]

The national-socialist revolution does not only mean that a party with sufficient strength takes power; this revolution means a total revolution in our German existence ... Heil Hitler!
Martin Heidegger[2]

So when I appear as a kind of shamanistic figure, or allude to it, I do it to stress my belief in other priorities and the need to come up with a completely different plan for working with substances. For instance, in places like universities, where everyone speaks so rationally, it is necessary for a kind of enchanter to appear.
Joseph Beuys[3]

I wanted to take in everything that was forbidden during Hitler's reign.
Joseph Beuys[4]

More than is realized, the artist's attitude toward his audience, emblematic of the kind of reciprocity he wants to establish with it, is the fundament of his art. Indeed, aesthetic originality bespeaks an "original" attitude toward the audience. To put this in a more extreme and telling way, every art projects its own audience. Its character is determined by the fantasy of the audience the artist imagines he is relating to in the process of making the art. The artist has a wish for a certain kind of audience that amounts to a wish for a certain kind of self. His art embodies both wishes.

The audience itself intuits the artist's attitude toward it through the medium of the work before it understands anything else about the art. However conscious or unconscious the artist is of his attitude, its intensity is what engages the audience, convincing it that the art is worth the trouble of serious attention. The art must be significant if the artist feels so strongly

about the audience, whether with love or hate, care or contempt. Whether it arouses a pleasurable integrative or an unpleasurable disintegrative sensation, the art will not be compelling unless the audience believes it is deliberately addressed to it, the audience, rather than made for the artist's narcissistic edification as a sign and proof of his creativity. In short, the audience must feel the artist's will to relate to it in order to find elementary value in his art.

The artist's sense of his audience informs every aspect of his art, from its material medium to its aesthetic manner. There are two fundamental, contradictory attitudes toward the audience: that of the traditional artist, who experiences a harmony with his audience worthy of that of a mother and her infant; and that of the avant-garde artist, who revolts against it like an adolescent against his family. The former does not just reconcile himself to his audience, but feels part of it. He imagines it is as perfect as he wishes his art to be. Whatever else his art does, it affirms the audience. The latter believes he cannot be himself so long as he has an audience, so he pushes it away through his art. For him the audience is always imperfect, reflecting his unconscious sense of his own imperfection. He transfers his feeling that he has no right to exist onto his audience, negating it. He tries to make the audience feel it has no right to exist, at least as it does. This dialectic of imperfection haunts his art, making the artist feel unconsciously that it is imperfect and wrong, however perfect and right he wishes it to be and tries to make it, and even consciously believes it is.

The traditional artist assumes that he and his audience share the same "spiritual" space. Because of this mutuality, they "naturally" understand and respect each other. He works in a familiar medium in a familiar manner, which is the unquestionably right way to work since it produces art readily readable by the audience. The correctness and accessibility of his art is premised on his comfortable relationship with his audience. Each takes the other for granted as a normal part of life. The audience does not have to struggle for attunement to the art, but spontaneously experiences it as inherently valuable by reason of the art's basic familiarity and social propriety. In contrast, the avant-garde artist, implicitly and often explicitly critical of his audience, tends to be innovative in medium as well as in manner, or else stretches a known medium and manner to their breaking point. He moves his art toward radical unreadability, as if that were a position of defiant strength. His art lacks propriety, which makes it insulting; because of that alienating defect the audience is blind to its point. In the most extreme critical cases, such as those of Warhol and Beuys, material and manner were perverse and scandalous to the extent of making their art seem not to be art. It became art by default, or by being inconceivable as anything else.

A comparison between them is not arbitrary, especially as a gambit for understanding Beuys, who was everything Warhol was not. Both came into their own in the sixties and were equally representative of the unconscious sense of illegitimacy of their different societies – victorious America in Warhol's case, defeated Germany in Beuys's case. Postwar America and postwar Germany were equally changed by the war and felt equally guilty

in its aftermath, if for different reasons. Warhol and Beuys, in their different ways, found new modes of expression, expanding the sense of art – although for some they continue to remain quasi-artistic because of the performative, transient character of their work – to give voice to this sense of change and guilt. They showed their insubordination by making the unconscious conscious through artistically illegitimate means. This illegitimacy was the objective correlative to the pathology they made manifest, a poetically just form for it to take. Moreover, toward the end of their lives they acknowledged a certain common ground on which they met, however casually and transiently. In my opinion it had to do with the fact that, while critical of their audience – and so implicitly of themselves – they catered, even pandered, to it, as if to please it by their critiques of it.[5] Neither was reluctantly famous, a star despite himself. Each wanted his audience's acclaim and attention, however much he subliminally hated it (because it made him suspect he had betrayed himself). It was this self-doubt – this agonizing sense of self-contradiction – that brought them together at the end of their careers.

Warhol's attitude was one of regal indifference under the guise of democratic tolerance, reflecting his perverse sense of independence. In fact, he confused isolation with independence, confused the inability to relate with autonomy. Not only was his art unsupportive of the American audience it pretended to support, it insidiously annihilated the audience. Warhol treacherously rubbed the audience's nose in its banal, ugly-duckling appearance while affording it the narcissistic satisfaction of believing it could be changed into a swan – a star – by the cosmetic magic of "media-ization." Media-ization is the democratic form of sublimation, everyman's means of metaphysicalization. It is through the media that democratic man becomes aristocratic. Everyman believes that the self "mediated" becomes ideal, acquiring infinite charismatic charm. But Warhol mocked everyman's wish to be ideal, turning it into a bad joke by implying that ideality was nothing more than a glamorous illusion, a trick of public appearance. More particularly, ideality was a matter of decorative surface, of the right cosmetics. It could even be the wrong cosmetics, so long as they were applied with ingratiating media uniformity. Ideality was a cheap invention of a "mediation" so inadequate one could see through it at once.

In general, for Warhol artistic mediation was a simple matter of choice of cosmetics and their manner of application, aiming to create a pseudoaristocratic appearance, to create whatever the current fashion in democratic-looking aristocracy was. With delicate sadistic malice and no doubt subliminal glee, Warhol brought his audience, however unconsciously, to its emotional knees, forcing it to admit self-defeat. He did so not only by confronting it with its narcissistic need to be ideal, but by showing the hollowness of that ideal – its necessary hollowness in a democracy. In general, ideal media appearance is a shallow social construction – the readily available opium of the banal masses. Warhol could not care less for his audience. He disillusioned the audience about itself even as, in appropriating media methods, he furthered the illusion that it was ideal. It could really be ideal only when, satisfying his narcissism, it identified with him – the biggest star

of them all. But that ultimately intensified his feeling of self-defeat, articulated as his feeling of being nothing. For, more than anyone else, he knew the spuriousness of glamour, of socially ideal appearance. Indeed, his own pimply faced, relatively unretouched – for all his change of costume and wig – somewhat less than ideal appearance always belied it.

In contrast to Warhol's ironic indifference to his American audience – which in a sense was simply an instance of Duchamp's general principle of ironic difference – Beuys had great concern for the welfare of his German audience, carried to the extreme of a commitment to it greater than was its commitment to itself. His care for it cured it of a sickness and suffering it did not know it had. His care witnessed the inner life the audience did not want to admit to itself, and was midwife to a self that did not want to be born. His care reminded it of a creativity it did not know it had or needed, and that could only make trouble for it in everyday life. Warhol sadomasochistically identified with his audience, in resentful infantile dependence on it for his own narcissistically ambivalent stardom. This was ultimately a bullying dependence, for with a kind of passive aggressivity it tried to convince the audience of the validity of stardom even as it debunked stardom by recognizing that stardom depended on the audience. As such, it was invalid, for nothing made one inherently a star. Warhol was thus an ironic conformist, paradoxically unreconciled to society. Beuys had a mature dependence on his audience, a reciprocity with it through which he attempted to cure himself by caring for it, as much as he attempted to cure it with his care.[6]

He knew that both he and his German audience suffered from the same problem: the need to recover a sense of individuality after their totalitarian society, which promised to make them whole, was defeated and destroyed, leaving them feeling somewhat less than whole and individual. For Beuys art was a mode of care that attempted to restore the creativity – the power of individuation or self-differentiation – that is every human being's birthright. He wanted to restore it to people who had lost it, especially to those in an authoritarian Nazi society that attempted to stamp it out. For Beuys, one had to invent whatever devices one could to make art because the modes of art in Nazi society were tainted by its suppressive totalitarian ideals. In Nazi Germany creativity was not simply repressed; it was exterminated as fundamentally inimical to the utopian ideal of socially uniform purity. Creative individuality was treated as an obstacle, a flaw in social perfection and a stumbling block to simplistic social unity. Beuys, indeed, was a deliberate stumbling block in postwar German society, a self-conscious nonconformist mocking its sense of socioeconomic order and reason as a new threat to creativity and individuality. Even more deeply, he attempted to restore a sense of the enchantment of life to people who were disenchanted by it. Without that sense, one did not feel fully alive and fully oneself. Beuys addressed disenchanted Germans, especially disenchanted young Germans like himself. They were consciously disenchanted with the not-so-remote Nazi past and unconsciously disenchanted with life and with themselves by reason of being raised in Nazi society. Indeed, he spoke to all people who felt betrayed by the totally administered modern society, as Adorno called it.

Warhol openly expressed the cynicism postwar America preferred to keep hidden under the surface of its success, a cynicism that came in part from the ease of that imperialist success, the international competition having destroyed itself. Similarly, Beuys openly expressed the despair postwar Germany swept under the carpet of its consciousness in order to gain the resolve and nerve to rebuild after its defeat and failure. Only in a Germany shaken by the collapse of the fascist ideal of rigid monolithic homogeneity, reifying a simplistic idea of the Germanic, could a radical yet socially committed individualist like Beuys appear. And only in an America confident to the point of mindless arrogance could a socially indifferent and mock individualist like Warhol appear. Only in a Germany in which avant-garde art had been declared degenerate and stifled, and in which creativity had become compliant to ideology, could an avant-garde artist like Beuys emerge, willing to take social and aesthetic risks that were unthinkable even before Hitler. And only in a self-satisfied America could avant-garde art reify itself and become socially conformist, attaching itself to the apron strings of media sensibility, with its determination to present everything with mystifying banality.

In a sense, Beuys refused to be stuck on the horns of the ethical dilemma Adorno posed for art at this "final stage of the dialectic of culture and barbarism. To write poetry after Auschwitz is barbaric. And this corrodes even the knowledge of why it has become impossible to write poetry today."[7] Poetry, and art in general, seemed like "idle chatter" in the face of "the most extreme consciousness of doom." Art no longer had the "salt of truth" in it, for it had no power to oppose and reverse, with its idealism – its *promesse du bonheur,* as Adorno called it[8] – the historical realization of doom, absolutized as it had never been before in the Holocaust. Indeed, with Auschwitz, unthinkable doom – a doom that even religious apocalypses and inferno had not conceived – became banal historical fact, a routine, even rote death, so mechanical as to be almost abstract. This perverse reification of suffering and death demonstrated the immanence of history in every life, and in doing so made eternity a farce, suggesting the ridiculousness of art's claim to transcendence of history and eternal verity. "Suffering, what Hegel called consciousness of adversity . . . demands the continued existence of art while it prohibits it; it is now virtually in art alone that suffering can still find its own voice, consolation, without immediately being betrayed by it."[9] At the same time, in "turning suffering into images" art treats it with a style it does not deserve, subtly betraying its reality and inwardly shaming us before the sufferers. As Adorno said, even "the so called artistic representation of the sheer physical pain of people beaten to the ground by rifle butts contains, however remotely, the power to elicit enjoyment out of it," if an unconsciously sadomasochistic pleasure. "Even the sound of despair pays its tribute to a hideous affirmation"[10] by affording aesthetic pleasure. Thus while it is true that only art can express the suffering of the doomed without exploiting it, it is also true that art is intrinsically exploitive by reason of the aesthetic consolation it gives.

Nonetheless, art, like theodicy, is an argument that what is lost to evil can be miraculously made good, without mourning – the ultimate healing. It makes the suffering of the doomed into the promise of utopia by giving it

eternal aesthetic presence. But to do this is to reify both suffering and care, not in such a way as to degrade them completely (as Beuys thinks politics does by regarding them as inevitable, by resigning itself to both), but in such a way as to subvert them as witnesses to the habitual brutality of society.[11] Moreover, art itself has become an ironic politics. That is, the avant-garde artist no longer takes a stand against society, but rather against other avant-garde artists, and even against art as such. Indeed, from Manet through cubism and Duchamp, art was as much at war with itself as it was at war with society, defeating itself in the process of baffling society (which art assumed was defeat enough for society). Ironically, society declares the most baffling, oppositional art to be the winner in the Darwinian struggle for social survival. Society views – half-correctly – oppositionality as the most ingenious of the competitive ploys, a true sign of fitness, and as such the most perfect reification of art.

What is the way out of Adorno's crippling ethical paradox, which perversely dismisses art as inconsequential pleasure – false pleasure[12] – in the very act of privileging it as the voice of suffering? Even Beuys's homeopathic artistic objects, as he called them,[13] reeking of both the barbarism and the suffering they magically attempted to cure, have been regarded as aesthetic, thus invalidating them as forms of conscience and mourning. Some of his materials have to do with the "barbarism" of nature, others with the barbarism of Auschwitz. In his performances, Beuys applied both to his own suffering psyche and body – meant to be emblematic of postwar Germany, its territory literally broken on the rack of history, and then split – like a kind of healing poultice. Apart from this personal and symbolic performatory use as homeopathic treatment, the performances had no significance, according to him.

For Beuys, the artist could cut the Gordian knot Adorno tied only by becoming a shaman – in the ultimate irony, a shaman healing not those who survived Auschwitz but the barbarians who built it. Auschwitz was the answer they gave the Sphinx, proving their superior knowledge of life: it was death in disguise. Auschwitz was the Nazi equivalent of the French guillotine, serving the same, equally utopian idea of total revolution and social transformation that Heidegger thought Hitler represented. But Auschwitz existed in the name of the unrealistic, immature goals of purity, absolute power, and archaic wholeness of self. That is, it existed for the sake of the wholeness of the prelapsarian self, an omnipotent, infantile self that would never know dialectical differentiation and inner conflict, and so would always be absurdly innocent. It did not exist in the name of the realistic, mature goals of liberty, equality, and fraternity, which are hard to realize but not impossible, like the goals of the Nazi revolution. To conceive, with the infallible logic born of true belief in themselves, and then actually carry out scientifically the final solution, was the sign of Nazi sincerity. The Nazis attempted to realize utopia on earth by destroying those who were, in their view, unfit to live in it.

Beuys addressed the suffering Germans felt because of the failure of Auschwitz, for all its technical success. For the Germans were not praised by the world for finally solving the age-old "problem" of the Jews, but con-

demned as barbarians, making them doubt themselves. It was a new form of an old problem, going back to Roman antiquity, when the Germans were scorned for their barbaric beliefs and their resistance to civilization. Their guilt did not rise from within them, in horrified recognition of the inhumanity of their ideal of purity, but was forced upon them by the world's judgment. It was acknowledgment of defeat, not of repentance. It was a shallow guilt, not profound suffering. In a sense, there was nothing for them to work through, for they had no inner comprehension of what they had done. Indeed, the Germans would have shrugged off Auschwitz if the world had let them. They were disenchanted with Hitler only because the world had punished them for believing in him, not because they saw anything inherently wrong with him. How was it possible for Beuys to preach to ex-Nazis who did not really think there was anything seriously wrong with having been a Nazi? Only because the Nazis lost did they consider themselves wrong. How was it possible to deal with people who had such little power of self-observation, and virtually no conscience? How was Beuys to heal people who did not know they were ill, or even misguided – who did not see the basic error of their ways, but rather only that their Nazi way was not welcome in the world?[14] These questions suggest the impossibility of Beuys's position, the strange pathos of his artistic program of shamanistic enchantment, which to many was as barbaric as those to whom it was addressed.

But the German issue is deeper than the Nazi issue, deeper even than the Germans. They became the exemplary modern people because, under the auspices of the Nazis, they showed that the enlightened belief in order and reason (Ordnung und Vernunft) could cause profound suffering. Carried to a perfectionist extreme, order and reason were pathological. The order of Auschwitz was reason's perfect product; the slightest hint of conscience would have been reason's failure of nerve.[15] Auschwitz demonstrated that rationality could be more insane than irrationality. To act in the name of reason could be rhapsodically narcissistic, precluding empathy. The Germans had to be cured of their pathological belief in the authority of reason, which they readily put before life itself. Their postwar problem was that they could not imagine a society that was not totalitarian, that did not regulate every detail of life in the name of reason. Nevertheless, through bitter historical experience they knew the inhumanity such a society was capable of, knew that reason could easily become a Moloch demanding a steady diet of living sacrifices, and they were uneasy with this. Disenchanted by order and reason, they felt abandoned by history; the truth was not on their side. Beuys's shamanism was addressed to Germans who were depressed by German history, and who knew that Germany could never again afford to be barbaric. But what was it to be civilized?

Beuys's shamanistic art, then, addresses those unconsciously disenchanted by modernity, with its elevation of rational order that is scientifically and technologically realized. The late modern man is in a double bind: outwardly, his world is the proud scientific creation of instrumental reason, but inwardly he feels devastated by it. He knows that reason, a necessity of life, can easily turn against life, suppressing and consuming it. Reason can

put life in its proper low place and process it like so much raw material to be refined into reasonable form. (If the Jews – among others, such as Slavs, Gypsies, and homosexuals – represented the dregs of raw life that the Germans denied in the name of reason, Auschwitz was the processing plant in which they were forcefully converted into good Germans, for they were transformed into such higher goods of rational society as soap. They were in effect purified, alchemically cleaned.) Of all modern peoples, the Germans seem the most conspicuous victims of the late modern double bind by reason of their obscene history, but they are far from alone. Unconscious – and increasingly conscious – disillusionment with reason and the pathological use to which it is put, is widespread. Nevertheless, there seems no alternative to reason, however decadent it has become. Hence the pervasive sense of futility and helplessness in the late modern world.

Shamanism is no doubt irrational in principle and seems a primitive means of healing, but its irrationalism and primitivism exist in opposition to an order and reason that have historically proved more barbaric. The latter have not lived up to their promise of true civilization, but have instead become the instruments of a profound barbarism, one that was inconceivable without them. Shamanistic materials also stand in opposition to abstract art. They seem hardly as aesthetic and civilized – as little as are the wild shamanistic performances of which they are the residue. Beuys is always acutely aware that he is offering an alternative, not a new absolute. His art is the subjective Dionysian answer to the objective Apollonian absolute, which has been carried to a destructive historical extreme. It is customary to think of Dionysian instinct as destructive and regressive, but it can be constructive and progressive in a society in which Apollonian reason has become inhumane. The return to natural instinct is not necessarily barbaric in a society that has been made barbaric by order and reason. Reason, too, can be stultifying and imprisoning, especially when it is pure. Indeed, administrative reason, which is pure reason at its most practical and totalitarian, can cause as much suffering and doom as instinct unleashed, as Kafka suggests. Beuys's shamanism reminds us that civilization is not what it seems – that the Apollonian can be more violent and unforgiving and authoritarian than the Dionysian.

Nietzsche, like many before him, regarded the truth as disillusioning, but this derives from the fact that it can be depersonalizing, even dehumanizing. It has, after all, been described as "cold." Indeed, a strange lack of compassion seems to go with knowledge of the truth, especially when those in the know "apply" the truth to life like a corrective punishment, as if life had to be brought to order or taught a lesson for its own good, like a retarded, unruly child. This "adult" coldness makes life seem absurd and problematic to the extent of not being worth living, as Nietzsche said. Only "art . . . that redeeming and healing enchantress" can restore the self's loss of faith in life, reminding it that life is inherently more enchanting than art, and can even be more enjoyable.[16] Only art can resurrect love of life and joie de vivre after they have been destroyed by the truth, that unwitting – and sometimes too witting – killjoy.

Shamanistic art is a sorceress especially expert in healing, for it warms the cold truth, bringing it to life. More to the point, shamanistic art shows that there is a warm and a cold truth: the truth of disorder and unreason, as warm as life, and the truth of order and reason, as cold as death. Only through shamanistic immersion in disorder and unreason can the human being depersonalized and dehumanized by order and reason be repersonalized and rehumanized. Shamanistic art subtly transforms reason and unreason, reequilibrating them in the process. Reason becomes magical ritual, initiating the self into irrational chaos, which becomes possibility and which legitimates personal pleasure in an impersonal, unpleasurable rational world.[17] Only shamanistic art can anarchistically melt hardened, authoritarian reason, allowing the individual to find creativity and happiness in unreason. Only shamanistic art can reintegrate reason and unreason, order and disorder, in recognition of art as the primordial origin and alembic of both. It reconciles the reality principle, which uses reason to survive in the world, and the pleasure principle, which insists that orgasmic joy is necessary to love life, which would become depressing and oppressive without it. Art not only gives pleasure its due, but insists that it is realistic to do so.

Beuys made this point when he stated that "everything, both human and scientific, stems from art. In this totally primary concept of art everything is brought together, one comes to the conclusion that the scientific was originally contained in the artistic."[18] His shamanism was an attempt to bring the human and scientific together again, as in primordial art. Indeed, for him shamanism *was* primordial art, and a good part of his purpose was to make art once again primordial, to restore to it the primordial power of healing it once had. It is as if, in overcoming the modern dissociation of sensibility T. S. Eliot spoke of – the bifurcation of the self into irreconcilable feeling and thinking parts – Beuys's new primordial art signaled the true purpose of art.

No doubt his shamanism was an act, but only from a cold, scientific point of view. In fact, it worked on a symbolic level: Beuys's hat became the alternative to Hitler's moustache, giving the Germans a choice they did not have before. The hat hid a war wound, burying it but at the same time marking its grave, so that it would never be forgotten.[19] It was a reminder of the damage Germany had done to itself. Beuys embodied both the ruined, defeated old Germany and the hopeful new Germany, determined to heal its wounds. Beuys was warm where Hitler was cold, and above all Beuys was a benign, biophiliac artist rather than a malevolent, necrophiliac one (to use Fromm's distinction). Of course Hitler was a failed artist, and Beuys, it should be recalled, was a successful politician, a founder of the Green Party.[20]

Shamanism, then, was the alternative to authoritarianism. It signaled an altogether different intention: the will to heal rather than to harm. If the essence of creativity is the intention to heal – to repair what has been destroyed and to make reparation for loss – then Beuys's self-conscious attempt to heal through shamanistic creativity was meant to catalyze the

creativity of those in need of reconstruction and repair so that they could heal themselves through an inward shamanistic process.

The Germans had to realize their need to be healed – to be repaired, to be made whole – on a more than superficial, material level. They had repressed the wish to be healed, as if to say there was nothing spiritually wrong with them, and above all to avoid the painful feelings of lack of integrity and of self-betrayal – the sense of the inner catastrophe they had become as well as the outer catastrophe they had caused – that had to be acknowledged to begin the healing process. The shock therapy Beuys wanted to administer to his German audience is intended to remind it of those catastrophic feelings, ripping the scab off old wounds that festered underneath. When finally the Germans allowed themselves to wish to be healed, they would realize the need to accept the truth of those feelings to be healed. They would then accept their responsibility for the spiritual as well as material suffering they had caused others. They would empathically know and care for them as well as do them material good. Through empathic identification with their victims – which is what Beuys's shamanistic art encouraged, by way of identification with himself – the Germans could recover their sense of humanity as well as that of their victims. They lost this sense in denying the humanity of their victims and privileging their own. In a sense this was their greatest crime against their victims, the real crime of Auschwitz. Empathy for one's victim reintegrates oneself, which disintegrated by committing its crime. It also reintegrates the self of the victim one first spiritually destroyed (by regarding him as subhuman), which then gave one leave to literally destroy him. The Germans' belated empathy for their dead victims would repair their humanity, and that of the Germans themselves, for empathy is truly homeopathic magic, truly creative.

Shamanistic art can trigger a creative, empathic intrapsychic process, but the audience must see it through. The work's creation is the model for the healing of the self, just as its wholeness is a model for the self's integrity. As many have said, the modern work is fragmentary; but it is also a mythical whole – an entity unto itself – in its audience's eyes. As such it signifies, through its explicit fragmentariness, the hidden wound that the audience must heal and, through its implicit ideal wholeness, the sense of integrity, with its accompanying feeling of well-being, that the audience will experience when it is healed. The best art induces the audience to unconsciously identify with it, as if it embodied the tension between the audience's feeling of fragmentariness and its wish for integrity – a tension more painful than the suffering caused by the fragmentation of self inflicted by the trauma of history. Continuing to believe in the work's utopian wholeness despite recognition of its fragmentariness, the audience wills its own integrity, however inconclusively.

Beuys consciously set himself up as Hitler's opposite in every way. Indeed, his shamanistic uniform mocked the Nazi military uniform, which looked sinister in comparison. His wounded appearance spoke the German historical truth, giving the lie to the fantasy that Hitler could make the Germans primordially whole and strong and unconquerable, restoring them to myth-

ical barbaric greatness. The question remains whether Beuys offered a new utopian authoritarianism. Is the shaman, a mediator of the primordial, another pathological, authoritarian leader? Is primordiality merely purity in disguise, yet another touchstone separating the strong from the weak and the wholesome from the unwholesome, much as, on entering Auschwitz, the sound and healthy, capable of being worked to death, were separated from the infirm and infantile, who were immediately put to death? Is primordiality the privilege of a new creative elite, and as such not the basis for a democratic society? Whatever the answer to these questions, there seems to me to have been nothing authoritarian about Beuys as a person or teacher, although there are opinions to the contrary.[21]

Let us examine in detail Beuys's conception of his healing mission. If the artist's basic task after Auschwitz is to restore primordial healing power to art – if the only kind of art that can be practiced after Auschwitz is the healing art – then it is necessary to know how art can heal. Beuys offers the most comprehensive modern theory, since Kandinsky and Matisse, of why it does so. "My intention: healthy chaos, healthy amorphousness in a known medium which consciously warmed a cold, torpid form from the past, a convention of society, and which makes possible future forms."[22] Beuys's own wounded body was a cold, torpid form from the Nazi past, and the fat and felt the nomadic Tartars wrapped his body in, warming it to new life, were the healthy chaos, healthy amorphousness in a known medium.[23] These remained the primordial healing materials for him. They healed by liquidating obsolete past forms into the primordial chaos they themselves embodied. From this chaos new forms could emerge; chaos was not a dead end, but a new start.

Beuys summarizes the change healing effects in his "Theory of Sculpture," calling it "the passage from chaotic material to ordered form through sculptural movement."[24] It is the difference between honey and beeswax. The artist is a bee refining pollen into honey, crystallizing honey into wax, and transforming wax back into nourishing, healing honey when it is needed.[25] The shamanistic artist is the impresario of this mysterious "sculptural" process, which is altogether unlike traditional modeling or carving. In my opinion Beuys, however unconsciously, intended to give a positive meaning to "liquidation," a term tainted by its Nazi and Soviet use. He reversed the meaning of this euphemism for the methodical extermination of those deemed unfit to live by authoritarian regimes that were determined to purify themselves into utopian wholes. To Beuys, liquidation meant the return to healthy chaos, to healthy amorphousness, not to unhealthy chaos or unhealthy amorphousness. It meant the return to honey, not to ashes. The essence of the healing process was liquidation of the old for the sake of the new, not liquidation as an end in itself. It was the difference between healing liquidation and pathological liquidation. Also, crucially, liquidation was a voluntary process: one chose to liquidate one's old self because one knew that was the only way one could become a new self. Liquidation was not forced on one by those who thought one was unworthy of life. There is no doubt a risk in healing liquidation – the cure may take longer than expected, the outcome is not guaranteed – but this is preferable to the certain

outcome of pathological liquidation. Beuys thus wrested liquidation away from the politicians, who had corrupted its meaning.

Beuys, then, attempted to provoke regression in order to progress. To be healed, one must regress to one's deepest self, repressed to the extent of being unknown even to oneself. Shamanistic art is a "provocative statement [that] addresses all spontaneous forces in the spectator that can lead . . . to the center of the, today, often suppressed feeling, to the soul of whatever one wants to call this subconscious focal point."[26] "The increasing chaos of the spectators"[27] indicates the success of the artistic healing process. The artistic shaman attempts "to break off all the residues present in the subconscious and to transfer a chaotically detached orderly procedure into turbulence; the beginning of the new always takes place in chaos."[28] The regressive emotional chaos of the spectators, as evidenced by their expressive spontaneity and loss of composure, suggests that their psyches are in flux. They become aware of birth and death, especially of their own.[29] That is, they become aware of the primordial rhythm of existence.

To facilitate this awareness, Beuys became a shamanistic "helping spirit," sometimes taking "animal form,"[30] for "the animal symbolizes a real and direct connection with the beyond."[31] The animal is chaos from the human point of view, and as such representative of primordial warmth. Apart from identifying with a variety of animals, Beuys regarded himself as a shepherd. As a child, he "acted out" or "behaved like a shepherd," going "around with a staff, a sort of 'Eurasian staff,' . . . and I always had an imaginary herd gathered around me."[32] Beuys could thus play either role, animal or shepherd, suggesting his oscillation between patient and healer, and also suggesting that he was always playing for himself, trying to heal himself. Like many artists, he was engaged in a process of self-healing, and was his own best audience. There is a touching photograph of the young Beuys, with a kind of staff, walking with his parents on a street in his hometown of Kleve.[33] He is in effect shepherding them – implicitly in charge. It is significant that his overcoat is wide and casually open, while his mother's overcoat is tightly closed, and that of his father is open with the proper degree of decorum.

I believe that Beuys understood himself as the shepherd of the Twenty-third Psalm, who walked "through the valley of the shadow of death" but feared "no evil," because the Lord's rod and staff comforted him, and anointed his head with oil (or honey). But Beuys was his own Lord and as such was Lord of the Germans – shepherd to himself as well as to the spiritually disturbed Germans who had survived the death of Germany. The shaman-shepherd is their "natural" leader, because he "can forsake the human condition, is able in a word 'to die.' "[34] He knows death as he dies, which is why he is able to be reborn, while others simply die without experiencing death – without knowing what is happening to them. Beuys wanted to give the Germans the courage to face death with open eyes and thus be reborn, rather than to dwell in the shadow of death forever, like ghosts in Hades.

"Death is quite a complicated thing" for Beuys.[35] It is only "through death" that one can "reach [primordial] material," a notion that he calls

"the liberation of death,"[36] meaning that it is not simply the "state of decay that [the] one-sided understanding of [scientific] materialism" thinks it is, but rather involves the "transformation . . . of substance . . . through concrete processes of life."[37] Shamanistic dying is thus a metaphor for the alchemical transformation of *prima materia* into *ultima materia*.[38] This, in turn, is a metaphor for therapeutic transformation, Beuys's ultimate concern. As Beuys said, he did not want "to return to . . . earlier cultures" in which "shamanistic or magical behaviour" was regarded as "sacred," but rather "to stress the idea of transformation and of substance" – the transformative power of primordial substance. "This is precisely what the shaman does in order to bring about change and development: his nature is therapeutic."[39] The shaman-shepherd is the psychomoral core of Beuys's nomadic performances. They are not only an attempt to establish the "open movement [that] channels the warmth of chaotic energy into order or form," indicating that "chaos can have a healing character,"[40] but a "reminder of the relationship between healing and decay."[41] Beuys's vision of therapeutic transformation through shamanistic performance with primordial substances – substances embodying healing decay or chaos – is clearly mystical in import. But it is also dialectical, as Beuys himself thought. Adorno wrote, "Dialectics means intransigence towards all reification."[42] With a dramatic dialectical flair, Beuys fought fetishistic reification in whatever sphere he found it, whether art, politics, education, or human relations. In a sense, his art was a kind of dialectical materialism, in that certain primordial materials had profound dialectical, or transformative, therapeutic effect for him. Indeed, they had the power to change life fundamentally. Shamanistic performance was also dialectical in that it could not be reified in aesthetic objects. The materials Beuys used – some, such as fat and felt, he regarded as inherently primordial; others, such as newspapers, he primordialized through deliberate misuse[43] – were later fetishized in museums. That is, they were passively exhibited as cultic relics, neutralizing the transformative power they acquired through their ritual use in the performance. But even as passive culture they seemed magically active and alive. They retained their intransigence to the aesthetic, and their correlate therapeutic significance, in that they could never be dissociated from Beuys's remarkably intense dialectical personality, which oscillated with astonishing ease between the opposites of sickness and health, death and life. Embracing the extremes in his manic art, Beuys worked his way through the depression induced in him by World War II and the death of Germany, a depression that clearly had its roots in the characteristic German reification of and obedience to order and reason.

Healing is avant-garde art's last stand. In Beuys's German hands, it was a barbaric form of healing for a modern society too decadent to acknowledge its own pathology until it had been brought close to death by it, and then too decadent to imagine health. Such a society, rational beyond reason, is the ultimate barbarism. It would be completely mediocre if it were not murderous. In such a society healing is also rational and scientific, but for Beuys rationality and science could not transform a fundamentally sick attitude toward life, for they were part of it. They helped rationalize the

attitude as inevitable, which, circularly, necessitated their ministration – and administration – of it. A little – perhaps much – magic is required to change a basic attitude. Beuys wanted to take art back to the time when it was magical thinking, and as such barbaric. There was no doubt something artificial about this regression to the "basic nature" of art. The sophistication of its methods, and its sophistication about itself, have carried it far beyond its origins. But Beuys knew that in a rationally barbaric society magical thinking is culturally sophisticated and humanly functional, and as such an effective counterweight to the barbarism of reason. There is a kind of wholesome psychotic reversal in Beuys's primordialism – a genuinely psychotic, emotionally responsible realism. For Beuys, healing is initiated by conscious radical reversal – through the artistic administration of a shock – of unconscious social presuppositions so fundamental or embedded as to be inadmissible. This is the only way to expose and dislodge them. Such reversal seems psychotic because it is socially unexpected and absurd, which is why it is individually effective. The primordial shocks modern society because the primordial is irreconcilable with reason, which is concerned with logically ordered consequences rather than with chaotic sensory immediacy. Beuys's general artistic point is to generate irreconcilability (which for many people means that he is inherently psychotic), as his regression to primordiality already indicates – especially when he premises the impossibility of reconciliation with society as it exists and has always existed. It has been said that magical or concretized, animistic thinking – which is what Beuys's shamanistic materials embody – is a "radical disruption in the capacity for symbolic thought," but such anarchistic disruption is necessary when society has itself become psychotic; that is, when it has conceptualized itself in a completely unrealistic way, as in the case of Nazi Germany.[44]

The perversity of Beuys's conception of shamanistic artistic healing, addressing tragically conceived modern man – in Kohut's sense of fragile and fragmented, depleted and disintegrated "tragic man" – epitomizes avant-garde perversity or reversal in general. The avant-garde artist makes a double archaic transference to society or to his audience: both an enraged, punishing and self-punishing identification with its inner tragedy, and a grandiose self-identification as its empathic savior. (In my opinion what Renato Poggioli calls avant-garde antagonism and agonism are the manifest symptoms of this latent rage and grandiosity.)[45] Through these narcissistic identifications the avant-garde artist becomes, at least in his fantasy, society's inner voice. (If he can convince society of the truth of this – and he is likely to, since the position of inner voice is a rotating one, and his turn will come – he will become famous.) He fantasizes that by articulating through his art the inner tragedy inarticulately felt by everyone (and Beuys seemed to embody this in his person), he can liberate society from it.

Beuys's claim to fame ultimately rests on this ambitious desire to be of reparative service to pathological society. Of course, that society regards this as pathological in itself. The grandiose wish to heal society – to revolutionize its psychology so that it can evolve in a healthy, humanistic way, as Beuys said – is in fact deluded, but not just because society resists curative

change through art, regarding it as absurd. Rather, the artistic results of healing betray the suffering they sublate because they invariably become aesthetically ideal, however un-ideal they initially seem. Beuys tried to avoid art's seemingly built-in power of idealization by his materially gross and poignantly gauche performances, but his narcissism got in the way. His performances invariably became a kind of self-idealization, indeed, a self-deification, however much they were about his feelings of physical vulnerability, hypochondria, and disturbed body image in general – which confirms their narcissism.[46]

Because the means of healing became contemplative ends in themselves, the performances lost their meaning as healing events. Beuys, a physician manqué,[47] may have unconsciously intended that this occur, as if he wanted to enshrine his lost destiny – from which his healing intention survived – in sacred shamanistic objects, actual healing being secondary. This would confirm his overarching narcissism. Being an artist, after all, is more narcissistically satisfying than being a healer, for as an artist one is ultimately answerable only to oneself. Beuys tried to make himself answerable to his audience by presenting himself to it as its healer, but in the end he only staged his own tragedy. The artist – especially the narcissistically vulnerable avant-garde artist – wants more from the audience than he gives to it: he wants it to heal him, or rather let him heal himself by performing for it, that is, by exhibiting his wound to it. He is really more interested in finding and helping himself through his audience than in reaching out to and helping others through his art. In the last analysis the audience is a more credible medium than the art object, for by working through the audience, the artist does indeed find – if incompletely heal – himself. At the same time, while working through the art object, the audience finds only a small part of itself and never really heals itself. In general, the artist is more likely to solve his own narcissistic problems by making art than to solve any of the audience's emotional problems, although it no doubt puts the audience in touch with emotions it did not know it had.

Beuys represents the most strenuous avant-garde attempt to reconcile the roles of artist and healer, to make art a kind of healing and to make healing artistic (which is clearly unscientific, if still materialistic). Nevertheless, he vitiated his empathic healing intention by the increasing didacticism and self-righteousness of his performances. He became more interested in being a guru than a psychoanalyst. That is, his shamanism got the better of him. He actually began to think his person was magical, which was a narcissistic delusion. The guru depends on his audience, the psychoanalyst wants to give it its independence. The guru indoctrinates in the already known truth, which is presented like a kind of tall tale, an entertaining wisdom, and is universally dispensable whatever the case. The psychoanalyst tries to fit the truth to the patient, which may lead to the discovery of new truths. The guru's truth tends to boil down to a few simple platitudes, while the psychoanalyst's truth tends to become increasingly dialectical and complicated. The guru leads a cult – the bigger the better, to go along with the guru's grandiosity – and presents his teachings in public to the masses, while the psychoanalyst interprets individuals to themselves in privacy. In retrospect,

`rmances seem like narcissistic extravaganzas in which he was
`nfirm his charisma, that is, to continue to believe in himself. He
` increasingly – manically – sure of himself, as his didacticism and
`-righteousness suggest, but in fact his morbidity and depression intensi-
fied to a climactic pitch, as his last ultraregressive object works suggest. It
was as if he were trying to convince himself that he was true to himself on
a public stage that made him false to himself. Perhaps art invariably fades
into narcissistic grandeur after the audience to which it is addressed has
passed into history or abandoned it. This seems especially the case with per-
formances, which depend even more than art objects on the moment and
situation of their production to be "moving."

Beuys is the grand climax of a long line of self-contradictory avant-garde
narcissists in conflict with a society they want as their audience. Each
idealizes himself while showing society that it is far from ideal, especially
compared to himself. Society celebrates their tragic selfhood and tragic re-
lationship to it in order to deny its own tragedy. With each avant-garde art-
ist it accepts and assimilates, it vindicates and reassures itself. With each
avant-garde artist whose isolated suffering it rationalizes, it proclaims its
collective solidarity. Ultimately society banalizes the avant-garde artist's
narcissistic suffering and conflict with it into a universal ideology of heroic
selfhood triumphing over great odds and obstacles. This justifies society's
own grandiose belief in itself, for it put the artists in that triumphant po-
sition. The avant-garde artist may tantalize society with a sense of its inner
tragedy, if at the arm's length of art, but society produces the tragic drama
of the avant-garde artist-martyr as proof of its own omnipotence. The real
tragedy of the avant-garde artist is that he wants to heal a society that
has a vested ironic interest in his pathology. Conversely, the tragedy of
society is that it does not want to be healed by any means, for it thinks it is
fundamentally sound. Art is simply a pawn in this frustrating standoff.
Avant-garde art's oppositionality is a necessary social illusion because it
strengthens society's conviction in its own invincibility. Society's assimila-
tion of avant-garde art demonstrates this; it is immune to artistic transgres-
sion. The museum is the symbol of society's power to neutralize any artistic
threat.[48] (Beuys's German audience seemed less impressed by the intro-
spective power and pathos of his art than by its overt barbarism, which re-
flected the social barbarism with which German society defended against
inner recognition of its tragedy. In the past, German society had assigned
the introspective role to a few token artists and philosophers while it went
its merry barbaric way, returning to them for consolation only when its bar-
barism got it into trouble.)

Nonetheless, the avant-garde artist is idealized as the messenger of bad
emotional news, if not as the great, messianic reeducator avant-garde artists
from Kandinsky to Beuys thought they were. Part of this idealization results
because the artist is destroyed for bringing the bad news. He is made into
a scapegoat: the tragedy he announces is displaced onto his person and art.
The latter become part of a ritual of social sacrifice intended to guarantee
the society's survival, even immortality, despite its human failings. Thus so-
ciety ironically accepts the avant-garde artist's self-definition as one more

sinned against than sinning. The avant-garde artist is in fact society's trag-
edy in ideal and harmless public form, allowing society to believe that it is
less pathologically tragic than it is. It dismisses its tragic pathology as less
dangerous than it is, for this pathology is confined to a few conspicuously
pathological individuals, the avant-garde artists.

Expressed through avant-garde art, tragic pathology will presumably
not be enacted on a grand social scale. Indeed, it is a matter of social
faith — part of the willing suspension of disbelief in art — that venting tragic
suffering through art is healthy. Art is supposedly a rough-and-ready, if ul-
timately facile, way of working one's troubles through. The existence of
highly differentiated, particularized works of art creates the illusion that
the individual's tragic suffering is particular to himself — a vicissitude of his
development — rather than a symptom of social tragedy and failure. But in-
dividual suffering in and of itself is a sign of social tragedy and failure. Art
can change nothing emotionally basic, only acknowledge what *is* emotion-
ally basic. It cannot change tragedy, only allow us to admit it to ourselves.
Beuys's personal tragedy was that he did not understand that his avant-
garde performance of Germany's tragedy not only failed to heal it, but un-
wittingly justified Nazi Germany and its criminal behavior. He should have
been more of a clown than he was. Tragedy may state the pathology — with
special narcissistic vehemence and morbidity in avant-garde tragic art — but
comedy alone heals, if healing is possible.[49] Comedy is ultimately more en-
chanting than tragedy, even for those disenchanted by themselves because of
their own tragedy.

CHAPTER 7

THE DECADENCE OR CLONING AND CODING OF THE AVANT-GARDE
APPROPRIATION ART

An offensive act may arouse anxiety about the ritual code; the offender allays this anxiety by showing that both the code and he as an upholder of it are still in working order.

Erving Goffman[1]

I'm just a public entertainer who has understood his time.

Pablo Picasso[2]

Mr. el-Masri said the discovery suggested to experts that this could have been the site of a temple complex in the reign of Ramses, who ordered more buildings and colossal statues than any other pharaoh did. On the other hand, he added, Ramses is known to have carved his name on statues of previous pharaohs or to have re-shaped them.

New York Times, December 17, 1991

By now the connection between [Robert] Mapplethorpe and [Patti] Smith is well known, almost overknown, overshadowing what meant so much; the mechanisms of fame always seem to need to suck just one image out of the fuller picture.

Ingrid Sischy[3]

How was it with the painters of the New York School at the beginning of the 1960s? I scarcely knew them. . . . It was more the fame of these people that astonished me.

Interview with Gerhard Richter[4]

In the 1960s, in three "actions" of radical self-understanding and self-definition, Beuys sharply differentiated himself from other artists – from the dadaists, Duchamp, and Robert Morris – in order to avoid public mis-understanding of his therapeutic intention. (These actions will be discussed in detail later.) He may have misunderstood their intention, but he made transparently clear what he regarded as the only authentic intention of avant-garde art. No doubt he arrogated it to himself, in effect asserting that his art was truer to the primordial healing intention of art than theirs was. But, more crucially, he signaled the difference between true avant-garde and

mock or pseudo-avant-garde art. In differentiating the two, Beuys implied, however unwittingly, that from its beginning modern art was split into two avant-garde lines, simultaneously if unevenly developing, with a family resemblance but with fundamentally different intentions.

From Beuys's point of view, pseudo-avant-garde art threatened to drive out true avant-garde art the way bad money threatened to drive out good money. There is always more of the former than of the latter. There are always more artists who are able to perform mock miracles, like the magicians of Egypt, than can perform true ones, such as the shamanistic shepherd Aaron. With God's help, Aaron was able to change a rod into a real serpent rather than simply create the illusion of such a change. For Beuys there were always too many pseudowise – merely shrewd – artists. The truly wise artist could not eliminate them the way Aaron's serpent swallowed up all the serpents made by the Egyptian magicians (Exodus 7:11–12).

Today Beuys's worst fears have been realized: pseudo-avant-garde has displaced true avant-garde art as the standard-bearer of artistic significance. Its values have prevailed. It has militantly declared its falseness as if it were a virtue. It is as if the Antichrist or false Messiah were mistaken for the real Christ or true Messiah. The former looks like and successfully copies the latter, but behaves in a more socially acceptable, less offensive way; he acclaims himself rather than waiting for society to discover and acclaim him. Where the true avant-garde artist goes about his work with the support of other true believers, in relative isolation from society as a whole – even if finally acknowledged and celebrated by it (usually for the wrong reasons) – the pseudo-avant-garde artist is socially entertaining and ingratiating. That is, like kitsch – for it is a kind of "kitschification" of avant-garde art – his art distracts people from the devastating reality and truth of their lives. In using his art to do this, the pseudo-avant-garde artist is quite unlike the avant-garde "prophet," who attempts to remind people of how far they have strayed from the true path – how far from the True Self they have fallen – and seems to castigate them for it. Such an avant-garde art of existential conscience, affording a kind of emotional and existential self-knowledge, means to effect a change of heart, a genuine spiritual revolution or personal conversion.

But perhaps the greatest difference between the pseudo-avant-garde and the true avant-garde artist – although neither necessarily exists in ideal, unadulterated form – is that the former declares himself a worldly king, not merely a spiritual savior. The avant-garde savior was a threat to Rome, but the pseudo-avant-garde artist is not likely to be a threat, for he affirms Rome's values. He is not a critic of it, but rather a propagandist for it. Worldly success matters more for the Antichrist than does spiritual guidance. He wants to receive, not give. It is as if the pseudo-avant-garde artist wants to be materially rewarded on earth in order to blind people to the fact that his art has no heaven to give.

Indeed, worldly success is the final arbiter of artistic value in the pseudo-avant-garde art world. Worldly power bestows worldly success in gratitude for endorsement of the world it has created. Success is the reward for

becoming this world's advocate and disseminating its values, in effect joining its belief system. Success is social power's way of giving a share of itself to those who truly believe in it. The recipients then help administer it, indeed have a vested interest in it. This is the lesson taught by Warhol's success. His notion of business art affirms America's belief in business above all else, and he was richly rewarded for affirming it. Warhol was never as dadaistically tongue in cheek – as authentically critical – as some of his more intellectual art-world fans thought. They wanted to redeem him for the avant-garde and to rationalize the embarrassing fact that he was always all business, all-American. Indeed, he never quarreled with the cruel reality that in bourgeois society, as Karl Marx said, there is "no other nexus between man and man than naked self-interest, than callous 'cash payment'."[5] Warhol seemed to have measured his "personal worth" in the impersonal terms of "exchange value," probably reflected in his indifference and tendency toward depersonalization. He stripped the occupation of artist, "hitherto honored and looked up to with reverent awe," of its halo, of its last vestige of divine meaning. Nevertheless, he kept the halo, obviously happy that it was made of gold.[6] Warhol, indeed, was the first, or at least the first highly visible, unashamed pseudo-avant-garde appropriationist artist.

Why should the pseudo-avant-garde artist be so socially welcome when the pioneering avant-garde artist was not? The pseudo-avant-garde artist believes that he is as socially offensive, and thus as critical and authentic, as the avant-gardists were, although in a different way. He believes that his art is equally risky, aesthetically and socially. He wants the cachet of critical offensiveness and riskiness, the birthright of every avant-garde artist. Witness Jeff Koons's pornographic photographs, hyped as ironic and as paintings to make them seem even more ironic. But what Koons – among many others – has done is appropriate an imagery that is already highly successful and cash in on its success. That success is due in part to its shock value and sensationalism, however faded. Even his strategy of transposition, supposedly the most shocking and sensational thing about his work – bringing banal or vulgar imagery into the gallery, making both more exciting than they would otherwise be – is a convention of avant-garde success. That is, unlike the original avant-garde artist, the pseudo-avant-garde artist does not bring the visual status quo into question, which in effect would also bring the psychosocial status quo – which it puts a good face on – into question. He simply "enhances" it by ironically recontextualizing and reworking it, which does not necessarily mean rethinking it. In fact, our society thrives on "decorative" recontextualization, on "creative" recycling of old ideas and images. Bringing the status quo into question has itself become a standard part of the bourgeois status quo, a familiar part of the art and social scene. One has no (art-)worldly status if one is not critical.

Pseudo-avant-garde art confirms the decadence of criticality and the "redesign" of the already known by ironic appropriation of it. It has become increasingly difficult to imagine questions that would truly threaten the bourgeois status quo. Irony is no longer really critical, or rather it is a comfortable form of criticality, a criticality that causes no self-questioning. It is

a criticality without the "agonbite of inwit," to use James Joyce's phrase for conscience. Irony has become a form of propriety. It gives no offense. There is no risk in it.

Indeed, ironic appropriation is unconsciously a form of melancholy submission to the visual and psychosocial status quo. The pseudo-avant-garde artist reifies already reified – by reason of their social success (secular sanctification) – avant-garde and kitsch art into ironic aesthetic phenomena, as if to return them to dialectical process. But irony is always resignation to the insight that nothing basic can be changed. The status quo can only be made more bearable; that is, one can learn to take a more flexible attitude towards its rigidity, which may bend it a bit and incline it to favor one with good fortune. Treating the status quo with aesthetic irony – aestheticizing it through irony – is one important way of accomplishing this. Seen through the filter of irony the world looks particularly perverse, which makes it seem more magical – seductively wish-fulfilling – than it can ever be in reality. (Aesthetic irony, and irony in general, is thus a way of retaining intellectual honor in the face of emotional futility. It masks the depression that comes with the recognition that it is impossible to change the world significantly with a pose of profound insight into it. It is as if such pseudo-insight kept alive the intention to change the world despite the lack of any will to do so. To put this another way, aesthetic irony keeps the idea of revolutionary change alive while reifying it into a strategy of artistic evolution. In general, disillusionment is at the core of irony.)

The wider the appeal of the appropriated work, whether avant-garde or kitsch – and the popularity of kitsch is the ultimate model of appeal for the pseudo-avant-garde artist – the more likely it is to become a cult object. Indeed, the process of mass reproduction and consumption that makes it appealing also makes it a cult object. Full of appeal, it becomes peculiarly anonymous, losing the emotional and existential specificity that made it significant to a particular individual. It is no longer a medium through which he can find himself, a catalyst of individuation. Similarly, appealing artists join the pantheon of plaster saints mechanically idealized by the masses in unconscious self-pity. Duchamp and Walt Disney have equal credibility in this pantheon because they are equally successful. The worshipers hope that one of the saints of success will hear their prayers for narcissistic comfort. Because of his success, the pseudo-avant-garde artist thinks the social charm of his art gives it spiritual significance. Some people think there is truth to this – the status quo loves having spiritual significance attributed to it, loves thinking that submission to it has the power to end one's suffering, or at least console one – and believe the pseudo-avant-garde artist's bankrupting of avant-garde intention is a brilliant rethinking and revitalization of it. This is a sign of jaded times.

Taken together, Beuys's three episodes of rejection of other artists – as if, like a changed Peter, he affirmed rather than denied the healing, Christlike character of art (and no doubt of his own person) three telling times – amount to a parable of appropriation art, the climactic development of pseudo-avant-garde art. On February 3, 1963, at the first Fluxus concert, Beuys made clear that his "action ['Siberian Symphony']" had

absolutely nothing to do with a Dadaistic concept. . . . it concerned itself with something possessing a totally different point of value."[7] On November 11, 1964, Beuys's action "The Silence of Marcel Duchamp is Overestimated" "aimed at combating the cult of genius and the uncritical reception of artists."[8] More particularly, Beuys expressed "disapproval of Duchamp's antiart concept," and contrasted Duchamp's silence – his giving up art to pursue chess and writing – with that of Ingmar Bergman in his film *The Silence*.[9] Finally, on December 1, 1964, on the occasion of the performance of the Fluxus song "The Chief" in Berlin, Beuys asserted that, in contrast to Robert Morris, who was performing the same piece at the same time in New York, his "actions and methods have absolutely nothing to do with vanity and transitoriness." Rather, he said, "I am a transmitter, I radiate out," that is, he works for others as well as for himself.[10] Earlier he asserted that "the rigid form of the box [*Rubberized Box*, 1957] has nothing to do with minimalism," alluding to Morris's boxlike works of the early sixties.[11] In the same vein, Beuys contrasted "the transformation of substance that is my concern in art" with "the traditional aesthetic understanding of beautiful appearances."[12] Beuys did not want to make a beautiful appearance, but rather an energetic one. He wanted the energy he radiated to transform his audience substantially.

In each case Beuys separated his art from one that looked like it but lacked the same spiritual valence – the humanistic healing purpose – as his own. Indeed, Beuys sharply contrasted his own and Bergman's spiritual art from generally spiritless art, which has only its avant-garde novelty going for it. Beuys's *Rubberized Box* is formally or technically of the same stylistic family as Morris's minimalist box. Beuys's Fluxus actions looked dadaistic, but their intention toward the audience was altogether different. Beuys wanted to shock the audience for its own emotional and existential good while the dadaists did so in order to mock the audience's feelings and existence, to strip it of its raison d'être or to show it its nothingness. Duchamp's silence looked like that of Bergman – how is one to differentiate one silence from another? – but the latter was emotionally resonant and existentially urgent rather than deadpan and self-defeating. Duchamp's silence was a shrewd irony at the expense of art, a debunking strategy that was ultimately, for Beuys, an empty gesture. It showed cold contempt rather than warm feeling for the audience. To put this in Winnicott's terms, Duchamp's silence coldly dropped the audience, while that of Bergman "held" it warmly. For Duchamp, the silence of art relieved one of the feelings of life; his repudiation of art's physicality and his intellectualization of it were in effect a repudiation of the primacy of feeling. For Bergman on the other hand, it was only in the silence of art that one could discover what one truly felt, and thus feel freely (which is why art gives one the feeling of freedom). Duchamp, the dadaists, and Morris were false Egyptian magicians, faking their art. They made a farce of the very idea of art, especially as an attempt to emotionally and existentially help others, while Beuys privileged himself and Bergman as authentic artists, making art that was not only innovative but helpful.

Beuys's relationship with Morris was especially telling. For him, Morris went through the motions of the performance correctly but without feeling anything, without having anything spiritual to transmit to the audience. The audience will feel Morris's lack of feeling – will sense that his art did not come from the inside – and thus experience his performance as subtly inadequate, even as it respected his effort and the technical complexity of its synchronization with that of Beuys. Morris's duplicate performance was necessarily vain – and in vain – because he did not empathically understand the dialectic of suffering and healing that informed Beuys's performance. He reduced Beuys's conviction to a stylistic construction. It is as if, by copying the performance, Morris intended to deny that it had anything to do with inner life. In other words, Morris was a sterile clone who coded the performance for its technical reproduction and consumption. He was, in this situation, the artist as machine, like Warhol, rather than the artist as originator. This did not so much destroy the aura of Beuys's performance as fail Morris himself. That is, Morris did not recognize that his own inner life and authenticity were at stake in the performance. Also, by not being personally involved with all his being, but by impersonally performing one more work in a career move, Morris failed the audience. The audience can pick up and participate in the emotion with which a performance – and art in general – is given, and can "read" the intention implicit in that emotion. The artist's intention, presented with emotional conviction, is contagious, and can transform the audience. But if there is no emotionally convincing intention, the art exists only technically and formally, that is, for intellectual contemplation.

A clone is an asexual reproduction of a sexually produced organism, and as such is sterile. Beuys's performance was a union of suffering and healing – a morbid sexual process, as it were – with an uncertain outcome. However, its self-certain reproduction by Morris made it unambiguous and as such unevocative of either opposite. It thus lacked the tension that has transformative effect, which made it irrelevant, for all its novelty. "Unintentional" innovation has no unconscious effect on the audience. It is Beuys's performance that we remember, not that of Morris. Or rather, we remember them in very different ways. To put this another way, Morris's performance reified Beuys's performance by encoding its spiritual intention as a physical message. In a sense, Morris, operating from a different world of meaning than was Beuys, could not help but be blind to the spiritual intention of Beuys's performance, and could not conceive of it as other than purely physical and strategic in character. Through the indifference implicit in his presence, Morris in effect denied that Beuys could ever have any spiritual intention. They were profoundly at odds, but only Beuys knew it. Morris was too busy being artistically different or innovative, eagerly trying out another style. Beuys correctly perceived Morris as a threat. That is, Beuys saw the destructiveness and inhumanity of Morris's Duchampian – militantly indifferent or uncaring – attitude. He considered it especially inappropriate for a German audience that was too inwardly disintegrated to make even the effort of masking its feeling of nothingness with hostile indifference.

Thus Morris missed altogether the expressive point of Beuys's performance. But his own inexpressive performance could not be distinguished from it, except by contextualizing Beuys's performance in terms of his spiritual intention, and perhaps above all that of his audience. The fundamental difference between the simultaneous performances lay in what the Berlin and New York audiences were ready to receive from them. This depended on the difference between the spiritual needs of each audience. The German audience was more likely to recognize its pathology and to try to heal itself than the American audience, which was more interested in the aesthetic smartness and novelty of the performance. For it is un-American to suffer and want to be saved from oneself. Nonetheless, as I remarked in the last chapter, the German audience's insight into itself cannot be assumed. The New York audience of victorious Americans and the Berlin audience of defeated Germans were inherently different. They necessarily responded to the performance in emotionally and existentially different ways, for by reason of their different histories they necessarily found different intentions – that is, different selves – in it.

Appropriation art is informed by the decadence syndrome: the sense of the decline and impending death of art. This is expressed as a feeling of déjà vu and a sense of art's loss of significant human purpose – its inability to afford an important perspective on the lifeworld – as well as on the wish for rejuvenation. This wish is expressed by envious exploitation and subordination – veritable colonization – of avant-garde art that had been vitally alive and had startled the world with its revolutionary ambition, as though to suck the dregs of that faded vitality and ambition from it. But whatever the morbid nostalgia of appropriation art touches turns to stone. It is deadened into historical and linguistic fact, reduced to intellectual rhetoric, as it were. It becomes a cross between artifact and arty fact, losing its point as art. The appropriation artist has little respect for the authenticity of what he appropriates – how could he, since he is inauthentic? – which is why he feels free to treat it flippantly and ironically (without understanding the unconscious import of his irony). Simply put, he has no feeling for or perspective on it, and thus no sense of its relevance. This is true even when, as in the case of Peter Halley, he affirms continuity with it as a concept (if not as a particular image), and asserts its broad – indeed, its universal – cultural significance.[13] But this universality bankrupts it as an individual achievement speaking to a spiritual need. "Perspective," Alfred North Whitehead wrote, "is gradation of relevance" and "the outcome of feeling; and feeling is graded by the sense of interest as to the variety of its differentiations."[14] In other words, because the appropriation artist lacks empathic understanding of the art – he doesn't even have the will to have such intimate understanding – he has no feeling for its vital importance. It is important to him because it has survived as a cultic object, a mass-reproduced and completely socialized or domesticated text that is consumed in a variety of popular and intellectual ways, whether as a good luck charm on a living room wall or as cabalistically significant esoterica.

The appropriationist artist has no sense of the subtle sensorimotor nuances – the immanent erotic differentiation – that constitute the art he ap-

propriates. In fact, he eliminates them, generalizing the art into a puritanical surface. Indeed, his appropriation presents the art in a peculiarly undifferentiated way, the indifferent way it exists in its social success. This is what Sherrie Levine does to the famous avant-garde male artists she appropriates, with depressive irony. For Levine, maleness is simply a signifier and guarantee of success, and in scooping or hollowing out other artists' success she destroys their maleness. This is what Mike Bidlo does to the famous avant-garde artists he inexpressively copies. The appropriation artist is not at all influenced by what he appropriates, in the traditional sense of the term, for what he appropriates is not an inspiration and catalyst to him. Rather, he denies its value as a creative resource, indeed, denies it as a creative achievement. It is viewed, with pseudo-sophistication, as simply a visual construction. As such, the feeling and intention implicit in it are neutralized and discarded. The appropriation artist in effect suppresses what he appropriates by the very matter-of-factness and nonchalance with which he appropriates it. Indeed, flat affect or so-called coolness carried to the point of complete inexpressivity – affective inertia or the lack of expressive response to what is being appropriated – is characteristic of appropriation art. It masks a destructive paranoid-schizoid attitude toward the "parental" art.[15]

Thus appropriation art is a crisis in the sense of the purpose of art. It is the outward expression of an inner crisis. It implies creative bankruptcy, or the reduction of avant-garde creativity to an ironic game played for its own amusing sake. It reduces avant-garde creativity to "a fine disregard" for the old rules of art in order to make a new game.[16] With unwitting bad humor, appropriation art tells us that art is finished, but that the game can go on and clever new games can be invented for the ironic fun of it. Appropriation art is the death rattle of the avant-garde, or a way of dancing on its grave.

John Gedo has noted "the continuing assault upon cultural traditions in our century, aptly named the age of the avant-garde."[17] By midcentury the avant-garde itself became a cultural tradition, as Harold Rosenberg famously noted.[18] The self-opposed-and-giving-offense-to-society became a cultural syndrome, indeed, an aesthetic cliché, even though Rosenberg still regarded it as vital and influential.

The indifference of Warhol, minimalism, and Morris acknowledges the avant-garde syndrome as a dead end even as they seem comfortably to inhabit it. Indeed, their comfort with it – the readiness with which their art is seen as an offense to society, and the pleasure society takes in being offended by it – testifies to the art's banality. Above all, the way the artists reduce offensiveness to irony speaks of its outmodedness. It is, after all, part of the cultural furniture. At the end of this century the avant-garde is a dead cultural tradition, as appropriation art indicates. It turns avant-garde truisms into pseudo-avant-garde metaclichés. It turns important avant-garde works of art, half-embalmed by history, into waxworks, giving them an ironic permanence.

Correlate with "the enfeeblement of tradition" that ironically leads to the institutionalization of every innovation as traditional – which means to its trivialization – the artist turns "his focus more and more upon himself,

with less and less pretension of offering aspects of his own experience as specific examples of certain human universals. Moreover, the mandarinate is embarrassed about professing any value system at all . . . Under these circumstances, all creative activities threaten to become all too pragmatic quests for fame and fortune."[19] This is especially the case for the pseudo-avant-garde artist.

Avant-garde art was offensive – provocative – because it communicated human values in an innovative way that caused them to be deeply felt by the public, as if the art were a mode of introspection and the voice of its own conscience. Avant-garde art reconciled modern society's repressed wish to be human – which was too impractical – with its belief in innovation, which epitomized its modernity and that carried with it the wish to "correct" the human. The avant-garde artist was resisted, but he eventually became famous because his art was emblematic of modern innovation, and also because it reminded society of its humanity despite itself.

The pseudo-avant-garde artist appropriates the avant-garde artist's fame, misunderstanding it as success. The pseudo-avant-garde artist sees the fame and fortune won, however belatedly, by the avant-garde artist's art; he does not see its dialectic. The pseudo-avant-garde artist assumes that avant-garde art is a means to the end of fame and fortune, not a thing with intrinsic value. He abandons the values that informed it – its innovation as well as its humanity – without ever having understood them. He is left with the narcissistic pursuit of fame and fortune. This might be interpreted in pathetic terms as the compensation he feels he needs for the supposed impossibility of having any abiding value system, human or aesthetic, in changing modern society. In fact, his pursuit of fame and fortune shows his complete acquiescence in, even complicity with, bourgeois society. Appropriation art bespeaks this acquiescence, as well as the lack of belief in the intrinsic value of the art appropriated. Completely extrinsic, appropriation art mocks and trivializes the innovativeness of the art it appropriates. It cannot comprehend innovation from the inside any more than it can comprehend human values. Its power to neutralize both, and thus to create an air of indifference around the art it appropriates, gives it a perverse perfection.

At the same time, the pseudo-avant-garde artist is haunted by the decadence syndrome, which bespeaks his unconscious sense of enfeeblement. The syndrome is the perverse subjective correlate of his pragmatism, his social objectivity. The pseudo-avant-garde artist may be ironic about his own quest for fame and fortune, but the irony defends against the feeling of helplessness and vulnerability – the emotional consequences of the lack of any human value system – implicit in it. His art has lost the healing ideal of avant-garde art, although the decadence syndrome suggests that he is still concerned about healing himself, that is, about rejuvenating himself in fear of his decline, whatever his social success. Inwardly he is constantly anxious about decline, while outwardly, in narcissistic defense against his anxiety, he relentlessly pursues fame and fortune. But one cannot heal oneself without trying to heal others, which is the point of Beuys's shamanistic art, and also the point of making art a performance explicitly addressed to a particular audience that can identify with the artist and thus find its hidden

identity as sufferer. (This conception of art stands in sharp contrast to the previously mentioned conception of it as a game whose rules can be arbitrarily changed, and which regularly are. It thus seems always novel and pointless, as if mocking Kant's conception of art as "purposive purposelessness.") The wish to be healed arises only from the baffled recognition of the inescapability of suffering that Beuys's anguished performances conveyed.

Moreover, the pseudo-avant-garde artist misunderstands his own wish for rejuvenation: he does not realize that rejuvenation is a metaphor for being made whole. Becoming young again, even in spirit, is not the issue of the decadence syndrome. To be made whole does not mean that one does not suffer, but that one's wholeness is stronger than one's suffering. One's wholeness contains one's contradictions, no doubt with great strain, but without shattering. Suffering becomes a test of fundamental integrity, demonstrated in the strength to bear that suffering. The difference between an art in which wholeness contains suffering, and one in which suffering shatters wholeness, is the difference between a "classical" and an "expressionistic" art.[20] The pseudo-avant-garde artist understands neither. That is, he understands art neither as the expression of suffering nor as an expression of the need for healing wholeness. As long as there is a famous art to appropriate he feels vitally young, even as the act of appropriation announces his decadence. He thinks he has abandoned creativity, but it has abandoned him. He thinks suffering and integrity are different kinds of jokes, but they play a joke on him in the form of the decadence syndrome. His fear of decline implies recognition of his lack of integrity as well as fear that this lack will be found out, even as he openly declares it by parasitically appropriating the integrity of avant-garde artists to create a semblance of his own. Appropriation hardly means having an artistic life and creativity of one's own. Indeed, appropriation makes such a travesty of creativity that one cannot help but see a death wish at work in it. The life wish – the wish to rejuvenate – obliquely acknowledges the life left in the appropriated art. This life, however faded, can never really be the pseudo-avant-garde artist's own, however much he thinks its fate is in his hands. His mock rejuvenation of avant-garde art in fact means finishing it off so that other people will find no life in it, but he never comes near it. His dependence on it would be pathetic if it were not criminal. However, his ingenious annihilation of avant-garde art through his ironic appropriation of it is a sad way of avoiding his own feeling of not existing as an artist in his own right. Irony always builds sand castles with the ashes of catastrophe, as it were, and aesthetic irony tries to make the best of the catastrophe of having no creativity of one's own.

Appropriation art has an ironic ulterior motive: to convince society that to be avant-garde, art does not have to be offensive, only to look offensive. Similarly, the pseudo-avant-garde artist has only to look like an avant-garde artist, but his pursuit of fame and fortune shows society that he is really just like everybody else. The deeper point is that the pseudo-avant-garde artist wants to save society's face, and in so doing, save art's face. It can be soothing, not offensive, restorative rather than destructive. His art's fame and fortune make it a cultic commodity, and as such truly magical. Entering the

social space of mass reproduction and consumption, it becomes completely believable and comforting, to the extent of being able to create the illusion that the audience's luck might change for the better. This is the great hope – the big wish, the big lie – that art must arouse to be socially successful. It must stir the narcissistic wish to be a star and fulfill it in fantasy. The illusion that anyone can become famous and fortunate – that the powers that be can smile upon anyone – restores the audience's confidence in itself. The illusion inspires the audience to believe in individual possibility – in personal good luck because of mysterious personal charm – just when it felt defeated by social necessity. Just when the audience had given up hope – which is why it turned to art – it can hope that fate might favor it. Art surprises it with this impossible hope, hope that flies in the face of recognition of reality, hope that almost psychotically seems to suspend the reality principle. This in itself affords a kind of pleasure.

This mysterious personal charm is creativity. The pseudo-avant-garde artist stirs the wish to be creative in the audience and creates the illusion that the pseudo-avant-garde artist's art could just as easily have been made by anyone in the audience had he taken the time and trouble to think of making it. From Duchamp through Warhol, and to a lesser extent to Beuys – who encouraged the audience's creative possibilities but regarded his shamanistic performances as uniquely his own – the pseudo-avant-garde artist fosters the illusion of mass creativity. He democraticizes creativity, making it an anonymous, diffuse force. At the same time, he shows that "individual" creativity can be socially rewarding. The artist-star creates the illusion that anyone can be creative and successful, that the two are not mutually exclusive. He is unique among stars because he can convince people of this. Anyone can become a star, but only an artist can become a star for his creativity, for making a fetish of it to the apparent exclusion of all else in life. The artist is ostensibly someone who renounces the lower goods of life for the higher good of creativity, but the higher good can bring more mundane, ordinarily desirable goods in its wake.

Particularly acclaimed is the pseudo-avant-garde artist who makes creativity seem easy while preserving a vestige of its unpredictability and uncertain outcome. Such an artist maintains a sense of art as a dialectical working-through with no necessary resolution as proof of its avant-garde authenticity. No one really wants to work at being creative, especially not at taking the avant-garde risk of confronting society with the human values it does not live up to and challenging it with an innovation it may not welcome. Yet everyone wants to look as if they are creative, especially creatively confrontational and challenging. (There is a telling episode in a film in which Peter Halley draws a line, with a ruler, on a canvas otherwise completely painted by his assistant. Everyman can make art, Halley says, à la Warhol.[21] The assistant is in effect everyman, and the "individual" gesture of the ruled line symbolizes the personal character of his creativity. It is not clear that Halley means this ironically. Rather, his irony is so ingrained – his cynicism so unself-conscious – that it seems sincere.)

In giving the audience faith in itself – a hope for a better creative life – the artist-star saves art's face: art seems not an offensive esoteric activity,

but rather socially beneficial. It is not a fancy fraud: it is full of the *promesse du bonheur*, if in a more perverse form than Adorno imagined. Art is indeed a confidence game in that it gives the audience confidence in itself. This is why the audience rewards the artist with fame and fortune, giving him, in turn, confidence in the significance of his creativity. Art fuses artist and audience in a mutual narcissism, satisfying the grandiose wish of each to be creative as a sign of personal omnipotence. In the case of the pseudo-avant-garde artist and his audience, it is a mutually cynical, face-saving narcissism because of the corruption of creativity.

Artists such as Kiefer and Schnabel make a show of true selfhood, while artists such as Halley and Levine make a show of innovation. The issue is not how convincing the show is – it will be convincing to the pseudo-audience – but how rooted it is in obsolete avant-garde notions of true self-hood and innovation. They show that there is no way forward in art today, only different ways backward toward a past that is only technically usable, not emotionally and existentially convincing. They show that a kind of plagiarism has become the ideal of art. "In art," Gauguin wrote, "there are only two types of people: revolutionaries and plagiarists. And, in the end, doesn't the revolutionary's work become official, once the State takes it over?"[22] Plagiarists find it easier to appropriate yesterday's revolutions, but the pseudo-avant-garde artist unwittingly makes the point that it is easier to plagiarize the reified idea of the revolution – as inherently a falsification of it as a straightforward plagiarization – than the actual one, which belongs to history. Neither Kiefer nor Baselitz look back to early twentieth century German expressionism, but to the idea of it. Their art is an emblem of its negativity and irrationality, not of its substance. (Their kind of conceptual art is no doubt more appropriate for the end of a century than for the hopeful beginning of a new one. In general, the conceptual attitude in art, as it might be called, signals the end of the avant-garde revolution, for it stylizes and systematizes the very idea of artistic revolution. That is, it administers the revolution commissar – Stalinist – style, keeping its intentions pure if simplifying them in the process.) As such, it is more socially accommodating and ingratiating – and indeed more socially successful – than the original German expressionism was. Similarly, Halley turns geomorphic abstraction into an emblem of rational innovation, stripping it of its power to effect unconscious transformation.

Every emblem is a form of unrequited desire for what it reifies, but the point here is that the pseudo-revolutionary emblem puts a good social face on the revolution. It is a tactful presentation of it so that it is socially acceptable, at least in appearance. If, as Erving Goffman writes, "maintenance of face is a condition of [social] interaction, not its objective,"[23] then pseudo-avant-garde art, however well-intentioned humanly and as innovation, is a hypocritical effort to save the face of avant-garde art by turning it into a theatrical emblem – a kind of death mask of itself – that makes it less offensively direct. This also saves the face of the society interacting with it, which finds it easier to deal with manufactured rather than spontaneous revolt. Pseudo-avant-garde art allows the avant-garde to maintain its revolutionary "line"[24] while denying its revolutionary intention, that is, its

offensive disruptive power. Avant-garde shamelessness is neutralized by pseudo-avant-garde heartlessness.[25]

What results is a kind of truce in which pseudo-avant-garde art mediates avant-garde art with a society that does not want to take it seriously. Pseudo-avant-garde art performs the face work that reconciles avant-garde art and society, allowing each to maintain its face. That is, the pseudo-avant-garde artist defends the original avant-garde artist in effect by pleading, through his own "good-looking" art – the result of a kind of plastic surgery on avant-garde art – that the avant-garde artist's offense was "unintended and unwitting," that he "acted innocently," or that it was "incidental . . . an unplanned by-product" of his activity.[26] Society must never be allowed to believe that the avant-garde artist intended to cause "open insult" – that he "acted maliciously and spitefully."[27] This reestablishes "ritual equilibrium" between avant-garde art and society.[28] Indeed, pseudo-avant-garde art is a kind of ritualized version of avant-garde art, which is usually not well-equilibrated, that is, whose inner conflicts are not resolved into unity but left negatively dialectical. Pseudo-avant-garde art hypermodernizes it into the false consciousness of a unity.

Thus pseudo-avant-garde art gets society to accept avant-garde art's line without really taking it seriously. This diminishment of the seriousness with which avant-garde art, and by implication art in general, should be taken by society, is perhaps pseudo-avant-garde art's most important accomplishment. It goes hand in hand with the lack of seriousness with which the pseudo-avant-garde artist is taken by reason of his pursuit of fame and fortune – thereby compromising his creativity and above all its human relevance, in Gedo's sense – before all else. The pseudo-avant-garde artist gets society to have a " 'working' acceptance" of avant-garde art – the final seal of approval on it – "not a 'real' one," that is, not a "heart-felt" one.[29] It is given "lip service," but not really felt, which suggests its underlying unimportance to society.[30] In a sense, the "strong feelings" expressed by avant-garde art disrupted society's "expressive mask." Pseudo-avant-garde art suggests that they were really not as strong as they seemed when avant-garde art was first made.[31]

The denial of the subjectivity implicit in avant-garde art is a particularly important accomplishment of pseudo-avant-garde art, in line with the general denial of subjectivity in modern society.[32] In a sense, avant-garde art's original offensiveness and aggressivity had to do with its assertion of subjectivity, reminding the audience of its own subjectivity. Avant-garde art's display of heart, as it were, makes it obscene and dangerous.[33] This is its real breach of conduct and etiquette. Goffman points out that "emotions function as moves, and fit so precisely into the logic of the ritual game [of social interaction] that it would seem difficult to understand it without them. In fact, spontaneously expressed feelings are likely to fit into the formal pattern of the ritual interchange more elegantly than consciously designed ones."[34]

But the emotion implicit in true avant-garde art was disruptive of social ritual rather than supportive of it, because it was of the origin; that is, it was primordial in intention. Emotion that is an ordinary part of social in-

terchange – of the conventional expressive mask – must be distinguished from emotion that ruptures its surface and interrupts its flow, however temporarily. Causing a "psychotic break" in the expressive mask of society makes it lose its self-certainty and begins a process of social transformation which may or may not work itself out. The effect of the expressive rupture will certainly not be lost on the larger social process. Still, it can have profound liberating effect on the individual. It will at least remind him of the possibility of another kind of emotion and expressivity, of the existence within him of another self than the one society tells him he has.

It is avant-garde art's power to alter the ego, and through that, society – its function as an expressive alter ego for both the individual and society – that pseudo-avant-garde art destroys through the "technical correction" that gives face to avant-garde art. It is this defeat of avant-garde art's radical expressivity, severing its subjective from its objective reality and thus clarifying it, that is pseudo-avant-garde art's most socially constructive achievement, however injurious it is to the individual. But the repressive desublimation of avant-garde art gives it a social savoir faire that makes it expressively attractive to an audience of one-dimensional individuals, ready to alter their self-expression for fame and fortune. The pseudo-avant-garde completes the cultification of the avant-garde by making it completely like its audience. Only comic appropriation still allows avant-garde art the credibility of irreconcilability with its inexpressive audience, and thus can have some healing effect on it, can afford it comic relief from its tragic pragmatism.[35]

NOTES

1. Avant-Garde and Neo-Avant-Garde

1. Donald Allen, ed., *The Collected Poems of Frank O'Hara* (New York, Knopf, 1971), p. 48.
2. James Boswell, *The Life of Samuel Johnson* in *The Portable Johnson and Boswell* (New York, Viking, 1947), p. 115.
3. Max Frisch, *Sketchbook, 1946–1949* (New York, Harcourt Brace Jovanovich, 1983), p. 258.
4. Peter Bürger, *Theory of the Avant-Garde* (Minneapolis, University of Minnesota Press, 1984), pp. 57–8, writes that "today, the avant-garde is already historical. . . . the neo-avant-garde institutionalizes the *avant-garde as art*," announcing the "failure of the avant-gardiste attempt to reintroduce art into the praxis of life" (p. 57). "The antithesis between art and praxis of life" remains (pp. 93–4).
5. Friedrich Nietzsche, *The Will to Power* (New York, Random House, 1968), p. 423. "The *herd man*," Nietzsche writes, "will experience the value feeling of the beautiful in the presence of different things than will the *exceptional* or over-man." One might say that the avant-garde artist – the self-proclaimed exceptional artist – attempts to teach his audience of bourgeois herdmen to experience the beauty of the very different kind of art things he makes, and thus emotionally benefit from their presence.
6. The artist is, to use an idea of Karl R. Popper, *The Open Society and Its Enemies* (Princeton, N.J., Princeton University Press, 1950), p. 459, "a Great Man, a Hero wrestling with fate," a leading actor on the "Stage of History." Popper's remarks are worth quoting at length (pp. 458–60):

> And, indeed, our intellectual as well as our ethical education is corrupt. It is preserved by the admiration of brilliance, of the way things are said, which takes the place of a critical appreciation of the things that are said (and the things that are done). It is perverted by the romantic idea of the splendor of the Stage of History on which we are the actors. We are educated to act with an eye to the gallery.
> The whole problem of educating man to a sane appreciation of his own importance relative to that of other individuals is thoroughly muddled by these ethics of fame and fate, by a morality which perpetuates an educational system that is still based upon the classics with their romantic view of the history of power and their romantic tribal morality . . . a

system whose ultimate basis is the worship of power. Instead of a sober combination of individualism and altruism . . . – that is to say, instead of a position like "What really matters are human individuals, but I do not take this to mean that it is I who matters very much" – a romantic combination of egoism and collectivism is taken for granted. That is to say, the importance of the self, of its emotional life and its "self-expression," is romantically exaggerated; and with it, the tension between the "personality" and the group, the collective. . . . "Dominate or submit" is, by implication, the device of this attitude; either be a Great Man, a Hero wrestling with fate and earning fame ("the greater the fall, the greater the fame," says Heraclitus), or belong to "the masses" and submit yourself to leadership and sacrifice yourself to the higher cause of your collective. There is a neurotic, a hysterical element in this exaggerated stress on the importance of the tension between the self and the collective, and I do not doubt that this hysteria, this reaction to the strain of civilization, is the secret of the strong emotional appeal of the ethics of hero-worship, of the ethics of domination and submission.

. . . We shall make sacrifices, it is said, but we shall thereby obtain honor and fame. We shall become "leading actors," heroes on the Stage of History; for a small risk we shall gain great rewards. This is the dubious morality of a period in which only a tiny minority counted, and in which nobody cared for the common people. It is the morality of those who, being political or intellectual aristocrats, have a chance of going into the textbooks of history. It cannot possibly be the morality of those who favor justice and equalitarianism; for historical fame cannot be just, and it can be attained only by a very few. The countless number of men who are just as worthy, or worthier, will always be forgotten.

7. Enrico Baj, "The Transparence of Kitsch," *The Garden of Delights* (Rome, Fabbri, 1991), p. 26.
8. Alfred North Whitehead, "Symbolism, Its Meaning and Effect," *An Anthology* (New York, Macmillan, 1953), pp. 533–4.
9. Ibid., pp. 534–5.
10. Ibid., p. 535.
11. Ibid.
12. Ibid., p. 556. As Whitehead writes, sense presentation is not "aboriginal . . . later to be sophisticated by the inference to causal efficacy. The contrary is the case. First the causal side of experience is dominating, then the sense-presentation gains in subtlety." The artist is the representative of this shift in and intensification of sensibility.
13. Leo Bersani, *The Freudian Body, Psychoanalysis and Art* (New York, Columbia University Press, 1986), p. 26.
14. Susan Sontag, "Against Interpretation," *Against Interpretation* (Englewood Cliffs, N.J., Prentice-Hall, 1967), p. 13.
15. Erich Fromm, *Escape from Freedom* (New York, Avon 1965), p. 285.
16. Ibid., p. 284.
17. Ibid., pp. 284–5.
18. According to T. S. Eliot, "The Metaphysical Poets," *Selected Essays, 1917–1932* (New York, Harcourt, Brace, 1932), p. 247, "in the seventeenth century a dissociation of sensibility set in, from which we have never recovered." Sensibility split into "sentimental" and "ratiocinative" parts (p. 248). Feeling lost precision because of its separation from intellect – "every precise feeling tends towards intellectual formulation," Eliot thought ("Shakespeare," p. 115) – and the more intellectually refined we became the "more crude" the feeling associated with our intellectual formulations became.
19. Fromm, *Escape*, p. 285.
20. D. W. Winnicott, "Ego Distortion in Terms of True and False Self," *The Maturational Processes and the Facilitating Environment* (New York, International Universities Press, 1965), p. 148.
21. Ibid., pp. 142–3.

22. Ibid., p. 146.
23. Ibid., p. 147.
24. Ibid., p. 150. Winnicott, for whom "health . . . is closely bound up with the capacity of the individual to live in an area that is intermediate between the dream and the reality, that which is called the cultural life," an area that requires "a capacity for the use of symbols," seems to implicitly privilege the artist as necessarily healthy. But while there is no "poverty of cultural living" for him, and while his "capacity for using symbols" can hardly be regarded as "poor" – Jerzy Kosinski described art as "the using of symbols by which an otherwise unstable subjective reality is made manifest" – it is hardly the case that the false "compliant aspect of the self" and its true "creative and spontaneous" side are necessarily more integrated or less split in the artist than in anyone else. He too may "collect impingements from external reality" and fill his art with "reactions to those impingements," which, indeed, is one way of understanding avant-garde art, especially in view of its "extreme restlessness."
25. Ibid., p. 148.
26. Hermann Broch, "Hofmannsthal und seine Zeit. Eine Studie," *Dichten und Erkennen, Essays* (Zurich, Rhein, 1955), vol. 1, p. 61. Analyzing "Sprachmystik," Broch writes: "Wo von Ur-Assoziationen, Ur-Vokabeln, Ur-Symbolen gesprochen wird, wo das Irrationale am Werke ist, da scheint der Mythos nicht ferne zu sein, und in der Tat, tief im Unbewussten aller Kunst, aller grossen Kunst ruht der Wunsch nochmals Mythos werden zu durfen, nochmals die Totalität des Universums darzustellen" (p. 60). One should also note in this context "the mystic's withdrawal into a personal inner world of sophisticated introjects," his "retreat to a position in which he can communicate secretly with subjective objects and phenomena, the loss of contact with the world of shared reality being counterbalanced by a gain in terms of feeling real." Winnicott links this to the "inherent dilemma" of "the artist of all kinds," namely, "the co-existence of two trends, the urgent need to communicate and the still more urgent need not to be found." Winnicott, "Communicating and Not Communicating Leading to a Study of Certain Opposites," *Maturational Processes*, pp. 185–6. In a sense, mysticism of the medium solves the dilemma. The artist's withdrawal to it invests it with inwardness so that it becomes emblematic of the secret meditative world in which he can communicate with his introjects, which is what makes the medium seem the most real part of his art to him. At the same time, it becomes the transitional or potential space of culture, as Winnicott calls it, in which the artist's introjects are objectified in the expressively urgent symbolic form which communicates them to others. The artist hides in the medium, but hints at where he is hiding.

 Jan Mukarovsky distinguishes between the "artistic sign" and the "communicative sign," remarking that where the latter "pertains to *things*," the former pertains "to a certain *attitude* toward *things*, a certain attitude on the part of man toward the *entire* reality that surrounds him. . . . The work does not, however, communicate this attitude – hence the intrinsic artistic 'content' of the work is also inexpressible in words – but *evokes* it directly in the perceiver." Mukarovsky thinks "the visual arts are the most effective of all in performing this basic task of art in general." Jan Mukarovsky, "The Essence of the Visual Arts," *Semiotics of Art: Prague School Contributions*, eds. L. Matejka and I. R. Titunik (Cambridge, Mass., MIT Press, 1976), pp. 237, 244. The medium, with its particular subjective qualities, is the inexpressible artistic content of the work – its mystical core – while the attitude implicit in it becomes explicit in the perceiver's psyche. It spontaneously positions him in his secret world, making him feel more real than he does in the everyday world with which he must

comply. His introjects are evoked by those of the artist, giving him a sense of inward communion – mystical intimacy – with the work of art, which makes it seem extraordinarily real. As W. Somerset Maugham, *The Summing Up* (New York, New American Library, 1946), p. 187, writes, "The value of art, like the value of the Mystic Way, lies in its effects."

27. As Jerome D. Oremland, *Michelangelo's Sistine Ceiling: A Psychoanalytic Study of Creativity* (Madison, Conn., International Universities Press, 1989), pp. 21–2, writes, the artist relates to his medium as to the object of a drive. It becomes emblematic of the internal object representation – not unlike Winnicott's introject, if ambivalently frustrating and satisfying – which the artist relates to "for self-validation, self-verification, and self-transcendence." Thus the artist's relationship to his medium comes to seem the truly valid, transcendent aspect of his art.

28. As Winnicott writes in "The Location of Cultural Experience," *International Journal of Psychoanalysis*, 48 (1967):371, "maximally intense experiences [occur] *in the potential space between the subjective object and the object objectively perceived*, between me-extensions and the not-me. This potential space is at the interplay between there being nothing but me and there being objects and phenomena outside omnipotent control." This is the space of play, which is "neither a matter of inner psychic reality nor a matter of external reality" (p. 368). In "Playing and Culture," *Psychoanalytic Explorations* (Cambridge, Mass., Harvard University Press, 1989), pp. 205–6, Winnicott writes that "play is always exciting . . . *not* because of the background of instinct, but because of the precariousness that is inherent in it, since it always deals with the knife-edge between the subjective and that which is objectively perceived." The potential space of play is transitional between them. Neither is abandoned in the playfulness of this "intermediate area which has to do with living experience and which is neither dream nor object-relating," which is a paradox "we need to *accept*" (p. 204). Indeed, its playfulness consists in and its vitality follows from its paradoxicality and intermediate, "unclear" character.

29. André Breton, "Artistic Genesis and Perspective of Surrealism," *Surrealism and Painting* (New York, Harper & Row, 1972), p. 74, describes "the lesson taught by . . . Leonardo da Vinci that one should allow one's attention to become absorbed in the contemplation of streaks of dried spittle or the surface of an old wall until the eye is able to distinguish an *alternative* world." "Leonardo's paranoiac ancient wall," as Breton calls it in the course of a discussion of Oscar Dominguez's decalomania, which Breton regards as "this wall *perfected*" (p. 129), invited one to find meaningful, coherent hallucinations in incoherent, meaningless marks. To do so was to perform a miracle of emotional and cognitive rejuvenation: one's imagination breathed new experiential life into old visual bones. Fascination with Leonardo's wall pervades modernism, as part of its belief in the madness of art. To find emotionally resonant form in seemingly formless surface is the most "mad" act of art. It is inseparable from modernism's effort to restore the child's "pure" vision of the world, or at least to suggest it. Indeed, the paranoid moment when significant form is "recognized" in the insignificant surface of the wall is essentially that of an infant's "transitional" relationship to an object. Winnicott, "Communicating and Not Communicating Leading to a Study of Certain Opposites," pp. 180–1, states that "the infant experiencing omnipotence under the aegis of the facilitating environment *creates and re-creates the object*. . . . Yet the object must be found in order to be created." The infant has no problem with this paradox, as little as the modern artist does. The wall, incidentally, functions as a facilitating environment, but also symbolizes the infant's omnipotence. Several of Picasso's

sculptures are supposedly inspired by "strange faces, created from two or three hollows in the wall, but so evocative, so expressive." Dore Ashton, ed., *Picasso on Art: A Selection of Views* (New York, Viking, Documents of 20th-Century Art, 1972), p. 16.

30. Freud introduced the idea of primary or original narcissism, in which individuals take "as a model" for "their later choice of love-objects . . . not their mother but their own selves," in "On Narcissism: An Introduction" (1914), *Standard Edition* (London, Hogarth Press and the Institute of Psycho-Analysis, 1957), p. 73. "The narcissism which arises through the drawing in of object-cathexes [is] a secondary one, superimposed upon a primary narcissism that is obscured" (p. 75). This distinction has been much debated, some analysts going so far as to deny that primary narcissism exists. Heinz Henseler, "Narcissism as a Form of Relationship," *Freud's "On Narcissism": An Introduction* (New Haven, Conn., Yale University Press, 1991), pp. 209–10, speaks of "the myth of primary narcissism," arguing that while "there is no doubt that primary narcissistic experience exists . . . the term 'primary' can be applied to the earliest form of narcissistic experience [and] need not denote the earliest form of relation in time [as] Freud thought in 1914." "Paradise . . . was only later constructed, composed out of memory traces of a psychophysiological state, satisfying experiences with objects, and wishful fantasies of happiness and harmony – which can be understood as reaction formations to frustrating reality. Hence, primary narcissism and the narcissistic constellations that later develop from it are a wonderful human achievement, a subsequent invention, offering us withdrawal from harsh reality into an 'intermediate area' (Winnicott) in which reality and fantasy can still blend in an agreeable way. Primary narcissism would then be a myth, in the best sense of the word: although never having taken place historically, it yet tells us something true." The myth has its perverse, infantile uses, as Béla Grunberger, *Narcissism: Psychoanalytic Essays* (Madison, Conn., International Universities Press, 1990), p. 52, remarks in his discussion of the "pseudo relation of the narcissist" to others. "Certain famous narcissists (artists, politicians, etc.) . . . very readily form a relation with no matter whom, without the least affinity for the person in question, provided that that person affords them an opportunity for narcissistic gratification, which they constantly need. Such bonds are superficial in nature, however; there is no object relation. The narcissist does not love, he lets himself be loved." This undoubtedly describes the relationship of many artists to their audience.

31. See my "Freudian Note on Abstract Art," *Journal of Aesthetics and Art Criticism,* 47 (Spring 1989):117–28, for this argument.

32. See my *The Dialectic of Decadence* (New York, Stux, 1992).

33. Gilles Deleuze, "Active and Reactive," *The New Nietzsche,* ed. David B. Allison (Cambridge, Mass., MIT Press, 1985), p. 102.

34. Ibid., pp. 102–3.

35. Nietzsche, *Will to Power,* p. 40.

36. Ibid., p. 419.

37. Ibid., p. 421.

38. Ibid., p. 422.

39. Ibid., p. 423.

40. Ibid., p. 420.

41. Ibid.

42. Ibid., p. 422.

43. Ibid., p. 421.

44. Ibid.

45. Ibid., p. 428.
46. Ibid., p. 422.
47. Ibid., p. 434.
48. Ibid., p. 444.
49. Ibid., p. 429.
50. Ibid., p. 434.
51. See Philip Rieff, *The Triumph of the Therapeutic: The Uses of Faith after Freud* (New York, Harper & Row, 1968). "Cultures," Rieff writes (p. 233), "achieve their measure of duration in the degree that they build releasing devices into the major controls. These are the devices that modern psychotherapy seeks to develop; it is this development which gives to psychotherapy its present importance in the history of culture." Avant-garde art, to the extent it claims to be therapeutic, is one of these releasing devices. Indeed, it resurrects art, which had become too traditional – too much a part of the social apparatus of major control – as a releasing device. This is why avant-garde art has met with such an ambivalent response. Society wants to bring it under control by institutionalizing it, but to do so is to undermine its purpose as a releasing device – "free self-expression" – which society subliminally knows it needs. It is the fierceness – aggressivity verging on violent hostility – of the avant-garde response to modern society that terrifies it, because it reminds modern society that it has been perhaps too controlling or overcontrolled. But then avant-garde art represents complete lack of control, which means the destruction of society.

Jacques Ellul, *The Technological Society* (New York, Random House, 1964), p. 415, deals with the same issue in a not dissimilar way. "It is often objected," he writes, "that skeptics fail to understand the nature of technological society because they are unwilling or unable to accept the extraordinary power of spiritual resistance to technical invasion of which human beings are capable. Everywhere, it is said, human liberty affirms itself in a world that the skeptics have declared closed to it. In proof of this, literary and musical forms are invoked like magical incantations. Abstract painting, surrealism, jazz . . . are said to be manifestations of the supremacy of human freedom and will in the technical society. . . . It is true that man has psychic power, the strength of which is not yet known. Man is capable of outbursts of passion and violence. It does not seem that those sources of vital energy which might be summarized as sexuality, spirituality, and capacity for feeling have been impaired. But every time these forces attempt to assert themselves, they are flung against a ring of iron with which technique surrounds and localizes them." In other words, technique, which represents control, institutionalizes avant-garde art, in effect devitalizing it and destroying its spiritual magic. The release it promises is contained by the institution of art. It becomes a timed release, as it were. That is, the freedom of feeling it embodies is slowly released over the infinite duration called immortality, which makes it a somewhat emasculated freedom.

For Ellul, "jazz is one of today's most authentically human protests" (p. 416). But Theodor W. Adorno, "Sociology of Art and Music," *Aspects of Sociology by the Frankfurt Institute for Social Research* (Boston, Beacon, 1972), p. 113, reminds us of the futility of jazz and the irony of its social assimilation. "Now the formula of jazz is this, that precisely by virtue of his weakness and helplessness this subject represented by irregular rhythms adapts himself to the regularity of the total process, and because he, so to speak, confesses his own impotence, he is accepted into the collective and rewarded by it. Jazz projects the schema of identification: in return for the individual erasing himself and acknowledging his own nullity, he can vicariously take part in the power and the glory of the collective to which he is bound by this spell. . . . While to the

naive consciousness jazz, now long standardized, occasionally seems anarchic, the expression of uninhibited erotic impulses, it permits these impulses only in order to cut them off and to reassert the system," that is, the inhibition of control. The case of the jazz release is in fact emblematic of all "uninhibited" avant-garde art and of its post-avant-garde conversion into one among many standard models of art. It may be that the increasing narcissism of art – perverting art for art's sake into the ironic cannibalistic appropriation of avant-garde art by neo-avant-garde art – is its way of denying the futility of this situation. Falling back on itself, in imaginary omnipotence and grandeur, it masters its depression at being socially controlled, and thus its inability to function as a durable release from society. At the same time, it should be noted that Rieff, *Triumph* (p. 236), describes "the therapeutic [as] a man of leisure, released by technology from the regimental discipline of work so as to secure his sense of well-being in highly refined alloplastic ways." Avant-garde art, conceived as a process of perpetual therapy – each mode of avant-garde art is a different therapeutic means – is one of these.

Clement Greenberg, "The Plight of Culture," *Art and Culture* (Boston, Beacon, 1965), p. 33, asks whether, "with work becoming universal once more, may it not become necessary . . . to repair the estrangement between work and culture, or rather between interested and disinterested ends, that began when work first became less than universal?" In fact, the modern individual necessarily engages in interminable therapeutic work – including the healing "work" of art – to survive in all-controlling, ever more efficient technological society. It is such work, filling both his ordinary work time and his leisure time, that effects the reconciliation between interest and disinterest, that is, between society's interests and the self existing for its own disinterested sake and well-being. Therapy becomes a way of life – a whole life-style, indeed, the consummate, fashionable style of modern and postmodern life.

52. Ibid., p. 422.
53. Max Scheler, *Ressentiment* (New York, Free Press, 1961), p. 45. Scheler describes *ressentiment* as "a self-poisoning of the mind . . . a lasting mental attitude, caused by the systematic repression of certain emotions and affects which, as such, are normal components of human nature. Their repression leads to the constant tendency to indulge in certain kinds of value delusions and corresponding value judgments. The emotions and affects primarily concerned are revenge, hatred, malice, envy, the impulse to detract, and spite." Indeed, the "thirst for revenge is the most important source of *ressentiment* . . . revenge tends to be transformed into *ressentiment* the more it is directed against lasting situations which are felt to be 'injurious' but beyond one's control – in other words, the more the injury is experienced as a destiny. This will be most pronounced when a person or group feels that the very fact and quality of its *existence* is a matter which calls for revenge . . . Through its very origin, ressentiment is therefore chiefly confined to those who *serve* and are *dominated* at the moment, who fruitlessly resent the sting of authority." The postmodernist artist is motivated by *ressentiment* against the avant-garde artist, to whom he defiantly submits. Nietzsche, who first formulated the idea of *ressentiment*, argued that it perversely inverts life values, making a virtue of its own "impotence" and "inability to retaliate." Postmodernism is ironic obedience to avant-garde art, in the sense that "submission to those whom one hates is 'obedience' (obedience toward one of whom they say that he decrees this submission, – they call him God)." Profoundly ambivalent to avant-garde art because of the success of its revolution, postmodernism contemptuously deifies it as an inescapable destiny injurious to the existence of art as such and yet of its essence.

Behind postmodernism's irony and contempt is profound depression at the inability to alter the history of art as completely as avant-garde art did.

54. Friedrich Schlegel, "Ideas," *German Aesthetic and Literary Criticism: The Romantic Ironists and Goethe,* ed. Kathleen Wheeler (Cambridge University Press, 1984), p. 59.

55. Alfred North Whitehead, *Adventures of Ideas* (New York, New American Library, 1955), pp. 458–60.

56. Steven Naifeh and Gregory White Smith, *Jackson Pollock: An American Saga* (New York, Potter, 1989), p. 701.

57. Albert J. Lubin, *Stranger on the Earth: A Psychological Biography of Vincent van Gogh* (New York, Holt, 1987), pp. 12–13, writes that "although Vincent gave up church religion in favor of art, ideas of rebirth and religion continued to fill his mind. . . . Vincent viewed his emergence as an artist as a rebirth. . . . Painting itself was a magical means of inducing this rebirth; defining art as 'recreation' rather than imitation, he thought it would give him a 'second youth.' But even if this did not happen, 'even though my own youth is one of the things I have lost,' there would be 'youth and freshness' in his pictures." "Vincent compared himself to the lowly caterpillar that is miraculously reborn as a butterfly, a common symbol of Christ's Resurrection" (p. 18). " 'There is only a constantly being born again,' Vincent said . . . 'a constantly going from darkness into light' " (pp. 18–19). The recurrent use of various metaphors of transformative rebirth in Van Gogh's conception of art indicates his general belief in its therapeutic efficacy, as well as his personally desperate attempt to heal himself through its practice. For him, the "hard work" of art was the last therapeutic resort – the only thing that stood between him and " 'that melancholic staring into the abyss' " of madness (p. 22), and no doubt his fear of falling into it.

As indicated by Mondrian's statements in "From the Natural to the Abstract: From the Indeterminate to the Determinate," *De Stijl,* Hans L. C. Jaffe (New York, Abrams, 1967), he also believed in and felt the need for the healing power of art. It showed the way to overcome "the tragic [that] exists both in inward and in outward life" (p. 76), the tragic that is the result of the "duality" or conflict of opposites (p. 77). The "exact" equilibration of their relationship in the plastic terms of art was the model of therapeutic integration for him (p. 77). "If the tragic can be destroyed only through (final) unification, this is far less possible in outward than in abstract life. Art can realize the union of opposites abstractly: that is why art precedes real life" (p. 75).

58. Discussing Sherrie Levine's copies of modernist works, Rosalind E. Krauss, *The Originality of the Avant-Garde and Other Modernist Myths* (Cambridge, Mass., MIT Press, 1985), p. 170, writes that "insofar as Levine's work explicitly deconstructs the modernist notion of origin, her effort cannot be seen as an *extension* of modernism. It is, like the discourse of the copy, postmodernist. Which means that it cannot be seen as avant-garde either. . . . In deconstructing the sister notions of origin and originality, postmodernism establishes a schism between itself and the conceptual domain of the avant-garde, looking back at it from across a gulf that in turn establishes a historical divide." Origin and originality – epitomized by primordiality – may be a "fictitious condition . . . splintering into endless replication" as Krauss says, but, as Henseler writes about "the myth of primary narcissism," the myth of originality "yet tells us something true" (note 31). What is original is not what is first, but what is inevitable. Thus the copy – a "secondary mimesis," to use Barthes's term (p. 168) – is not unlike secondary narcissism. It is evidence for an originality – "primary mimesis" – it does not understand. Indeed, the copy does not so

much deconstruct the original, as attempt to strip originality of meaning, but in doing so unwittingly discloses its necessity. Thus to copy an original is to attempt to invalidate it by turning it into history – the already happened. Copying reads the primary away into the secondary by reifying it as peculiarly foreknown, if incidentally incremental. It socializes the original, showing that its difference is less than meets the eye. But in replicating an original, copying implies its irreducibility, and as such functions as an ironic means of making its logic self-evident.

59. The postmodern breakdown of the distinction between authenticity and inauthenticity signifies the self-defeat of the avant-garde. Daniel Bell, *The Cultural Contradictions of Capitalism* (New York, Basic, 1978), writes that "the life style that became the imago of the free self was . . . that of the [avant-garde] artist defying the conventions of society . . . [but] it is the artist who begins to dominate the audience, and to impose his judgment as to what is to be desired and bought" (p. xxiv). "The paradox is completed when . . . Modernism as an attack on orthodoxy, has triumphed and become the regnant orthodoxy of the day." When the avant-garde "adversary stance" of revolt (p. xxii) becomes paradigmatic and universal – when it is adopted by the audience it attacks – it becomes patently absurd. It becomes a hollow gesture of style, as do the products that justify and speak for it: "the new and experimental" that signifies "the self (in its quest for originality and uniqueness)."

It is worth noting that many postmodern artists are aware of the breakdown of the ability to distinguish between the authentic and inauthentic, and play upon the apparent similarity between the two while privileging themselves as authentic in the now traditional avant-garde way. Thus Sigmar Polke chose as a catalogue essay for a gallery exhibition Friedrich Dürrenmatt's short story "The Death of Socrates, or The Wise Man Knows Nothing." The story deals with "the fate of the wise man, or truth-sayer, in a hostile environment, and the demand for equivocation from one whose profession is defined by authentic discourse. A parable for the situation of the contemporary artist, who often finds himself trapped in a conflict between the imperative of intellectual honesty and the demands of the market, Dürrenmatt's caustic fable . . . illuminates the role of the 'truth-sayer' in a materialistic, mediatized society, where real and fake are often confused." *Journal of Art*, 4 (Dec. 1991):56.

In a sense, copying is an instrument of orthodoxy. Adversarial art, copied, acquires the patina of legitimacy. Its oppositional character seems compromised. Are the copyists unconsciously in the service of the establishment? They seem to reify avant-garde art in order to keep its adversarial stance from having any psychosocially revolutionary effect. This in effect makes it another aesthetic placebo in the praxis of life. Thus the copyist is not just ironically conservative, but reactionary. He stops the avant-garde process in its tracks by reducing it to a series of staccato episodes. He dismembers the process, in effect denying that it is the consistent development of a revolutionary intention, however erratic its material results. Even more insidiously, the copyist falsifies art that attempts to intervene in and thus become part of the life process into a stage in the history of style – into part of establishment art history. This completely castrates its challenge. The copyist turns avant-garde art into another rear-guard action in defense of the glory and vanity of art. Thus, idolized by being copied, avant-garde art becomes indifferent – it makes no difference: it loses the possibility of having transmutative effect on the lifeworld – to its audience.

60. Max Horkheimer, *Critique of Instrumental Reason* (New York, Seabury, 1974), p. 99, writes that "the development of art has been anticipating that of

mankind itself; in expressing the truth, that is, the dissolution of the ego, the soul, and all that used to be thought eternal, it leads to its own negation." "An immanent law has brought painting from the critical phase associated with the names of Kandinsky, Max Ernst, and the early Picasso . . . into pure wall decoration and is accepted as such, at least by the wealthy who buy it. The dimension of the absolute is disappearing from an art that thinks of itself as wholly free. . . . Abstract pictures are now simply one element in a purposive arrangement. . . . Works of art . . . buy their future at the expense of their meaning."

61. In both Lacan and Derrida, pretentious, pseudo-avant-garde wordplay becomes the preferred mode of communication. Their writing is "literature on the borderline," to use a phrase of Didier Anzieu, "Beckett and Bion," *International Review of Psychoanalysis*, 16 (1989):167. It is an "assault on verbal thought," in which "the very idea of a plan . . . or of any temporal progression is systematically destroyed." They use a kind of schizophrenic language, in which "the links established by verbal thought" are attacked (p. 166). Can one say that suffocated by language, they attempt to destroy it as a container (p. 167)?

Walter Redfern, *Puns* (Oxford, Basil Blackwell, 1986), p. 80, notes that "punning becomes manic" in Lacan, suggesting the disintegrative tendency of his language. Redfern is "not convinced by Lacan's attempts" to articulate "ambiguity, double meaning, repressed meaning, slips" by means of puns. Bertrand Poirot-Delpech remarks that Lacan's "text twitches with semio-tics" (quoted, p. 81), as does Derrida's.

What Réda Besmaia, *The Barthes Effect: The Essay as Reflective Text* (Minneapolis, University of Minnesota Press, 1987), p. 87, says about Barthes's use of language is also true of Lacan's and Derrida's. "The avowed goal of [their] approach is above all to prevent 'a meaning from taking hold,' to keep 'system' from prevailing," which is understood as "the text's closing in upon itself or degenerating into 'dissertation,' 'boredom,' or *pensum*." "Opposition – whatever form it may assume: antithesis, *Adhomination,* contradiction, and so on – is no more than an 'occasion for writing': what is sought in amphibology is not polysemy, but duplicity. . . . When an opposition appears, it is not taken at face value: what one aims at through it is the plurality it implies and not the conflict." What is desired is "not simple polysemy (the 'multiple of meaning'), but meaning as 'duplicity,' word as *gesture*, image as phantasm, 'figure' as *schema,* 'the body's gesture caught in action,' or 'operatic aria' " (p. 39). Thus semiotics has become a strategy for stimulating – simulating? – free intellectual association (intellectualizing free association?), perversely undermining psychoanalysis by reducing it to a textual matter. Indeed, semiotic playfulness misconceives the psychoanalytic process. Intellectual associations are generated by and defend against emotional conflict. To privilege the plurality of signifiers and codes that come into pseudo-play in pseudo-free intellectual association, and to use them to obscure and deny conflict and oppositionality can be understood as an attempt to render unconscious emotional reality meaningless, even to deny that it is real. The French pseudo-avant-garde thinkers have in effect turned the psychoanalytic process on its head, perhaps deliberately falsifying – certainly distorting – it for the sake of intellectual spectacle, entertainment, and rhapsody: they regard its phenomenological surface – the disclosures of free association, in which subject and object, body and language, merge in the compromises of fantasy – as its dynamic substance. But conflict, enacted in the dialectic of transference to language (a secondary object?), is its real substance; the linguistic symptoms of transferential free association disclose and enact the tension of the conflict, indicating that free association is never free. Uninterpreted, these intellectual symptoms seem more inflated and mysterious than they really are.

The refusal of Barthes, Lacan, and Derrida to interpret their own intellectual associations may be a calculated attempt to make them look more intellectually avant-garde than they are, as well as to avoid acknowledging the conflicts that motivate them.

In general, one cannot help thinking of this narcissistic, elated use and quasi-infinite playfulness of language – this grandiose effort to find primitive gratification in it – as simulated regression to an undifferentiated state in which the writer is not only "safe from any contact with reality" (Grunberger, *Narcissism*, p. 11) but has the " 'physiological' delusion" that he is "in perfect equilibrium with himself" and as such is free of conflict, indeed, forever immune to inner conflict, especially the fundamental conflict between sexual and aggressive drives, or Eros and Thanatos (p. 16), as well as the conflict between external and internal reality. That is, behind their apparent intellectual disinterestedness is narcissistic self-satisfaction. However, it is disturbed, even contradicted and undermined, by their duplicity. Not only does duplicity convey the writer's ambivalence, that is, his conflicted attitude about his reader – the writer's child, as it were, and a childish writer by reason of being a reader – but it generally suggests the writer's deep conflicts.

62. I mean "value" in the sense Béla Grunberger does in *Narcissism: Psychoanalytic Essays* (p. 15). "The notion of value is crucial for understanding narcissism – not value that expresses an objective evaluation and can be calibrated, but exactly the opposite, value per se, intrinsic, without foundation and not linked to merit or quality, for the fetus knows nothing of such things." When, as Daniel Bell, *Cultural Contradictions* (p. xxiii), writes, there is "no longer some consensual agreement on standards," "the fetal sense of self-*value*," in Grunberger's words, has taken over society and reigns in all areas, in an ironic triumph of individualism. Avant-garde art can be understood as a steady attack on consensual agreement on artistic standards, until finally, in postmodernism, there is no longer any consensus possible, so that only narcissistic value – the artist's self-valuation – is convincing, which means that nothing is convincing, certainly not absolutely.

63. Oscar Wilde, "The Critic as Artist," *The Artist as Critic: Critical Writings of Oscar Wilde,* ed. Richard Ellmann (Chicago, University of Chicago Press, 1982), p. 380.

64. Joseph Sandler, *From Safety to Superego* (New York, Guilford, 1987), discusses the fundamental need to feel safe, noting that "perhaps the most convenient way of heightening safety feeling is through the modification and control of perception," whether "*within* the ego" or through "deliberate and purposive behavioral manipulation of the external world so that the sense organs are subjected to altered and different stimulation" (pp. 5–6). In a sense, art attempts to do both. It is, as it were, an explicit demonstration of the way perception can be used "in the service of the safety principle" (p. 8).

65. Heinz Kohut, *The Analysis of the Self* (New York, International Universities Press, 1971), pp. 63–4, speaks "of an undisturbed primary narcissistic equilibrium, a psychological state whose perfection precedes even the most rudimentary differentiation into the later categories of perfection (i.e., perfection in the realm of power, of knowledge, of beauty, and of morality)." The psychotherapeutic action of art consists in its power over our narcissism: its ability to evoke the narcissistically fundamental feelings of perfection and safety – the latter also "develops from an integral part of primary narcissistic experience" (Sandler, p. 4) – so as to restore a sense of self-containment (from which follows an extraordinary sense of well-being) which reality ordinarily deprives us of, indeed, seems to systematically deny and destroy.

66. Claude Lévi-Strauss, *The Way of the Masks* (Seattle, University of Washington Press, 1982), p. 144.
67. Ibid., p. 148.
68. Ibid., p. 277.
69. See Bell, *Cultural Contradictions*, p. xxvi.
70. Quoted by Kenneth Winetrout, "Toynbee's Mortuary for Civilizations," *The Boundaries of Civilization in Space and Time*, eds. Matthew Melko and Leighton R. Scott (New York, University Press of America, 1987), p. 270.
71. See my "Archaeologism: Postmodernism as Excavation," *The New Subjectivism: Art in the 1980s* (Ann Arbor, Mich., UMI Research Press, 1988), pp. 531–7, where I discuss the subliminally anguished historicism of postmodern art. In "Fin de Siècle Abstraction: The Ambiguous Re-Turn Inwards," *Tema Celeste*, No. 34 (Jan.–March 1992):53–55, in the context of a discussion of appropriation abstraction, I describe this archaeological tendency as recapitulative reification.
72. Mariani is a major example of a painter who has embraced the archaeological attitude in a sophisticated way, wittily justifying his appropriation of the neoclassical mode as a return to avant-garde origins. His classicizing representation of modernist works by famous avant-garde artists, so that the works seem transcendentally beautiful, confirming the artist's fame, shows the archaeologicizing intention at its most ironic. By being subsumed as attributes of the nude – often hermaphoditic, to suggest the healing reconciliation of opposites – that symbolize neoclassical beauty, they ironically acquire the patina of ideality – even perfection – associated with the tradition they rebelled against.
73. Roger L. Williams, *The Horror of Life* (Chicago, University of Chicago Press, 1980), p. xix. Erich Fromm's distinction between biophilia and necrophilia is worth noting in this context. Where Freud posited a duality of life and death instincts, Fromm posited a choice between them. For him, death was not the inevitable victor over life. Rather, as he writes in *The Heart of Man: Its Genius for Good and Evil* (New York, Harper & Row, 1964), p. 50, "the 'death instinct' is a *malignant* phenomenon that grows and takes over to the extent to which Eros does not unfold."
74. Ibid., p. 215.
75. Ibid., pp. x–xi.
76. Joseph Kosuth, "Art After Philosophy, I and II," *Idea Art*, ed. Gregory Battcock (New York, Dutton, 1973), p. 80, argues that the "change – one from 'appearance' to 'conception' – was the beginning of 'modern' art and the beginning of Conceptual Art." It was effected by Duchamp, who first raised the question of "the function of art" and who first gave "art its own identity." "All art (after Duchamp) is conceptual (in nature) because art only exists conceptually." "The 'value' of particular artists after Duchamp can be weighed according to how much they questioned the nature of art; which is another way of saying 'what they *added* to conception of art' or what wasn't there before they started. Artists question the nature of art by presenting new propositions as to art's nature" (pp. 80–1). If this is so, then Beuys, with his "totalized concept of art," extending the "question of [artistic] form" "to all forms in the world" – "social forms or legal forms or economic forms, or also agricultural problems or also to other formal and educational problems" – was the ultimate conceptual artist. For he "applied" art to all natural, personal, and social forms, or rather regarded them as inherently artistic. Art totalized becomes the immanent core of life, and "refer[s] principally to every man's possibilities to be a creative being and to the question of the social totality." Götz Adriani, Winfried Konnertz, Karin

Thomas, *Joseph Beuys: Life and Works* (Woodbury, N.Y., Barron's Educational Series, 1979), p. 283.

77. Lévi-Strauss, *Way of the Masks*, p. 277.
78. I am alluding to the second of the two epigraphs on cults that preface this book. Robert Jay Lifton, "Cults: Religious Totalism and Civil Liberties," *The Future of Immortality and Other Essays for a Nuclear Age* (New York, Basic, 1987), p. 216, writes that "the dispensing of existence, the absence of the right to exist, can be literalized; people can be put to death because of their alleged doctrinal shortcomings, as has happened in all too many places, including the Soviet Union and Nazi Germany." In a sense, neo-avant-garde art puts avant-garde art to death because of its doctrinal shortcoming, namely, its conviction that art can have a therapeutic effect. The neo-avant-garde artist is the taxidermist of avant-garde art. After he gets through skinning and stuffing it, it exists only as a semblance of itself. It has only simulated life, for it lacks the therapeutic intention that gave it inner being.

This intention was revealed through its transformation of traditional art, which involved the reconceptualization and rearticulation of form as dynamic rather than static. Indeed, the difference between the static and the dynamic – between the harmonious, stable, integral form and the seemingly unstable, disintegrative, sublime form, or so-called formless form – bespeaks the great divide between traditional and modern sensibilities. Modernity is oriented to the dynamic; it searches out and develops new modes of dynamism, articulated in new, increasingly abstract form. For it, structure is dynamically at odds with itself and can never stabilize into durable, clear form. In contrast, tradition believes that all things are foreordained by God to converge in harmonious stasis – a well-ordered world that bespeaks his creative power. It is art's task to serve God by articulating that implicitly perfect order, symbolizing the convergence of God and his creation and revealing their underlying correspondence or oneness. One should note that this distinction can be understood in terms of Bürger's distinction between "the avant-gardiste work [which] proclaims itself an artificial construct" and the traditional "organic work of art" (p. 86). However, I do not think the avant-garde work's declaration of artificiality and demonstration of construction, and with that the implication of art's independence from nature, is an end in itself. Rather, it is a means of abstracting the dynamic from the context of nature, asserting its autonomy, and appropriating it for culture, which constructs itself rather than, strictly speaking, grows. Also, while I believe, with Bürger, that "the organic work promotes, by its very form, the illusion of a world that is whole, even though the explicit contents may show a wholly different intent" (p. 86), this illusion is psychosocially necessary, as a reminder that "the contradictions of society," as well as those of the self, must be confronted by the idea of possible wholeness or integrity, if society and the self are to survive their contradictions. Without the hope of wholeness, which organic art supplied, contradictions have a disintegrative effect rather than becoming a creative opportunity. They also seem inevitable, rather than a sign of society's failure to construct itself properly, which invariably has a negative effect on the growth of the self.

Moreover, for avant-garde art – modern art's cutting edge – form is not simply dynamic as such but has a transformative effect on the spectator, that is, functions as a catalyst of fundamental change in his life. The perpetual motion of dynamic form is contagious, as it were. It stirs up forces the spectator did not know he had in him, destabilizing him. Just when he thought his life was well-ordered, he becomes convinced he must change it – in what way he does not know. It creates a sense of risk and possibility – danger and adventure – in

him. This contrasts with the traditional sense of the homeostatic function of form, that is, form as the spectator's instrument of self-regulation, as a means of stabilizing his being and maintaining the balance of known forces in his life. For neo-avant-garde art, form, whether dynamic or static, is a social artifact, having only ideological significance. It conveys no *promesse du bonheur*. It says nothing about human possibility, only about social actuality. Every form has its place in the history of forms, and art making is an ironical manipulation of this history for a contemporary ideological purpose.

Just as the avant-garde sense of the transformational dynamics of form undermined the traditional sense of stable form as a demonstration of the underlying unity of man and God, so neo-avant-garde art's grim realism about art, however cunning in its pseudo-playfulness, betrays the idealism of the avant-garde sense of therapeutic purpose. Avant-garde art attempted to make man aware of and reconcile him to his seemingly limitless possibilities, to show him that the abyss within, seen in another light, is his own dynamic openness. This awareness initially panics him, that is, has a disintegrative effect on him. (Panic and an ecstatic sense of possibility coexist in avant-garde dynamics.) In sharp contrast, neo-avant-garde art conveys a sense of human as well as artistic limitation. There is a diminished sense of human and artistic expectation in it – a loss of the sense of possibility, that is, the sublime. It is about frustration – perhaps justifiable unhappiness – with both humanity and art. This is what makes it seem pseudo-classical, rather than naively romantic, as avant-garde art, seen through a neo-avant-garde lens, seems to be.

79. Jeffrey Deitch, "The Art Industry," *Metropolis, International Art Exhibition Berlin, 1991*, eds. Christos M. Joachimides and Norman Rosenthal (New York, Rizzoli, 1991), p. 39. I cannot resist comparing Deitch's uncritical endorsement of the art industry with Max Horkheimer and Theodor W. Adorno's critique of "The Culture Industry: Enlightenment as Mass Deception" in *Dialectic of Enlightenment* (New York, Seabury, 1977; originally published in 1944). For them, the artist is "completely fettered" by "the pressure (and the accompanying drastic threats), always to fit into business life as an aesthetic expert. . . . Not to conform means to be rendered powerless, economically and therefore spiritually – to be 'self-employed' " (p. 133). Since they wrote this, pressure to conform is no longer necessary. The artist conforms spontaneously and unthinkingly – this is part of his postmodernism – because he wants economic power and the shadow of spiritual substance, however thin. Deitch would no doubt agree with, and probably not see the irony and despair in, their assertion that "The culture industry can pride itself on having energetically executed the previously clumsy transposition of art into the sphere of consumption, on making this a principle, on divesting amusement of all its obtrusive naivetes and improving the type of commodities" (p. 135).

As for the connection of novelty and commodity, "the word 'new' fixed to a product creates consumer interest," as the designer Milton Glaser knows. Asked to redesign the French magazine *Paris-Match*, "Glaser created a design . . . that, among other refinements, added the word *nouveau* to the logo. Almost immediately the magazine enjoyed a 20 percent boost in circulation." From "The Making of a Tiny Empire," *Newsweek,* July 16, 1984, p. 52.

Correlate with the commodification of avant-garde newness is the postmodernist rise of the art dealer as a celebrity, every bit as famous as the artist, if not more so. If, as Michael Kinsley writes, art has become just another "currency of fame," then the art dealer ultimately has more currency than the artist. Michael Kinsley, "The Superrich Are Different," *Time,* May 23, 1988, p. 82. And if, as Leo Braudy writes, "fame shades imperceptibly into fashion," then the art

dealer is ultimately more fashionable than the artist, for the art dealer determines changes in art fashions. Furthermore, if surface is "easily detachable" from substance in neo-avant-garde art, then the art dealer ultimately has more substance than the artist, for in showing the artist's work the dealer turns its substance into surface. See Leo Braudy, *The Frenzy of Renown, Fame and Its History* (New York, Oxford University Press, 1986), p. 4. Also see Edith Newhall, "The Art of the Dealer," *New York*, October 10, 1988, pp. 56–62, on Arnold Glimcher, owner of the Pace Gallery; Frank Rose, "Last Laugh," *New York*, June 25, 1990, pp. 46–52, on Jay Gorney; and Andrew Decker, "Art a Go Go," *New York*, September 2, 1991, pp. 38–44, on Larry Gagosian. See also Phoebe Hoban, "The Art of the Hot," *New York*, May 23, 1988, pp. 40–50, on Lisa Phillips, a curator at the Whitney Museum of American Art, who, "in an art market where painters have become businessmen . . . displays all the savvy of an investment banker."

See also "High Finance Makes a Bid for Art," *New York Times*, February 3, 1985; C. Carr, "Money Changes Everything: The East Village Art Mart," *Village Voice Literary Supplement*, No. 38 (Sept. 1985):6–7; Martin S. Ackerman, *Smart Money and Art: Investing in Fine Art* (Barrytown, N.Y., Station Hill, 1986); "Manic Market, Prices of Hottest Art Reach Stunning Levels as Boom Keeps Going," *Wall Street Journal*, November 28, 1988, on "art for money's sake"; Deborah Weisgall, "A Megamuseum in a Mill Town," *New York Times Magazine*, March 5, 1989, pp. 32–5, 54, 57, 82, 84, on the "museum industry"; Robert Hughes, "The Decline of the City of Mahagonny," *New Republic*, June 25, 1990, on "art, money, New York, the 1980s"; John Taylor, *Circus of Ambition* (New York, Warner, 1990), on high rollers in the "money-loving '80s," including an artist who wanted to "become a millionaire overnight." There is also a 1990 advertisement for *Money* magazine that pictures a wall of works by avant-garde artists, beneath the headline "The Rewards of Money."

80. Robert Pincus-Witten, "Timothy Greenfield-Sanders," *Tema Celeste*, No. 31 (May–June 1991):67. The contemporary tendency to substitute the photographic portrait of the artist for his work, as though his presence alone carried conviction and gave the work conviction, epitomizes the ease with which art can be reduced to the artist's narcissism in postmodernist culture. Such portraits have proliferated astonishingly, whether in the form of artists painting other artists in mutual narcissistic admiration, as in the case of Chuck Close, or in fashionable publicity portraits, such as those made by Greenfield-Sanders. He specializes in "alchemically" transmuting, by means of photography – presumably it generates a greater effect of immediacy and aliveness than painting – crudely narcissistic artists into refined public personae. Clearly, the point is to create a cult of artistic personality, as though the artist's exceptional appearance assures us that his art really is exceptional. The strategy of exceptionalization, as it might be called, has become the rule in the art world, because no one knows any longer why art is exceptional. As Bürger (p. 93) writes, in the wake of "the failure of [the] avant-gardiste intentions," which made avant-garde artists and art exceptional, the "post avant-gardiste art" that institutionalizes them establishes "the legitimate side-by-side existence of styles and forms of which none can any longer claim to be the most advanced." In this situation, "where the formal possibilities have become infinite . . . authentic creation [has] become correspondingly difficult."

The production of artist publicity photographs is of course not a contemporary phenomenon, although it has clearly come a long way from Henri Toulouse-Lautrec's photographic double self-portrait, comically showing him posing for himself and probably meant for his private amusement. In contrast,

it has been said that Alfred Stieglitz's photographs of Georgia O'Keeffe made her reputation. The same thing is supposedly true of the artists Hans Namuth has photographed. His "Permanent Faces," as they were called in a 1991 museum exhibition, were imprinted on the collective consciousness as the artists' works could never be. The publicity photograph can create the myth of the artist, as Marjorie Welish has shown in the case of Yves Klein's notorious photograph, *The Leap into the Void*, 1960. Marjorie Welish, "The Specter of Art Hype and the Ghost of Yves Klein," *Sulfur*, 12(Fall 1985): 22–8. The artist publicity portrait has clearly come a long way from the photographs of surrealist artists, their eyes ironically closed, presumably to express their inner vision, in *La Révolution surréaliste*, December 15, 1929, or even from Alexander Liberman's elegant photographs of *The Artist in His Studio* (New York, Random House, 1988) and Arnold Newman's portraits of celebrity artists. Indeed, the trend has gotten out of hand, as "The Artist Project," a 1987 exhibition of three hundred portraits of contemporary New York artists by photographer Peter Bellamy indicates. David Robbins's 1986 publicity photographs of raw "Talent," each presented as a work of art in itself, is another instance of a quantitative rather than qualitative "assessment" of artists.

The contemporary style of the publicity photograph is to show the artist casually at home if nonetheless self-important, as in Phoebe Hoban, "Artists on the Beach," *New York*, July 1–8, 1991, pp. 38–44. Hoban's article features photographs of, among others, Roy Lichtenstein proudly posing like an elder statesman in his studio and Eric Fischl and April Gornik embracing with their eyes on the photographer. In the words of Roger Ailes, the man who coached various Republican presidential candidates to victory, the intention is to create a "style that's . . . relaxed, informal, crisp and entertaining" – "an effective communicator." "Bush's Media Wizard," *Newsweek*, September 26, 1988, p. 19. The photographs of Picasso by David Duncan and Andre Villers set the model for this kind of down-home artist-as-pal photograph. It certainly belongs to an altogether different world of imagery than Irving Penn's formal photographs of artists in grand isolation. Only the exhibition "Picturing 'Greatness,' " curated by the artist Barbara Kruger for the Museum of Modern Art in New York (1988), brings the publicity photograph into question. Collecting forty-one photographs of famous artists (dated 1893–1964), Kruger mocks the artist as a "star-crossed Houdini with a beret on, a kooky middleman between God and the public." Her criticality has hardly made a dent in the artist celebrity photograph business, which has reached a new apogee in the photographs of Robert Rauschenberg and Larry Rivers, among other artists, wearing Gap clothing (1991).

It should be noted that the new pluralism, as it has been called – the postmodernist abundance of artists gaining recognition (going along with the so-called new affluence and inflation of the significance of everything) – need not be interpreted as pessimistically as Bürger does. It can be understood in terms of Lifton's concept of protean style, which itself can be understood as an enthusiastic, if manic, answer to the question about selfhood modern life invariably raises, with its pressure to be all one can, to realize all the possibilities in oneself (as the publicity photograph is supposed to demonstrate), rather than accept a fixed, limited place in existence. The modern ideology of self-realization necessarily induces intense self-doubt, to the point of disintegration anxiety, for it seems an impossible task. One is always haunted by the specter of unfulfillment that threatens one's conventional sense of self. In postmodernity, the self overcomes disintegration anxiety and fulfills the modern mandate of self-realization ironically: it multiplies – by developing a protean style – rather

than reintegrates the terms of its old style, which have been shattered forever by disintegration anxiety. Pluralistic neo-avant-garde art, taken as a whole, is an exemplary demonstration of protean style, in all its self-contradictory irony. (See Corinne Robins, *The Pluralistic Era: American Art, 1968–1981* [New York, Harper & Row, 1984], for an account of American neo-avant-garde pluralism. The explosion of European art in the eighties expanded the neo-avant-garde scene. Now, in the nineties, art has become so protean – it seems able to take any shape – that it is hard to know what art is, or even what it prefers to be.)

Lifton, "Cults," p. 17, describes the protean style as "a series of explorations of the self in which one tries out various involvements and commitments toward people, ideas, and actions; and shifts from them, leaves them for new ones at relatively minimal psychological cost." The identifications are "contradictory and seem to take one in opposite directions simultaneously." For Lifton (p. 18), the emergence of the protean style is correlate with an increasingly accelerated "breakdown of traditional symbols, in a sequence from premodern to modern to postmodern experience." This seems to afford self-expansion, but there comes a point when self-expansion – narcissistic glorification of the limitlessness of the self – becomes self-breakdown, that is, narcissistic nihilism, the self glorying in its own porousness and self-destruction. One can convince oneself that one can be anyone or anything – a psychotic extension of Rimbaud's "I am an another" – because one lacks the inner conviction that one is in fact someone and something particular. Lifton (p. 19) acknowledges the relationship of his concept of protean self to Kohut's self-psychology, implying that one can read protean style as disintegration anxiety in action, as well as a manic defense against it.

Recalling the epigraph by Frank O'Hara that begins this chapter, Kenneth Koch remarks that O'Hara "had an ability to fantasize himself to be almost anybody, anything, anytime, anywhere." (Quoted in Mutlu Konuk Blasing, *The Art of Life: Studies in American Autobiographical Literature* [Austin, University of Texas Press, 1977], p. 147. Blasing speaks of O'Hara's "sordid identifications," and notes their "self-destructive" or nihilistic character – the invariable consequence of the narcissistic fantasy of omnipotence.) In psychological fact, O'Hara's protean style suggests his lack of a core sense of self. He can have no identity of his own, which is why he is "free" to identify with whomever and whatever he wishes. His compulsive, clinging identifications bespeak disintegration, that is, convey what Kohut in *The Restoration of the Self* (New York, International Universities Press, 1977), p. 105, calls "states of self-dissolution." In the end O'Hara demanded fame as compensation for his lack of self. That is, he had a sense of self only when he identified with his audience, in effect appropriating its sense of self. The pathos of this dependence on audience suggests that O'Hara's "personism," as he called it, hides the hollowness of his own protean style. It is an exemplary instance of the dialectic of narcissism – the oscillation between self-idolization and self-loss (both of which involve self-advertisement, that is, the use of art as advertisement for a self that does not truly exist, in a psychotic attempt to assert that it does) – that informs the modern artist's "romantic" existence and that becomes explicit in postmodernism, when it almost completely takes over his existence. In the situation of the breakdown of once universal symbols, art's task is to maintain the grandiose fantasy of protean freedom so as to afford the illusion of selfhood, however frayed and passé – historical – the sense of self it affords may ultimately come to seem.

The postmodern corruption of protean freedom is suggested by Julian Schnabel, who fancies himself the American Picasso. See Michael Stone, "Off the

Canvas," *New York*, May 18, 1992, pp. 28–36. Subtitled "The Art of Julian Schnabel Survives the Wreckage of the Eighties" – which begs the question, depending upon what "survival" means – the article quotes Schnabel as saying, "I'm as close to Picasso as you're going to get in this f____ing life . . . Everyone wants to be the greatest in their life, but only one person can be that" (p. 31). This sounds like America calling itself the greatest country in the world, in ignorance of other countries and of itself.

Even Picasso had to be recognized, but, in "this age of self-anointment," as Maureen Dowd calls it, in which Norman Maileresque self-advertisement is a matter of course, one can recognize one's own greatness in public and get away with it. To call oneself great is to be great in our postmodern wonderland. One only has to do so in the right social space – the never-never land of media hype ("In Elections as in Romance, It's Often a Matter of Chemistry," *New York Times*, March 8, 1992, "Week in Review," p. 1). Today it is acceptable for an artist to appropriate the name of an acknowledged genius as his own, in effect declaring himself as great a genius without waiting for any audience to do so, indeed, without even having the production of a lifetime to back up one's claim to fame. The audience, like that forced to passively witness Napoleon crowning himself, in what was then a radical gesture of autonomy and independence, lends credence to the claim by its silence. Of course, in this postmodern age when artist Napoleons are commonplace, such silence may be simply indifference, and as such a kind of protest. One is inured to the delusion of grandeur of the self-proclaimed genius, accepting his art and statements as publicity business as usual.

Schnabel, one might say, has become enough of a public nuisance for the public to take his art seriously. But his work's uniqueness seems to lie more in his proclamations of its uniqueness than in anything else. In our embarrassment for him we assume that he has made himself into a public spectacle. More than most artists, he seems to have perfected exhibitionism, to the extent that it seems his natural manner. Surely all that smoke must mean there is some fire, unless of course it's just a smoke screen for an attack on our sensibility. But such postmodern "show business" should not be mistaken for a modernist manifesto. It has more to do with social practice than artistic theory. Schnabel is the master of the big social lie, and his art suggests the big lie protean style has become in the postmodern world. It is now a method of self-inflation rather than of self-exploration, of working over rather than of working through. As such, it is no longer a convincing sign of true selfhood. Schnabel's reification of protean freedom suggests that it has become a necessary format for the false self – a new artistic prop of good social form – in the postmodern world.

The difference between Picasso and Schnabel can be stated in another way. Arthur Koestler, *The Act of Creation* (London, Arkana, 1989), pp. 82, 84, describes an incident in which Picasso acknowledged that he often painted fakes, meaning that he was sometimes "second-rate, repetitive . . . uninspiring" – that he aped himself. One could never imagine Schnabel making this admission. By his own estimation, he is always first-rate, original, inspired. In fact, everything he does is, by reason of its unequivocally derivative character, inherently second-rate, repetitive, uninspiring. Indeed, to cleverly ape first-rate, original, inspired art is by postmodern definition to be a genius, which suggests the upside-down world of postmodern values.

81. Freud said as much. In "The Paths to the Formation of Symptoms," *Introductory Lectures on Psycho-Analysis*, standard ed. (London, Hogarth Press and the Institute of Psycho-Analysis, 1963), Vol. 16, pp. 376–7, he wrote: "An artist is once more in rudiments an introvert, not far removed from neurosis. He is

oppressed by excessively powerful instinctual needs. He desires to win honour, power, wealth, fame and the love of women; but he lacks the means for achieving these satisfactions. Consequently, like any other unsatisfied man, he turns away from reality and transfers all his interest, and his libido too, to the wishful constructions of his life of phantasy, whence the path might lead to neurosis. . . . An artist, however, finds a path back to reality in the following manner. In the first place, he understands how to work over his daydreams in such a way as to make them lose what is too personal about them and repels strangers, and to make it possible for others to share in the enjoyment of them. He understands, too, how to tone them down so that they do not easily betray their origin from proscribed sources. Furthermore, he possesses the mysterious power of shaping some particular material until it has become a faithful image of his phantasy; and he knows, moreover, how to link so large a yield of pleasure to this representation of his unconscious phantasy that, for the time being at least, repressions are outweighted and lifted by it. If he is able to accomplish all this, he makes it possible for other people once more to derive consolation and alleviation from their own sources of pleasure in their unconscious which have become inaccessible to them; he earns their gratitude and admiration and he has thus achieved *through* his phantasy what he had achieved only *in* his phantasy – honour, power and the love of women." What is important here is that the artist's success ultimately depends upon the audience's repressed needs. If his art does not address or in some way articulate them, it will be perceived as inadequate. Freud says something similar in "Formulations on the Two Principles of Mental Functioning," standard ed., Vol. 12, p. 224: "In a certain fashion [the artist] actually becomes the hero, the king, the creator, or the favourite he desired to be, without following the long round-about path of making real alterations in the external world. But he can only achieve this because other men feel the same dissatisfaction as he does with the renunciation demanded by reality, and because that dissatisfaction, which results from the replacement of the pleasure principle by the reality principle, is itself a part of reality."

One might say that where the avant-garde artist achieves success by taking the frustrating, difficult path of changing the way art is made – altering the traditional reality of art – the neo-avant-garde artist achieves it by altering nothing. Neo-avant-garde art is a relief to the audience, which is weary of being at once threatened and seduced by irrational promises such as the myth of wholeness, conveyed by organic traditional art, and the myth of possibility, suggested by avant-garde constructions. Neo-avant-garde art offers neither wholeness nor possibility, only fragments of the historical actuality of art. That is, it is uncritical: it does not see aesthetic modification of the world as dialectical transcendence of it, but rather as routine accommodation to it. (Some neo-avant-garde artists quote kitsch art to signal this accommodation, however unwittingly.) Thus it does not frustrate us by challenging us with what we, and the world, are not: whole – unself-contradictory – and invigorated by a strong, almost dizzying sense of possibility. To feel postmodern is to feel that the modern age – a time of new human and artistic possibility – is over. But there is relief rather than despair, for the modern seems pretentious in retrospect. Its promise was not fulfilled.

For the neo-avant-garde artist, the traditional and the avant-garde are equally valid, legitimate, conventional modes of art making. Creativity consists in merging the traditional and the avant-garde so that each seems to acquire the substance of the other. An artist like Mariani makes the traditional look avant-garde, and an artist like Kiefer makes the avant-garde look traditional. The result is a kind of superior kitsch, as it were. That is, after their mating softens

both, neither the traditional nor avant-garde seem opposed to conventional consciousness. It is as though, in postmodernity, both have been turned inside out, so that what once seemed like spontaneous, unexpected gifts – the sense of wholeness, the sense of possibility – seem self-evident and forced, and thus lose therapeutic effectiveness, that is, their subliminal effect on the audience. Because art has become all too self-conscious, it loses power over the unconscious.

The neo-avant-garde artist has the sense of working in a cul-de-sac of history from which there is no way out. He is resigned to art. It has no secrets and surprises. He does not so much create works of art as revive old modes of art making, turning them into closed systems by reducing them to relatively simple linguistic codes, comprehensible to all and easily learned. Thus art making becomes entirely "practical" at the same moment it becomes facilely theoretical: it is the application of a concept that has been reified as a formula. In part because of the neo-avant-garde attitude toward avant-garde art, in part because of its institutionalization and academicization as another treasure of Western civilization to be preserved for posterity, it comes to be regarded in a superficially enlightened way by its audience. It is acknowledged – given its place in the social sun – but neither deeply felt nor understood, and as such is instantly gratifying. This confirms that it has lost its aura of mystery and revolt, indicating the painful need to change.

Neo-avant-gardism signals the end of the age-old notions of creative inspiration and critical self-consciousness – in a word, artistic and generally creative genius. Art is no longer a "bohemian" calling, but rather an honorable bourgeois career. It is no longer a sign of nonconformity and resistance to the psychosocial status quo but another, if unusual, kind of conformity. The artist no longer mediates the sociohistorical contradictions that theorists find unable to explain – in an act of critical introspection of their effect upon him – as he did when he was avant-garde. (See Siegfried Gohr, *Der Kult des Künstlers und der Kunst im 19. Jahrhundert* [Cologne, Bohlau, 1975; Dissertationen zur Kunstgeschichte, Vol. 1], for another version of this idea.) Instead, he becomes the ironic case par excellence of reconciliation and accommodation. Thus neo-avant-garde art is not an introspective art, as avant-garde art was. The neo-avant-garde artist is indifferent to the effect of society's irrationality upon himself – the profound suffering inflicted by a "late-capitalist society . . . so irrational that it may well be that no theory can any longer plumb it," as Adorno thought (Bürger, *Theory,* p. 94). Rather, he stylizes its irrationality into elegance, accepting it as the unchanging status quo. Because of this, he is likely to receive fame and wealth earlier in life than the avant-garde artist did.

82. Kiefer's idea that art is sick and has to heal itself, however ironically intended – and it is not clear that it is ironically intended – is a noteworthy example of a neo-avant-garde artist's appropriation of avant-garde art's therapeutic intention for his own narcissistic purpose. It is no doubt a matter of secondary narcissism. Art, wounded by the world, because conceived as both degenerate (decadent) and a commodity, and above all as unscientific, even antiscientific, as well as a technological joke and thus socially regressive and anachronistic, turns inward. It becomes at best recuperative entertainment, that is, emotional rest and recreation from the serious work of the world, a kind of emotional holiday from the real business of life. It needs all its strength to heal itself, while still hoping to artistically heal the seriously sick world. (Kiefer's blackness symbolizes, among other meanings, both this inwardness and sickness – the rot of art and the world. One of the symptoms of the world's sickness is its use of art as a scapegoat. That is, the world projects its unconscious feeling of being decadent onto art, which is then purged and suppressed. It is as if, by

devaluing and downplaying art, the world hopes to free itself from its "sick" feeling about itself.)

Mark Rosenthal, *Anselm Kiefer* (Chicago, Art Institute and Philadelphia, Philadelphia Museum of Art, 1987: exhibition catalogue), p. 66, writes: "There are intervals in the mythic life of art when it is in a weakened state. The title of *Sick Art*, 1975, suggests this condition, underscored by the red forms in the landscape, which have been identified as suppurating sores. Since a central ambition for Kiefer was to abolish the beauty of nature, we might conclude that his art is 'sick' because it has been unable to modify or completely obliterate the splendor of the Norwegian landscape. Yet Kiefer notes that the title is based on the Nazis' notion of 'degenerate' art, which for him is spurious. Art exists or it does not, but art cannot be ill. Nonetheless, Kiefer willingly joins the company of the despised degenerate artists by intentionally making the landscape appear to be sick; his art is thereby perverted."

Whatever Kiefer's ambiguity about the idea of art's sickness, his own art is an attempt to heal German art. (In fact, his sense of art as sick, even dying and in decline, repeats an old avant-garde idea, in whatever attenuated, compromised form; see Chapter 3, note 6.) No doubt he wants his art to help German society heal itself, but this concern is subsumed, as it were, by his determination to heal German art, and so is secondary to it. Kiefer at first seems to be saying that both tasks are equally important and should be carried out simultaneously. That is, he seems to want an art that makes a social point, as well as one that exists for its own sake. The fate of German art, as art, and that of German society are inseparable. German art can have a strong ego only if German society does. The health of the one is inconceivable without the health of the other. No doubt post–World War II German art regains health by interpreting German society's sickness to it, affording it healing insight into itself. This is what German expressionism and Neue Sachlichkeit did, before and after an earlier war. But post–World War II German art can truly recover from the devastating effects of Nazi suppression only if it acknowledges and assimilates the avant-garde methods developed while it was in limbo and puts them to new use. It must catch up artistically, as it were: it must overcome artistic decadence before it can help German society out of its own decadence.

But recovery can be complete only if German art is able to label German society degenerate the way it was once labeled degenerate by German society. This, I think, is the major effort of Kiefer's art. He "blackens" German society, as it were, suggesting its decadence. In effect, he turns German society's destructive attitude back on itself, taking revenge for its destruction of avant-garde art under the Nazis. In so doing, he reoriginates it as oppositional. To put this another way, he uses the avant-garde art condemned as degenerate by German society to damn German society as degenerate, in effect turning the tables on it, however belatedly. The blackness of his art also bespeaks its degeneracy, that is, Kiefer's empathic identification with the avant-garde artists victimized and martyred by the Nazis. He suffers and experiences what they did, so to speak. Kiefer wants to bring German society to guilty consciousness of its crimes against art by confronting it with the simulated degeneracy of his art. This is its avant-garde task – his ironic way of regenerating avant-garde art in Germany.

Rosenthal unwittingly suggests the perverse dialectic of German art and German society reflected in Kiefer's art in his discussion of Kiefer's idea of "the character of the artist": his "frequent identification of the artist with the soldier" (p. 115), as though both were interested in personal and national glory. In view of the world's dread of German militarism, based on the experience of invasion in both world wars as well as the Franco-Prussian War, this seems to be

a perversely aggressive conception of the artist – something only a provocative as well as desperate post–World War II German artist would be capable of. But in identifying the artist with the soldier, Kiefer implies that the soldier can be identified with the artist. Just as the artist should consciously think of himself as a kind of soldier, so the soldier should unconsciously regard himself as a kind of artist. This reversal is the covert point of the identification. It is clearly related to Kiefer's idea that German society, not German art, is degenerate.

The reversal is also a devious way of defending the German soldier, representative of the old Germany: for was he not in fact an artist – a landscape artist, indeed, an earth artist who remade the landscape of Europe, especially Germany? Many of Kiefer's works suggest as much, however ironically. They are an artistic rationalization, even an apologetics for Germany's militarism, however much they show the devastation wrought by it. Indeed, the devastation is the sign of its power. (Once again art accomplishes the aesthetic miracle of making evil look good, without deeply understanding and feeling it.) At the same time, the reversal suggests that art should have the power of the military, the power to blacken the landscape. Kiefer makes a kind of military art – an art with military muscle, an art that is peculiarly victorious in that it presents German defeat and devastation in a grand way, subsuming them as spectacle. It is thus an art appropriate to a Germany no longer weak and defeated. With one conceptual stroke he restores the honor of the German soldier and the German artist. To have honor – self-respect – is to have the rudiments of emotional health. Unlike German expressionism, with which it can be superficially identified, Kiefer's art is not a long, futile convalescence, but a healthy – because militant – German art, about a healthy Germany, freshly on the march. His blackness is death, but it is also heroic power.

Kiefer's blackness – clearly overdetermined – also signifies the " 'blemish' . . . on the soul of humanity, especially the German nation," which "is very nearly impossible to remove" (p. 104). Nonetheless, while not able to remove it, he makes it look attractive. His blackness voices incurability, but with too much eloquence. This is why his audience sees it in a positive light. "Kiefer is uncomfortable when his art is positive or perceived to be so, for he believes that this attribute is not sensible or realistic given history and the present world situation" (p. 104). But this is the postmodernist paradox: the audience sees whatever is put before it, no matter how negative, in a positive light, because what it sees is invariably rationalized as "beautiful" by reason of the fact that it is never presented in a self-contradictory way, as in modernist art. The audience does not have to struggle with Kiefer's blackness, nor is it overwhelmed by it: it is all too self-evident and spectacular. With Kiefer, German expressionist blackness has lost its insidiousness.

Kiefer himself does not struggle with this blackness or find it dangerous. On the contrary, he seems very comfortable with it, as though blackness has become habitual artistic dress – a facile fate. He mass-produces it, as it were. He has turned blackness – the ashes of war – into an aesthetic absolute. He shows how neo-avant-garde art involves the perverse return of beauty. It no longer symbolizes mythical, unattainable wholeness, but rather functions cosmetically to make the ugly truth palatable to the eye. Kiefer's blackness looks apocalyptically deep, as if it symbolizes the pathos of history as well as the abyss of melancholy that Van Gogh was afraid of falling into – the darkness behind the lifeline of color to which Van Gogh held fast – but it is merely aesthetically convenient. It is too beautiful to be deep enough to drown in.

83. Quoted by Erich Heller, "Introduction," *The Basic Kafka* (New York, Washington Square, 1979), p. xiii.

84. Ibid.
85. Kathleen Wheeler, "Introduction," *German Aesthetic and Literary Criticism: The Romantic Ironists and Goethe* (Cambridge University Press, 1984), p. 16, notes that already for the romantics, unity was a problematic concept and was always "paradoxically expressed." According to Friedrich Schlegel, Goethe particularly had a "fondness for far-fetched connections" and "a 'cultivated randomness' or surface unity" which masked "a deep and all-embracing synthesis" that was "not readily grasped," even by those who admired Goethe. The reader had to "retrace" the connections made by the artist's creative imagination, but, as Wheeler writes, the romantic "fragment genre was . . . designed to break down conventional technical unity in art, and entice the reader to discover the unity of the fragments through relating the ideas they expressed in his own unique way." It is the audience's romanticism that counts, as it were. The romantic audience gives the work its "final" shape, a notion echoed by Duchamp.
86. James S. Grotstein, *Splitting and Projective Identification* (Northvale, N.J., Aronson, 1985), p. 3, defines splitting "as *the activity by which the ego discerns differences within the self and its objects, or between itself and objects*," and regards it as a normal, universal phenomenon. Acceptance of "the *passive* experience of primal splitting, the act of birth separation," allows for actively conducted perceptual and cognitive splittings (p. 4). "Splitting thus undergoes the epigenesis of the modality of separation" (p. 16). The cognitive splitting of a perception into figure and ground is a typical example of splitting.

 However, splitting can also be pathological when, as Otto Kernberg writes, it refers to "the process of active keeping apart of introjections and identifications of opposite quality" (*Borderline Conditions and Pathological Narcissism* [Northvale, N.J., Aronson, 1990], p. 94). Heinz Kohut, *The Analysis of the Self* (New York, International Universities Press, 1971), pp. 176–7, distinguishes between vertical and horizontal splits in the psyche. "The ideational and emotional manifestations of a vertical split in the psyche – in contrast to such *horizontal splits* as those brought about on a deeper level by repression and on a higher level by negation . . . – are correlated to the side-by-side, conscious existence of otherwise incompatible attitudes *in depth*." In general, the split represented by unresolved contradiction, in which neither side knows that the other exists, while the psyche oscillates wildly between both, compounding the irrationality of the contradiction, is the sign of narcissistic pathology – a profound wound to the psyche's integrity.
87. Clement Greenberg, "Avant-Garde and Kitsch," *Art and Culture* (Boston, Beacon, 1965), p. 15, makes this point clear. "The ultimate values which the cultivated spectator derives from Picasso [avant-garde] are derived at a second remove, as the result of reflection upon the immediate impression left by the plastic values. It is only then that the recognizable, the miraculous and the sympathetic enter. They are not immediately or externally present in Picasso's painting, but must be projected into it by the spectator sensitive enough to react sufficiently to plastic qualities. They belong to the 'reflected' effect. In Repin [kitsch], on the other hand, the 'reflected' effect has already been included in the picture, ready for the spectator's unreflective enjoyment . . . Repin predigests art for the spectator and spares him effort, provides him with a short cut to the pleasure of art that detours what is necessarily difficult in genuine art." In a sense, the gratification of feeling and understanding an avant-garde work affords is infinitely postponed, and finally depends on the depth of the spectator's sensitivity and understanding. In contrast, the kitsch work, by presenting itself as easily felt and understood, prevents the spectator from realizing his inherent depth of feeling and understanding.

88. I am arguing that Salle's art is an ingenious, exemplary instance of what Theodor W. Adorno, *Aesthetic Theory* (London, Routledge & Kegan Paul, 1984), p. 22, calls "hyper-modernism" – the reification and experience of avant-garde disharmony and discontinuity as harmony and continuity, a consequence of both habituation to it and the difficulty of sustaining it.

Hypermodern art, which in a sense "positivizes" modern art's negative dialectic, is always more fashionable than it is. When Salle says, in the context of *Vogue* magazine, that "to be a serious artist in America is always to be marginal and alienated," he implies that marginality and alienation have become fashionable. They are in media and commercial vogue, as it were. (See Dodie Kazanjian's "Salle Days," *Vogue*, 182 [May 1992]:303.) Marginality and alienation are hardly the stuff out of which fashion is made. To make them seem chic is no mean feat. Salle turns symptoms of existential anguish into existential glamour. To sophisticate the negativity of existence is to perform an artistic miracle. It is also to make this negativity superficial, to undermine its existential urgency. Salle's negation of the negative feelings of marginality and alienation makes them impersonal passing moods, casually experienced, rather than expressions of inescapable, deep-seated suffering, individual and social. In effect, he simulates the negativity of existence; it is as if a black mood was good for the picture's complexion. Similarly, Schnabel's art simulates uncontrolled, importunate impulse, sovereign aggression and libido; his is a designed regression. Both Salle and Schnabel offer the façade rather than the substance of expression – false fronts of feeling in the Potemkin village of postmodern effects. Both are masters of the politics of quotation; their art's credibility comes from its cunning mediation of the seemingly unmediated expressiveness of their avant-garde elders.

Thus as strange as it may seem, to be marginal and alienated, or impulsive, no longer means one is a social outcast, an avant-garde pariah who must be quarantined because he is suffering from the contagious disease of psychic disintegration. Rather, however perversely, it means one is socially proper. To be avant-garde now means to belong, because to be avant-garde means to make the emotionally unpresentable socially presentable, to make what is humanly painful artistically pleasurable, to transmute the unspeakable into an elegant nonsense language. Society recognizes itself in the avant-garde artist, but this means that the avant-garde artist can no longer recognize himself. This reversal of meaning is the essence of the postmodern falsification of the modern. Just as it institutionalizes the avant-garde, postmodernization standardizes suffering until it seems a technical matter rather than a spiritual inevitability.

89. Frederic Wertham, *The Show of Violence* (Garden City, N.Y., Doubleday, 1949), p. 170. Herostratus replaced the spiritual grandeur of the temple with the narcissistic grandeur of his act of destruction. He in effect proposed himself as an alternate mythical figure to the goddess, belittling her. (Did his destruction of the phallic mother's temple originate in *ressentiment* against her?) Her creative healing power restored the sense of life's spiritual meaningfulness. His pathologically destructive power suggested that life could become meaningless – spiritless – at any moment because it could be arbitrarily destroyed. (Did his act bespeak his sense of the meaninglessness of his life?) The question of the relationship of narcissistically destructive to psychosocially reconstructive force in avant-garde art remains unresolved.

90. I am alluding to Heinz Kohut's conception of the narcissistic mirroring and idealizing transferences. The former involves "the mobilization of the grandiose self," the latter "of the idealized parent imago." See Kohut, *The Analysis of the Self*, p. 28, and passim. The neo-avant-garde artist sits at the feet of avant-garde

art, as though it were an ideal parent in whose eyes he found his own perfection reflected, while at the same time consuming it in an act of appropriation that testifies to his own delusion of grandeur.

2. Preliminary Therapeutic Attitude

1. Pierre Cabanne, *Dialogues with Marcel Duchamp* (New York, Viking, 1977), p. 34. Hereafter Duchamp.
2. D. W. Winnicott, "Psycho-Neurosis in Childhood," *Psycho-Analytic Explorations* (Cambridge, Mass., Harvard University Press, 1989), p. 71.
3. Robert Motherwell, "Introduction," Duchamp, p. 11.
4. Heinz Kohut, *How Does Analysis Cure?* (Chicago, University of Chicago Press, 1984), p. 43.
5. Ibid., p. 42.
6. Ibid., p. 60.
7. Ibid., p. 16.
8. Ibid., p. 45.
9. Ibid., p. 44.
10. Harold Rosenberg, "The Avant-Garde," *Discovering the Present: Three Decades in Art, Culture, and Politics* (Chicago, University of Chicago Press, 1973), p. 74, argues that "the primary quality of avant-garde art is freshness." While, as Rosenberg writes, "to the humanist the transitoriness of works in the modern mode embodies not a radical response to the dynamics of social and physical reality but a decadent wish for death and disintegration" (p. 78), "the compulsion of the avant-garde to wipe the slate clean," epitomized by the transitory work, that is, the work that wipes itself clean, as it were, is in fact an attempt at "demolition" and as such inherently destructive (p. 79). The "dissolution of forms" in avant-garde art bespeaks the tragic "temporariness of things" in modern life, giving rise to an "uneasiness . . . more fundamental . . . than shock" (pp. 80–1). "No work is avant-garde that does not induce uneasiness . . . and once its effect of uneasiness is lost the work ceases to be advanced" (p. 81). Improvisation, with its effect of transitoriness and freshness, is uneasiness in practice.
11. I am alluding to Marshall Berman, *The Experience of Modernity: All That Is Solid Melts into Air* (New York, Simon & Schuster, 1982), which makes clear that the avant-garde artist epitomizes the bourgeois spirit, even in his opposition to the bourgeois. Duchamp's "rubber objects" epitomize the ironical melting form. As he says, "the form was *ad libitum*," and after "three or four years . . . the rubber rotted, and it disappeared" (Duchamp, pp. 59–60).
12. Kohut, *Analysis*, p. 58.
13. Charles Baudelaire, "The Salon of 1859," *The Mirror of Art*, ed. Jonathan Mayne (Garden City, N.Y., Doubleday, 1956), pp. 234–5, wrote, "It decomposes all creation, and with the raw materials accumulated and disposed in accordance with rules whose origins one cannot find save in the furthest depths of the soul, it creates a new world, it produces the sensation of newness."
14. From Maurice Vlaminck through Willem de Kooning avant-garde artists have protested the uniform of style – a system of art making – as the cul-de-sac of creativity. Vlaminck, "Prefatory Letter" (1923), *Theories of Modern Art*, ed. Herschel B. Chipp (Berkeley, University of California Press, 1968), p. 145, remarked, "Style *a priori* like Cubism, roundism, etc., etc., leaves me cold. . . . For me 'the Cubist uniform' is very militarist, and you know how little I am 'the soldier type.' Barracks make me neurasthenic and Cubist discipline reminds me of my father's words: 'The army will do you good! It will give you character!' "

He also wrote, "I try to paint with my heart and my loins, not bothering with style" (p. 144). Wassily Kandinsky, "The Problem of Form," *Voices of German Expressionism,* ed. Victor H. Miesel (Englewood Cliffs, N.J., Prentice-Hall, 1970), p. 50, writes, "Form should not become a uniform. Works of art are not soldiers. A particular form for a particular artist may be excellent on one occasion and completely inappropriate on another. In the first instance the form was dictated by inner necessity, in the second by external necessity: pride and greed." (This states, in an overessentialized yet accurate way, the difference between what motivates modernist form and postmodernist form.) De Kooning, in "What Abstract Art Means to Me," in Chipp, *Theories,* p. 560, states: "Some painters, including myself, do not care what chair they are sitting on. . . . They are too nervous to find out where they ought to sit. They do not want to 'sit in style.' Rather, they have found that painting . . . to be painting at all, in fact – is a way of living." Picasso said: "Basically I am perhaps a painter without style. Style . . . locks the painter into the same vision, the same technique, the same formula during years and years, sometimes during one's whole lifetime. One recognizes it immediately, but it's always the same suit, or the same cut of the suit. . . . I myself thrash around too much, move too much. You see me here and yet I'm already changed, I'm already elsewhere. I'm never fixed and that's why I have no style." *Picasso on Art: A Selection of Views,* ed. Dore Ashton (New York, Viking, 1972), pp. 95–6. Hereafter Picasso.

15. José Ortega y Gasset, "The Dehumanization of Art," *The Dehumanization of Art and Other Writings on Art and Culture* (Garden City, N.Y., Doubleday, 1956), p. 21, writes that modern art is "inhuman not only because it contains no things human, but also because it is an explicit act of dehumanization. In his escape from the human world the young artist cares less for the *'terminus ad quem,'* the startling fauna at which he arrives, than for the *'terminus a quo,'* the human aspect which he destroys. . . . For the modern artist, aesthetic pleasure derives from such a triumph over human matter. That is why he has to drive home the victory by presenting in each case the strangled victim." Ortega explicitly alludes to Picasso. In "Cubist Hypochondria: On the Case of Picasso and Braque," *Artforum,* 28 (September 1989): 113–14, I describe the loss of the sense of being human in cubism in terms of the depiction of "the body – all bodies, the very bodiliness of the world – . . . in the process of disintegration," involving "a feeling of depersonalization and disembodiment – mistaken as intellectualization."

16. Picasso, p. 8.
17. Ibid., p. 24.
18. Ibid., p. 9.
19. Ibid., p. 8.
20. Duchamp, p. 98.
21. Ibid., p. 93. Picasso, pp. 18–19, remarks that the assumption that "painting is the equivalent of nature . . . isn't anything more than a question of signs," but the issue is "to illumine them from the inside." See also p. 66.
22. Picasso, p. 11.
23. Ibid.
24. Duchamp, p. 23.
25. Ibid., pp. 93, 22.
26. Ibid., p. 31.
27. Picasso, p. 43.
28. Dali notes the "humor, more or less black" – the color of shit, as he says – of dadaism, and Duchamp's dadaist "interest in the preparation of shit." Quoted in Duchamp, p. 13. Duchamp himself remarks that what "especially interested"

him was art that had humor, such as Laforgue's *Moralités legendaires,* which he illustrated (p. 30). In "this little bulletin, *Rongwrong*" which he put out with Picabia, "there was nothing, nothing. . . . There were some little things, with the drawings of an American humorist who did pipes, inventions like a bent rifle for shooting around corners" (p. 56). He admired Man Ray's *TNT, The Explosive Magazine,* which like his bulletin did not last long, and was put out "with a sculptor, Adolf Wolff, who was imprisoned as an anarchist" (p. 56). Humor is anarchy for Duchamp, and anarchy – the nihilistic demonstration that everything is shit – is humor, which was the teaching of Picabia. The point was to infiltrate high art with anarchistic humor, and make it "amusing." In his youth, Duchamp in fact made cartoons for two French newspapers (p. 21), and lived among cartoonists (p. 22). Picasso, p. 82, remarked that "when one paints a portrait, one must stop somewhere, in a sort of caricature. Otherwise there would be nothing left at the end," suggesting that humor alone stopped him from completely destroying the object. Picasso in fact was advised by Feneon to become a cartoonist, and seems to have regarded the *Demoiselles d'Avignon* as a kind of cartoon (p. 153).

In general, Duchamp wanted to make works that would be like "fireworks, jokes, lies" (p. 24). He had the "intention of introducing humor into painting, or, in any case, the humor of word play" (p. 20). It was basically aggressive in character, as he acknowledged (p. 56) – a "provocation" (p. 47) – and part of his "practice" of "irony" (p. 39). Not believing in "positions," he wanted to "attenuate" every position – including that of science (p. 39) – "by irony or sarcasm" (p. 89). As he said, "It's always the idea of 'amusement' which causes me to do things" (p. 47). As Jasper Johns said, the Large Glass was essentially "a Hilarious picture" (Duchamp, p. 109).

29. Duchamp, p. 47.
30. Ibid., p. 94.
31. Ibid.
32. Ibid., p. 93.
33. Picasso, p. 82, remarked that "any form which conveys to us the sense of reality is the one which is furthest removed from the reality of the retina." Compare this with Duchamp's assertion that "everything was becoming conceptual, that is, it depended on things other than the retina" or "visual language" (p. 39). Duchamp said that his "antiretinal attitude" came "from too great an importance given to the retinal. Since Courbet, it's been believed that painting is addressed to the retina. That was everyone's error. The retinal shudder! Before, painting had other functions: it could be religious, philosophical, moral" (p. 43).
34. Duchamp's account of "Fresh Widow" suggests how a work by him is a conceptual construction, involving the deliberately overdetermined interplay of the visual and verbal. "It was another pun. Fresh, French, Widow, window," says Cabanne. "Yes, 'fresh' widow, meaning 'smart'," responds Duchamp, going on to say: "The combination amused me, with French window. . . . The little panes are covered with black leather, and would have to be shined every morning like a pair of shoes in order to shine like real panes" (p. 66).
35. Duchamp, p. 33. See also p. 46 for the general importance of the unexpected in art.
36. As Cabanne, *Dialogues,* said, Duchamp had an extraordinary "need for freedom" and "taste for distance," even during his early years, "when painters were living in groups, even cliques, exchanging their research, their discoveries, their misgivings, and when friendship played a considerable role" (p. 27). Picasso, p.

75, said, "If there's a single freedom in what one does, it's the freeing of something within oneself. And even that doesn't last."

37. Duchamp, p. 33, acknowledged his "anti-social ideas." After the refusal of the Société des Indépendants, of which he was a founding member, to accept *Nude Descending a Staircase* in 1912 in Paris, and the rejection of *Fountain* for the Armory Show of 1914, Duchamp had little to do with groups (p. 54), with the exception of his participation in the surrealist exhibition of 1938 in Paris (p. 81). This occurred because the surrealists liked him enough to "borrow" him. Picasso, p. 84, said, "I cannot work except in solitude," for "it is necessary that I live my work and that is impossible except in solitude." He also said, "I've created my own solitude which nobody suspects." He admired Cézanne, who "lived in unbelievable solitude," which was at once "a blessing" and a "misfortune."

38. But even then, as I argued in "Cubist Hypochondria," p. 112, Picasso was as fratricidal as fraternal in his relationship with Braque, indicating that he was determined to maintain his independence despite his dependence on him. Indeed, he claimed that since "it is the realization alone that counts . . . it is true that cubism is Spanish in origin and that it was I who invented cubism" (p. 154).

39. Picasso, pp. 34–5. Picasso thought "the spirit of research has poisoned" modern art, leading to an "attempt to paint the invisible and, therefore, the unpaintable" (p. 4). However, he also said, "Paintings are but research and experiment" (p. 72). Duchamp described *Three Standard Stoppages* as "three separate experiments" (p. 47), and in general called his works, however ironically, "experiments" (p. 73).

40. Picasso, p. 52, remarked that "I would rather copy others than repeat myself," noting that "my past doesn't interest me anymore."

41. For Duchamp, form was explicitly *ad libitum* (p. 59).

42. Duchamp was "looking for scandal" (p. 55), as a symbol of "revolt" and part of a general "enterprise of destruction" (p. 62).

43. Duchamp, p. 67, said that "after forty or fifty years a picture dies, because its freshness disappears. . . . Afterwards it's called the history of art."

44. Duchamp, p. 32.

45. Ibid.

46. Ibid., p. 31.

47. Ibid., p. 37.

48. Picasso, p. 24.

49. Ibid., p. 73.

50. Ibid., pp. 82–3.

51. Ibid., p. 19.

52. Ibid., p. 18.

53. Duchamp, p. 72.

54. Ibid., p. 60.

55. Ibid., p. 92.

56. Ibid., p. 88.

57. Ibid.

58. Ibid., p. 40.

59. Picasso, p. 82.

60. Duchamp, p. 40.

61. This was part of Duchamp's "refusal of social purpose," which "above all is important" (p. 19). It was the absence of such purpose that made chess "the ideal work of art."

62. Ibid., p. 41.
63. Ibid., p. 18. That is, he wanted it to be impersonal and detached, like chess. More particularly, he did not want it to show any signs of attachment and anxiety.
64. Duchamp, p. 76, said, "The family . . . forces you to abandon your real ideas, to swap them for things it believes in, society and all that paraphernalia!"
65. Picasso, p. 75.
66. Ibid., p. 38.
67. Ibid.
68. Ibid., p. 24.
69. Duchamp, p. 15.
70. Ibid., p. 70. "Posterity is a form of spectator," Duchamp said (p. 76). "The artist is unaware of the real significance of his work and . . . the spectator should always participate in supplementing the creation by interpreting it" (p. 69).
71. As Cabanne noted, Duchamp "had a considerable notoriety" (p. 83). Ronny H. Cohen, "Mass Media: Pablo's American Image," *Art in America*, 68, December 1980, p. 43, points out that "with its marked capacity to inspire love or hate at first sight, Picasso's art has always been ideal grist for the media mill." In fact, "American newspapers and mass-circulation magazines have lavished over half a century's attention upon Picasso – both the man and the artist." There has been a virtual "campaign" on his behalf, as Royal Cortissoz, art critic of the *New York Herald Tribune*, wrote in 1939. Thus, "where chicanery" – and, one might add, conspiracy – "begins and art ends . . . is difficult to decide," as Wendell Hazen, art critic of the *Boston Post* wrote in 1942. Picasso was hardly shy about publicity, as his appearance, or that of his work, on the cover of ten magazines – *Time, Today's Living, Newsweek*, the *Atlantic, Life,* and *New York* – from 1939 to 1980 indicates (pp. 44–5).
72. Duchamp, p. 93. Similarly, "For Picasso, I said that the public of any period needs a star, whether it be Einstein in physics, or Picasso in painting. It's a characteristic of the public, of the observer" (p. 84).
73. Ibid., p.45.
74. Ibid., p. 70.
75. Picasso, p. 124.
76. Duchamp, p. 71.
77. Ibid.
78. Ibid.
79. Ibid., p. 104.
80. Picasso, pp. 45, 66.
81. Ibid., p. 80.
82. Ibid., pp. 86–7.
83. Quoted by John Russell, "Introduction," Daniel-Henry Kahnweiler (with Francis Cremieux), *My Galleries and Painters* (New York, Viking, 1971), p. 10.
84. Duchamp, p. 70.
85. Ibid.
86. Ibid., p. 30.
87. Ibid., p. 70.
88. Ibid.
89. Ibid., p. 71.
90. Ibid.
91. Stendhal, *On Love* (Garden City, N.Y., Doubleday, 1957), compares crystallization, the process in which one discovers "fresh perfections" in the beloved (p. 7), to the Salzburg bough. Thrown into the depths of an unused salt mine in

Salzburg, a leafless bough becomes "entirely covered with glistening crystals" in a few months (p. 324). Brought up into the sunlight, these "diamond boughs" eventually melt. Similarly, imagination makes the work of art seem more than it is. Sooner or later it lets one down and becomes matter-of-fact and dead. I have detailed this process in "The Short Happy Life of the Work of Art: From Artifact to Art to Arty Fact," *Tema Celeste* (Summer 1992): 54–7.

92. Duchamp, p. 65.
93. Ibid., p. 64.
94. Picasso, p. 62.
95. "Art must put forward an alternative," Picasso said in the context of a discussion of his two panels of *War and Peace* (p. 158). According to a perhaps apocryphal story, a German officer apparently asked Picasso, in Paris during World War II, whether he was Jewish. He said he wasn't but wished that he were.

3. The Geometrical Cure

1. Erwin Panofsky, *The Life and Art of Albrecht Dürer* (Princeton, N.J., Princeton University Press, 1955), p. 162.
2. All four begin with the sense of having lost their way in human life – and in art and thought – and end with a sense of relationship to an absolute that transcends it, and in doing so heals it. They move from uncertainty to certainty, from despair to acceptance of their own existence, and from a sense of purposeless temporal becoming to an awareness of eternal being, purposeful in itself. The depressing sense of having lost something essential – something one did not know one had until it was felt to be lost – always precedes the systematic search for and exhilarating discovery of something that seems bigger and more important than oneself, yet grounds one's being in such a way that it seems to be its very source. As Dante writes at the beginning of *The Divine Comedy*, he had lost "the straight way," and felt "so bitter . . . that scarcely more is death." Virgil showed him "another road," leading to the gate of purgatory, and finally to awareness of "the All-Mover's glory." Thoughtful art, in which feeling and idea integrate so that they become inseparable, is the means of systematic movement to this higher consciousness of a higher being.

 Benedict de Spinoza, "On the Improvement of the Understanding," *Ethics Preceded by "On the Improvement of the Understanding"* (New York, Macmillan, 1949), p. 3, writes, "After experience had taught me that all the usual surroundings of social life are vain and futile; seeing that none of the objects of my fears contained in themselves anything either good or bad, except in so far as the mind is affected by them, I finally resolved to inquire whether there might be some real good having power to communicate itself, which would affect the mind singly, to the exclusion of all else: whether, in fact, there might be anything of which the discovery and attainment would enable me to enjoy continuous, supreme, and unending happiness." In their different ways, Mondrian and Malevich begin with the same almost overwhelming sense of despair – Kierkegaard's sickness unto death – about social and personal reality, that is, an unhappiness with object relations as they exist in the historical world and with their effect on the self. And they find, in and through the solitude of their art, "some real good having power to communicate itself" that rescues the self and affords guiltless transcendence of the world. Whether or not this real good be called "God," it is experienced as primordial and as having a healing, integrating effect on the self. Religious sensibility at its best acknowledges the need for the reintegration of a self that has been disintegrated by disastrous object relations in a miserable world.

3. Piet Mondrian, "From the Natural to the Abstract: From the Indeterminate to the Determinate," *De Stijl*, ed. Hans L. C. Jaffe (New York, Abrams, 1971), pp. 82, 85, explicitly acknowledges the religious dimension of his art. (Hereafter Mondrian.) It conveys a sense of "God," a "universal" which no longer lies *outside* man" in the form of an image, as was the case in the past, but, to the extent he is a "mature universal *individual*," inside him in "determinate" plastic form. Such a man is "capable of *pure plastic vision*" of "all expressions of life," that is, of seeing the "original form" of God's creation through the "veil" of nature which seductively hides and distracts us from it, yet seems to emanate from it. As Mondrian says, he wants to make a *"truly religious art"* that "transcends" or "towers far above us": "Far above is that art which directly expresses the universal. Such an art, like religion, is one with life at the same time as it transcends (ordinary) life" (p. 62).

4. Mondrian, pp. 65–6, remarking that *"nothing in the world can be conceived in or by itself; everything is judged by comparison with its opposite,"* notes further that "only in our time – with its maturing and growing equilibrium between the inward and the outward, the spiritual and the natural – has the artist come consciously to recognize this ancient truth . . . The artist came to this awareness *through the way of art, an outward way.*" That is, he is able to crystallize natural oppositions into *"exact relationship,"* plastically expressing opposites *"as unity in a single outwardness* (the work of art)." Thus through "Abstract-Real painting, art has realized the law of opposites," achieving "an *equilibrated plastic of extreme opposites,"* that is, "equilibrated expression of man and nature, of inward and outward." In the past, such equilibration was articulated symbolically, as in the cross, but abstract-real painting is not bound by such "limitation," which also precludes a sense of the vital, dynamic character of the equilibration. That is, it precludes the struggle to achieve equilibrium, to overcome the tragedy of *"disequilibrated expression of the universal and individual"* (p. 78). Neoplasticism shows the process of equilibration at its most "pure," implying that the *"abolition of the tragic,"* which is "life's goal," is a real possibility (p. 78).

5. Mondrian, p. 78.

6. For example, Giorgio de Chirico writes that "to be really immortal a work of art must . . . come close to the dream state, and also to the mentality of children." Quoted in Marcel Jean, ed., *The Autobiography of Surrealism* (New York, Viking, 1980), p. 7. Wassily Kandinsky, *Concerning the Spiritual in Art* (New York, Dover, 1977), p. 17, describes children as "the greatest imaginers of all time," for they are able to make much out of little. He advises artists to make art the way they play games. Kandinsky, "On the Question of Form," *The Blaue Reiter Almanac* (New York, Viking, 1974), p. 176, notes "the enormous unconscious power in the child" that expresses itself in his art, and remarks that "the academy is the surest way of destroying the power of the child." The child's vision, in which the "inner sound" of things is "revealed automatically" (p. 41), is the major means of healing art that is "dying of the masses and of materialism," as Victor Aubertin wrote in 1911. "It dies because the land it needs is all built up, the land of naïveté and of illusions." Art is also dying of science. "They are deadly enemies: where one of them exists, the other flees." (Quoted in Klaus Lankheit, "A History of the Almanac," p. 11.) The child's vision, an antidote to materialism, the masses, and science, lends art naïveté and the power to create emotionally convincing illusions, regenerating it. Mondrian's abstract-real painting "will not be seen as a *degeneration"* because it has something of the naïveté of the child's vision – indeed, in a sense it is a child's vision of geometry, however aesthetically sophisticated – in that it creates the

illusion of equilibration of opposites, when in personal and social reality they are in conflict.

7. As Mondrian says, "The artist of the future will not have to follow the path of gradual liberation from natural form and colour: the way has been cleared for him; the mode of expression is ready; he has only to perfect it. *Line and colour as plastic means in themselves* (i.e., free from particular meaning), are at his command so that he can express the universal determinately. . . . humanity will *no longer move from individual to universal, but from the universal to the individual through which it can be realized*" (p. 85). For Mondrian, only the individual who is mature enough to realize the universal, and to realize that "individuality becomes *real* only when it is transformed to universality" (p. 85), is worthy of the name artist.

8. "There is no abstract art," Picasso said. "You must always start with something. Afterward you can remove all traces of reality. There's no danger, then, anyway, because the idea of the object will have left an indelible mark." Dore Ashton, ed., *Picasso on Art: A Selection of Views* (New York, Viking, 1972), p. 65. Picasso does not understand the need to transcend the object, however impossible it may be.

9. "An important event for me was the discovery of Matisse, in 1906 or 1907." Pierre Cabanne, *Dialogues with Marcel Duchamp* (New York, Viking, Art, 1971), p. 22. As he said, "Matisse interests me enormously" (p. 93). Indeed, as noted in the previous chapter, Duchamp became a "particularly intense" fauvist (p. 23). Duchamp's repudiation of painterliness, retinality, physicality, the aesthetic – all being more or less synonymous (p. 11) – and turn toward the conceptual or mental can be understood as a reaction formation, on the order of disgust, against the intense bodiliness and eroticism conveyed by the Fauve figure as well as the material color and gesture that renders it.

No doubt this is typical of the dadaist attitude, but it is not clear that it aims at what Richard Huelsenbeck has called a "new integration" rather than "nihilism." It seems far from "the total, human personality" – "a new consciousness of human totality" – Huelsenbeck thought the "dadaist destruction of art" aimed at. On the contrary, it affirms a deep split in the self and a passive acceptance of this split, as well as an old fear of the erotic, which Duchamp treats in a mechanical, routine way, in pseudo-mastery of it. Richard Huelsenbeck, *Memoirs of a Dada Drummer* (New York, Viking, 1974), p. 140.

It should be noted that the dadaist attitude has been understood as a source of eternal artistic youth. "Dada, in contrast to constructivism, surrealism, and cubism, was the only art movement to continue spreading; it has never grown old and even today, after fifty years, it shows no symptoms of old age or senility," that is, of decadence (p. 136). But Duchamp's conceptualism seems to have become dated just because it blindsided the bodily and trivialized the erotic, in a futile attempt to repress it.

10. "No more 'likenesses of reality,' no idealistic images – nothing but a desert! But this desert is filled with the spirit of nonobjective sensation which pervades everything. . . . leaving 'the world of will and idea,' in which I had lived and worked and in the reality of which I had believed . . . a blissful sense of liberating nonobjectivity drew me forth into the 'desert,' where nothing is real except feeling." Kasimir Malevich, "Introduction to the Theory of the Additional Element in Painting," *Theories of Modern Art*, ed. Herschel B. Chipp (Berkeley, University of California Press, 1968), p. 342.

11. Spinoza, *Ethics*, p. 187. Jaffe, in Mondrian, pp. 20–21, writes, "Spinoza chose the geometrical method of presentation in order to be able to prove the principle of his ethics in a way that transcended personal arbitrariness and was thus

irreproachable. The artists of De Stijl had a similar purpose when they chose to restrict their means of expression to elements of unalterable validity in order to be able to give creative form to the essential content of their philosophy: harmony." Like Spinoza, they were involved in a "compulsive search for the absolute." Spinoza, says Mondrian, thought that *"truth is self-revealing"* (p. 61). Similarly, Mondrian thinks it is possible to make a self-revelatory, profoundly truthful, and equally self-explanatory, art (p. 61).

12. Ibid.
13. Ibid., p. 127.
14. Ibid.
15. Ibid.
16. Norman Kemp Smith, *New Studies in the Philosophy of Descartes, Descartes as Pioneer* (London, Macmillan, 1963), p. 66.
17. Ibid., p. 67.
18. Ibid., p. 63.
19. Spinoza, "On the Improvement of the Understanding," p. 6.
20. Ibid.
21. Ibid., p. 3.
22. Ibid., p. 7.
23. Frederick J. E. Woodbridge, "Spinoza," Spinoza, p. xxvii.
24. Spinoza, "On the Improvement of the Understanding," p. 27.
25. Ibid., p. 3.
26. Ibid., p. 5.
27. Spinoza, *Ethics*, p. 252.
28. Ibid., p. 279.
29. Spinoza, "On the Improvement of the Understanding," p. 4.
30. Ibid., p. 3.
31. Ibid.
32. Ibid., p. 5.
33. Ibid., p. 13.
34. Baruch Spinoza, *Principles of Cartesian Philosophy* (London, Peter Owen, 1961), p. 18.
35. Mondrian, p. 39.
36. Ibid., p. 65.
37. Ibid., pp. 66–7.
38. Ibid., p. 53.
39. Mondrian speaks of "visual internalization of the material" of art, correlate with its universalization (p. 55).
40. Ibid., p. 54.
41. Erik H. Erikson, *Identity and the Life Cycle* (New York, International Universities Press, 1959; Psychological Issues, Vol. 1, No. 1), pp. 132–3, n. 9.
42. Peter Christian Lang, *Hermeneutik Ideologiekritik Asthetik* (Konigstein, 1981), p. 190, remarks that for Adorno "Die Erkenntnis, welche Kunst ist, hat es (das Wahre), aber als ein ihr Inkommensurables."
43. Mondrian, p. 76.
44. Ibid., p. 64.
45. Ibid., p. 53.
46. Kazimir Malevich, "From Cubism and Futurism to Suprematism: The New Painterly Realism" (1915), *Russian Art of the Avant-Garde: Theory and Criticism, 1902–1934*, ed. John E. Bowlt (New York, Thames & Hudson, 1988), p. 123.
47. Ibid., p. 118.
48. Malevich, "Introduction to the Theory of the Additional Element," p. 343.

49. Malevich, "From Cubism and Futurism," pp. 128, 130.
50. Malevich, "Introduction to the Theory of the Additional Element," p. 342.
51. Ibid.
52. Ibid., p. 343.
53. Ibid.
54. Ibid.
55. Ibid., p. 344.
56. Ibid., pp. 344–5.
57. See my essay "Malevich's Quest for Unconditioned Creativity," *The Critic Is Artist: The Intentionality of Art* (Ann Arbor, Mich., UMI Research Press, 1984), pp. 159–60, for a discussion of Malevich's cross works as a cul-de-sac and betrayal of his suprematist intention.
58. Erikson, *Identity*, p. 133.
59. Ibid.
60. Ibid.
61. Malevich, "From Cubism and Futurism," p. 131.

4. The Expressive Cure

1. Wassily Kandinsky, *Concerning the Spiritual in Art* (New York, Dover, 1974), p. 12. (Hereafter Kandinsky.)
2. Paul Klee, "Creative Credo," *Voices of German Expressionism*, ed. Victor H. Miesel (Englewood Cliffs, N.J., Prentice-Hall, 1970), pp. 87–8. (Hereafter Miesel.)
3. Salvador Dali, "The Stinking Ass," *Surrealists on Art*, ed. Lucy R. Lippard (Englewood Cliffs, N.J., Prentice-Hall, 1970), p. 100.
4. Kandinsky, p. 2.
5. Ibid., p. 9.
6. Ibid.
7. Ibid., p. 15.
8. Ibid., p. 14.
9. Ibid.
10. Miesel, p. 137, quoting the noted German expressionist Georg Kaiser, states that perhaps the most important aim of avant-garde expressionism was " 'Vision' dedicated to 'the regeneration of man'."
11. Kandinsky, p. 14.
12. Ibid., p. 14.
13. Ibid., p. 13.
14. Ibid., pp. 35–6.
15. Piet Mondrian, "From the Natural to the Abstract: From the Indeterminate to the Determinate," *De Stijl*, ed. Hans L. C. Jaffe (New York, Abrams, 1971), p. 78.
16. Klaus Lankheit, "A History of the Almanac," *The Blaue Reiter Almanac* (New York, Viking, 1974), pp. 18–19, n. 8.
17. As Lankheit notes, the *Blaue Reiter Almanac* devotes much space to "the relationship of painting and music. . . . The idea is not new; Plato has said: 'Painting is controlled by the same laws as musical rhythm" (Republic III, 10ff.). Since the pre-romantic movement the idea of 'color-music' had become topical, and, by about 1900, the idea of a relationship between these arts may be considered a general conviction of painters and musicians. But . . . the *Blaue Reiter* was the first to be serious about its realization" (ibid., p. 41). In the *Almanac* Arnold Schonberg wrote about "pure musical effect" (p. 93), while Thomas von Hartmann wrote "On Anarchy in Music." L. Sabaneiev discussed the "musical color

sensations" (p. 131) and "intuition of color-sounds" (p. 133) in Scriabin's "Prometheus." In addition, N. Kulbin wrote about "Free Music." Finally, Kandinsky's "The Yellow Sound," with music by von Hartmann, was published.

After the *Almanac's* publication, it became fashionable to regard nonobjective painting as visual music. Mondrian, for example, rationalized his paintings by comparing them, seemingly contradictorily, to the music of Bach and to jazz. He seemed to think they were a kind of translation of music into a medium that had affinities with it. The particular composers mentioned probably mattered less than the advocacy of the musical principle in visual art. The notion that nonobjective painting was an "imitation" of music the same way, in Renaissance painting, *ut pictura poesis* was the rule, has become a standard apologetic for it. This remains, even in the "compromise formations" of postmodern abstraction, an unwitting assumption.

In general, nonobjective painting aims to have the same unique expressive effect as music while being equally conceptual. Indeed, it was a solution to the problem of the reconciliation of the retinal and conceptual (which Duchamp tore asunder) before the problem occurred. To put this another way, music became painting's model and ideal because it was the first art to become modern or "pure," that is, the first to liberate form from conventional content and meaning, and articulate it as a content and meaning in itself. It was the first art to realize consciously that form is simultaneously concrete and abstract, and to make creative use of this fact to achieve profounder and more intense expressive effects than traditional art could. That is, it realized that form as such could break through the repression barrier to achieve a sense of spontaneous and hitherto unexperienced, incomprehensible, and extraordinarily concentrated emotion. Ordinary content and meaning confirmed and reinforced the repression barrier, however much their refinement through artistic mediation seemed to break through it.

The sense of breakthrough traditional art afforded was in fact fleeting and tentative. The audience tended to wonder if it had actually occurred, so quickly did the surprising feelings fade and the work settle back into mundaneness, into conventional readability and interpretability. Even the most modest sense of expressive breakthrough was in fact an illusion, because the repression barrier was constituted by conventional content and meaning. Indeed, traditional art did not so much effect an expressive revolution as channel disorganized unconscious emotion into some already existing, well-organized, institutionally dogmatic system of philosophy or belief – one and the same? – making it seem unconditionally convincing. Thus traditional art tried to instill faith or conviction rather than present the play and depth of feeling as an end in itself. Avantgarde purists intuitively realized that habitual, everyday content and meaning are in psychological fact a kind of resistance to the profound, intrinsically valuable expressive effects that could be mediated by pure form.

Freud's resistance to music is worth noting, for he explained it in a typically bourgeois way. It says a good deal about why the avant-garde revolution of pure art met with social resistance and incomprehension, not to mention scorn and contempt, before it was assimilated. In this case, assimilation meant consideration as another creative novelty, as a fresh sign of the madness of the artist and as a good design – reifications that bespeak the bourgeois's belief that he was right in not taking pure art seriously in the first place. Kohut, *The Restoration of the Self* (New York, International Universities Press, 1977), p. 294, writes that Freud's "preference for the content of thought, for the clearly defined and definable . . . made him shun the areas of contentless forms and intensities and unaccountable emotions." As Freud himself said, "Some ratio-

nalistic, or perhaps analytic, turn of mind in me rebels against being moved by a thing without knowing why I am thus affected and what it is that affects me" (quoted p. 295).

Moreover, Freud was compelled to verbalize his experience as a way of mastering it, while pure music "requires from the listener the ability to confront intense nonverbal experiences" (p. 294) and tolerate them in all their nonverbal and unverbalizable character. Freud's "need for the steadfast predominance of rationality" ultimately led to his "rejecting and fun-poking attitude" to modern art in general, "similar to the attitude prevalent among the *petite bourgeoisie* of his time" (p. 295). Kohut thinks that "Freud's rejection of modern art goes hand in hand with his reluctance to immerse himself in archaic narcissistic states . . . and with his failure to recognize the importance of the vicissitudes of the cohesion and disintegration of the self – topics that, as the leading psychological tasks of our times, had entered into the work of the pioneering artists of the day long before they became targets for the investigative efforts of the scientific psychologist" (p. 296). This refusal to face the self at its deepest is typically bourgeois. While the reluctance is understandable because of the dangers of decadence and disintegration that seem to come with any deep self-recognition, however shallow the artistic mirror, such reluctance easily turns into a refusal to be conscious of the self.

Such lack of "self-consciousness" eventually leads to the "argument" that consciousness of the world is more important than consciousness of the self, for the world supposedly completely forms and controls the self, which exists more in name than in substance. This declension of the self unwittingly acknowledges the ego's – as distinct from the self's – feeling of victimization by and helplessness in the world.

18. W. Ronald Fairbairn, *Psychoanalytic Studies of the Personality* (London, Routledge & Kegan Paul, 1952), pp. 5, 8, thinks the "strange confusion of past and present, or of phantasy and reality, known as 'déjà vu'," involves "a schizoid process." Like "feelings of 'artificiality' (whether referred to the self or the environment), experiences such as 'the plate-glass feeling,' feelings of unfamiliarity with familiar persons or environmental settings," as well as more serious phenomena such as "full-fledged depersonalization and derealization," it is "essentially schizoid."

19. Franz Marc, "Two Pictures," *Blaue Reiter,* p. 67. Marc, like Kandinsky, seemed to believe that the inner life of the work of art speaks directly to the inner life of the spectator, very much the way Freud thought the unconscious of the analyst and analysand could communicate without words. Removing external distractions and concentrating on the work, the spectator could find the work's emotional wavelength and attune to the inner life implicit in it, in effect communing with it. (Without such attunement, the work existed only technically.) The abstract work appeared to reciprocate: it seemed as sensitive to the spectator as the spectator was to it. It seemed to operate on the wavelength of his inner life, quickening and clarifying its current the more inwardly absorbed in it he became. The abstract work of art, by eschewing representation of outer life (however many traces of it remained in the work) removed a major obstacle to such unverbalizable intimacy and communication. By facilitating it, abstraction seemed to become its necessary condition, to the extent of making it seem an illusion when there was no tendency to purity in the work.

20. Kandinsky, p. 32.
21. Ibid., pp. 26, 33.
22. Ibid., pp. 3, 29, 54.
23. Ibid., p. 30.

24. Ibid., p. 29.
25. Ibid., p. 32.
26. Ibid., p. 17.
27. Ibid., p. 33.
28. That is, the expressive cure is a revolutionary therapeutic attempt to save the true self from destruction by the false self, or at least to reassert the rights of the true self within a self that is dominated, even totalized, by the false self. There is no doubt something wild, even violent and certainly grandiose in this effort, but then a self that has become totally false is already dead to itself, for it has implicitly capitulated to the grandness of the world. It has unconsciously accepted the world's delusion of its grandeur, endorsed its lack of perspective on itself. Thus only extreme measures – they may look like shock techniques to the bourgeoisie – can bring the self back to true life. Kandinsky's abstract expressionist articulation of extravagant, undefeatable aliveness through indefatigable and undefinable spontaneous gesture, is a major example. The argument that Kandinsky constructed his spontaneity acknowledges unwittingly the difficult achievement genuine spontaneity is apart from parapraxis.

 I am speaking in terms of D. W. Winnicott's distinction between the True Self and False Self in "Ego Distortion in Terms of True and False Self," *The Maturational Processes and the Facilitating Environment* (New York, International Universities Press, 1965). (See also Chapter 1, notes 20–3.) "The True Self is the theoretical position from which come the spontaneous gesture and the personal idea. The spontaneous gesture is the True Self in action. Only the True Self can be creative and only the True Self can feel real. Whereas a True Self feels real, the existence of a False Self results in a feeling unreal or a sense of futility. The False Self, if successful in its function, hides the True Self, or else finds a way of enabling the True Self to start to live. . . . The True Self comes from the aliveness of the body tissues and the working of body-functions, including the heart's action and breathing. It is closely linked with the idea of the Primary Process, and is, at the beginning, essentially not reactive to external stimuli, but primary" (p. 146). One might say that the expressive cure attempts to "collect together the details of the experience of aliveness" (p. 146) – to totalize the experience in a single work of art, and so convey a sense of its being absolutely true to itself. In contrast, there is the work of the False Self, "represented by the whole organization of the polite and mannered social attitude, a 'not wearing the heart on the sleeve' " (p. 143).
29. Erik H. Erikson, *Identity and the Life Cycle* (New York, International Universities Press, 1959; Psychological Issues, Vol. 1, No., 1), p. 23.
30. Kohut, *Restoration*, 206, 243, distinguishes between Guilty Man and his dynamic conflicts and Tragic Man with his sense of fragmented, enfeebled, and depleted self – his sense of living in a "world devoid of unmirrored ambitions," a "world devoid of ideals." The feeling of unreality bespeaks the self's unconscious sense of its tragedy. Such a feeling of unreality carries the self's sense of decadence, falseness to itself, and lack of integration to a psychotic extreme.
31. Fairbairn, *Psychoanalytic Studies*, pp. 11–12, speaks of the "libidinal situation" as conferring "tremendous significance upon the states of *fullness* and *emptiness*." The child who feels unfull because unfed and deprived not only feels "empty himself, but he also interprets the situation in the sense that he has emptied his mother – particularly since deprivation has the effect not only of intensifying his oral need, but also of imparting an aggressive quality to it. Deprivation has the additional effect of enlarging the field of his incorporative need" and increasing *"anxiety over destroying his libidinal object."* By reason of the full, gesturally expansive art of the expressive artist – no doubt overfull

or overexpressive to bourgeois eyes – one can assume that he is overcoming and compensating for a profound feeling of emptiness and deprivation. Because society is not fulfilling to him, he must make his fulfillment for himself.

In a sense, the pioneering avant-garde artists were unconsciously searching for sources of fullness other than society, which generally seemed emotionally unfulfilling to them. Where Monet, Gauguin, Van Gogh, and Cézanne found a new source of fulfillment in instinctive reciprocity with nature (however different their perceptions of it), Kandinsky, Malevich, and Mondrian found fulfillment through transcendence of both nature and society. In a sense, such transcendence was fulfilling in itself. Certainly the art of all of them is informed by a sense of conflict and oscillation between the sense of the world as empty and art as full. In general, the dialectic of fullness and emptiness is a major factor in the development of avant-garde art.

The aggressive attitude of so many avant-garde artists to their audience, representative of society as a whole, can also be understood as anxious destruction of a libidinally unrewarding object. The world is in effect destroyed and emptied of presence – all fulfilling presence is appropriated for art – in resentful retribution for the world's apparent determination to convince the avant-garde artist of his emptiness and insignificance, thus threatening his very life. Indeed, by depriving him of fulfilling recognition, thus carrying deprivation to the extreme of indifference, the world not only inflicts a serious narcissistic injury, but in effect invites him to commit suicide, as if to confirm that he is already dead in its eyes.

32. Emil Nolde, "Primitive Art," Miesel, p. 35, celebrates primitive art for its primordial aliveness. "The primeval vitality, the intensive, often grotesque expression of energy and life in its most elemental form – that, perhaps, is what makes these native works so enjoyable. . . . There are enough overrefined, pallid, decadent works of art and perhaps that is why artists who are vital and developing seek guidance from vigorous primitives."

33. Fairbairn, *Psychoanalytic Studies,* p. 20, describes intellectualization as "a very characteristic schizoid feature. It constitutes an extremely powerful defensive technique. . . . Intellectualization implies an over-valuation of the thought processes." It involves "an effort to work out . . . emotional problems intellectually in the inner world," to no avail, for "emotional conflicts springing from deep sources in the unconscious defy solution in this way." In general, "the search for intellectual solutions of emotional problems . . . gives rises to two important developments: (1) The thought processes become highly libidinized; and the world of thought tends to become the predominant sphere of creative activity and self-expression; and (2) ideas tend to become substituted for feelings, and intellectual values for emotional values." This seems an accurate description of what psychologically occurs in the geometrical cure, which involves the overvaluation of art almost to the point at which it becomes an exclusive obsession. This may also describe the conceptualization of art as a more or less completely intellectual matter, or one in which feelings are subsumed in ideas. Duchamp's bifurcation of art into the retinal/physical and the conceptual/mental, and his elevation of the latter over the former, suggests a similar schizoid split and intellectualization.

34. Ibid., p. 22.

35. Ibid., p. 10, regards "splitting of the ego as the most characteristic schizoid phenomenon."

36. In *The Studio,* 1855, Courbet presented himself as the center of the world as well as the artistic lever from which it could be moved in its entirety. His self-inflation and self-centeredness – his massive egotism – were perhaps most

apparent in his bragging about his physical strength, which Fritz Novotny thinks is translated into the "arrogant animality of the living beings and the heavy power of all matter in his pictures." *Painting and Sculpture in Europe, 1780–1880* (Baltimore, Penguin, 1960), p. 141.

37. Fairbairn, *Psychoanalytic Studies*, p. 6.
38. Ibid., p. 7.
39. Ibid., p. 14. Fairbairn speaks of the "depersonalization" and "de-emotionalization" of the object, involving "a regression in the quality of the relationship" as well as a "simplification" of it, often taking "the form of a substitution of bodily for emotional contacts." Geometrically pure art can be understood as an intellectual simplification of the sensorimotor reality of the body, with feeling rendered secondary and impersonal when not altogether neutralized. In contrast, expressively pure art can be understood as an attempt to reexperience the spontaneity of the body through lived painterly gesture, functioning as pictorial tissue. The work becomes emblematic of the reemotionalized and repersonalized body. The expressive work as a whole has intellectual quality to the extent that it is harmoniously organized.
40. Ibid., p. 3. Fairbairn notes that "contrary to common belief, schizoid individuals who have not regressed too far are capable of greater psychological insight than any other class of person, normal or abnormal – a fact due, in part at least, to their being so introverted (i.e. preoccupied with inner reality) and so familiar with their own deeper psychological processes." I submit that the pioneering pure artist was an exemplary type of schizoid introvert, and that his articulation of his feelings in the form of abstractions is characteristic of the schizoid mode of representation of inner life, whether carried out in visual or verbal terms. Indeed, in attempting to visualize rather than verbalize the unverbalizable core of inner reality, pioneering pure art is truer to it and its inwardness than is verbal representation of it, however ultra-avant-garde (e.g., the recursive stream of consciousness in James Joyce's *Finnegans Wake*).
41. Franz Marc, "Spiritual Treasures," *Blaue Reiter,* p. 59.
42. Von Hartmann, "Anarchy in Music," p. 117.
43. E. L. Kirchner, "Drawings," Miesel, p. 23.
44. Fairbairn, *Psychoanalytic Studies*, pp. 19–20, remarks that "to mitigate a sense of impoverishment following giving and creating, the individual with a schizoid component often employs an interesting defence. He adopts the attitude that what he has given or created is worthless. . . . On the other hand, a totally different form of defence against loss of contents may be adopted." There may be an "attempt to safeguard . . . against a sense of loss by treating what [has] been produced as if it were still a part of [one's] own contents." Artists seem to employ a mix of the two. "For by means of artistic activity they are able both to substitute showing for giving and, at the same time, to produce something which they can still regard as part of themselves even after it has passed from the inner to the outer world." It seems possible to say that abstract art is the extreme case of showing rather than giving. One might even say it signals a self, however far away in the work of art, rather than gives a self in an intimate relationship with another. However, an abstract work of art is likely to be experienced as more intimate – more a part of oneself, more inward – than any object in the modern world, where extensive networks of primary relationships seem to be nonexistent or in a state of decay. The abstract artist may unconsciously realize this, which is why he makes works with which the spectator can unconsciously bond more deeply and safely than he can with modern objects.

45. Ibid., p. 15.
46. André Breton, *Surrealism and Painting* (New York, Harper & Row, 1972), p. 70.
47. Ibid.
48. Ibid., pp. 347–8. Breton defines miserabilism as "the depreciation of reality in place of its exaltation" (p. 348).
49. Ibid., p. 52.
50. Ibid., pp. 56–7.
51. Ibid., p. 101.
52. Ibid., p. 105.
53. Ibid., p. 254.
54. Ibid., p. 251.
55. Ibid., p. 286.
56. Ibid., p. 325.
57. Ibid., p. 286.
58. Ibid., p. 362.
59. Ibid., p. 359.
60. Ibid., pp. 357–8.
61. Breton, who wanted art to have psychoanalytic purpose as if that alone could save it from becoming aesthetically hollow, clearly understood the purpose of psychoanalysis. Barnaby B. Barratt, *Psychic Reality and Psychoanalytic Knowing* (Hillsdale, N.J., Analytic Press, 1984), pp. 270–1, writes: "Psychoanalysis is not a philosophy of stable essences existing beneath the appearances of semiotic construction. Rather, it is a *dynamic* account of desire. Desire enters self-consciousness in the repressed condition of polysemous contradictions. As a negative dialectic, psychoanalytic reflection and interrogation act within and upon this 'return' of the repressed so that desire now enters self-consciousness as its own notion. This reappropriation of the repressed is not a static repossession, for, in emerging as its own notion, desire is neither formally possessed by semiotic construction nor fixedly self-certified within the semiotic system. Psychoanalytic knowing thus restores desire by restarting the dialectic movement of psychic reality. Such knowing is negative in that it pursues the nonidentity of semiotic construction, and in that it is a dialectic of knowing that restarts a dialectic of being. . . . As a praxis that, so to speak, turns the semiotic constitution of the world against itself, Freud's psychology exhibits the process of becoming of a dialectic discourse that negates the whole sphere in which it moves, thus imploding the Hegelian epithet '*das Wahre is das Ganze*' – the true is the whole *but* the whole is false. . . . Psychoanalysis, as the science of discourse, moves against the ideology of everyday life. Ideology is here defined as a semiotic closure, the fixating functioning of the subjectivity of psychic reality as an immobile point of self-reference, or as the frozen and final boundary of the possible conditions of knowing and being. This mode of functioning prevents the subject's entry as process into a historicized and mobilized dynamic of self-consciousness and the materiality of desire." Similarly, surrealism, in Breton's understanding of it, undermines the ideology of everyday life, disrupting its semiotic structures by articulating the desire that contradicts it and them, thus creating an effect of negative dialectic. Postmodernist art destroys the negative dialectic of desire informing the avant-garde pursuit of primordial expressivity. It does so by semioticizing the means of conveying it into fixed, everyday ideological structures, making these negative means positive and self-identical ends. (This is what it means to "stylize," that is, to reify artistic process as absolute style.)

62. In the words of the famous sentence that ends Breton's *Nadja* (New York, Grove Press, 1960), p. 160, "Beauty will be CONVULSIVE or will not be at all."

5. Fame as the Cure-All

1. Andy Warhol, *The Philosophy of Andy Warhol (From A to B and Back Again)* (San Diego, Calif., Harcourt Brace Jovanovich, 1975), p. 85.
2. Benedict de Spinoza, "On the Improvement of the Understanding," *Ethics Preceded by "On the Improvement of the Understanding"* (New York, Macmillan, 1949), p. 4.
3. Lin Yutang, ed., *The Wisdom of Laotse* (New York, Random House, 1949), p. 144.
4. Kynaston McShine, "Introduction," *Andy Warhol, a Retrospective* (New York, Museum of Modern Art, 1989; exhibition catalogue), p. 14, describes "Warhol's fascination with beauty and stardom," "the idea of the glamorous" and celebrity. Early in his career, in the mid-fifties, he made a number of " 'celebrity shoes,' personifying such stars as Mae West, Zsa Zsa Gabor, Elvis Presley, Julie Andrews, and Kate Smith," as well as drawings of Truman Capote, Greta Garbo, and James Dean. A particularly telling instance of his fetishistic identification with and appropriation of stars was his pursuit of Capote after seeing the author's photograph. Warhol attempted to contact him through numerous letters and phone calls, "ceasing only when Capote's mother ask[ed] him to stop" (p. 403). Pat Hackett, ed., *The Andy Warhol Diaries* (New York, Warner, 1989), traces Warhol's obsessive-compulsive star collecting from 1976 through 1987, the year of his death.
 Warhol was the first artist to pursue consciously the celebrity of the star, which "confers . . . power to make the ordinary extraordinary. It is the alchemy of fame. And so Warhol . . . wanted above all to be a famous artist" (p. 14). However much he was aware of "the ambiguity of fame" (p. 16), "from childhood, Warhol believed in the myth of stardom," identifying with Rauschenberg by picturing him as "someone rising from an impoverished background to fame and fortune" (p. 17), thus fulfilling the American Dream. It was entirely materialistic. It didn't matter why and how one became famous and fortunate, so long as one did. Warhol finally achieved the status of a society painter; to be "estheticized" by him conferred fame and confirmed fortune (p. 19). See David Bourdon, "Andy Warhol and the Society Icon," *Art in America*, 63 (January–February 1975): 42–5.
 Bourdon's *Warhol* (New York, Abrams, 1989) is the fullest documentation of the "career" Warhol made "out of appropriating famous images and products in order to promote his own reputation. By preempting the celebrity of his subjects – from Campbell's Soup and Coca-Cola to Marilyn Monroe and Elvis Presley – he parlayed his own name and face into commercial commodities that became recognized – and valued – around the world. His paintings of brand-name products reflect the essential materialism of American culture, with its entrenched devotion to consumerism, advertising, packaging, promotion, and the processing of just about everything, from guided missiles to Miss America, into economic entities" (p. 9). In other words, Warhol achieved fame by association with the already famous, that is, through a kind of parasitic identification or symbiotic mimesis.
 Warhol's decentering and democraticization of fame seem liberating, for they invite everyone to be famous. Fame is no longer out of reach, the privilege of the few. At the same time, however, these things devalue fame, making it virtually meaningless. It is there for the asking, if one knows how to ask for it, but what

is one getting? The triviality of fame, and of the people who have it, is clearly conveyed by Warhol's famous remark, "In the future everybody will be world famous for fifteen minutes." "Warhol in His Own Words," *Warhol, a Retrospective*, p. 460. (Warhol's words have become famous themselves, as suggested by Deyan Sudjic, *Cult Heroes: How to Be Famous for More Than Fifteen Minutes* [New York, Norton, 1990].) In trivializing fame Warhol trivializes achievement; fame is no longer recognition for particular achievement, and thus no longer an acknowledgment of social value. Society awards fame indiscriminately and gratuitously to cover up the fact that it has no clear criteria for determining value. Warhol's own celebrity trivializes the supposed achievement of art, devaluing it and making it merely the slickest way of becoming famous. Upward mobility is a joke when all one has to do to get to the top is associate with and imitate, however ironically, those already there. Fame is a farce when one becomes famous for wanting to be famous. As Warhol said, "being famous isn't all that important" (p. 78). "The best reason to be famous" "is so you can read all the big magazines and know everybody in all the stories." The contemporary triviality of fame is summed up in the title of a panel discussion on "Fame, Genius, Celebrity: Are Your Fifteen Minutes Up?" at the Santa Barbara Contemporary Arts Forum on January 25, 1991. The panel was organized by Leo Braudy.

To measure achievement, and to regard some achievements as more important than others, implies a hierarchy of values. Democratic society is reluctant to establish such a hierarchy on the grounds that it is implicitly elitist and dogmatic. But without a vertical differentiation of value, value becomes relative to the point of being random. Warhol's ideology of fame – fame as the opiate of the masses – embodies this paradox. His art demonstrates that fame becomes the only value when there are no other values, implying that the idea of inherent value is bankrupt, including finally that of fame. As Warhol nihilistically says, "the only people I can ever pick out as unequivocal beauties are from the movies, and then when you meet them, they're not really beauties either, so your standards don't even really exist" (p. 68).

5. See Warhol, *Philosophy*, pp. 182–3, for a dialogue on nothingness. Life is nothing, one is living for nothing, ideas are nothing, the only purpose in life is nothing, one believes in nothing, everything is nothing, sex is nothing, etc. In this litany of nothingness, Warhol is reminiscent of the character in Ernest Hemingway's short story "A Clean, Well-Lighted Place," 1938, who recites a revised Hail Mary: "Hail nothing, full of nothing, nothing is with thee." In his nihilism, Warhol shows his decadence and modernism. Moreover, in his sense that there is no alternative to decadence except resurrection as a star (which is the ultimate decadence of ironical nihilism), Warhol shows his postmodernism. Warhol, pp. 112–13, reflecting on his death, states the hollow paradox of immortal stardom: "At the end of my time, when I die, I don't want to leave any leftovers. And I don't want to be a leftover. . . . The worst thing that could happen to you after the end of your time would be to be embalmed and laid up in a pyramid. I'm repulsed when I think about the Egyptians taking each organ and embalming it separately in its own receptacle. I want my machinery to disappear. Still, I do really like the idea of people turning into sand or something, so the machinery keeps working after you die. . . . Since I believe in work, I guess I shouldn't think about disappearing when I die. And anyway, it would be very glamorous to be reincarnated as a big ring on Pauline de Rothschild's finger." See my "The Only Immortal," *Artforum*, 28 (February 1990):110–18, for a discussion of the sense of nothingness that bespeaks depressive awareness of death while claiming triumphant indifference to it as well as to immortality.

6. Warhol, *Philosophy,* p. 113. "That's one of my favorite things to say. 'So what.' . . . It took a long time for me to learn it, but once you do, you never forget."
7. As McShine, "Introduction," says (p. 19), in effect Warhol destroyed the face of the famous star while seeming to picture it with photographic precision. The star loses face in Warhol's works while seeming to save, even gain face. That is, he loses what Michael Eigen in *The Psychotic Core* (Northvale, N.J., Aronson, 1986), p. 334, calls the "original face," the inner face of the True Self. Warhol keeps the social face of the False Self intact while suggesting the lack of any personal (expressive) face and thus of any True Self. At his best, Warhol brilliantly goes beyond the obvious while seeming to present it indifferently. His famous stars are not so much two-faced, as one might expect, but, unexpectedly, have no real face underneath their social makeup, under their false faces or masks. This reduction of the star to absurdity, beyond ordinary contradiction, is the saving grace of Warhol's art.

 Thus Warhol indicated that the famous star was a complete social fabrication, that is, a self invented by society, existing only to the extent that it is socially visible. As such, it is a kind of will o' the wisp, a mass illusion. The star in the False Self reified into a social absolute. His *Camouflage Self-Portrait* indicates his own sense of being an illusion. There is no self to camouflage; or rather, the self is a construction of camouflage. As he said, "If you want to know all about Andy Warhol, just look at the surface. . . . There's nothing behind it." ("Warhol in His Own Words," p. 457.) Similarly, his *Camouflage Statue of Liberty* indicates his sense of America as a land of illusion, *Camouflage Last Supper* his sense of the illusion of religion, and *Camouflage* per se the illusion of it all. In general, the camouflage works, all 1986, are Warhol's last testament, his final nihilistic statement of disbelief in the reality of what he sees.
8. As evidenced by his cynical belief in business art (not to speak of his cynicism in general). "Business Art is a much better thing to be making than Art Art, because Art Art doesn't support the space it takes up, whereas Business Art does. (If Business Art doesn't support its own space it goes out-of-business.) So on the one hand I really believe in empty spaces, but on the other hand, because I'm still making some art, I'm still making junk for people to put in their spaces that I believe should be empty: i.e., I'm helping people *waste* their space when what I really want to do is help them *empty* their space" (p. 144). His admiration for Hitler's artistry, indeed, his conception of him as a "society artist," further confirms Warhol's reactionary tendency. "The best, most temporal [transient] way of making a building that I ever heard of is by making it with light. The Fascists did a lot of this 'light architecture.' If you build buildings with lights outside, you can make them indefinite, and then when you're through using them you shut the lights off and they disappear. Hitler always needed buildings in a hurry to make speeches from, so his architect created these 'buildings' for him that were illusion buildings, completely constructed by lighting effects, where he defined a very big space" (pp. 157-8). This description is in effect a metaphor for Warhol's way of constructing his own "timely" art, of constructing a glamorous star who is in effect an "illusion building" making a speech that hypnotically induces a state of infantile conviction in the audience, which loses the criticality that makes ego. To glamorize a face is to make it a starlike illusion that exists only as a social projection, like a politician's speech that promises everything and delivers nothing.

 The question of the fascist aspect of Warhol's art must be taken seriously, especially in view of his assertion: "I want everybody to think alike. . . . It's happening here all by itself without being under a strict government; so if it's

working without trying, why can't it work without being Communist? Everybody looks alike and acts alike, and we're getting more and more that way." "Warhol in His Own Words," p. 458.

9. Warhol said that "the reason I'm painting this way is that I want to be a machine, and I feel that whatever I do and do machine-like is what I want to do." "Warhol in His Own Words," p. 457. He also said: "I think everybody should be a machine. I think everybody should be like everybody." Quoted in McShine, "Introduction," p. 23.

10. See Victor Tausk, "On the Origin of the Influencing Machine in Schizophrenia," *Psychoanalytic Quarterly*, 2 (1933):519–56. As Eigen, *Psychotic Core*, p. 329, writes, "In the influencing machine delusion, the psychotic patient feels that his mind is being taken over and influenced by a distant machine. Tausk understood this as a projective expression of a mechanized body self. For Tausk, the machine is a symbolic petrification of the sexually alive body, an attempt to freeze or deanimate the threat of feeling, of life itself." Eigen argues that the "mental ego" is also involved, "in particular, the sense of omniscience and the immateriality-invisibility of mental life as such" (p. 330). Heinz Kohut, *The Analysis of the Self* (New York, International Universities Press, 1971), p. 8, speaks of "the all-powerful persecutor and manipulator of the self in the psychoses: the influencing machine whose omnipotence and omniscience have become cold, unempathic, and nonhumanly evil." Warhol, *Philosophy*, p. 27, writes: "I think that once you see emotions from a certain angle you can never think of them as real again. That's what more or less has happened to me."

11. There is an important photograph of Warhol with de Chirico (c. 1974) in *Warhol, a Retrospective*, p. 443. Warhol not only is far from his usual pseudoenigmatic deadpan look, but looks authentically expressive, perhaps deceptively, for the photograph is probably staged. It is in effect a picture of godfather and prodigal son.

12. Giorgio de Chirico, "Meditations of a Painter" (1912), Herschel B. Chipp, ed., *Theories of Modern Art* (Berkeley, University of California Press, 1968), p. 397.

13. Warhol, *Philosophy*, p. 21, writes that "at a certain point in my life, in the late 50s, I began to feel that I was picking up problems from the people I knew. . . . I had never felt that I had problems, because I had never specifically defined any, but now I felt that these problems of friends were spreading themselves onto me like germs. I decided to go for psychiatric treatment, as so many people I knew were doing. I felt that I should define some of my own problems – if, in fact, I had any – rather than merely sharing vicariously in the problems of friends." He went to a psychiatrist, who promised to call to make another appointment, but never did (p. 23). "As I'm thinking about it now, I realize it was unprofessional of him to say he was going to call and then not call. On the way back from the psychiatrist's I stopped in Macy's and out of the blue I bought my first television set, an RCA 19-inch black and white. I brought it home to the apartment where I was living alone, under the El on East 75th Street, and right away I forgot all about the psychiatrist. I kept the TV on all the time, especially while people were telling me their problems, and the television I found to be just diverting enough so the problems people told me didn't really affect me any more. It was like some kind of magic" (pp. 23–4). Television kept Warhol from being contaminated through emotional contagion, but it did not exactly turn him into an empathic listener. It was a means of avoiding introspection as well as serious relationships, of denying his inner life as well as those of his friends. The whole story of the postmodern conception of art as a diversionary strategy is contained in this important anecdote. In general, the theme of seriously disturbed friends is a leitmotiv of Warhol's account of his life, with Warhol not so much

above the storm of their emotions as in its quiet center. That is, he was not so much aloof as indifferent. In a way, he was mocking the "neutrality" of the psychoanalyst.

Warhol, in "Warhol in His Own Words," p. 465, remarks that "now and then someone would accuse me of being evil — of letting people destroy themselves while I watched, just so I could film them and tape record them. But I don't think of myself as evil — just realistic. I learned when I was little that whenever I got aggressive and tried to tell someone what to do, nothing happened — I just couldn't carry it off. I learned that you actually have more power when you shut up, because at least that way people will start maybe to doubt themselves. When people are ready to, they change. They never do it before, and sometimes they die before they get around to it." The last sentence shows Warhol's cynicism at its profoundest. Also, it seems clear that he was silent because he felt, as he did as a child, helpless to change the course of human events. In general, he was not so much detached, as has been thought, but incapable of being involved. At times he seemed to show social concern: he gave leftover food to the homeless (Warhol, Philosophy, p. 70), but this was clearly part of his ironic philosophy of "recycling" (p. 93) as well as a public enactment of his private obsession with cleaning up (p. 218). Also it seems likely that it was a publicity stunt — the food was somewhat fancy — staged to conform to the public's expectation that the stars share their wealth through philanthropy as a gesture of noblesse oblige. In other words, it was a simulated charity event. Warhol, "Warhol in His Own Words," p. 466, said that "publicity is like eating peanuts. Once you start you can't stop." See John Russell, "The Season of Andy Warhol: The Artist as Persistent Presence," New York Times, April 11, 1988, p. C13, for a review of Warhol's policy of publicity. Is it possible that Warhol's art was simply a publicity stunt to make him famous, nothing but self-promotion? It certainly deserves a place in Candice Jacobson Fuhrman's Publicity Stunt! Great Staged Events That Made the News (San Francisco, Chronicle Books, 1990), an account of publicity stunts that made business history.

As for being evil, Warhol was in fact cruel, especially to those closest to him. Diana Vreeland, D.V. (New York, Random House, 1985), pp. 255–6, describes a telling incident of sadism. Her eyesight was so poor that at first she did not notice that Warhol had an assistant with him when he came to photograph her. She remarked that he didn't need one. But Warhol said she would like the assistant, because "he's very good-looking." Vreeland asked him if that was in fact the case. The assistant was Chinese, and did not understand English, so he said nothing. As Vreeland said, "You never know what you're going to get with Andy Warhol." Warhol in effect mocked Vreeland, for he knew she saw too poorly to determine whether the assistant was in fact good-looking. Warhol's perversity here is particularly noteworthy, because it has to do with looks, that is, with the visual medium that was his own and Vreeland's. For the argument that Warhol's imagery is inherently sadistic see my "Andy's Feelings," The New Subjectivism: Art in the 1980s (Ann Arbor, Mich., UMI Research Press, 1988), pp. 397–402.

When not relating to people with his usual understated sadism, Warhol seduced them with success and then in effect abandoned them, in incomprehension of their inner life. Perhaps the most notorious instance of this was his relationship with Jean Michel Basquiat, with whom Warhol made collaborative works in 1985. Basquiat died of a drug overdose on August 12, 1988, at the age of 27. See Cathleen McGuigan, "New Art, New Money: The Marketing of an American Artist," New York Times Magazine, February 10, 1985, pp. 20–8, 32–5, 74; "Jean Michel Basquiat: Hazards of Sudden Success and Skyrocketing

Fame," *New York Times,* August 27, 1988, p. C10; and Phoebe Hoban, "SAMO Is Dead," *New York,* September 26, 1988, pp. 36–44. " 'I'm going to be a famous artist,' Basquiat would say often" (p. 43). The ambition to be a famous artist is mocked by Réne, an artist whose only works are paintings on Soho walls of the words "I Am the Best Artist" in giant letters. See "A Wall in Soho; Enter 2 Artists, Feuding," *New York Times,* November 6, 1990, p. B1. For context, consider that in 1988 at the Tunnel there was an exhibition of works by Picasso, Dali, Warhol, and LeRoy Neiman, among others, titled "The Most Famous Artist Alive," accompanied by "exotic belly dancing."

Basquiat and Warhol were of course hardly the only artists who pursued fame and fortune through art. Perhaps the most tragic cases are those of husband Carl Andre and wife Ana Mendieta. She supposedly committed suicide because they "had a quarrel about the fact that I was more . . . exposed to the public than she was." Quoted in Jan Hoffman, "Rear Window, The Mystery of the Carl Andre Murder Case," *Village Voice,* March 29, 1988, p. 25. Mendieta, like Andre, was on a "we're-gonna-be-famous high." Robert Katz, *Naked by the Window: The Fatal Marriage of Carl Andre and Ana Mendieta* (Boston, Atlantic Monthly Press, 1990), p. 21.

14. Warhol, *Philosophy,* p. 92, describes his realization "that 'business' was the best art," and that "making money is art." On p. 200 he describes his obsession with, envy of, and awkward attempt to imitate the rich, down to the detail of the way they eat and talk. Imagining himself president (p. 14), he made Robert Scull "head of Economics . . . because he would know how to buy early and sell big." "My ideal wife," Warhol writes on p. 46, "would have a lot of bacon, bring it all home, and have a TV station besides." At the same time, he fantasized "that people who are really up-there and rich and living it up have something you don't have, that their things must be better than your things because they have more money than you." Warhol, *Philosophy,* pp. 100–1, recognizes that in America "the richest consumers buy essentially the same things as the poorest," which is "what's great about this country." But while "Think rich. Look Poor." may have been his motto (p. 103), in fact he emulated Robert Scull, as the art fortune he amassed indicates. Warhol's capitalist mentality is also shown in his conception of the artist as "somebody who produces things that people don't need to have but that he . . . thinks it would be a good idea to give them" (p. 144). This exemplifies the Marxist idea that capitalism encourages people to need things they don't need, including, according to Warhol, art.

See the cover stories, with cover photographs of Warhol (the ultimate publicity), "Andy's Empire, Big Money and Big Question," *New York,* February 22, 1988, pp. 32–9, and "The Selling of Andy Warhol" or "Art for Money's Sake," *Newsweek,* April 18, 1988, pp. 60–4. According to the author of the *New York* article, "The total value of the Warhol estate may run between $75 million and $100 million" (p. 35). (Recent estimates have put its value at close to $600 million.) The *Newsweek* article was followed by one on "The Art Auction Boom." Despite the fact that the art market is in sharp recession, as suggested by "Art Auctioneers Glumly Take Stock," *New York Times,* August 19, 1991, the art world continues to measure value by economic success if it is not entirely money-mad. Thus the cover story of the October 1991 issue of *Connoisseur* is about "Brice Marden: Millionaire Minimalist." In the November 1991 issue of *Vanity Fair* is an article titled "Art or Commerce?" on Jeff Koons, "the ultimate eighties art star." There has clearly not been much change in attitude since the October 15, 1984 issue of *Newsweek* ran a story on "Golden Paintbrushes," subtitled "Artists are developing a fine eye for the bottom line." Koons, incidentally, has made publicity into a fine (?) art – tautologizing fame

as it were – to the extent that his art has come to be regarded as simply a matter of publicity. See "The Art of P.R., and Vice Versa," subtitled "For Jeff Koons, it seems, and many other artists, to be seen is to exist," *New York Times*, October 27, 1991. Koons created controversy through his use of quasi-pornographic imagery, but controversy generates publicity and raises prices, as indicated by "Publicity Is Enriching Mapplethorpe Estate," *New York Times*, April 16, 1990. The "capitalization" of art has become complete when the museum of art is regarded as a treasury and royal palace in one, as suggested by the January 4, 1989, *New York* cover story "Party Palace, The High Life at the Gilded Metropolitan Museum." Warhol simply led the way. (In a sense, he was more in the social than in the art avant-garde.) For an account of "The Marriage Between Art and Commerce" see Stuart Ewen, *All Consuming Images: The Politics of Style in Contemporary Culture* (New York, Basic, 1988), pp. 47–53. Warhol's works can be understood as all-consuming media images reduced to commercial as well as stylistic absurdity.

15. Hermann Broch, "Der Kitsch" in "Das Böse im Wertsystem der Kunst," *Dichten und Erkennen, Essays*, Vol. 1 (Zurich, Rhein, 1955), p. 348, argues that Nero, when he burned Christians while playing the lute, exemplified the attitude of kitsch, which values theatrical spectacle – "aesthetic" appearance in general – above ethical values. Kitsch is thus "radical evil."

16. *Newsweek*, December 2, 1991, p. 72.

17. See my "Sincere Cynicism," *Arts Magazine*, 65 (November 1990):60–5, for a further discussion of this idea. Erich Fromm, *The Greatness and Limitations of Freud's Thought* (London, Jonathan Cape, 1980), p. 26, argues that the conflict between "consciousness of faith" and "unconscious cynicism and complete lack of faith" is one of the major issues, personal and social, that exist in our time. Warhol seems to have been consciously cynical. He was able to make cynicism fashionable only because society no longer had faith in itself. Does reproduction come to the fore as a cynical mode of art making when society no longer believes it has the organic capacity to be creatively productive? Is cynicism a defense against creative decadence? John Guttman's 1934 photograph of Hollywood figures, *Cynics*, suggests the link between a mentality which thinks in terms of media clichés – such as Warhol's – and cynicism. See Peter Sloterdijk, *Critique of Cynical Reason* (Minneapolis, University of Minnesota Press, 1987) for a consummate discussion of cynicism.

Postmodern loss of faith in art or cynicism about it, in contrast to modern faith in its transcendence and healing power, seems epitomized by the difference between Warhol and Reinhardt. "Art," said Reinhardt, "is not the spiritual side of business." Barbara Rose, ed., *Art as Art: The Selected Writings of Ad Reinhardt* (New York, Viking, 1975), p. 56. For Warhol, art was just that. Reinhardt was quite aware of Warhol, whom he regarded as temptation incarnate – the ruin of art. "But finally it was Andy Warhol. He has become the most famous. He's a household word. He ran together all the desires of artists to become celebrities, to make money, to have a good time, all the surrealist ideas. Andy Warhol has made it easy. He runs discothèques. . . . " (p. 27). Long before the current triumph of Warholesque cynicism, Reinhardt clearly understood the difference between keeping faith with art and using it cynically: "Without a true academy, high ideals, rational standards, and a formal, hieratic, grand manner, we have only our overcrowded, ignoble profession. We are, with Jack Paar, 'for anything that catches on,' and though some scoff, some of us, with Liberace, 'laugh all the way to the bank,' and with Lawrence Welk and his champagne music, 'We hope you like our show, folks' " (p. 208).

18. Warhol's sense of humor is hardly that of Duchamp, but he writes in *Philosophy*, pp. 48–9: "Some people can have sex and really let their minds go blank and fill up with sex. . . . The other type has to find something else to relax with and get lost in. For me that something else is humor. Funny people are the only people I ever get really interested in, because as soon as somebody isn't funny, they bore me. . . . If I went to a lady of the night, I'd probably pay her to tell jokes."

19. Warhol's preference for emptiness seems to be a projection of his own sense of inner emptiness. Warhol, in *Philosophy*, p. 144, writes: "When I look at things, I always see the space they occupy. I always want the space to reappear. . . . I believe that everyone should live in one big empty space. It can be a small space, as long as it's clean and empty." His portraits can be understood as an emptying of the inner space of their subjects, and as such a desubjectifying of them.

20. Warhol, *Philosophy*, pp. 13–15. On p. 100, Warhol remarks that "the President has so much good publicity potential that hasn't been exploited. . . . I fantasize about what I would do if I were President – how I would use my TV time."

21. Heinz Lichtenstein, "Identity and Sexuality: A Study of Their Interrelationship in Man," *Journal of the American Psychoanalytic Association*, 9 (1961):206.

22. D. W. Winnicott, "Primitive Emotional Development," *Through Paediatrics to Psycho-Analysis* (London, Hogarth and the Institute of Psycho-Analysis, 1958), pp. 152–3.

23. Warhol, with his "affectless gaze" (p. 10), was an important (non)presence in Germano Celant's exhibition *Unexpressionism* (New York, Rizzoli, 1988).

24. Jochen Schulte-Sasse, "Theory of Modernism versus Theory of the Avant-Garde," Foreword to Peter Bürger, *Theory of the Avant-Garde* (Minneapolis, University of Minnesota Press, 1984), p. xxi.

25. Kenneth J. Gergen, *The Saturated Self: Dilemmas of Identity in Contemporary Life* (New York, Basic, 1991), p. 134.

26. Ibid., p. 137.

27. Ibid., p. 147.

28. Ibid., p. 166.

29. I would argue that regression to prepsychological flux – in which all inner structure is lost, or in which fragments of structure float disconnectedly – while in a sense impossible, is necessary for truly original creativity. It can be viewed positively as a "creative flux," to use Whitehead's term, rather than negatively to articulate a theoretical extreme of disintegration of the self, as Kohut does. Regardless, regression to primordial flux, the dissolving of known structures and codes, signifies unconscious awareness of creative possibility in what would otherwise be experienced as a claustrophobically closed system of authoritarian objective forms. The reversal of objectivity implied – the resubjectification of experience to a no doubt dangerous extreme from which there may be no return (but then there seemed no return from overobjectivity) – is inseparable from creativity. (Creativity in fact testifies to return from extreme subjectivity – but not to extreme objectivity – and can be understood as the effort of return, however aborted the return may seem in the objective work of art that is its vehicle. Creativity establishes the dialectical balance between the subjective and objective without necessarily generating a work that satisfies a conventional sense of what the balance between them should be.) As has been said, the artist can tolerate regression and return from it refreshed, and the potentially great artist can tolerate regression to the point of disintegration and return from it original, that is, with a new idea of integration – an unexpected reintegration.

Heinz Kohut, *The Restoration of the Self* (New York, International Universities Press, 1977), pp. 286–7, admits as much. "The musician of disordered

sound, the poet of decomposed language, the painter and sculptor of the frag-
mented visual and tactile world: they all portray the breakup of the self and,
through the reassemblage and rearrangement of the fragments, try to create
new structures that possess wholeness, perfection, new meaning. The message
of the greatest of them – Picasso's perhaps . . . – may be expressed with such
visionary originality, through the employment of such unconventional means,
that it is still not easily accessible." If this account of disintegration and rein-
tegration is a psychologically accurate description of what occurs in avant-
garde art, then Warhol neither disintegrates nor reintegrates himself, but
remains mechanically self-same and peculiarly primitive and simultaneously
uniform, or fixed in structure – and as such is uncreative.

Warhol introduces some fluidity into static images of the self, but that is
hardly a creative act. He superficially enlivens them, creating an effect of what
Kohut, *Restoration*, p. 5, calls "pseudo-vitality," an "overt excitement" behind
which "lie low self-esteem and depression – a deep sense of uncared-for worth-
lessness and rejection, an incessant hunger for response, a yearning for reassur-
ance." Pseudovitality is "an attempt to counteract through self-stimulation a
feeling of inner deadness" – Warhol's sense of being nothing. Giving a perfect
example of his sense of being inwardly dead, Warhol writes: "Before I was shot,
I always thought that I was more half-there than all-there – I always suspected
that I was watching TV instead of living life. People sometimes say that the
way things happen in the movies is unreal, but actually it's the way things hap-
pen to you in life that's unreal. The movies make emotions look so strong and
real, whereas when things really do happen to you, it's like watching tele-
vision – you don't feel anything" (Warhol, *Philosophy*, p. 91). When Warhol
decided to be a "loner," he unwittingly reified his unconscious – and not-so-
unconscious – sense of feeling and being nothing (p. 24).

The sense of the discrepancy between feelings in the movies and television
and feelings in life – between artificial and real feelings – is the American way
of expressing decadence, that is, of conveying the feelinglessness of living death.
It is no doubt true to many people's experience in the media age; Warhol was
clearly the prophet of its psychotic character, suggesting that he was well-
adapted to it by reason of his own psychotic character. But the key point is that
for Warhol creativity – such as it is – is defensive against the psychotic sense of
nothing. It is not transmutative and integrative, creating something surprisingly
new and thus does not overcome psychosis. In this Warhol exemplifies the post-
modernist artist's attitude toward modernist art, for the postmodernist artist
is struggling with the depression and sense of defeat that creative, original
modernist art induces in him. He takes his revenge on the avant-garde the way
Warhol took his revenge on the creative self, namely, by making it seem simul-
taneously garish and stale.

30. Warhol admitted as much. He was awkward with people, as he acknowledged
in the example – did he intend it to generate sympathy for him? – of his em-
barrassment with maids, because of their job of cleaning up after one (Warhol,
Philosophy, p. 102). He felt physically uncomfortable and unattractive as well,
making a virtue of the fact by declaring that "a good plain look is my favorite
look" (p. 68).

6. Enchanting the Disenchanted

1. Quoted in Moises Kijak, "Further Discussions of Reactions of Psychoanalysts
to the Nazi Persecution, and Lessons to be Learnt," *International Review of
Psycho-Analysis*, 16, Part 2 (1989):215.

2. Ibid.
3. Quoted in Caroline Tisdall, *Joseph Beuys* (New York, Guggenheim Museum, 1979; exhibition catalogue), p. 23.
4. Götz Andriani, Winfried Konnertz, Karin Thomas, *Joseph Beuys: Life and Works* (Woodbury, N.Y., Barron's Educational Series, 1979), p. 13. Beuys also said: "The human condition is Auschwitz. . . . I have found myself in permanent struggle with this condition and its roots. I find for instance that we are now experiencing Auschwitz in its contemporary character. This time bodies are outwardly preserved (cosmetic mummification) rather than exterminated, but other things are being eliminated. Ability and creativity are burnt out: a form of spiritual execution, the creation of a climate of fear even more dangerous because it is so refined." Quoted in Tisdall, *Joseph Beuys*, p. 23.
5. Beuys and Warhol have been linked in the exhibition "Beuys and Warhol: The Artist as Shaman and Star" at the Boston Museum of Fine Arts (1992). Trevor Fairbrother, the curator of the exhibition, writes; "The bewigged Warhol and the behatted Beuys were savvy and charismatic. They projected both the ceremonious aura of the shaman (the tribal healer, priest, and leader) and the brand-name allure of the star (the commercialized fame-driven performer). Although they did not meet until 1979, they had long recognized that they shared certain unconventional approaches." Quoted by Patricia Hills, "Beuys, Warhol, and Curatorial Interventions," *Art New England*, 13 (February–March 1992):24.
6. W. Ronald D. Fairbairn, "Object-Relationships and Dynamic Structure," *Psychoanalytic Studies of the Personality* (London, Routledge & Kegan Paul, 1952), p. 145, distinguishes between "*Infantile Dependence* . . . chiefly manifested in an attitude of oral incorporation towards, and an attitude of primary emotional identification with the object," and "*Mature Dependence* . . . [which] is characterized by a capacity on the part of the differentiated individual for co-operative relationships with different objects." "Independence" is an illusory ideal of maturity, in that "a capacity for relationships necessarily implies dependence of some sort."
7. Theodor W. Adorno, "Cultural Criticism and Society," *Prisms* (Cambridge, Mass., MIT Press, 1983), p. 34.
8. Theodor W. Adorno, *Aesthetic Theory* (London, Routledge & Kegan Paul, 1984), p. 17, writes: "Art's *promesse du bonheur*, then, has an even more emphatically critical meaning: it not only expresses the idea that current praxis denies happiness, but also carries the connotation that happiness is something beyond praxis."
9. Theodor W. Adorno, "Commitment," *The Essential Frankfurt School Reader*, eds. Andrew Arato and Eike Gebhardt (New York, Continuum, 1985), p. 312.
10. Ibid., p. 313.
11. Beuys said that "the concept of politics must be eliminated as quickly as possible and must be replaced by the capability of form of human art. I do not want to carry art into politics, but make politics into art." Quoted in Adriani et al., *Beuys*, p. 277. As Tisdall, *Joseph Beuys*, writes, Beuys had a "passionate conviction that faith in state, government and political parties can only lead to disaster" (p. 16). He came to this realization through his war experiences, which had a "shattering and complex" effect on him. The "collective trauma" of World War II "was a totally alienated and ignoble struggle of brute force and vested interest" (ibid.).
12. Adorno, *Aesthetic Theory*, p. 18, writes that "art does not come to rest in disinterestedness. It moves on. And in so doing it reproduces, in different form, the interest inherent in disinterestedness. In a false world all *hedone* is false. This

goes for artistic pleasure, too. Art renounces happiness for the sake of happiness, thus enabling desire to survive in art."

13. Speaking about "the objects and drawings related to Auschwitz which he had done over the years and placed . . . in a single showcase," Beuys remarked: "I do not feel that these works were made to represent catastrophe, although the experience of catastrophe has certainly contributed to my awareness. But my interest was not in illustrating it, even when I used the title *Concentration Camp Essen*. This was not a description of the events in the camp but of the content and meaning of the catastrophe. That must be the starting point – like a kind of substance – something that surmounts *Concentration Camp Essen*. Similia similibus curantur: heal like with like, that is the homeopathic healing process." Quoted in Tisdall, *Joseph Beuys*, p. 21. Tisdall, p. 17, notes that the "ritualistic respect for the healing potential of materials" was an essential part of Beuys's art. He conceived his use of them as "a psychoanalytical action in which people could participate" (ibid.).

14. The ideas here continue the line of thought about the Germans developed in Alexander Mitscherlich, *Die Unfähigkeit zu trauern* (Munich, Piper, 1967), and in Heinz Kohut, *Self Psychology and the Humanities,* ed. Charles B. Strozier (New York, Norton, 1985). Kohut, p. 63, writes: "Narcissistic blows are unavoidable and the propensity to respond to them with rage is ubiquitous. The question, then, is what historical circumstances will provoke a large part of a nation (like the Germans under the Nazis) to develop increased narcissistic vulnerability and become susceptible, on the one hand, to undertake a supra-individual, nationally organized vendetta of merciless persecution, genocide, war, and destruction and, on the other hand, to pursue a vision of total control over the world?" While, as Kohut says, the presence or absence of "a gifted pathological leader" (such as Hitler) "might well decisively influence the course of events, group regression, independence of a leader's influence, [occurs] in a variety of ways" (p. 63). Two "lines of regression" develop. One leads "to such manifestations as inclinations toward vague mystical religiosity . . . and the search for an external embodiment of the omnipotent self-object into whom one can merge" (p. 64). The other "leads to the reinforcement of archaic grandiosity, attitudes of intolerant certainty, arrogance, and the extolling of an external embodiment of the grandiose self in the nation" (p. 64). In such situations of social regression, "creativity in all fields is choked off. There is no one in empathic touch with the diseased group self" (p. 84).

Nazi Germany, of course, choked off avant-garde art. But even in Weimar Germany, many people from "all classes and . . . with all levels of education . . . were not in touch with modern German art and felt preconsciously that modern German art was out of touch with them" (p. 89). They were disappointed with "the fact that their artists had failed to understand their needs and had failed to portray them with any degree of sensitivity" (p. 89). "The Nazis accurately reflected" this disappointment in their labeling of avant-garde art as "degenerate" (p. 89). Kohut writes, p. 89, that "the leading experimental art of the Weimar republic . . . had switched from dealing with man's conflict to dealing with man's suffering a defected, fragmented, depleted self. But, like an inaccurately focused interpretation in therapeutic analysis, it was off center and too far away from Germany's particular experience; it was too general. Furthermore, the artists themselves were . . . outsiders who had become insiders. Perhaps their lingering resentment made them either oblivious to the prevailing psychological needs or contemptuous of them." According to Kohut, "initial formal strangeness" was less the cause of resistance to avant-garde art than the audience's unconscious sense that the art did not empathically address and understand its needs, especially its need for healing, narcissistic and in general.

It should be noted that Beuys (and later Kiefer) attempted to redress this avant-garde wrong, which added narcissistic insult to narcissistic injury – thus further wounding German pride and intensifying (indeed, hardening) regressive German attitudes – by using avant-garde methods to deal with Germany's particular experience. Their art is an attempt to form a therapeutic alliance with its German audience. Particular works are meant to function as focused interpretations of its tragic narcissism, effecting a cure. Indeed, the repetitiveness of many of their works is reminiscent of the repetitiveness – the seemingly endless working through, the seemingly interminable going over and retracing the same ground, as if it had become blurred through amnesia – ultimately necessary to effect a fundamental change in psychosocial attitude.

15. Kijak, "Further Discussions" p. 214, writes that "no genocide ever had such an efficient organization" as "the German genocidal project." "Everything was perfectly organized, like a factory in which nothing is left to improvisation. Nothing was lost that might be put to use from the victims: their goods, their capacity for work as slaves (the branches of the I. G. Farben and Krupp factories near the gas chambers) and, after they had been killed, their clothes and shoes, their orthopaedic appliances and gold teeth, their hair. Everything was strictly recorded and distributed. Never was a genocide carried out with such perfect co-ordination between the political, military and spiritual leaders and their respective subordinates. Science never contributed so much and, in its way, never became so 'enriched' as during the Nazi genocide."

16. Friedrich Nietzsche, *The Birth of Tragedy from the Spirit of Music* in *The Philosophy of Nietzsche* (New York, Random House, 1927), p. 985. Fritz Stern, *The Politics of Cultural Despair: A Study in the Rise of the Germanic Ideology* (Berkeley, University of California Press, 1974), pp. 116–27, discusses the idealization of art by certain twentieth-century German thinkers, particularly as an instrument of revolt against science. For a discussion of Beuys's sense of art as a healing process involving the warming of cold structures and systems to life see my "Joseph Beuys: The Body of the Artist," *Artforum,* 29 (Summer 1991):80–6.

17. As Beuys has said, "I inform people only of their possibilities." Quoted in Adriani, Konnertz, and Thomas, *Beuys,* p. 242.

18. Ibid., p. 66.

19. Ibid., p. 18. Beuys was in fact wounded five times in World War II, and received the gold ribbon for the wounded. Tisdall, *Joseph Beuys,* p. 21, points out that "the idea of the wound . . . runs through his work in every medium."

20. Beuys was involved in the founding on June 1, 1971, of the Organisation für direkte Demokratie durch Volksabstimmung (Freie Volksinitiative, e. V.) (Organization for Direct Democracy through Referendum [Free People's Initiative, Inc.]) and on June 24, 1977, of the Freie Internationale Hochschule für Kreativität und Interdisziplinäre Forschung (Free International University for Creativity and Interdisciplinary Research). Heiner Stachelhaus, *Joseph Beuys* (New York, Abbeville, 1991), p. 91, points out that Beuys's famous *"Aufruf zur Alternative,"* which first appeared in the *Frankfurter Rundschau* on December 23, 1978, was the "fundamental document" of the social program of the Green Party. Beuys's conception of direct democracy was modeled, as he acknowledged, on Rudolf Steiner's Bund für Dreigliederung des sozialen Organismus (Alliance for the Three Structures of the Social Organism), founded in 1919. As Adriani, Konnertz, and Thomas, *Beuys,* write (pp. 220–1), Steiner's "basic idea . . . was that the social life of mankind could only be healthy if it was consciously structured. The independently developed individual should no longer recognize the total power of the state. The working power of the individual should not be degraded as a commodity. . . . To attain these goals . . . there

needs to be an independence of state, economy, and intellectual life," that is, "liberty in spirit, equality before the law, fraternity in economic matters." Steiner proposed a revitalization of "the old ideals of the French Revolution." Beuys's Organization für direkte Demokratie was explicitly intended to heal a sick society and to realize Steiner's conception of the ideal – healthy – social organism. For Beuys, art was in the service of social health, from which individual health would follow.

21. In 1968 Beuys was accused by nine of his fellow professors at the Düsseldorf Art Academy "of endangering the orderly working of the academy through political dilettantism, demagogic practice, intolerance, defamation, and striving for power." In 1972 he was dismissed from his position at the academy. He sued, and after six years won the right to retain "the title of professor in Düsseldorf" – while working at the Vienna school of applied arts – and his room in the academy, which he used as a branch of the Free International University. Adriani, Konnertz, and Thomas, *Beuys*, pp. 178–80, 254–62. Beuys was called a "misfit," involved in "revolutionary show business," where he performed "Jesus-kitsch."

22. Quoted in Adriani, Konnertz, and Thomas, *Beuys*, pp. 107–8.

23. Tisdall, *Joseph Beuys*, pp. 16–17, discusses the "absolutely determining power" of Beuys's experience among the Tartars. In 1943 his airplane was shot down in a snowstorm. "He was found unconscious among the wreckage by Tartars," who saved him from death. "They wrapped my body in fat to help it regenerate warmth, and wrapped it in felt as an insulator to keep the warmth in." Thus originated the primary materials of his art. The idea of the shaman also came from the Tartars, although since childhood Beuys had fantasized himself a shepherd. Adriani, Konnertz, Thomas, *Beuys*, p. 12.

24. Quoted in Tisdall, *Joseph Beuys*, p. 44.

25. Ibid.

26. Quoted in Adriani, Konnertz, and Thomas, *Beuys*, p. 98.

27. Ibid., p. 111.

28. Ibid., p. 72. See also the discussion of pre-psychological flux in Chapter 5, note 29, especially in conjunction with Beuys's involvement in Fluxus (pp. 87–95).

29. Ibid., p. 92.

30. Following mystical tradition, Beuys believed that animals had "extraordinary powers." They could "pass freely from one level of existence to another." Quoted in Tisdall, *Joseph Beuys*, p. 21. Beuys drew the horse, the swan, and the hare, and performed with a dead hare ("How to Explain Paintings to a Dead Hare," Düsseldorf, 1965, and "Eurasia," Copenhagen, 1966) and a living coyote ("I Like America and America Likes Me," New York, 1974). See also his sculptures "Two Hares and an Easter Egg" and "The Unconquerable," both 1966. The latter depicts a small toy soldier taking aim at an indestructible giant hare.

31. Mircea Eliade, quoted in Tisdall, *Joseph Beuys*, p. 36.

32. Quoted in Adriani, Konnertz, and Thomas, *Beuys*, p. 12.

33. Ibid., p. 11.

34. Eliade, quoted in Tisdall, *Joseph Beuys*, p. 36.

35. Quoted in ibid., p. 34.

36. Ibid.

37. Ibid., p. 23.

38. See my "Beuys: Fat, Felt, and Alchemy," *The Critic Is Artist: The Intentionality of Art* (Ann Arbor, Mich., UMI Research Press, 1984), pp. 345–58.

39. Quoted in Tisdall, *Joseph Beuys*, p. 23.

40. Ibid., p. 21.

41. Ibid., p. 214. "Show Your Wound," 1976, is intended to be an explicit demonstration of this (pp. 214–16). In 1978 Axel Hinrich Murken published *Joseph Beuys und die Medizin*, taking Beuys seriously as a healer (p. 217).

42. Adorno, p. 31.

43. Adriani, Konnertz, and Thomas, *Beuys*, p. 275, describe the classic case, Beuys's use of fifty copies of the *Wall Street Journal* in "I Like America and America Likes Me," 1975. "The coyote urinated on the newspapers. Beuys remembers that which is lost to us: the natural reference to the world, the obvious intercourse with nature."

44. John E. Gedo, *The Mind in Disorder: Psychoanalytic Models of Pathology* (Hillsdale, N.J., Analytic Press, 1988), p. 190. Such disruption can be in the service of creativity, in that it can be a mode of rebellion against the world of bureaucratized symbols. Beuys said that "the creativity of the democratic is increasingly discouraged by the progress of bureaucracy," and is also hidden "by competitiveness and success-aggression." Quoted in Tisdall, *Joseph Beuys*, pp. 278–9. The apparent loss of the capacity for symbolic thought can be a refusal to think in terms of institutionalized symbols signaling repressive social order. If, as Beuys said, "criminality can arise from boredom, from unarticulated creativity" (p. 279), then the deliberately criminal act of disrupting institutionally enforced conventions of symbolic thinking – which is what Beuys's shamanism effects – is creative. At the least, it is a breakthrough into creativity, an initial heroic articulation of it.

45. See Renato Poggioli, *The Theory of the Avant-Garde* (New York, Harper & Row, 1971), pp. 30–40, for a discussion of antagonism and pp. 65–8 for a discussion of agonism, two of the four "moments" in the avant-garde dialectic. The other two are activism and nihilism.

46. Gedo, *Mind in Disorder*, p. 91, conceptualizes "hypochondriasis as a very early form of hallucinatory wish fulfillment – one antedating imaging – in which the recall of previous somatic experiences is used as a coping device when the individual is facing a threat. Because the *typical* danger situation at the dawn of self-awareness is the loss of the sense of self, hypochondriasis is most likely resorted to when the self-organization is on the verge of disintegration."

47. Adriani, Konnertz, and Thomas, *Beuys*, p. 14, note that Beuys, when he was in secondary school in Kleve, "decided, because of his clear scientific talent, to begin a premedical course to become a pediatrician."

48. See my "The Magic Kingdom of the Museum," *Artforum*, 30 (April 1992):58–63.

49. See my "Tart Wit, Wise Humor," *Artforum*, 29 (January 1991):93–101.

7. The Decadence or Cloning and Coding of the Avant-Garde

1. Erving Goffman, "On Face-Work," *Interaction Ritual* (New York, Pantheon, 1982), p. 22.

2. Quoted in *Libro Nero*, 1952, from a statement to Giovanni Papini. The full statement is remarkably germane to the point of this book: "In art the mass of people no longer seek consolation and exaltation, but those who are refined, rich, unoccupied, who are distillers of quintessences, seek what is new, strange, original, extravagant, scandalous. I myself, since Cubism and before, have satisfied these masters and critics with all the changing oddities which have passed through my head, and the less they understood me, the more they admired me. By amusing myself with all these games, with all these absurdities, puzzles, rebuses, arabesques, I became famous and that very quickly. And fame for a painter means sales, gains, fortune, riches. And today, as you know, I am

celebrated, I am rich. But when I am alone with myself, I have not the courage to think of myself as an artist in the great and ancient sense of the term. Giotto, Titian, Rembrandt, were great painters. I am only a public entertainer who has understood his times and exploited them as best he could, the imbecility, the vanity, the cupidity of his contemporaries. Mine is a bitter confession, more painful than it may appear, but it has the merit of being sincere."

Wolfgang Max Faust's remarks about the meaning of Joseph Beuys's death are worth noting in conjunction with Picasso's disillusioning statement: "Das Zeitalter der 'Grossen Einzelnen' ist vorüber. Universalistische Weltbilder mit dem gleichsam luckenlosen Blick auf 'Einheit, Wahrheit, Finalität' – auch wenn sie aus der Perspecktive der Kunst entworfen werden – erweisen sich als wirklichkeitsverfehlende Illusion." (The age of the "great individualists" is over. Universal world pictures with the same seamless look of "unity, truth, finality" – also as they developed out of the perspective of art – show themselves as illusions lacking in reality.) "Joseph Beuys: Ein Werk Ohne Zukunft," No. 3 (1988) *Wolkenkratzer Art Journal:* 19.

3. Ingrid Sischy, "A Society Artist," *Robert Mapplethorpe* (New York, Whitney Museum in association with Boston, Little, Brown, 1987; exhibition catalogue), p. 82.

4. "Interview with Gerhard Richter by Benjamin H. D. Buchloh," *Gerhard Richter: Paintings* (New York, Thames & Hudson, 1988; exhibition catalogue), p. 16.

5. Karl Marx and Friedrich Engels, "Manifesto of the Communist Party," *Marx and Engels: Basic Writings on Politics and Philosophy* (Garden City, N.Y., Doubleday, 1959), p. 9.

6. Ibid., p. 10.

7. Quoted in Götz Adriani, Winfried Konnertz, Karin Thomas, *Joseph Beuys, Life and Works* (Woodbury, N.Y., Barron's Educational Series, 1979), p. 92.

8. Ibid., p. 119.

9. Ibid.

10. Ibid., p. 124.

11. Quoted in Caroline Tisdall, *Joseph Beuys* (New York, Guggenheim Museum, 1979; exhibition catalogue), p. 70.

12. Ibid., p. 10.

13. Peter Halley, "Abstraction and Culture," *Tema Celeste,* No. 32–3 (Autumn 1991):60, argues that "abstraction really has nothing to do with aesthetic concerns, nor can it be formally characterized by the use of specific shapes, techniques, or configurations." Rather, "abstract art is simply the reality of the abstract world." More particularly, "postwar abstraction chronicles ... the emotional blankness, emptiness, or numbness brought about by an abstract world where social relations have become as untethered as technology has." Thus Halley justifies the emotional blankness of his own abstraction and of appropriation art in general.

14. Alfred North Whitehead, *Modes of Thought* (Cambridge University Press, 1956), p. 13.

15. I am alluding to Melanie Klein's concept of the paranoid-schizoid position, in which experience is organized in terms of persecutory anxiety. In this position, one's own destructive feelings, emanating from the death drive and expressed in rage at the object, make one anxious. In self-protection and fear of retaliation, the self splits both itself and the object into good and bad parts, projecting all badness onto the object, making it hateful and hating all at once. This contrasts the depressive position, in which the self, recognizing that the object is both bad and good, continues to rage at it for the frustration it causes. However, now the self feels guilt and anxiety for the damage it has done in fantasy,

rather than fearing retaliation. See Juliet Mitchell, "Introduction," *The Selected Melanie Klein* (New York, Free Press, 1987), p. 20.

16. I am alluding to Kirk Varnedoe, *A Fine Disregard: What Makes Modern Art Modern* (New York, Abrams, 1990), p. 9, who describes the avant-garde artist in terms of the metaphor of the creator of rugby, "who with a fine disregard for the rules of football as played in his time, first took the ball in his arms and ran with it." The key point is that the "fine disregard" became objectified as the rule of a new game. The whole notion of avant-garde innovation as a "fine disregard" falsifies the anxiety and uncertainty – the desperate search for a new healing ground of art and self – implicit in it.

17. John E. Gedo, *Portraits of the Artist: Psychoanalysis of Creativity and Its Vicissitudes* (New York, Guilford, 1983), p. 284.

18. Harold Rosenberg, *The Tradition of the New* (New York, McGraw-Hill, 1965), p. 11, writes that "the famous 'modern break with tradition' has lasted long enough to have produced its own tradition. . . . The new cannot become a tradition without giving rise to unique contradiction, myths, absurdities." "In the arts an appetite for a new look is now a professional requirement, as in Russia to be accredited as a revolutionist is to qualify for privileges."

19. Gedo, *Portraits,* p. 284.

20. The difference was perhaps first articulated in Lessing's *Laocoon* (1766), where the distinction is made between the effort to carry "expression . . . beyond the limits of art," and art in which it is "subjected to the first law of art, the law of beauty." Gotthold E. Lessing, *Laocoon: Problems in Aesthetics,* ed. Morris Weitz (New York, Macmillan, 1970), p. 297. Lessing cannot imagine the art in expressing what seems beyond art, namely, "what is unsightly in nature" and life – the passions (p. 298). "These passions the old artists either refrained altogether from representing, or softened into emotions which were capable of being expressed with some degree of beauty" (p. 296). What Lessing calls the "concealment" of beauty (p. 297) is in fact repression. Lessing regards art as a defense against intense emotion rather than an expression of it as a quiddity of existence, fraught with implication for the self.

21. The film, produced in the Netherlands by Marijke Jongbloed, is titled *The Art Merry-Go-Round: Exploring the Labyrinth of the New York Art World* (1991). It is worth noting that Halley was recently the subject of a lawsuit filed by Sonnabend Gallery against the Gagosian Gallery, when he switched from the former, with whom he had shown for six years, to the latter. Sonnabend had "pre-sold the Halley works planned for [Halley's first Gagosian] show," and thus attempted to get an injunction against its opening. Halley received a "stipend" of at least $40,000 a month from Sonnabend; Gagosian apparently increased it – presumably one of the reasons for Halley's change of allegiance. See Carol Vogel, "Sonnabend Loses" in "The Art Market," *New York Times,* June 26, 1992. Halley's career shows the extent to which the significance of art has become a purely economic matter: if it sells it is "valuable." Other reasons – aesthetic, intellectual – for its importance and value are secondary, even trivial. This is why even the way the work is made does not much matter, as Halley unwittingly implies in the film. Art seems to acquire superior economic – and no doubt exhibitionistic – value when it is no longer clear what intrinsic value it has. Imparting it such luxury status amounts to a last-ditch defense of it.

22. Paul Gauguin, *The Writings of a Savage* (New York, Viking, 1971), p. 70.

23. Goffman, "On Face-Work," p. 12.

24. Ibid., p. 5, describes "a line" as "a pattern of verbal and nonverbal acts by which a [person] expresses his view of the situation [in his world of social encounters] and through this his evaluation of the participants, especially

himself." "A person may be said to *have*, or *be in*, or *maintain* face when the line he effectively takes presents an image of him that is internally consistent, that is supported by judgments and evidence conveyed by other participants, and that is confirmed by evidence conveyed through impersonal agencies in the situation. . . . The line maintained by and for a person during contact with others tends to be of a legitimate institutionalized kind" (pp. 6–7). An exhibition titled "Revolutionary Art" (all works 1968) in the Tunnel indicates how completely revolutionary art has been reduced to a social line. Thus the avant-garde degenerates into a sideshow in a disco, coming full circle from its dadaist days in the Café Voltaire in Zurich.

25. Ibid., pp. 10–11. Goffman writes that "the person who can witness another's humiliation and unfeelingly retain a cool countenance himself is said in our society to be 'heartless,' just as he who can unfeelingly participate in his own defacement is thought to be 'shameless'."

26. Ibid., p. 14.

27. Ibid.

28. Ibid., p. 19.

29. Ibid., p. 11.

30. Ibid.

31. Ibid., p. 18.

32. Theodor W. Adorno, *Aesthetic Theory* (London, Routledge & Kegan Paul, 1984), p. 45, writes: "The disproportion between the all-powerful reality and the powerless subject creates a situation where reality becomes unreal because the experience of reality is beyond the grasp of the subject. The surplus of reality is reality's undoing. By slaying the subject, reality itself becomes lifeless. . . . Modern art is as abstract as the real relations among men." On pp. 169–70 he writes: "As the helplessness of the independent subject grew more pronounced, inwardness became a blatant ideology, a mock image of an inner realm in which the silent majority tries to get compensation for what it misses out on in society. All this tends to make interiority increasingly shadowlike and insubstantial. And while art does not want simply to go along with these trends, it is impossible to conceive of art as wholly divorced from interiority." Thus "In art, the true point of reference continues to be the subject" (p. 63). "In art the subject, depending on how much autonomy it has, takes up varying positions vis-à-vis its objective other from which it is always different but never entirely separate" (p. 79). Through art, "the subject, however isolated it may be, can marshal sufficient critical reflection to avert full-scale regression" (p. 62). The dialectic of psychotic regression and critical reflection is articulated through "true modern art [which] is polarized into two extreme forms: on the one side, there is a kind of unmitigated and sad expressivity that staunchly rejects any conciliatoriness whatever and becomes autonomous construction; on the other side, there is pure construction without expression, signalling the impending eclipse of expressivity as such" and, one might add, the subject (pp. 63–4).

Leo Braudy, *The Frenzy of Renown: Fame and Its History* (New York, Oxford University Press, 1986), p. 3, argues that "the increasing number and sophistication of the ways information is brought to us have enormously expanded the ways of being known. In the process the concept of fame has been grotesquely distended, and the line between public achievement and private pathology has grown dimmer as the claims grow more bizarre." I would argue that the claim to fame grows more intense the more endangered and pathological the subject becomes. Information is the instrument of the desperate desire to be famous, but does not explain it. Fame becomes the subject's security prop, indeed, its lifeline, no doubt somewhat thin and liable to break at any moment,

but nonetheless all that it has to hold it to itself. Fame as such becomes the major achievement in such a situation, as Warhol's career suggests.

33. That is, a display of heart is obscene because it goes "against the scene," "withering" and disrupting it, by uncannily expressing what it denies. In "A Sceptical Note on the Idea of the Moral Imperative in Contemporary Art," *Art Criticism*, 7 (Autumn 1991):106–12, and in "Art and Statesmanship: A Moral Paradox and Parable," *Culture and Democracy* (Boulder, Westview, 1992), pp. 1–7, I have argued that the task of art is to create the genuinely obscene, which is hard to do because society appropriates it as the trendy scene.

34. Goffman, "On Face-Work," p. 23.

35. I am alluding to the streak of comedy and wit – comic cannibalization of the past, along with witty assertion of the self effecting it – in postmodern art, which I think is its redeeming trait. The work of St. Clair Cemin, Milan Kunc, and Ray Smith is particularly outstanding in this vein.

INDEX